UNITED STATES ARMY

MoM,

I have an emergency I need Flowers for Josei on Valentines Day! Just get her a bunch of Pink Flowers. Please do this for me Mom! Do not forget please!

When you come down after 8 weeks I'll get you money out of the ATM ok?

It really sux in here mom, the first 3 weeks are called "Total control" it's hell! but I got ordered to go to Sick call by the Drill Instructer, because my Shoulders are so tense they are cramping. He saw me grabing my shoulder and asked what was wrong. I told him I didit want to miss any trains but he ordered me to go! How lucky am I? So I got Motrin and Icy hot! Thank god. All my fire dutys have been 1st or last so I don't miss much sleep! everything is going as good as it could. Its because every one is praying for me.

Now you have to pray I don't go to Iraq, because there is going to be alot of deaths. Just pray I got stationed in America. So Josei doesn't have to wait a year for me. Or that I don't die! Gots ta go mommy I love you

Timmy

Dear mom,

I'm alive, but it really sux!
but I need the money, and it will
get really bad, but I'm getting buff
500 push ups the first day! O.K.
mom I envelope a week but
put lots of letters in there. tell Josci
I love her and dont put the
word "roster #" Just "332" I messed
up when I called her. Prt. McClellan Timothy,
I'll stick it out mom 332 "MADDOGS"
dont worry. We have to Delta company 1/50TH IN
go in the gas chamber Ft. Benning, GA 31905
next week! I'm sick, but I have not
gone to sick call. You have no clue
how mean they are. for me especially since
I never had a real father figure. Tell christi
I love him to. and you know how much
I love you. Sorry its so messy mom
but I have no time to write. They
give you imposible tasks to do in a short
time period Just so they can "smoke" you!
that means fuck you up! And they dont
let you mucles rest so $ in the morning
1 push up is like 50! got to go ma tell
all the children I love them, and tell
JJ if he Joins go in the air force for
sure! Love you mama
 Love
p.s. keep a close eye on Josci Timmy
make her baby sit alot! 969-6839

Feb 2

UNITED STATES ARMY

Moma:

1st time we got free time is today!
I'm trying to get you Family day info,
but if you ask a question - thats yelling in
your face and at least 25 push ups. I need
a picture of Christian please!

Anyway I snuck down stairs last night
and paid the guards off so I could try
to call Josci, but she didn't answer the
phone! So I called her house, and her mom
~~can~~ picked up she said she was baby sitting.
I was hoping you did your Job and you had
her baby sit, but she was out in the country
So her phone didn't work as soon as
Mrs. Dropp said "how are you?" I Just broke
down crying. It's so bad down here! Some
people in my platoon are so stupid mom! so we
get smoked all day long, but that Just helps
me keep my mind off of worrying about Josci,
but then they say something about girl friends
cheating on you in not the nicest words, but
I wont break for them, I'm going to make it
through without getting brain washed. Mom dont
forget about V-day! You should pre order
those flowers. If you want you could find
out the ~~xxxxxxx~~ info if you called Ft. Benning
and told them ~~xxx~~ you need to know what day
is family day for Delta company - platoon #3 -1/50 infantry
And they will send you info. Cuz Josci has

prom around then so we need to
see if she can even come so
I dont get my hopes up. Please
do that for me ⊗⊗⊗ mom.
So thats 3 things o.k.

1. Flowers

2. Plan for trip

3. Get info from Jose on when prom is
 and call Ft. Benning Information to
 find out when Family day is for
 Delta Company - 3rd platoon - 1/50th Infantry

Thank you so much mom
you know how I have a 1
track mind so untill I get a
letter from you I'm going to be here
staying up all night thinking about something
going wrong. I love you so much
Mom! Thank Love
 You
 Timmy sorry Pvt. McClellan

South Novato

956.7 Real

Army of one : six American

31111036688974

Content

"The U.S. military is the largest organization in the world. Roughly, we spend on our military what the rest of the world spends on its military, combined."

Rachel Maddow, in a conversation with Terry Gross,
on NPR's Fresh Air, March 27, 2012

TIMMY

Timothy McClellan, U.S. Army Infantry Veteran, born 1982, from Hibbing, Minnesota
a.k.a. **Nike**, his Army nickname

Joscelyn (or **Josci**), his ex-wife
Angelina and **Quentin**, their children
Britney (or **Brit**), his ex-girlfriend
Hope, his mother
Larry Christianson (or **Grandpa**), his grandfather
Jack, his first stepdad
Tim, his second stepdad
Erin, **JJ**, **Mikey,** and **Christian**, his brothers
Karl, his cousin
Vaughn, his friend
Uzi, his dog

2004
Hibbing, MN

I first met Timmy in Minnesota in the summer of 2004, while traveling with his brother Erin—who would later become my husband—across the United States. Erin tells me that Timmy has recently joined the Army and is now serving his first tour in Iraq. Operation Iraqi Freedom is still in its infant stages and America is not yet weary of hearing about it. The war is omnipresent; in the media and in people's conversations.

Timmy is twenty-one and has just become a father. To meet his newborn daughter Angelina, he is allowed a two-week leave after just a very short deployment time. He seems very detached from everything—the war, his daughter, his wife Joscelyn. He doesn't spend time with them, in fact, he really doesn't do much but smoke pot. I find his indifference and isolation disconcerting and fascinating at the same time. Here's this kid, in a war that everybody's talking about, and he doesn't even think it's a big deal! I can't quite wrap my mind around that. As a liberal European photo student, I don't understand why someone would join the Army voluntarily, to fight in a war that makes no sense to me, risking his life for no good reason. I remember asking Timmy several questions. I asked him: What exactly do you do all day when you're over there? Do you like being a soldier? Do you feel this war is necessary? Do you support Bush? This was the first time in my life I had ever met someone who had been part of an armed conflict.

A couple of days later, Timmy packs his bags and goes to Iraq to finish his first tour. A few months later, I move back to Switzerland and Erin moves with me.

When I first talked to Timmy interview-style in 2006, I was mostly interested in his role as father because I had started working on a project about young parents (for which I also interviewed Joscelyn). I quickly discovered that his fatherhood was connected to, and very much influenced by his job and I

expanded my questionnaire to ask him about his Army life. Two weeks after our talk, he left the U.S. for Iraq.

During Timmy's second tour, I did a lot of research on the U.S. Army, the war in Iraq, soldiers, and post-traumatic stress disorder (PTSD). I wrote down questions and notes for my next interview with him. I watched war movies and checked Timmy's Myspace profile daily to see if he was still alive. Erin and I received random emails from him assuring us that he was fine but that things were getting really bad in Iraq. "Don't worry about me, guys. I'm not going crazy," he said. In a few months, however, he would be diagnosed with severe depression and acute PTSD. His family would see a young man disintegrate before their eyes.

This book tells the story of my brother-in-law and three of his unit comrades whose lives were irreversibly altered by the war in Iraq—a war that the American public gradually lost interest in. Over the course of six years, I tried to find out what these four soldiers were going through and how, in turn, the consequences of their experiences affected their kids, their wives, friends, and parents at home.

Here's what we know:

The war in Iraq officially began on March 19, 2003 and lasted eight and a half years, until December 2011. There were 2.16 million U.S. troops—roughly 1 percent of the United States population—deployed in various combat zones between 2001 and 2010. More than 1 million Americans served in the Iraq war alone.[1]

According to the U.S. Department of Defense casualty report from May 22, 2012, 4,488 U.S. service members died while serving in Iraq. Many more troops committed suicide while in war or upon their return.[2]

The number of people who are currently displaced inside Iraq is estimated at 2.8 million, or one out of every ten Iraqis (this figure is cumulative and represents both those displaced before and after the U.S.-led invasion).[3] In 2007, the United Nations estimated that nearly 2 million Iraqis had fled the country and that number was growing by anywhere from 30,000 to 100,000 a month, with Jordan and Syria shouldering the bulk of the burden.[4]

Iraq Body Count, a British non-governmental agency that tracks only confirmed deaths, updates its estimate of war fatalities every day on their website: They calculate that about 162,000 people were killed in violence that took place from the beginning of the war until its formal end in 2011. At least 114,000 of those were civilians. The remaining deaths were of police, militia, and military personnel.[5]

The costs of the wars in Iraq and Afghanistan are often contested, as academics and critics of the component wars have unearthed many hidden costs not represented in official estimates. The most recent major report on these costs comes from Brown University in the form of the Costs of War project,[6] which states that the total cost for wars in Iraq, Afghanistan, and Pakistan is at least $3.2 to 4 trillion and counting (that is $4,000,000,000,000). The report disavowed previous estimates of the Iraq war's cost as being under $1 trillion, saying the Department of Defense's direct spending on Iraq totaled at least $757.8 billion,[7] but also highlighted the complementary costs at home, such as interest paid on the funds borrowed to finance the wars and a potential nearly $1 trillion in extra spending to care for veterans returning from combat with PTSD or other injuries through 2050.[8]

Post-traumatic stress disorder (PTSD) is a severe anxiety disorder that can develop after exposure to any event that results in psychological trauma. This event can involve the threat of death to oneself or someone else, or a threat to one's own or someone else's physical, sexual, or psychological integrity, overwhelming the individual's ability to cope.[9]

Throughout history, people have recognized that exposure to combat situations can negatively impact the mental health of those involved. High rates of PTSD in veterans have been found regardless of the war or conflict looked at. In fact, the diagnosis of PTSD originates from observations of the effect of combat on soldiers: Reports of battle-associated stress reactions appear as early as the sixth century BC. One of the first descriptions of PTSD was made by the Greek historian Herodotus. In 490 BC he described, during the Battle of Marathon, an Athenian soldier who suffered no injury from war but became permanently blind after witnessing the death of a fellow soldier.

In the early nineteenth century, military medical doctors started diagnosing soldiers with "exhaustion" after the stress of battle. This "exhaustion" was characterized by mental shutdown due to individual or group trauma—prior to the twentieth century, soldiers were expected to be emotionally tough at all times and show no fear in the midst of combat. The only treatment for this "exhaustion" was to relieve the afflicted from frontline duty until symptoms subsided, then send them back to battle. During intense and frequently repeated stress, soldiers become fatigued as a part of their body's natural shock reaction.

Although PTSD-like symptoms have also been recognized in combat veterans of many military conflicts since, the modern understanding of PTSD dates from the 1970s, largely as a result of the problems that Vietnam war veterans from the U.S. Army were still experiencing. Previous diagnoses—now considered historical equivalents of PTSD—include shell shock, battle fatigue, and traumatic war neurosis.

Rates of PTSD diagnosis increase significantly when troops are stationed in combat zones, have tours of longer than a year, or experience combat or injury. For the 2.16 million U.S. troops deployed in combat zones between 2001 and 2010, the total estimated two-year costs of treatment for combat-related PTSD are between $1.54 billion and $2.69 billion. A single PTSD diagnosis can cost $1.5 million in disability compensation over a soldier's lifetime.[10] Many soldiers awaiting the outcome of their evaluations have complained that Army doctors try to play down legitimate physical and psychological problems to reduce the long-term costs of health care and compensation. The backlog of unprocessed claims for PTSD disabilities is now over 400,000, up from 253,000 six years ago.[11]

There is a disturbing rise in homelessness among veterans all across the United States. Once veterans become homeless, they are likely to remain homeless longer than non-veterans. They are also more likely to report having serious health problems.[12]

Data from 2010 shows there are an average of 950 suicide attempts each month by veterans who are receiving some type of treatment from the Department of Veterans Affairs (VA). Seven percent of the attempts are successful, and 11 percent of

those who don't succeed on the first attempt try again within nine months. The VA reports that there are about eighteen veteran suicides a day: Every eighty minutes, a war veteran in the United States kills himself. Twenty percent of all suicides in the country in recent years were acts by veterans.[13] In 2012, more active-duty soldiers killed themselves than died in combat.[14]

This project is an attempt to break down all these numbers and statistics and focus on the single soldier—the lone-standing "Army Of One." Where do these soldiers fit into all this data? What story do they think I should tell? I wanted the veterans to understand that they owned their testimony and that this project was a collaboration. The title of this book is a reference to the U.S. Army's former recruiting slogan, which was replaced in 2006 by "Army Strong." "Army Of One" refers to the possibilities that the military has to offer: Be all you can be, take your future and your life into your hands and you will be as powerful as a whole army. Yet for many soldiers, it takes on the opposite meaning: You are a warrior on your own and the Army does not care at all about you as an individual. It saddens me tremendously to see how utterly alone many of these soldiers are. They continue to fight a war that they may never win.

1 www.journalistsresource.org/studies/society/health/psychological-costs-war-military-combat-mental-health

2 Get your daily casualty report at www.defense.gov/news/casualty.pdf

3 Internal Displacement Monitoring Centre, March 2010

4 www.unhcr.org/pages/49e486426.html

5 www.iraqbodycount.org

6, 7, 8 www.costsofwar.org

9 American Psychiatric Association (1994), Diagnostic and statistical manual of mental disorders: DSM-IV, Washington, DC: American Psychiatric Association, ISBN 0-89042-061-0

10 Veterans Affairs Faces Surge of Disability Claims, by James Dao, published May 16, 2012 in The New York Times

11 Branding a Soldier With Personality Disorder, by James Dao, published February 24, 2012, in The New York Times

12 According to a new report by the 100,000 Homes Campaign,
 www.100khomes.org, see also: Study Finds Homeless Veterans
 Stay Homeless Longer Than Others, by James Dao,
 published November 8, 2011, in The New York Times blog "At War"

13 www.armytimes.com/news/2010/04/military_veterans_
 suicide_042210w

14 www.guardian.co.uk/world/2013/feb/01/us-military-suicide-
 epidemic-veteran

Timothy McClellan

2006
Fort Hood, TX

*Timmy and Joscelyn live in a cookie-cutter home off post in
Killeen, the town next to Fort Hood where Timmy is stationed.
He usually gets up at 4:30 a.m. for PT and then goes back on
base for regular training later in the day. Timmy complains
about having to go to work every day, but with his unit being
deployed in two weeks, the soldiers have more time off than
usual.*

*Timmy is charismatic and jovial, especially when he drinks.
Every night after the kids go to bed, the four of us—Timmy,
Joscelyn, Erin, and I—sit out on the porch and talk. Just like
when I first met him, Timmy seems virtually unperturbed by
his war experiences. Yet many of the things he says are dark
and scary and sad.*

*Timmy and Joscelyn's relationship is rocky and things be-
tween them can, and do change quickly. At least once during
the two weeks we're here, Joscelyn cries to me while Timmy is
at work. They fight and bicker and openly talk about divorce.
Timmy tells me: "I'm so glad you guys are here—I haven't had
a real conversation in so long. I don't want you to leave."*

I've always known I was gonna join the Army. Because my
grandpa, who's pretty much my...idol, I guess, was in the
Army, he was Infantry—he was in the Korean War—and I've
always wanted to be like my grandpa, so that's pretty much
why I joined. My parents weren't gonna pay for college and
I needed to go out and have money, start a life, so I joined the
Army because they would pay for college for me. I'll have a
full scholarship and can study whatever I want wherever I
want when I get out. It's just a set limit of 50,000 dollars to
spend on books, classes, whatever.

I've always had a lot of jobs. Like, during high school.
I've always worked since I was able to work, which none
of my brothers have done...I used to mow lawns. And then

when I turned sixteen, I worked at Dairy Queen. After that, I worked at the Social Security office, the library, and then, after I graduated, I worked at Wal-Mart, and then I was like, I need a career . . . I need to go to college, and I need to pay for college, so. . . .

I already knew what job I was gonna do, the same job as my grandpa. The recruiters didn't have to sell me on anything. I just said, "I'm ready to sign up." And a month after that, I went to basic training. Before I went to basic training, I'd never really left my family. I guess I'm a pretty strong family guy—I really like my family—and I got really homesick. Like really, extremely homesick. So it was a lot harder for me than for the other soldiers. The physical part wasn't hard, the mental part was definitely a lot harder for me, the first half, and then, I don't know, you just kind of get broken in, and then it's fine.

Boot camp lasted for four months and I expected it to be horrible. It turned out to be even more horrible than I thought it would be, though, because they wouldn't just mess with you. They would mess with you saying that your girlfriend back home is cheating on you. Just any possible way to break you down, to make you feel like shit, they would definitely do it. That's what I hated about it.

Josci and I were dating before I went to boot camp and we got married a week after I got out of basic training. I definitely wanted to have a family, but I wanted to get a career going that I wanted, not the Army, like, after the Army, and be financially secure, before I started a family. We didn't try to get pregnant with Angelina. It was an accident. It's actually a really funny story. Did she never tell you? She came to me and she said, "I'm pregnant," and I said, "Oh, no!" She started crying. I mean I'm happy and I'm glad I have my kids, but I wish I could have had my kids later in life. I wouldn't take it back for anything, but I just wish I had had them later in life. Definitely. But when I heard that Josci was pregnant, I immediately thought, this sucks for the kids, because we're not in a good financial situation. We have money, but I mean, it's paycheck to paycheck. And it's just enough every month and it's really annoying to live like that, especially with kids,

because I just want the best for them. That's the way I feel.
I feel they should have a house, everything that they need.
They do have everything they need, but they deserve more.
So I wish I had more money.

We save up for their college education. Basically, when we
have an abundance of money, we put it away. When I go to
Iraq, I get a raise, and we put that away. And when we get tax
returns back, stuff like that. But that's pretty much my retire-
ment. So instead of me having a retirement, we're paying for
their college. The Army is trying to make this thing where
I can use my G.I. bill—my 50,000 dollars for college—and
give it to my kids, which would be great. That would take a
load off.

When I get out of the Army, I'm gonna make a lot of money
doing private security—body guarding—in the Middle East.
For that, I probably won't need to go to college nor will I have
time. I did want to go to college, but now that I already have
kids, and my job is all I know, I just can't stop working to go
to school: The kids need to eat. So I have to keep on working.
That's the problem, I have to keep on working until they're
old enough for college. And then I can go to one myself.

When I signed up for the Army, I knew I was gonna go
somewhere. I was pretty sure. In the job I took, Bradley gun-
ner in the Infantry, I knew I was gonna go to war. I thought
that I'd like to experience war. I don't know how to explain
it. It's just something ... I don't really know how ... just the
warrior spirit. I feel, like, it's something I had to do in my
life: go to war.

I train constantly. We constantly adapt to new situations
while we are here. They send reports down on what the
enemy is doing and we train here. Constantly. And stuff
changes. Like, what their new techniques are. There are
Army bases all over the United States, they're spread out all
over the place, even in Alaska and Hawaii.

I'm anti-Bush but I don't get into politics when I go to war.
I don't think about that because it's not gonna change any-
thing. I just focus on my mission, do my mission, and that's
it. And when people ask me I tell them I think there's no
need to be over there. There's no reason. It's never gonna

stop. Violence isn't gonna stop. You can't stop thousands and thousands of years of Iraqis being Muslims and their culture by us coming in there and saying, now democracy is the way to go! It doesn't happen that way. You have to find democracy by yourself. If they wanted democracy bad enough, they would start a revolution. They need to find a way. It's not that there's killing going on, like an oppression, like Nazis killing Jews, that we have to stop, or countries invading other countries where you have to stop it. We're occupying a country and we're taking their oil. That's it. That's the end of it. We're wasting tax payers' money, billions and billions of dollars, sending troops over there, we're wasting soldiers' lives for nothing, absolutely nothing. When I'm here and when I think about it and when I see dead soldiers, it pisses me off. But when I'm there, I just think of it as a regular war and something I have to do and do my mission, and just be a professional while you are at war, be as professional as you can, and do your mission, that's it. Just watch your buddy's back and your buddy's watching your back, and just come home alive and then worry about it. I mean, there's nothing a single person can do about it. The President's approval rating is down to, like, 30 percent: It cannot last that long. It has to be over soon. It's working in Afghanistan. Afghanistan is actually OK. It's not ever gonna work in Iraq. They've spent so many years with dictatorships, the only thing that they respect is fear. Unless they fear you completely, they don't really respect you. If you got caught planting a bomb and we tortured you, you would go down in Iraq. But we don't do that, we send them to jail for a couple of months and treat them like human beings, and nothing happens. They don't care. It's their culture.

The first thing I noticed in Iraq was the heat. The heat there ... imagine being in the desert and there's very hot air constantly blowing at you. I had sweat dropping from my nose constantly. My first mission that I went on, I We were about to go into this city, we'd captured this guy earlier—well, our sister unit had captured this guy earlier—and he said, I know where a lot of bad guys are, they're in this house, and they have a lot of stuff, they're in this town, so we all got our vehicles and we drove there. There were shops all

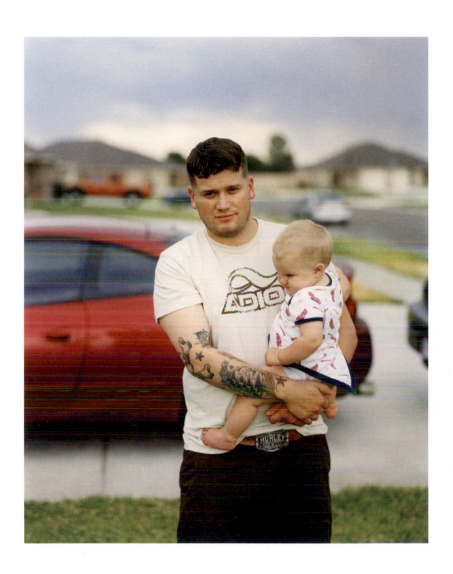

2006 — Fort Hood, TX

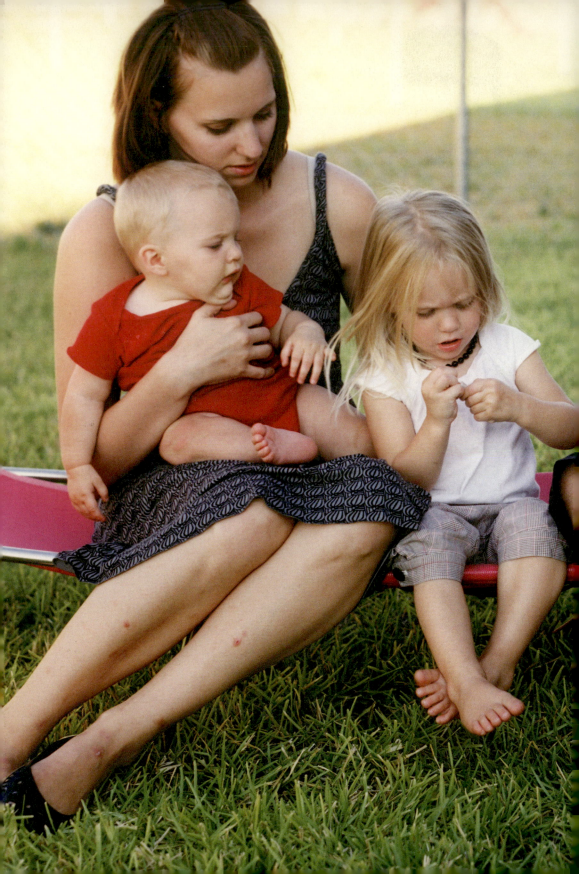

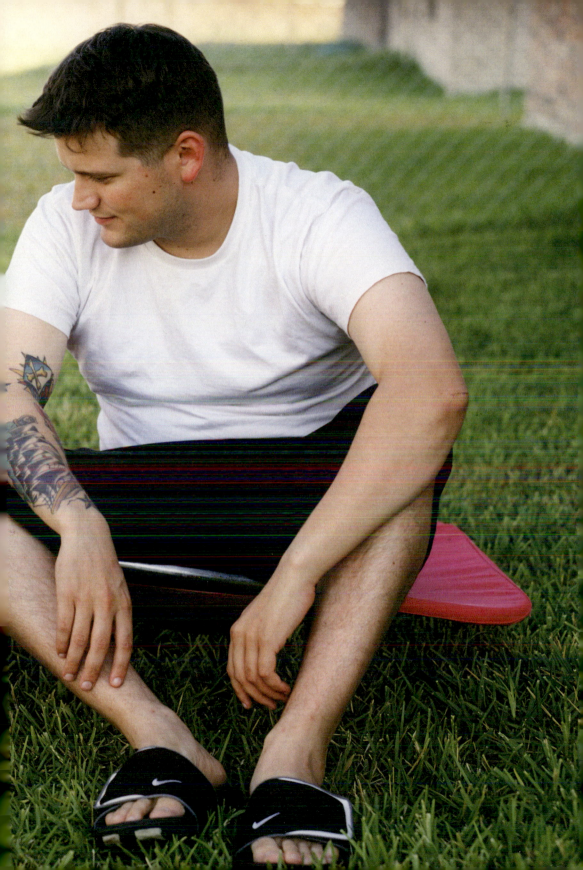

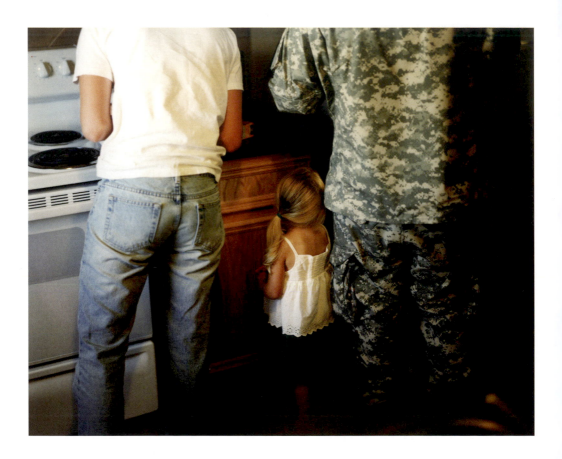

Timothy McClellan

along the side of the road, and all of a sudden all the shops closed down, and all the kids ran away and there's only males standing outside. I was like, oh, no! So we go in and a bunch of soldiers run inside the house and all I hear is gunfire and then people on top of the road were shooting and throwing grenades at us and stuff.... That was my first mission. So I got broken in right away. A lot of missions were just like that. They had us patrol for, like, a month after that, to get us relaxed to the situation: You think nothing is gonna happen, but I knew right away, at any time, something could happen. So I was always on guard. I was very professional.

We had an air conditioning unit, I had a TV, an X-Box, a gamecube, a DVD player ... I wasn't on the FOB very often, but when I did go there I lived well. I had to pay for all that stuff, but the trailer was provided for by the Army. When I went to Baghdad, we actually stayed in a place with no running water for three months. So that sucked. Another place, all forty of us slept in the same room. That sucked, too. Your living situation in Iraq depends on where you go on your missions. In the Infantry there's not many of us—you're constantly moving around to deal with pockets of resistance.

The camaraderie among soldiers is strong. I mean, you see me, I go to work at five o'clock in the morning and I don't come home till five in the evening, twelve hours a day, side by side in training, and in a war it's even more, it's a whole year. You get very, very close. It just comes naturally. We're brothers in arms. We know what we're doing and we know what we are about to do, and we're very close. If you don't trust a person, they usually kick them out of the platoon. If you know you can't depend on a person, they go somewhere else. It has to be a very tight group. You have to be able to know that while you're facing this way watching this guy's back he can't be playing his gameboy, or worrying about home: You have to know he's watching there, and you have to know you're safe.

When Sapp died, I started crying when he died, and that was very unprofessional. Because I should still be watching. Instead, I just cried. Not just cried, I actually broke down. I should have stayed and watched my sector.

2006 — Fort Hood, TX

During Timmy's first deployment, one of his best friends and fellow soldiers at the time, Brandon Sapp, died during an IED explosion. After his death, Timmy sent his condolences to Brandon's family and later drove down to Florida to meet his parents.

After my year in Iraq, I was gonna get out and I was very excited to get out and Josci came and said, I'm pregnant again. Quentin would have been born, like, a month or so after I would have gotten out of the Army. Having a baby is very expensive. Health care costs and having the baby and not having a job lined up: I would probably be in debt for the rest of my life. So I decided to re-enlist so that we were gonna be OK, so that my kids have health care. That was the reason I enlisted again. Instead of having to worry about me scrambling I decided I wanted security for my family. I did wanna get a job as a private security contractor but it could have taken some time, it could have taken up to four months for me to actually get a job like that and having a brand new baby, and having no income, that's pretty much impossible. And I didn't want to depend on my family. I thought I'd just toughen up, bite the bullet and waste three more years of my life, and just do it.

Sometimes I was scared of dying. I was never really scared of dying when bullets were flying at me, though, I'm trained for that, I'm more scared of going down a dirt road and waiting for a bomb to go off. There's nothing I could do about that. If there's something I can't control, I'm definitely scared. I'm not scared to do what I'm trained to do. We're the best trained soldiers in the world, sometimes you think to yourself, that's bullshit, but then you go out against the enemy and you see how easy it is, then you realize all the training was worth it. So I never really was scared, except for when bombs were going off, and driving down the road.

I get scared in everyday life from time to time. Like, on the Fourth of July here, I forgot it was the Fourth of July, I was by myself and fireworks went off: I didn't know they were fireworks, I did not know what was going on outside. I grabbed my gun, in my underwear, and I ran outside and I said, "I think something is going on here. What is going

on?" It's only when I'm by myself. Sometimes I can swear I hear gunshots and I grab my gun. Here, when the ice tray drops, sometimes I freak out a little bit. It sounds like distant gunshots—you know what it sounds like. And driving in the middle of the road. Right when I got back, without thinking about it because bombs usually come on the side of the road: You drive down the middle of the road so that they don't hit you.

I have war dreams about stuff that I've done. I have them maybe once a month. I have dreams where I'm at war and I kill people. But I don't wake up scared and I don't wake up regretting anything or in a cold sweat. I actually wake up and feel good. It's kind of weird. I don't feel sad at all. I don't have nightmares but I also don't really usually remember my dreams.

I killed a lot of people in Iraq, yeah. I definitely did. With my rifle or with my Bradley, shooting the big gun at them. Like, a bunch of them are in a house: Leveling the whole house, just blowing it up. Or by going into a house and kicking in the front door and killing them all in close combat or throwing grenades . . . I've done everything. It's Infantry. It's my job. My only job is to "find, fix and destroy the enemy in fire and maneuver." That's my job. Basically, all it means is "kill." That's what I'm good at, it's my profession. I don't feel weird about it because they would try to kill me. So I don't feel bad about it. I'd feel bad if I killed innocent people, which I'm sure I have. They're casualties of war. But I've never really seen it. So I never really worried . . . I've never seen dead civilians and thought, oh my God, I did that. We never try to kill civilians. Never, ever. Ever. It's really bad. Something they teach you, when you go on a mission, and you see how you're about to approach the mission, they have a thing where they say: OK, what's the mission, what's the enemy doing, what time is it, what's the terrain look like, and where are the civilians? That's how you base how you attack. And you think really closely how you're gonna solve the problem. Civilians are calculated into the problem. It depends on situations . . . sometimes we would go into a village and send PSYOPS through, which would go through loud speakers,

"Everyone leave this city right now! We'll search the whole city. On your way out you will be searched. Anyone in here, in an hour, is dead." Afterwards we would just go house to house throwing grenades. If you're still in there, you're a terrorist. Otherwise there would be huge, huge resistance. So when they're on their way out, they are searched. Plain and simple. So we know they have nothing on them, and then they just sit waiting for us until we're done purging. If we didn't do that they would try to fight you when you went in. But a lot of people wouldn't leave. Old people sometimes don't leave, and they die. But they know they are gonna die and we told them they were gonna die. It sounds horrible, but it's so much better than going in there, kicking in their door and having shitloads of enemy dead, shitloads of civilians dead, and a shitload of soldiers dead. This way you have lots of enemies dead, a few civilians dead, very few American soldiers dead, if any.

Right now, I hate going to work every day. I hate it because I hate doing the same thing over and over again. It's very repetitive and I'd rather go to war and do my job instead of sitting around training to go to war. I think it's just not fun training. It was fun when I first got in, but now when I know what to do and I know how to shoot . . . I know how to do everything. Unless it's something new, I just hate going. Like last night! I was at work, shooting guns on the range until two o'clock in the morning. Boring! Now I can't hear, and I didn't have any fun! Usually, I have fun shooting guns. But last night, I didn't.

I just need to go to war again. I need to go and get it over with again and then relax. But I won't get out until 2009. So I might have to go one more time: I might have to go to Iraq three separate times. You sign up for three or four years. I did four years, but I still had a year left on my contract but they've voided that. So basically I've signed up for three more years. I just . . . I feel like I have to provide for my family. That's why I re-enlisted. I just . . . I hate it. I hate worrying about money, I hate worrying about my kids, and I hate worrying about . . . just life. The situation. I hate being the sole provider. I wish Josci could work. That would take a load

off of me. But there is nothing I can do about it. She can't work. You can't get mad at her because she can't. Daycare is so expensive here that basically her working would only pay for daycare. It's ridiculous. Plus, daycare is horrible! So back home, I hope that my mom or her mom could help us out and watch the kids so she can go to work.

We really don't have a lot of money. We basically just pay for everything that we need. That's all. We have no spending money whatsoever. We have to be really tight with money, we have no choice. We're spending money now and relaxing, because I'm about to go to Iraq, and then we can pay it off because I know I'm gonna make a bunch of money when I'm in Iraq. I'll make an extra 1,000 dollars per month, plus we're not paying rent because Josci and the kids are staying with her parents, so that's, like, an extra 2,000 dollars. That's nice. Very nice.

Two months into his deployment, Timmy has a two-week leave, back home in Minnesota. He and Joscelyn are planning on getting a divorce, but then things between them improve again. Apparently, the night before Timmy has to go back to the airport, he breaks down and cries in the alley behind his parents' house: He's showing first symptoms of battle fatigue and PTSD.

Timmy's cousin Karl recounts: On his last day in the U.S., Timmy came over to our house and said that he wanted to go out drinking with me and my parents. My dad was like, "oh, I don't know, I gotta get up early tomorrow, blah, blah, blah..." Timmy said, "Uncle Ron! This might be the last time you ever see me. You cannot not come out drinking with me tonight!" How's my dad supposed to say no to that? So we all went to Zimmy's and did karaoke, got wasted, and Timmy just kept...you know like he does, where he keeps buying drinks for people and forcing you to drink and all this stuff? Then we were walking home that night—it was me and him and his friend Vaughn—and he just started crying. He hugged me and said he loved me and he said he didn't know.... He's like, "I'm never coming back." He's like, "You're never gonna see me again. This is it. I'm never coming back, this is my

last time." And then at one point, he was talking about the things that he's seen. He's like, "The things I've seen no one should ever have to see. I don't know why they're making me go back . . ." I told him, "I think you're coming back." I was like, come on, dude! You've survived everything, you're gonna come back. I was basically arguing with him about whether or not he was gonna come back!

After that, he cleaned himself up a little and stopped crying. He didn't say, don't ever tell anyone that this happened, but he was kind of acting, like, almost like it hadn't just happened. You know, where he immediately forgot that that event had just occurred. Not that he didn't care about it, but just that he was like, OK, that's done, I'm gonna put that behind me. But I also felt that he really wanted to communicate something to me in that moment. Or to us, to me and Vaughn. But it also, I think, had been the combination of that day of telling everybody this, and then getting really wasted, and then having a last moment to say whatever he was gonna say before he passed out.

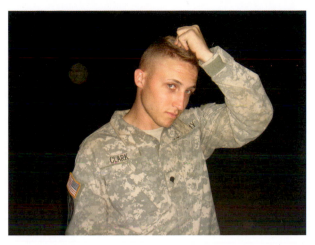

Evan. I don't know where or when. He was my best friend in the Army.

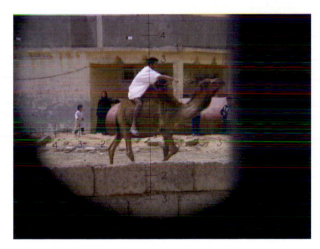

This is taken through one side of binoculars. I saw this camel and it was too far away to take a picture of, so I pointed my camera at the binoculars and took a picture. It actually turned out.

2006/2007 — Iraq

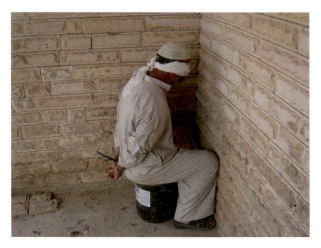

He is just a guy that we caught. He was in the village. He actually worked for the Iraqi government but had some bomb-making material at his house.

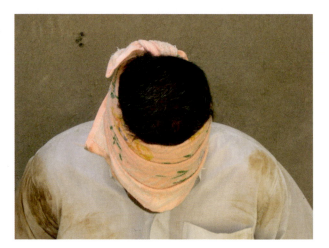

We took this guy's son — we found his son — and his son was wearing a G-Unit sweat suit. We're like "What the fuck?!" He was also in a bad spot and all the villagers said that they had seen him driving around with his dad's Glock. His dad was wanted. We interrogated him, made him cry really bad. He gave up his dad. That was funny.

Timothy McClellan

I took this in Buhriz. It's taken from an Iraqi police station.

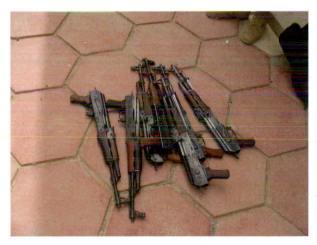

These are weapons that we have saved up, that we keep. We give them to the Iraqi Army or trade them. I don't know what they do with them, they might just give them back to the insurgents. I trade them for food and stuff. I traded a weapon for a puppy that we named IED. When we're on missions, we don't have a lot of food so the guns come in handy. One time, we traded an AK for a BB gun. This is what we have. It's available to us. Why waste our own money? We're not gonna do anything with the AKs, they can get as many as they want, they just don't want to spend the money. It's like 100 dollars an AK. All we care about is IEDs. They're not gonna go against us with weapons like that, they'll die so quick.

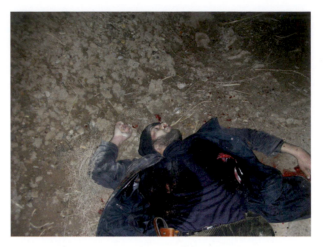

This is the Iraqi policeman I shot. He had mortar tubes and stuff.
I could see him through the night sight.

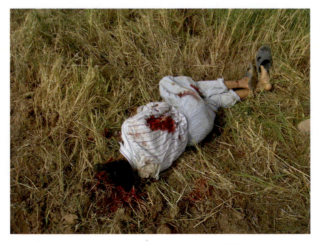

Maybe ten meters away from this guy's body is an IED, a detonation
device. He was just waiting for us to go down the road. Helicopters
saw him and shot him.

Timothy McClellan

Some cow that's tied up outside a house. It was afraid of me. Crazy.

We had just raided this house and I saw this and I was like "Holy shit." That's why I took a picture of it. It's weird.

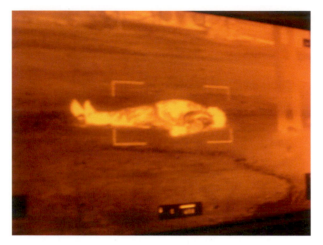

A dead guy that a tank just killed.

I don't remember taking this photo.

Timothy McClellan

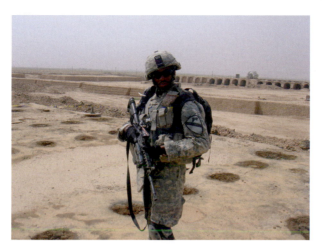

Sgt. Monroe

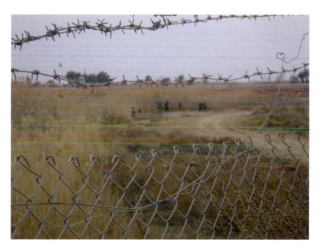

Just a picture I took of them searching the field from on top of the
Bradley. Sometimes people bury stuff and we have to search fields.
We're always searching fields.

2007
Hibbing, MN

Shortly before Christmas, Timmy comes home from his second deployment. He's exhausted and quiet and spends a lot of time by himself.

I went to Iraq October 4, 2006. When we got there, we went to Kuwait first, spent about two weeks in Kuwait, then we took a plane to Balad—a big airbase inside Iraq—and from there we took a helicopter to Baqubah, Iraq, FOB Warhorse. That's where we stayed. In Kuwait, we did gunnery, practiced shooting, stuff like that—clearing houses. We got ready, we got our ammo distributed . . . pretty much what we do in Texas every day, but we jammed a whole two weeks of shooting in. Like, in Texas, sometimes we go to the field for a month, sometimes we go for a week, sometimes we just go for a day. We're always training, but this is different because everybody knows: We're going to war.

After we arrived in Iraq, we started going on patrols right away—we first started out with probably eight hours of patrolling every day. But our patrol area was, like, two and a half hours away and we had to travel that way to get to our area so that added, like, five hours onto our time because we travel so slowly. It's bad because imagine being on an Iraqi road for two and a half hours extra and going through other people's sectors just to get to yours. You don't know if they're watching the road or anything. We got blown up a lot. The dangerous part was traveling, once we got inside the area we were alright. We've gotten attacked and stuff, but once you're on the base, you're usually good. We got mortared, but no big deal. We got mortared all the time.

Our patrols are presence patrols, just letting them know we are there. Sometimes we go into houses. It depends. Sometimes we do raids. On top of our regular patrols, we also do raids, snatch and grabs, cordon areas, and search entire

villages, huge operations, looking for cachets. That's on top of everyday missions. If you get off a mission, in an hour there will be a company mission, a big mission that you have to go do. And since there's only so many Infantrymen, you go on all of them, because that's your job. The cooks aren't gonna go out there and do it. In a snatch and grab, you get into a village fast, like a certain house, break open the door, trying not to use any lethal force, go in there and grab the guy, just grab him, put him in the car and drive off, really fast. You're not cordoning off a village, not starting a fight with the whole village, you're just going after one target. We did a lot of that, too.

For a long time, what we had to do each morning was pick up body parts. We found mass graves. . . . There's one place called Al Hamr, and it's a Sunni village and there's a Shia village right next to it. We found, like, thirty bodies in a grave right there. They kill each other all the time. We used to stand on top of our compound and watch them. They were standing on one side of the road and the others on the other and they would shoot back and forth. And we'd just watch. Sometimes we would interfere. Just go out there and park the Bradley. The shooting would stop. As soon as we pulled the Bradley back, they would get right back at it. It doesn't matter.

I've been hit by a lot of IEDs. One of them was pretty crazy. It was the only one where somebody in my vehicle died, but I've been on a million patrols where people died, in other vehicles. Not just my driver died that day, the vehicle that came to recover us got hit by an IED right in front of my Bradley. All three people in that vehicle died. They were waiting for them—that's how they do it. They do one, and then when the people come to help their buddies out, they hit them with another one. I was saying that the whole time I was there. We were traveling down the road, we were just sitting there, we got a call, "The compound is getting attacked, you gotta come back right away!" And we're like, OK, and we turn around, we're going really fast. I have two radios, I'm listening to two radios, so two people talk at the same time. My driver doesn't listen to any of the radios, just so he can focus on driving, and he started saying something, and at the

same time, me and my commander both screamed, "Shut the fuck up!" Because he was talking and we were listening to the radios, and then: BOOM!—I don't even remember that, all I remember is screaming, shut the fuck up, and then I woke up and I knew I was hurt bad, I knew that because my helmet was off. I felt really, really dizzy, and I looked over to make sure my BC was alive, and I shook him and he looked at me and goes, you're bleedin'. He was out of it. I told him, "you're bleeding, too!" He was bleeding from his chin or something, his face was all messed up, and at the same time we both started screaming for Branden Cummings, which is my driver's name. We just kept on yelling, "Branden! Branden!" and I peeked outside. I looked behind us and I saw the hole. I go to my commander and I tell him, "He is dead. This hole is huge." And when I looked at the front, the Bradley was sunk in like this, then I saw his helmet, way down the road, and I was like, he's dead, I guarantee it. I was like, I'll look at the hatch, and I pulled the hatch up to make sure, and I said, "But we have to make sure to get off this Bradley because there's guaranteed to be a secondary so when we get off, jump and run!" My BC's like, "OK. But first I'm gonna help you get Branden out!" I said, "Branden is dead, dude, I guarantee it! But I'm gonna go look."

So I open the hatch up, he looks over my shoulder and goes, "Oh my God!" Well, before we even opened it, there was a hand sitting on the hood, just a hand, and my Commander's like, "That's his little hand." That's exactly how he said it. Because Branden was only eighteen. A small kid. He said it like he was a baby or something. I opened up the hatch, and I knew he was gonna be dead. His whole head was jammed inside of the hatch. Just really gross. The only thing I remember for some reason is, I looked at his hair, and I thought that he needed a haircut. That's what I thought about the whole thing. I looked down and I'm like, holy shit, he needed a haircut. Then I closed the hatch again. I remember that because it was weird to me. I still think about his dirty, grimy hair—we've been out for, like, a month, and it was long, so I was like, uh! And then I was like, "OK, let's jump off the Bradley, we'll run into the field right there, there won't be IED in a field. We need to get off the fucking road!"

Then we see the Bradley in front of us start to shoot, the ramp drops and the medic starts running towards me. I'm waving, he's running right down the middle of the road to come save us, and I'm like, "Get off the fucking road, Doc," just screaming at him! We better jump off the road, so he doesn't get close to us! We jumped off, went into the field, and I called the Bradley over, the Bradley came by, dropped the ramp and I got in the back. Doc patched me up real quick, and I was like, take a picture! I remember saying, "This better be a good picture!" His hands were all shaking, because, you know, there's a dead body, his friend died, and then our Bradley is destroyed and we're both messed up, and it's his job to take care of us, so he's, like, really stressed out. He could barely hold a camera. That was funny.—We all carry cameras with us, always.—And then they called a Medvac for me. They took me to Baghdad into the Green Zone by helicopter and Air Force nurses patched me up. I got the Purple Heart for shrapnel in the face from this incident. I still have a scar on my forehead.

After we got hit, I went back on a mission three days later. I knew I still had months left, that I wasn't injured enough to go home, so I knew I was gonna go back. Our tour got extended—originally, we were supposed to stay there for twelve months, but then they said it was fifteen months. The surge didn't have anything to do with us, with our plan, or whatever. I never saw any surge . . . I never saw more people there than usual. It's just a numbers' game.

Physically it's harder to deploy than to redeploy. But mentally, you know, I wanted to come home. Knowing you're leaving for a year, to war. . . . It sucks. It's a bad feeling.

This second tour in Iraq was a lot worse. Specifically the violence between Sunnis and Shiites. The civil war. "Sectarian violence," they call it, it's not a civil war. That makes it a lot worse. They bomb each other's mosques and kill everybody and mortar each other. The IEDs are bigger. It sucks. It made my work a lot harder. There's only so many of us and we've got a lot of area to cover. Sometimes we interfere, but there's not a lot you can do, it's constant, you can't be there all the time. It doesn't matter. If you are there, as soon as you leave, it's just gonna continue.

Timothy McClellan

Soldiers take stuff off of dead bodies, that's fair game. If they're enemy, it's cool. That's not stealing! "To the victor go the spoils"—that's just war, right there. But off real people . . . soldiers have done it, like, if there's an abandoned house, they'll take something. But to hold someone at knife point and take their money out of their pockets or search them, just a random person, no, I've never seen that. It's not like they have money, anyway. The terrorists do—not the terrorists, I shouldn't say that. They're not terrorists. Freedom fighters: That's what I call them.

Timmy gave me a baseball cap for Christmas that he said he took from a live Iraqi, and some Iraqi money that he took from a dead body.

When we're on patrol, we knock on their doors, like, "Hi! Get everybody out of the house. The male of the house will search the house with me. Watch my soldiers search the house and I'll be watching you. Let's go." That makes him feel empowered, to get the women out of the house so soldiers aren't looking at them. Put him off in a corner, we search the house, thanks a lot, be here on Thursday and we come back with some flour or water or some shit. They're like, "OK, thanks, we love you!" Yeah, right.—We find stuff all the time. Like, RPGs, mortar rounds, AKs, sometimes night vision goggles, sniper rifles . . . bomb-making materials, wires, detonators. . . . You can find stuff in anybody's house.

If Iraqis carry guns in the streets, they are dead. "AK=OK." You can kill anybody outside their house with a gun. They only have home defense. We leave one rifle per house. We don't trust Americans with AKs but we're giving them to Iraqis, which is kind of strange. I think we should take away all their automatic weapons.

We work with Iraqis on a daily basis. One of the places we stayed at, we trained an Iraqi Special Forces unit, like, if we're on a helicopter, we would take them with us. They are highly trained Iraqis. That was nice to have them with us. Because they're just as trained as we are plus they know the language, they know everything. And they can tell when other Iraqis are lying, by the tone of their voices. You know,

just like I could tell you that my brother was lying, that he's full of shit. They can do the same thing. They can tell by the way he's talking if he's Sunni or Shia, the targets we're looking for—all that kind of stuff. That's why it's great to have them with.

Some Iraqis speak English, not many, though. We have interpreters to communicate with the Iraqis we train. Everybody knows, "Hello, mister!"—I must have been called "mister" a million times. And then kids are like, "Mister, give me chocolate." That's all they know. Iraqi kids learn English in school now.

I talk to the enemies all the time. I'm like, you're going away for so long! Just to rub it in that we've got them. We have a whole separate job for interrogating, though. It's called THT or TQ, tactical questioning. That's their whole job. We bring them with us, we take them to the camp, and get them interrogated. But we also do on the spot interrogating, we catch the guy, we sit him down, just us, and we'll be like, "Hey! Where's the cachet at? Where is this village?" Right when we get them. And we scare the shit out of them as much as we can, trying to get information out of them, right there. Because everybody knows once they take that guy and put him in interrogation, he's gonna rat and they're gonna move all the cachets. So you wanna try to get something right on the spot, something, anything, and work from there.

We lived on an Iraqi Army post, and they had cooks and everything so we would go to their cafeteria ... well, it wasn't really a cafeteria, more like a mud house, but we would drink chai and eat some bread there and chill out.

The Iraqis are not happy we're there. Not unless they work for us and they're making a lot of money. I mean, we're the devil. The great Satan. Western civilization—they're never gonna like us, no matter what.

I was supposed to go to college to study Arabic, in Texas. But then our company got a translator, so I didn't have to do it. But I got picked, me and two other guys, out of the whole company. I think that would have sucked, actually, because Arabic is really freakin' hard. And then to go to college for it ... I don't know, Arabic is so bad, it's so tough! I would still have been with my unit, I would still have to do my job, just

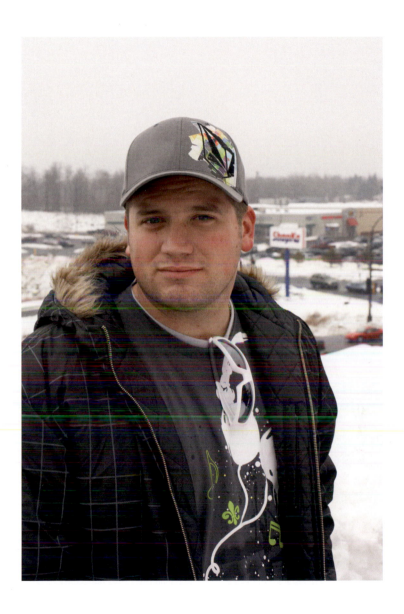

2007 — Hibbing, MN

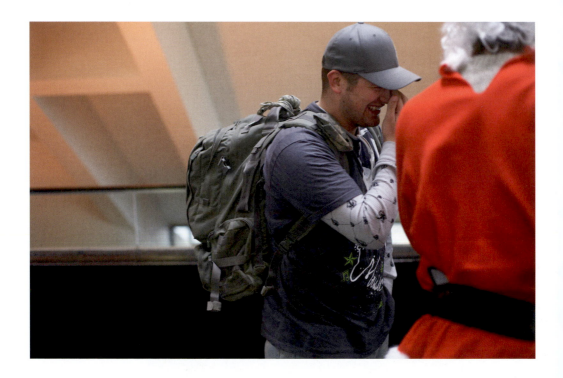

Timothy McClellan

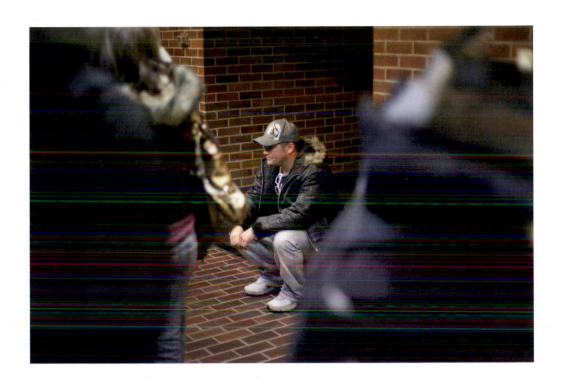

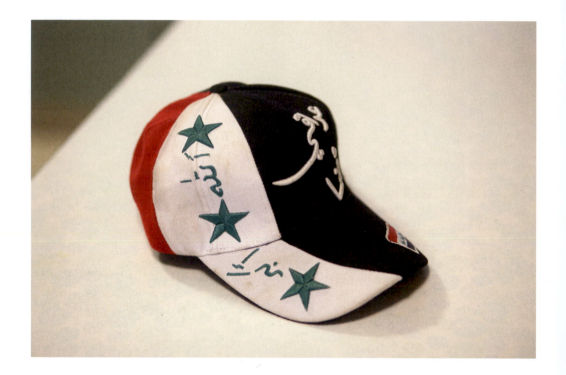

Timothy McClellan

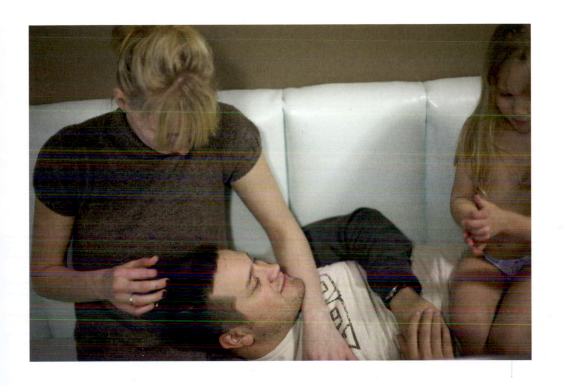

2007 — Hibbing, MN

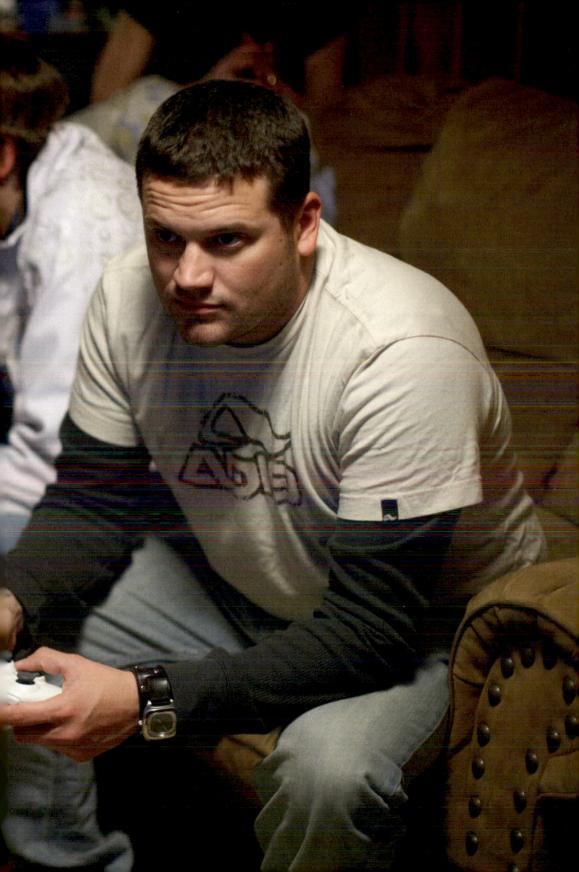

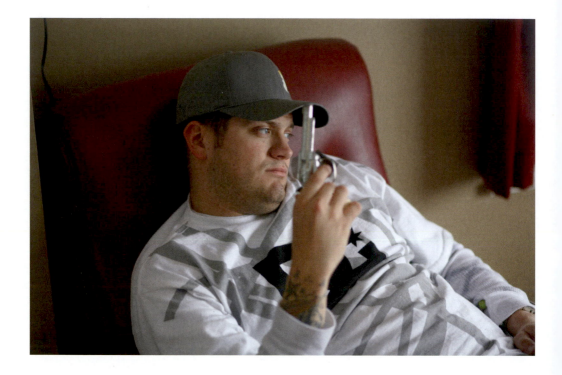

Timothy McClellan

speaking Arabic. My Arabic right now isn't so good. I know enough to get by. I probably know more than most soldiers. Most of them don't want to learn it. A lot of people don't talk about Iraq. They don't wanna talk about it at all. My buddy Evan, he never talks about it. If someone was like, oh, you guys just got back from Iraq, he'd just give you a blank stare. He doesn't want anybody to know. He doesn't wanna remember that he went, he tries to, like, blend it out. He's like, "stop talking about it!" It's really weird. But I don't ask him about it since he doesn't wanna talk about it. That's his choice. It's weird.

Everybody in our unit is pretty tight. We still say Sergeant and Sir and stuff but we're cool, joke around, hang out . . . I even hang out with some officers. Everyone's around the same age, say, from twenty-one to forty. So we all hang out, all go drink, have fun. It's illegal for soldiers to drink in Iraq. But everybody still drinks. You can't go a whole year without drinking anything! It's a stressful job. We drink probably, like, once a month, we would all take turns, like, sometimes my mom would send four or five bottles. One of my brothers sent, like, five bottles. But I share with everybody. And we all drink one night. So, when the others get a package, they share it with me. Everybody gets sent alcohol: You need it.

We call Iraqis "Hadjis" and I guess it is derogatory, we're not supposed to say that, but at the same time it's not really derogatory: When Muslims take the voyage to Mecca, which they have to do once in their lifetime, that's called the "Haj" and then after that they call him "Hadji." And "Hadji" also means "old man" in Arabic. We're supposed to call them "local nationals." Fuck that! They're Hadjis.

Our superiors always get us food. Somehow. And if they can't, I eat Iraqi food. A lot of people don't—I do. So I don't go hungry. I can just ask anybody on the side of the road, they'll give me some. Or I just go stop at a house and ask for samoon—bread—and they'll be like, OK. And I give them a case of water. They'll appreciate that, a case of water for free. Sometimes we get a lot of sleep, sometimes we don't. A lot of the time, we don't. We go on missions a lot. I take Stacker 3s—a diet pill—and I drink Red Bull, and I also drink 5-hour ENERGY. That stuff's awesome because you don't crash off

of it. A lot of people take pills and drink energy drinks. The people who don't take anything fall asleep in the back of the Bradley, but they wake up when the ramp drops. There's nothing they can do back there but sleep, anyway. When the Bradley stops, they're probably gonna wake up so by the time the ramp hits and all the Hadjis are looking inside the vehicle, everyone is wide awake.

Whenever we're in a firefight and we kill somebody we yell and shout. Because we're happy. Of course we are! They're trying to kill you and then you kill them. And then, you're, like, victory! That's the best . . . I mean, imagine someone's trying to kill you and you kill them. That's a big relief! You got no better adrenaline than when you actually feel like your life is in danger. Imagine feeling like that all the time! For hours on end. And eliminating that, you're gonna be pretty happy. They're trying to kill you so you should be happy to kill them first. I think every war in history was like that. That's just how it is. You have a good day in the battle, what else are you gonna do? You gotta celebrate, you did good. You're one of the best, so that's what we do, it's our job. But then you crash off the adrenaline, once you get back to the FOB.

Out of our battalion, which is, like, 600 people, forty died. Out of my platoon, about forty people, we lost two. That is a lot. You have a one in twenty chance of getting hit, that whole year.

I'm trying to think if anybody ever saved my life. Actually, one guy did on my first tour. We were talking behind this house and he's bothering me to move the whole time. I was like, "No, no, let's just sit here, let's sit here, let's sit here." He said, "No, let's move." It was just me and him. So I was like, OK, screw it, and we moved back onto the road. As soon as we stepped into the road, right where we were standing, a mortar hit! And I was like, "You saved my life!"

The last days in Iraq—you don't really think about anything but moving because you have to have all your bags, and everything has to be clean, you're not even thinking about leaving. You're thinking about getting ready to leave, like, packing all your stuff. You don't really think about home.

Some people get excited, but whatever . . . I didn't. It's my second deployment.

Before we get to go home, we have to pack everything up, clean up all the vehicles which is horrible and takes a long time. Then we take a helicopter to Balad, and then from Balad we take a cargo plane to Kuwait. We stayed there three days and then we got on a commercial flight that's chartered by the United States Army. That's how we came back. They drop you off at the parade field in Fort Hood and everybody's screaming. You walk up in formation, and the General gets on the podium and says, "Thanks for everything that you've done: You're released!" And then a huge wave of families come at us. I was walking away, me and my buddy Evan had big plans of going partying and stuff that night. I felt somebody push me from behind, somebody was hanging on me and I was like, ???—It was Josci! Josci surprised me at the parade field! I took her to Austin, we went and got tattoos, and partied on 6th Street—we had a lot of fun. After two days she left. Then I spent about three weeks in Fort Hood waiting to go on leave. You just go through reintegration training during that time. They give you classes, like, don't beat your wife, don't beat your kids, be patient, don't shoot anybody, don't drive on the wrong side of the road, you don't have any authority anymore. . . . Stuff like that. It's common sense! Some people just don't get it, that they can't pull a gun on anybody they want anymore; they can't treat people like they treat Iraqis, but some people have a tough time. I did experience that fellow soldiers have stepped over the line and were more brutal or abusive than they should have been, yeah, but I don't want to talk about it.

They don't directly ask you if you have post-traumatic stress disorder. They give you a series of questions, like, do you feel like hurting yourself, do you feel like hurting other people, do you have nightmares? Based on that evaluation, you go see another person, and if that person diagnoses you with PTSD, then you have to see another person who makes the appointment for you to see another person, and you will eventually get a doctor. But they're so backed up—it takes three to four months for the first appointment for your mental health, which is crazy.

Soldiers change during the year in Iraq—kids are usually more mature afterwards. I haven't seen anybody freak out or anything. I guess I'm a little calmer, too. I don't like to go out as much. I don't like people. I mean, I like people, I just don't like random people. It's weird. I just wanna chill. That's all I wanna do for a long time, until I go back.

Some people tried to get discharged. They said they're gonna commit suicide, have their wives divorce them and give them custody of the kids, so that they have to take care of the kids and get out, or they just play crazy, do whatever they can. I think about ten guys in our company, which is 120 men, tried to get out. I didn't try to get out. Well, I was gonna try for my back. They didn't have the technology or anything to actually look at my back—my back really was hurting really bad—so I was like, I can probably get out for this, but it didn't work. I went and they just gave me painkillers.

We don't really talk about traumatic experiences. Of course there are traumatic things that happen. But you don't talk about them, after. You focus on the mission. It's like a button, you're so well-trained, like, everybody knows what to do, as soon as a bullet hits, everybody gets down, everybody starts yelling, what direction it's coming from, the distance, and description, and from there, that's all we're gonna talk about. Fire this way, fire that way, that's it. You're not gonna sit and bullshit. Later, when we're back at the FOB, somebody might tell a story to the guys that weren't there. Usually about twenty people go out at a time, so they come back and brag, I guess. But we won't talk about it for weeks or anything like that. It's just, like, yeah, that's what happened.

If I see a kid, for example, with his guts hanging out, I'll go, "There was a kid over there with his guts hanging out." My buddy would go, "Oh, that sucks." Yep. That's it. We're not gonna, like, debate humanity and religion right there or anything—we're just like, yep. It happens all the time, it's a war zone. We get used to it after a while. I mean, it's still shocking, but there's nothing you can do about it, there's nothing you can do about it. There's no use getting worked up about it, or letting it take a hold of you, that's how you go crazy. And I'm not gonna go crazy over a war.

Timothy McClellan

I don't think we feel morally wrong for killing people—I personally don't feel morally wrong for killing people. I mean, if I killed innocent people or something, I would. But I don't feel like I potentially killed innocent people, so I have no remorse. Casualties of war happen a lot. Houses get blown up, people get shot, bolts go through houses.... So who knows, you know, how many people really die in a fight in the village? But I've never intentionally shot an old lady in the face or anything. I shot a kid off his bike once, but that's only because he didn't stop. I gave him two warning shots and all he did was go faster. I never went up to inspect the body but I'm sure he wasn't good.

I didn't really think of anything as I was shooting them. Just that they were targets, that they were threats. I looked at it just like it was training. I've never thought about his family or anything or what his life was like or what it would be like if I let him live, I don't worry about that stuff, I just do my job. My job is to eliminate the enemy and that's what I do, I don't feel bad about it, I don't think about it, I don't lay awake thinking about it, I just do it. I have twenty-eight confirmed kills, that I've seen the bodies after I shot them, but how many others that were running and I shot, like behind a wall or something with my Bradley, how many of those I got, I don't know. I only count the people that I saw the bodies of. Twenty-eight. We compare them among the platoon. I get the most. The next nearest guy has, like, eighteen or something. But I'm a gunner on a Bradley, so I can see at night, I can see for a long way, and I always scan so I can see people, I'm like, hmm, a shovel by the side of the road...boom, boom, boom! And that's an advantage to all the guys on the ground who shoot with their rifles and don't have time to look for bodies and have them confirmed. Plus, all of them are shooting at the same person, so they have to share. Share the glory. Me, I'm just: BOOM! Oh, yeah!

Josci and I were gonna get a divorce. I was depressed, so I didn't have any appetite for a long time. About the whole divorce thing. Because it wasn't a very clean divorce. It was a very emotional divorce. I was very depressed. Plus, being away from my kids, being away from civilization made it harder. We were talking about getting a divorce for, like, two

years: We've always talked about getting one. And when I was over there, she got the paperwork done. So we were like, OK, it's finally gonna happen. And then it didn't. Because I came home from Iraq on R+R and it worked out. She was happy to see me, I was happy to see her.

Timmy and Joscelyn just bought a house in their hometown Hibbing, where Joscelyn is working as a teller at a bank. She will be living there with Angelina and Quentin. Timmy plans on joining them when he is discharged in 2009.

All I do in my free time in Iraq is watch movies. That's all there is to do. Or go to the phones, and call home. Except when somebody dies, you go on blackout, so sometimes you can't call. Our time online is limited to thirty minutes per day. If you want to walk all the way there. It's far, like maybe a mile away. I'm American, OK? So that's far for me to walk! Home is always on my mind. I constantly think about it. I was very homesick. I was homesick for everybody, not just my kids, but mainly my kids. There's nothing you can do about it. When you call them, you get even more homesick.

I have nightmares now. Nothing bad. I mean, I don't wake up and I'm scared or I don't like it or anything. I just have dreams about battle, about killing people and stuff but I don't wake up scared or anything. Josci says, I'll, like, yell a little bit, but not like I'm scared. I've never woken up being frightened. But Josci says my heart beats really fast. It doesn't really bother me. In Iraq, I had a little insomnia, but I don't think it had anything to do with anything, I was just having trouble sleeping. I took Ambien and I was good.

I've never had a blackout and I've never thought about suicide. I cried once in Iraq, I think, when I was getting medevaced, after everything was all done, when the helicopter picked me up. When I was safe, finally.

Before I go out on a mission, I pray that God will forgive my sins if . . . I don't really know if he exists or anything like that. The older I get the less I do, the less religious I get. Before I went to Iraq, I was pretty religious—not pretty religious, but I definitely believed in God and everything. I had the fear of God in me. But not anymore. I just think that if

there was a God, all the cruel things wouldn't happen. He wouldn't let crackheads put their babies in microwaves and shit like that. I just don't think it's possible.

I don't think I have post-traumatic stress disorder. I was talking to a psychologist in Iraq, that was mostly just about the divorce, though. It was about personal shit, not about war. It just sucked that I was in war and all that was happening while I was in it, so that made it a lot worse. I started taking antidepressants, and they helped, but I don't take them anymore. I sometimes feel sorry for myself. You go through a phase where life sucks and you feel bad for yourself because no one else does.

I don't think about politics while I'm over there. I don't because it's not gonna change anything. I have no say in anything whatsoever, but I have a political view as a person, you know, just like everybody. But I don't get political about the war, while I'm there, saying, I shouldn't do this, or, I shouldn't do that, because I have no choice. There's no use complaining or making a fuss or doing anything because it's not gonna do anything but get you in trouble. My political view hasn't changed: I don't feel like being over there does anything for people over here. It keeps rich people richer. It's all about the oil and the corporations and gives the government more jobs. That's what Iraq's all about.

I love America, you know, I am a patriot. I want the best for America, but I don't feel like anything I have done has made it any better. Some people say they joined the Army because they want to serve their country, but I don't think they really did. I've never met anybody who actually said that.

I never thought we would occupy Iraq. I thought maybe we'd go to war. But occupy... that's just not what we do. You can just go to a country, blow the shit out of it, and then leave. That's what we did the first time. That's what everybody thought it was gonna be this time!

I'm proud that I'm a soldier, I guess. Not necessarily for the United States. I'm proud that I'm a soldier and well-trained. I always wanted to be a soldier growing up. I just can't do it anymore. I still like being a soldier but my back hurts, my knees hurt, I don't wanna go to war anymore—I'm

good! I feel like I've proven myself enough, I feel like I did everything—I got the experience of a lifetime that not many people can talk about.

I think I have a certain level of empathy—I know what people wanna hear, kind of. I think I would be good in a workplace environment, or anything, people seem to get along with me wherever I go. I'm not worried about fitting in anywhere else than the military. I'm just worried about what job I'm gonna get or take. I mean, I'm worried that I'll have a job that I'll hate and that's boring, but whatever.... You gotta do things. Things you don't like. You gotta put other people's needs in front of yours.

Being in the military is really hard on families. And they should pay us more. Last year, I made 40,000 dollars. That's because I went to war. Otherwise I would have made 28,000 dollars. It's not very much. The private contractors are doing the same thing, and they're making 100,000 dollars.

I would join the Army all over again. I just couldn't see myself not joining the Army. I told my mom for forever I was gonna join the Army. Even in high school, I was like, "Mom, don't worry"—you know, she would bug me about what I was gonna do—"I'm joining the Army!" She didn't believe me at all. Then I sat around for, like, six months after I graduated. She kept asking me, what are you gonna do? Joining! The! Army! I told you! She didn't believe me. So I took care of that and enlisted. I look up to my grandpa. Since I was a kid. He's a war hero. So I just wanted to do what he did when I joined the Army. But to me it's, like, the only job to have. If you join the Army to be a soldier—I'm a soldier. I'm not a cook, I'm not an engineer. I am a soldier. That's my job. That's what I wanted to do.

I have one more tour in Iraq, another year. I'm getting out as soon as that tour is done. So next Christmas, or right after next Christmas, I'll go back to Iraq. And then sit there for, like, fifteen months and then come back and then be out.

I would like to go to college—but it won't happen. What I really wanna go to school for is botany. Plant growing—not just weed. I wanna go out to the country and have, like, my own green house and everything. Plants are cool. I think it's a cool thing, growing exotic plants. But I don't know what

you could do as a job for that. I want to take botany classes. I don't know what university I'd have to go to for that. It'd be cool, though, growing plants. I am gonna grow plants no matter what. But what I'm gonna do for my job, I don't know.

Timmy's grandfather, Larry Christianson, was an Infantryman during the Korean war and spent a couple of years in the Far East. He almost never talks about the war and thinks it was an asinine venture. At one point during his service in the 1950s, he traveled to Tokyo where he was involuntarily tattooed on his forearm after he passed out at a bar. When I asked Grandpa for an interview, he hesitated at first, but then ended up talking very openly to me about his experiences in Korea.

When I was sixteen, I joined the National Guard for the extra three dollars a month we got. After I graduated from high school, the Korean war broke out and I was activated. I went down to Alabama for basic training for six months. We were supposed to replace troops over in Korea and Japan or wherever. I joined the National Guard for the money—training was just one day a month that we'd go for a couple of hours, and two weeks in the summertime. I never even dreamed of going to war! We went to Korea in January 1952. I was nineteen years old, and I probably felt a bit like Timmy, but not as much so—as you know, he was all gung-ho when he joined the Army.

I wasn't scared of going to war—when you first get there, you're not scared because you think: Nobody's gonna shoot me! I'm gonna shoot them! But then after the first skirmish you get scared.

I was in a rifle squad. We were taking country, which was mostly hills. It went back and forth and I thought war was stupid. It was like kids, throwing rocks across the streets at each other. I wasn't in Korea for very long, probably only about four months. Then they had another National Guard division from Oklahoma, I guess, and put them in our place and sent us to Japan where I stayed for over seven months. All the growing up I did in Korea—I lost all that in Japan and acted like I was back in high school or basic training. There

were fun things to do! I made 132 dollars a month of which I sent 100 dollars home; 132 dollars wasn't a lot of money at all at the time. But we didn't need much because we lived off of sea rations in Korea. It was a box containing three meals a day.

Before we went to Tokyo on leave—where I got my geisha tattoo—we sold our Army-issued cigarettes on the black market to get some money to have a good time in the Ginza bars. I don't know if the war changed me in any way, I guess somebody else would have to judge that. My mom said that I went in a skinny kid and came home a man, but I think that's just what she wanted to believe. If I was sixteen years old again, I would never join the National Guard. It was stupid! But I'm glad I got it behind me, if that makes sense. Especially when I was younger because I knew that they wouldn't be calling me for the draft, later on, during Vietnam.

I think Timmy would have joined the Army anyhow. He wanted to be an Infantryman because of me, and I tried to talk him out of that because it isn't the best outfit to be in. In fact, it's about the worst place in the Army! He should have joined the Navy or the Air Force. But he wanted to have a CIB, a combat infantry badge, just like me. I said to him, but you have to get shot at to get that! My being in the Infantry definitely influenced his decision—just like he wants my tattoo now! I also talked against that, and all of his other tattoos! He always says that he listens to what Grandpa says, but he doesn't listen to what Grandpa says at all. I have no idea why Timmy adores me so much. He was raised without a father—he didn't have anybody that he was close to. His dad was killed before he was born and his stepdad Jack was good for a little while, but once Jack had his own kids, he was a monster. I think Timmy was pretty tired of dads by then. So the only guy he had was me.

I was disappointed when Timmy joined the Army. I wasn't enthusiastic. Timmy was a good Infantryman, but the politics... it's been tough on him. He should be more in rank than what he's got. But we really don't talk about the Army a lot.

2008
Fort Hood, TX

A few weeks prior to my visit, Timmy is officially diagnosed with severe depression and acute PTSD by an Army psychiatrist, deemed unfit to carry arms and transferred to Rear Detachment. He calls me to tell me the news and I book a flight to Texas.

One of my goals on this trip is to meet Timmy's friends and interview them as well. I want to know about their lives before the Army and how their tours in Iraq have affected them. Are their views and experiences in any way similar to Timmy's? How do they deal with their experiences? Are they proud to be soldiers or did they enlist because they'd hoped to see the world and escape a depressing lower class life?

When I arrive, it strikes me right away how young these men are and how hard it is to guess their age. Most of them look significantly older than they actually are. The youngest soldier I've talked to is just nineteen years old and the oldest one eight days younger than me, twenty-eight. I learn that Timmy's Army buddies call him Nike because he got yelled at in training once for wearing socks with a swoosh. I originally introduce myself to the guys as Nike's sister-in-law, but after a while, everyone just refers to me as his sister, and I start calling Timmy my brother.

Killeen, next to Fort Hood, is an ugly, run-down town in the heart of Texas. Everyone here has something to do with the military. The soldiers come from all over the United States and miss their families, their friends, and their hometowns. They're lonely—drinking seems to be the only amusement that passes the time. Most of them already have serious substance abuse problems when they enlist and are used to taking pretty much any drug they can get their hands on: the more, the merrier. Almost every night, Timmy's friends meet at a bar called Sport Shack, drink, and smoke the occasional joint. Their moods turn

somber when they're drunk and high and they start talking about the war, their fallen friends, their hatred for the Muslims who killed them, the Muslims that they have killed. SPC Branden Cummings and SGT Daniel Morris—comrades who lost their lives in Iraq—are often in their thoughts. It's the only time that they ever voluntarily talk about Iraq and the only time they let on how much it actually affects them.

Their everyday lives seem typically American: They play video games, they eat mostly fast food, they listen to loud music in their cars and hardly ever wear seatbelts, they are constantly on their phones, they compare tattoos, and joke all day long. Happy relationships with girls are rare. Divorces or marital problems are not. The guys worry about their girl- friends at home—yet cheat on them in Killeen.

Timmy shares a duplex with fellow soldiers Luis Tristan and Nick Martinez in the same street that he used to live on with Joscelyn two years ago. Nick recently got married and his wife Lisa lives there now as well. Until a week ago, Timmy's best friend Evan would sleep on the living room floor. Their house is the preferred hang-out spot for many soldiers in Rear D, most notably Tom Edwards who comes over almost every day.

One night, we all stay up late, and as we are just about ready to go to bed, someone knocks on the door. It's the next-door neighbor, a beautiful young black lady who's also in the mili- tary. Just a couple of days earlier, I took a picture of her in her uniform. Now she's crying frantically, clutching her daughter who looks at us with big eyes. She says: "Please help, please help, my husband is trying to kill me, and take my baby away from me. He smashed my head against the kitchen coun- ter. . . . " She's barely intelligible because she's sobbing so hard. We shove her inside, Timmy calls 911 while I try to calm her down. When after quite a while two police officers arrive, I am appalled at how unfriendly and cold they act towards her. "Domestic disturbance . . . it happens all the time here. They are used to it," Timmy says.

Many of the soldiers I meet are in psychiatric treatment for PTSD. Like Timmy, they don't train with the other sol- diers in their regular unit; they have their own schedule. From their accounts, it's obvious how overwhelmed Fort Hood—and

I assume many more Army bases around the country—is with the amount of soldiers in need of treatment. It usually takes weeks, sometimes months, for them to be able to schedule their health appointments. Often, they're denied help until they claim that they're going to kill someone. Once the soldiers do get appointments, they are very short, and just cover whether or not the prescribed medication is working. It seems like their psychiatrists are not treating, but simply fighting symptoms, drugging soldiers into addiction.

The soldiers who are in treatment often swap their medication with other soldiers—many never take the pills that they're prescribed because they don't have the desired effect. Xanax, Percocets, Oxycotton, etc. are all readily available. After a while, everyone simply starts doing coke.

At one point during my visit, Luis Tristan is assigned to suicide watch: A soldier from a sister unit tried to kill himself and needs to be watched in the hospital twenty-four hours a day. Tristan, who suffers from depression and PTSD himself, is relieved when the detail is canceled.

Many of the soldiers come from dysfunctional families or were abandoned as teenagers by their parents. Out of the nine soldiers I interviewed, only one grew up with both his parents. Timmy tells me, "The camaraderie we share is a feeling of love that many of my friends are not used to." The sappy expression "brothers in arms" rings true for many of them. They see themselves as a family and hug or kiss each other—often in an exaggerated, theatrical way.

When I ask them whom they're going to vote for in the upcoming election, Barack Obama or John McCain, I am surprised to learn that most of them won't use their right to vote at all. I don't understand: How can they—as Infantrymen at the bottom of the food chain—be indifferent towards the candidates when their political decisions will influence their lives? The future president will determine whether or not they'll have to go back to Iraq one or two more times, or none. One soldier's answer was, "Unless you're a super square guy who doesn't have a social life, you're just worried about having fun before you go back to war and get—possibly—killed."

Every time I see Timmy, he seems a little bit more absent-minded and far away, even in company. He can be very moody

and inexplicably crabby or melancholic from one second to the next. He doesn't smile or laugh often but when he does, people around him relax: When Timmy is happy, everybody's happy.

Timmy's known to stand his ground in discussions with superiors and is not afraid to speak his mind. He's more educated than most of his friends and the soldiers in his unit look up to him. "Nike can get away with anything," they often tell me.

He always dresses impeccably and cares a great deal about accessories like watches and shoes. He loves sneakers and proudly shows them around whenever he gets a new pair. He's obsessed with money. Both his arms are tattooed and a work in progress. He likes to read but spends countless hours playing video games. He hates to be alone.

Timmy and Joscelyn are currently going through with the divorce and fighting for custody and child support, which adds additional strain to Timmy's post-traumatic stress disorder. He talks about Joscelyn often.

When he's drunk, his mood turns melancholic and he's not afraid to cry, hard. He mentions his own death and asks his friends what they would tell his kids about him. Would they take care of them? They respond, awkwardly, yes, of course. Sometimes he talks violently and urgently, other times like he's in confession. Once he tells me that he keeps thinking about the kid that he shot off his bike in Iraq. When he's sober, he hardly ever mentions the war.

I've come to know that despite his detachment and indifference, Timmy's very sensitive and constantly worries about everything. Yet I still have a hard time reading his emotions.

Before my weeks in Texas, Timmy had always answered all my questions in detail and with patience, but without much conviction, if you will. During this visit, our talks become more fluid and open. He often points me to things that he thinks are important for the project or his story. We're beginning to collaborate.

When I came down here after one month of leave in Minnesota, work was like usual. The only thing that was different was that I was living by myself and I started going to my mental health appointments. When I came back from leave

in January, they evaluated me and said I needed to see some-body. Work was just like usual: Stressful, it sucks, but what-ever. Then I went home on emergency leave for my mom's brain surgery and Josci said she wanted a divorce.

After the emergency leave, I was really, really depressed. My mom wrote the Senator of Minnesota this really long, crazy letter about how I wasn't getting enough appoint-ments with my psychologist and all this crazy shit, and how I was really depressed and they were trying to make me go do JRTC a month in Louisiana. So she wrote a desperate let-ter to the Senator and the Senator called somebody in Fort Hood. After that, I pretty much got instant appointments. They put me on antidepressants and said that I should prob-ably get out of the Army and not be around guns or anything anymore. And now I'm working in the motor pool: an easy job. After that, I'm gonna be transferred to WTU, they'll work on getting me out. I don't know the whole process. I don't know what my days are gonna be like. They just have to recommend you to get into WTU, you get a packet, your commander signs it, and you go. That's gonna happen with my next psychologist appointment, I guess.

I tell my psychologist I'd kill people if I had a gun but I wouldn't kill anybody. I guess I have the symptoms of PTSD. But then again, people that have it don't think that they have it. Or, like, my mom says that I have Asperger's, that I'm autistic. But I don't think so. At least I don't feel autistic!

Me and Josci have always had problems and now we're finally gonna go and get a divorce. Living down here by my-self, it sucks. I'm lonely. I want a girlfriend. There's not a stitch of pussy in Killeen. It's tough. Sometimes I'm lonely and that makes me depressed. I miss my kids. I could prob-ably never have pictures of them up because it would just kill me.

My youth was very easy and privileged. Not really privi-leged, but I never had an extreme want for anything. If I wanted something, I went out and got it no matter what. Selfish, I guess, I'm pretty selfish, very materialistic. I always have been, since I was little.

I don't know anything about my dad. He died before I was born and no one ever tells me stories about him, and I've

seen only, like, two pictures of him. My mom doesn't talk about him to me. She never has. I've never asked her anything and it was never brought up. When I was two or three or four, she got married to Jack. We called him Dad, growing up. It was pretty regular for us. Family life. I don't think that defined me in any way, growing up. It didn't really have an influence on me. As soon as they got a divorce, I was just like, pshhh . . . I didn't take it hard. I felt impartial, I guess.

At first, I didn't really like Tim, my mom's third husband, but he's good to my mom, that's good. And I don't know, we just all grew up together, and we got used to each other, but at first, it was kind of rough. When I joined the Army, he really started being more dad-like, I guess. He'll help me out with stuff if I need it or give me advice. He always will help me, no matter what. He's cool. We're a lot closer now than we were when I was a kid. It wasn't that we didn't get along when I was a kid, he just knew that I was selling drugs. He knew I was having sex with a different girl every night in his house. He knew I was doing drugs and staying out all night. But there's not much you can say when I'm still passing school and doing fine, going to work. He would get mad about it but that's who I was.

I've never really been into drugs, I just smoke weed, that's it. Long before I joined the Army, probably since I was thirteen. I went to my friend's house one time and he took some out of his dad's drawer, I think, we smoked some, and a couple of weeks later, somebody asked me if I wanted some, and I was like, yeah, sure. That was the first time I got really high. I was thirteen or fourteen and I was like, this is awesome! Ever since then I have smoked weed.

People can't tell when I'm high and when I'm not. When I don't smoke weed, I feel angry a lot. Irritable. Anything anybody does pisses me off, no matter what. I feel it more now, with the PTSD. I'm pretty moody, I guess. It's tough. I wish I wasn't. But I can smoke something that will put ten people to sleep and just feel normal. It's not the amount that I smoke, it's just what it does to me and has since I was a kid. Even my mom never complained about me smoking weed. She actually thinks it's good for me. She says, "Timmy, I don't know what weed does to you but it doesn't do what it does to other

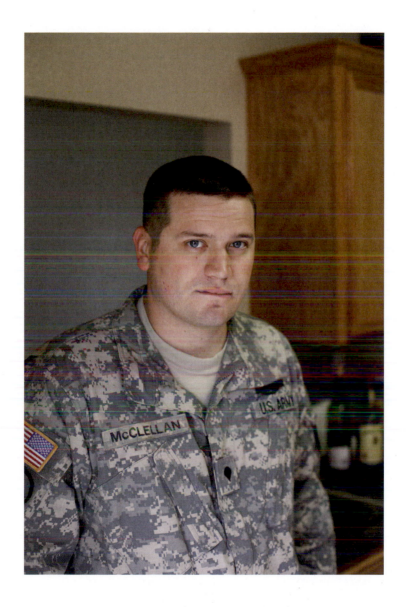

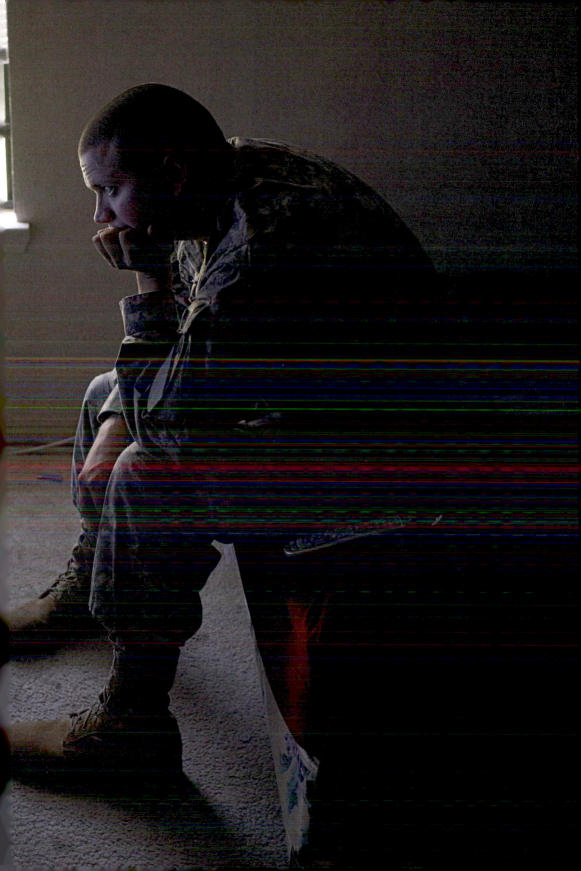

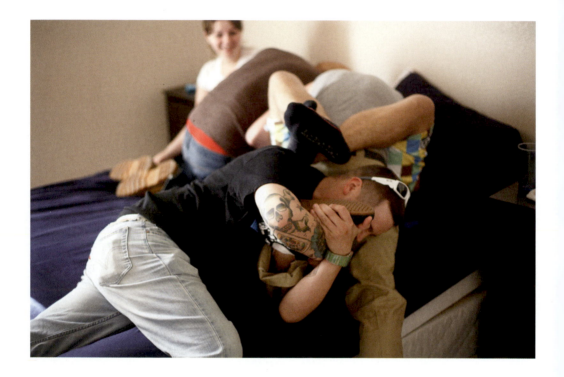

Timothy McClellan

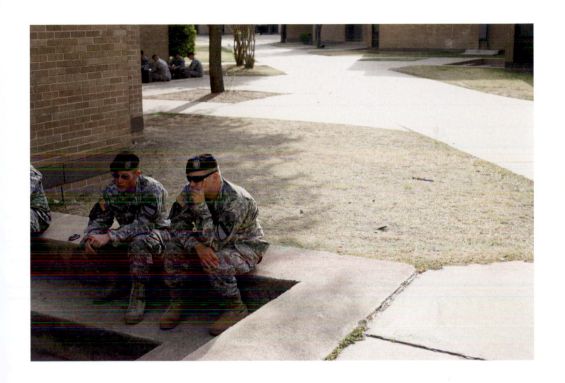

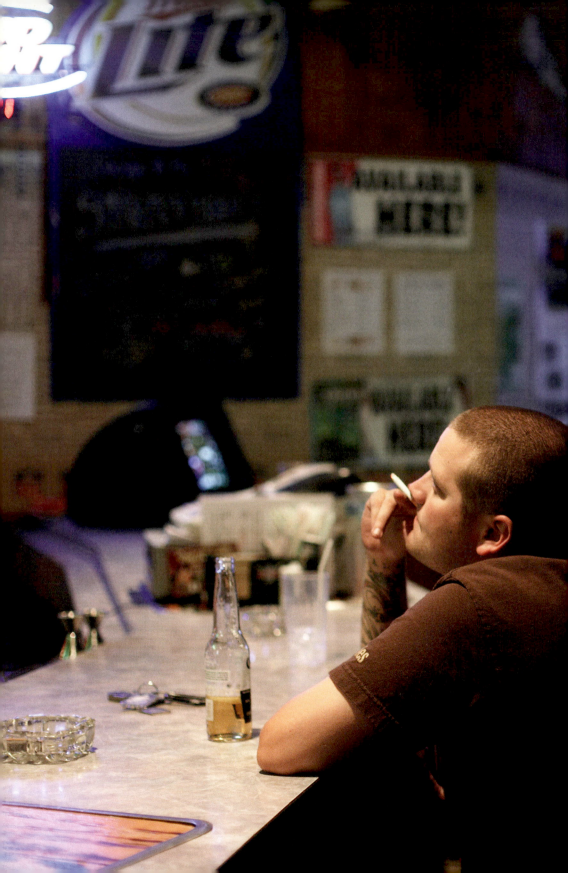

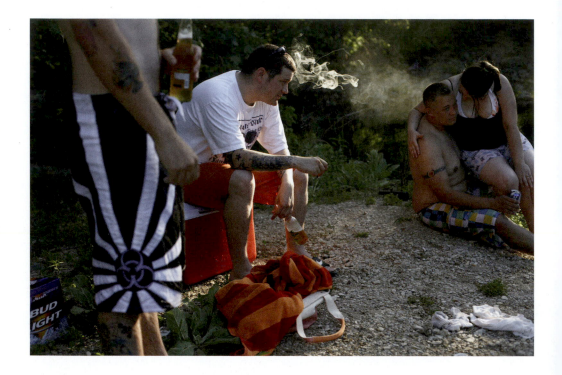

Timothy McClellan

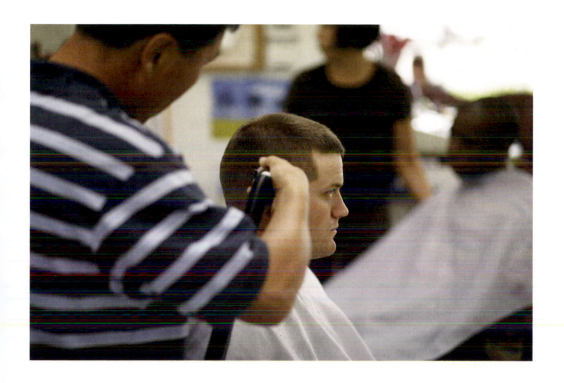

2008 — Fort Hood, TX

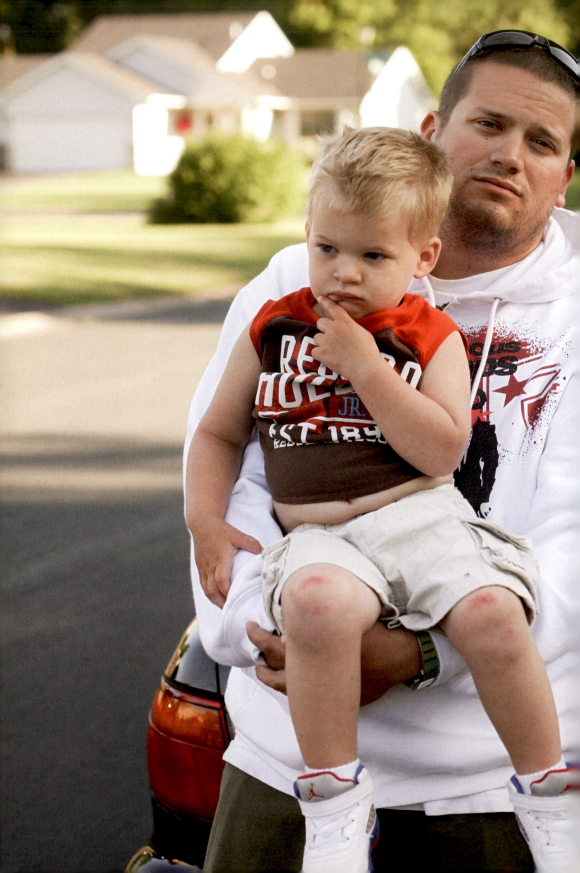

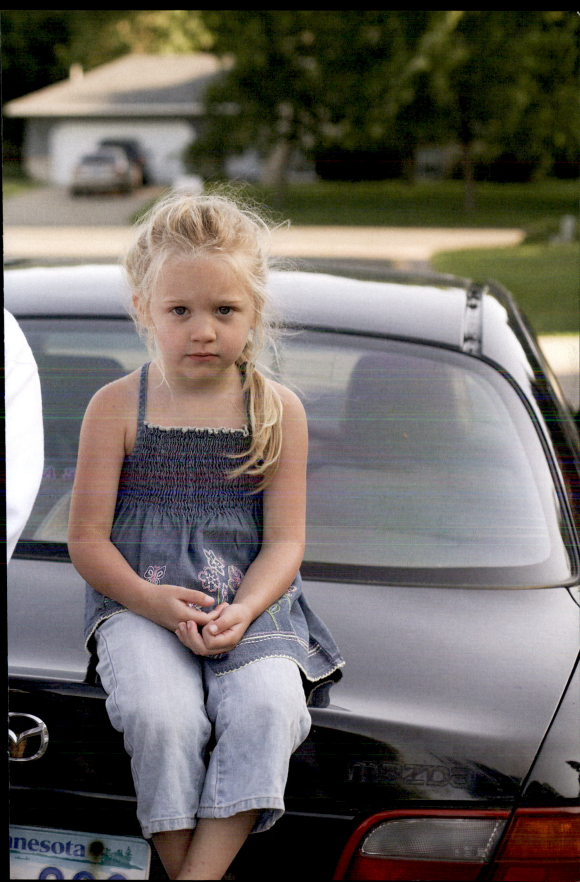

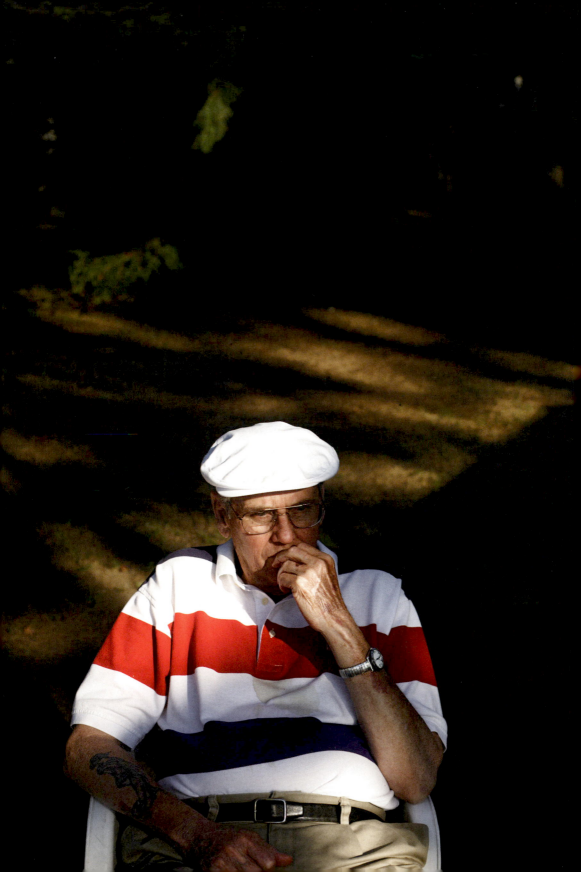

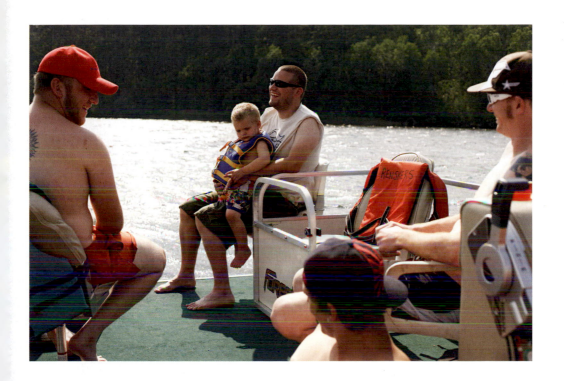

2008 — Fort Hood, TX

Timothy McClellan

2008 — Fort Hood, TX

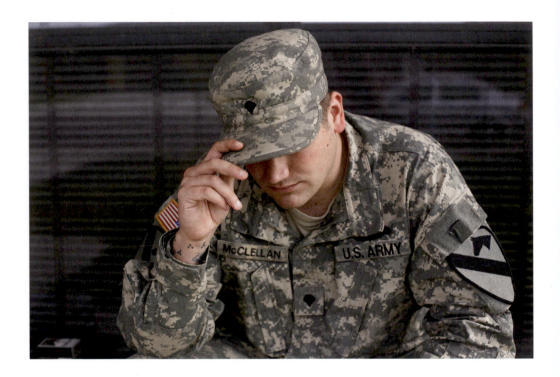

Timothy McClellan

people." I am normal. I feel normal. I actually feel something positive instead of being, you know, sad all the time. I don't know why I'm so sad all the time. (*He starts crying.*)

The whole divorce thing isn't that I like Josci, it's the rejection, kind of, like, why wouldn't someone wanna be with me? That's how I feel about every relationship since I was a kid. I don't care if I don't even like the girl but I want her to like me! It feels like I'm loved by everybody when I go home, but then I get depressed when I go home, too. I don't want to be depressed all day. I just can't help it. I don't want to be moody. I don't want to think about Josci and the kids. I try not to think about the kids, it just makes me upset. I'll call Josci and I'll be, like, well, you know, I do want the kids as much as I possibly can. I'll tell her, they are the most important thing to me, and she's like, "Oh yeah, since when? You weren't ever there, you're not here, you never will be, blah, blah, blah. . . ." She holds my job against me. Me putting my life on the line so she can have a house. But I'm not there. It's tough. I don't want to fight for my kids, I just want them. I just want them around when I wake up in the morning. I'm not really one to play with the kids, but I just like them around me. I like taking care of them. Teaching them stuff.

You know, they say the wife sympathizes with you? Josci never sympathized with me. She never once thought that what I was going through was hard. She was just like, you're a soldier, that's what you're supposed to do. She has never asked me anything about my job and she just isn't interested.

I felt that I was constantly trying to make Josci happy when I was on leave last Christmas. No matter what I did, it didn't do anything. I tried not even being myself. Whatever she asked me to do, I did. No matter what. So that's what I did. And it still wasn't good enough for her. She goes, "I shouldn't have to tell you what to do!"—It was just that she wanted a divorce. She wanted out. She said she wanted to make it work but I think she had it planned while I was in Iraq. So I would give her money. She wanted to make it work just for appearance's sake.

That's probably why I drink so much. For me, the love my buddies give me is nothing compared to where I come from. But for all of them that's a lot of love that they're not

used to. Except for Rollings. Rollings is probably the most loved person in his town. But, like, Skelton, he doesn't have that many. . . . Besides his sisters, we're his family. Not many people come from somewhere like me. Not many people have that. And you know, a lot of people actually tell me they love me. Like my friends tell me they love me. Back home, here. . . . If your friend actually tells you he loves you, that's really good. I've never met anybody besides Josci that just hated me. I've never met anybody who didn't laugh at my jokes, or anything, and that's what really attracted me to Josci. She didn't give a fuck if I liked her or if I didn't. I was really popular in high school: You should care! And that really intrigued me about her. She wasn't all over me. If I didn't give her attention, she wasn't gonna call me and bitch about it. Strong personality. I always like bitches. Like: fucking bitch! So I always dump nice girls because they're too nice. I don't think I would do that anymore. I still got a couple of years left in me, bouncing around.

The whole system, the way everything works in the Army needs to be looked at. It seems the smarter you are, the more you have an opinion, the more that's a bad thing. Like Tristan: He's really smart. And he's still the same rank as me. It's because we have opinions and we're smart. We're like, "Hey, that's a bad idea, we should do it this way, it would take half the time." "Shut the fuck up," that's the response you get. That's the way it goes. It's always been like that. It's the Army! Why work smarter when you can work harder? Hurry up and get in that line and wait for three hours! Can't we just, like, chill out, and wait for the light to die down? No, get in the fucking line! OK. Are you serious?—There's a point in discipline when it comes to listening to your orders when you're in battle. And there's a point where you're like, dude, this is stupid. Things that don't make sense. I'm always the guy that says what everybody's thinking. That's why everybody loves me. Because I don't give a fuck. I'm not gonna change who I am to go up in rank. I'm always gonna be who I am. Josci said, you know, we can get back together once you change. I'm not gonna change. I'm not gonna be fake. You loved me for who I was back in the day, that's who I still am now. Most people change. The only thing that's changed

Timothy McClellan

about me is that I've gotten more mature. I'm still the same kid. I feel the same. But sometimes, I look at myself in the mirror, like: Goddamn, you're getting old, Tim! I feel like I'm wasting my life here. I don't feel like I'm doing anything productive and I don't wanna feel that way. That's probably why I like growing plants and stuff. I can see progress and I'm in charge of it.

I think the training that we do is bullshit. Obsolete. And when we do do training, nobody's really listening, they're just checking the mark. The only way you can really learn . . . I mean, you can teach them basics, but the only way you're gonna learn is in battle, what works and what doesn't because the enemy constantly adapts. And whatever you're learning back in the States, they're already countering it in Iraq. You have to constantly adapt, too.

I'm gonna vote for Obama. He's gonna be the guy who makes a difference. Or at least he makes you believe so. I wouldn't have a problem with Hillary—universal health care! I hate Bush. Fuck . . . I hope he gets in a plane crash and dies.

The war is all like a blur. I don't remember anything unless something comes up about it. Why would I want to think about it? There's nothing good. You know, even when I talk about it, I don't think about it. It's like that for everything, I guess. I don't remember much anymore. My memory is really bad. I remember the most trivial things. Always. I'll remember big, important things, but it's gotta come up. Something will have to happen to make me remember. It's been like that a little before Iraq, but a lot more now. It's really weird. Memory loss is weird. But they say that's PTSD. My body tells my brain that it doesn't like the way it feels when I think about certain things, so it doesn't think about them.

Therapy is not gonna help me. Just living a normal life will. Because I can manipulate the psychiatrist. I shouldn't be able to do that. It's because I'm a sociopath. I don't know how I do it. It just comes natural to me. Everything that I tell him, I can tell that he wants me to tell him. At the beginning of every session, he asks, "Do you feel like hurting yourself?" "No." "Do you feel like hurting other people?" And I always say, "Yeah." Because I do think about hurting people. And

the only reason that stops me is the judicial system. Because morally, I couldn't give a fuck about killing a person: that I don't like, or hate. Which is weird to a lot of people, but truthfully, I would not feel the least bit of remorse. I'm a trained killer. That's all I know. Have you ever felt like your life was in danger before? Have you ever been stopped in a car or something, when you got really scared for your life, ever? Well, being scared for your life, if someone's trying to kill you, there's no feeling like that. If someone's trying to kill you: it's you or them. There's nothing like that. Maybe skydiving your first time. But when you get shot at, it feels like that every time. I don't feel the urge to kill because I have to kill. I feel the urge to kill because someone pisses me off. Like Josci's boyfriend. Like the Lieutenant says something to me at work. And what I'm thinking while he's yelling at me, is: I could kill you with my bare hands right now! You little piece of shit!

It doesn't scare me because I would never do it. I'm never gonna snap and start killing people. But if something happened with my family or something, I can totally see me doing something. I feel passionate about my family, that's about it. Like if someone hurt Angelina or Quentin, then I could see myself definitely going after a person and seriously murdering them. I'm gonna kill them and dispose of the body. I have it all planned out. I think I could do it. I really think I could do it. I would probably just shoot them. Or I would strangle them from behind, and have my trunk lined with plastic, put them in the trunk, and go to a designated spot where I would take the head, the hands, and the feet and then bury them all in different holes, far away, like different counties away. And take the body, wrap it in chicken wire, and cement both sides, and I would probably throw it in the mining pit. Because it's really, really, really deep. Chicken wire is good because the fish can eat the flesh but the bones won't rise to the top. Even if they do find the bones, they don't have anything that they can identify the body with. There's no head or hands or feet. That's how I would do it. I came up with that probably before I was even in high school. If we had an ocean, I would put it in the ocean. Head here, drive ten miles that way, body here, ten miles that way . . . I could be a hit man. But I wouldn't

want to do the clean-up every time. If it was just a hit, whenever, wherever, like, travel to the city and take this guy out, that would be so easy for me. Watch him for a day, then shoot him in the alley or something. I couldn't keep cleaning up bodies all the time, cutting them up. I'd have to feel real passionate about it to have to go through all that trouble, make somebody disappear. Because people disappear all the time.

A few weeks after my visit in May 2008, I go back to Texas to follow up on the soldiers and to accompany my brother-in-law on a two-week leave to his hometown Hibbing, MN.

The divorce process is still ongoing and worsens Timmy's condition. He's also still waiting to get into WTU but has no idea how long it will take to finally be transferred. In the meantime, he is on motor-pool guard or kitchen duty. Most days he doesn't do anything but show up to formation twice a day.

The process for PTSD patients to get discharged is hopelessly backed up and Army psychologists are overbooked. I'm impressed at how patient Timmy is in his situation: He desperately wants to leave—his psychologist even advised him to go AWOL if he didn't have kids—but needs to wait until his paperwork moves up the chain of command. He's also waiting for an appointment with the med board to determine how much monthly disability the Army will have to pay him once he's discharged.

His psychologist tells him that he can't survive without his medication. Little inconveniences like a flat tire on his car or a temporarily displaced wallet make him lock himself in his room and cry inconsolably. He often stays up all night and only sleeps a little bit during the day. He hardly has any appetite at all. When he's out of pot—his drug of choice—he tries to find anything to subdue himself: alcohol, painkillers, pills, etc. He is more jumpy than usual and jolts at unexpected noises.

Timmy has stopped taking his antidepressants and is either manically high or extremely brusque and curt. On some occasions, his tone towards me is so mean that my eyes well up with tears. One time during his leave in Minnesota, he tells his younger brother Mikey to go pick up some burgers, and when Mikey returns with just burgers and no fries, he is awful to him

and makes him cry, too. "I just can't believe you wouldn't bring fries! That makes no sense at all," explains Timmy.

Once, during my second visit, I write a note to Timmy (but end up not showing it to him): "I can't sleep or eat anymore because I'm so worried about your condition. . . . Everything you do or say concerns me because I see you as my brother, not just as an interesting subject from a journalistic point of view . . . I feel overwhelmed . . . I think I just fully realized how confused and injured you are and I cried so hard the next morning because I just want you to be well and thriving . . . I have a hard time seeing you so unhappy and depressed. . . . "

One night, we go out to the Sport Shack and then end up sitting on the porch until four in the morning, smoking cigarettes and drinking some more. Timmy is in a very dark mood and cries on and off. This is a part of our conversation that night:

I can understand how some people go to Iraq and are not affected by it. Take Rollings, for example. Rollings didn't really do much. He never got blown up and he never really had to shoot anybody. Like Tristan said: The gunners. Sitting there at night, seeing miles out. We were the killers.

Tristan had mentioned earlier how there was a tally between the Bradley gunners in their unit: Whoever had the most kills was the winner. If somebody didn't have very many kills, his buddies would make fun of him and say that he had some catching up to do.

I'm worried about karma. I feel like I've done bad things and I need to redeem myself. I mean, I've killed like thirty, forty plus, you know? I've destroyed whole villages. Who knows, really, how many I've killed. I've got twenty-eight confirmed kills, in my sights. But I've destroyed big villages, big buildings. Leveled. By me. After that, I felt good. I've killed innocent people and laughed afterwards. I went back to the FOB and didn't feel anything. I fucking hate those motherfuckers. All of them. It's hard not to.

That's the fucked up part about the Army. How is killing someone over there OK but over here it's not? For less moral infractions than what's going on here. That's the way I look

at it in my head. I killed someone because you told me to. What if I just want to kill someone? They just think that's normal behavior. They think you can just turn it on, turn it off. For five years, all I've known was killing. For five years, people telling me I'm a killer. My job is to find the enemy and eliminate them. That's my job description. Then you expect me to get out and do what? Make refrigerators? Fucking work in the mines? Sell cars? I'd rather be a goddamn dope dealer.

Did you know that I think about my funeral every day? Isn't that fucked up? Like, who would read my eulogy. Or who would say something about me. What would they say? No one really knows shit about me. Not even Josci. She doesn't know shit about me. Would my Army friends show up? Like, from out of state? I know they'd send letters or whatever, but who would show up? I know everybody in Hibbing would. Like at my dad's funeral. My mom said it was the biggest traffic jam ever in Hibbing. Everybody loved my dad. She said she was just amazed. I want it to be the same thing for me. It's so fucked up. I got so much weight on my shoulders. It's not even for me. Me—I don't give a fuck about me, you know. I don't. I'm worried about everybody else. I always have been. And they call me selfish. They just don't know what I'm thinking.

I just don't even know what I could do. I've always said I was gonna be a politician. For real. Why couldn't I be, besides my background? I couldn't go too big, obviously, like president. They would be like, you fucked, like, sixty bitches? Slanging coke? Are you fucking serious? Whatever, though, State Representative, one of the six that they have, I could do that. I'm a dirty motherfucker, but I would still be for the people. Everybody says that starting out, but me, I don't give a fuck. And I would help out everybody I could. That's something I could get into. That's something I could put twenty hours a day into. Actually making a difference in a state. Be the guy that a soldier's mom calls up. And I can make a difference. That's me. Working a fucking nine-to-five, going back to the fucking Middle East as a private security or Africa, that's the only thing I know how to do. But I've had people skills since birth. I'm not a shrewd. I have street sense, I know politics, I know history, I'm not a retard.

I know what I'm talking about when I talk about it. I'm not gonna talk about something I don't know what the fuck I'm talking about. If I don't know what I'm talking about, I'm gonna ask questions and find out. I definitely need to go to college or no one is gonna respect me.

I'm probably gonna end up selling drugs for the rest of my life. It's the only thing that gives me a rush. And self-esteem. I feel like I have power. I feel that way anyway. I'm not scared of anybody.

Earlier in the day, Timmy was summoned into Sgt. H.'s office because he had missed a formation a couple of weeks earlier. He had to fill out a form ("counseling statement") about the incident.

Like I said, when I did that counseling statement, there's two blocks: "agree" and "disagree." I've never seen anyone, in the entire five years I've been in the Army, put "disagree." And not only did I put "disagree" today, I wrote myself a statement. I wrote an "explanation." Sgt. H. was looking at me, like, are you out of your mind? And I didn't even blink. I don't stand at parade rest for him, I don't call him Sergeant . . . because he was our Platoon Sergeant. And right before we went to Iraq, he became Rear Detachment First Sergeant, meaning he didn't go to Iraq. He didn't do what we did. So to me he's a bitch and he knows that.

Before and after he read the counseling statement, he said, "Nike, you know I've got nothing but respect for you. I know what you did and I know what you went through, first tour and second. But that doesn't mean you can't show up for my formation. You get more leeway than anybody I've ever seen in the Army because of what you've done and who you are." So I was like, hmm, yes, hmm, hmm, hmm. I just sat there and nodded. And then I signed it. Under "disagree." And he was like, I don't know what they're gonna do. I've never even had anybody disagree before. All it's gonna do is move up the chain of command, that's what they say it does once you "disagree." The higher it goes, the more it's gonna get torn up. I don't think I'm gonna be in trouble for that. Tim McClellan, Purple Heart, two tours, both drivers died, war hero. Mother

called Congressman. Didn't go to work because it was past his profile or he had an appointment. Do you want to be on CNN? I don't think so. That's why Sgt. D. tore up my first Article 15 paperwork for not showing up on time. When you get an Article 15, they could take your pay away. He tore it up right in front of my face. Nike, I'm sorry. I'm sorry I can't control this. Sgt. H. does his own thing, he said.—Of course Sgt. H. waited to talk to me when everybody else was out of his office. Because he knew I'd do something stupid. I'd make a fucking ruckus.

But that shit got me worried like a motherfucker today, my back hurt like crazy. As soon as it happened, my back started hurting. They say half the back pain is psychological. I couldn't even sit down on the couch, my back was hurting so bad.

I wonder how people would think about me if they read about me in a book. Would they remember me? You know how every war has, like, its own story? I want people to look back for a war hero. And then my kids would be, like, that was my dad. That'd be cool. If I could live on forever . . . not forever, but, like, my kids will tell their kids and they would tell their kids. I'm gonna tell my kids about Grandpa Christianson. I'm gonna tell them about him all the time. I want my kids to pass that on. I don't want it to be forgotten. I'm greedy and selfish as fuck, when I come around I want people to wish that they were me. It's really fucking self-centered. I have really low self-esteem. It's obvious that I do. That's why I fuck everything. I'm not comfortable in my own skin. I dress to impress. Always have. Even when I had high self-esteem. I don't want people around me but I want people to want to be around me. They do, but it's not good enough for me. It just doesn't satisfy me at all. I've always thought on a bigger scale. I don't wanna blame my mom but it is on my mom. You're gonna do something great, Timmy, that's what she told me since birth. She always told me that. But I feel like I let her down. All the time. And she can tell that I think that. And she's told me, you already have, honey. You've done so much. You've made me so proud. But it doesn't matter. To me. I gotta do something. I know I'd be good at whatever I did. As long as I put everything I had into it. I don't settle for

second best for shit. I'm never gonna say anything like that to my kids. It just puts too much pressure on somebody. She didn't say that to any of her other kids, except me. Timmy, I just know—I know—you're gonna do something great someday. And I never felt like I did anything. Of course, to her, I'm the world. All I wanna do is make the family proud. I'd do anything for anybody in my family. I'd die for them. My kids, my brothers, you, even Josci. I wouldn't hesitate a second. I'd pick suffering eternal torture over the life of my kids.

Let's say I died in a car crash tonight. What would people say at my funeral? It'd be huge. I know that. A war hero dies in Hibbing. Everyone's gonna show up. It's gonna be in the paper. "War Hero Dies, Purple Heart, blah, blah, blah. . . . " But when my kids are in high school and their teachers see them and they're like, you know I knew your dad, what the fuck are they gonna say? I bought coke from him once at a bar?

I remember what people say about my grandpa. That he was the bravest person they ever met. That's crazy. Somebody told Jack that once. When he was a businessman, selling shit down in the Cities, he met someone from Kelly Lake. Jack was like, oh, you're from Kelly Lake, my father-in-law is from Kelly Lake, too, do you know Larry Christianson? And the guy was like, Larry Christianson? I was there, on Main Street, when he got on the bus to go to Korea. And he was the bravest person of the whole group. Nothing on his face, just got on and left—I must have heard that story when I was, like, seven. Never been repeated and I've never told anybody, you know, I've never mentioned it, ever. But I remember it, in my head. Like, wow! Somebody randomly met someone that saw my grandfather and said he was the bravest person he's ever seen. That's why I wrote the Sapp family. I wrote them what I would want someone to say about me. He was the bravest person I've ever met and he made the sergeants laugh, blah, blah, blah, you know. I basically did my own biography. What I thought would be perfect. And they read it at Brandon's funeral, which was crazy.

What would Angelina and Quentin say? Or be told? Of course from my family, everybody would say: Dad was a war hero. I hope that's implanted in their minds. When I was in

Iraq, sometimes I would think, you know, maybe the best case scenario is that I'd die in combat. In combat, you know, glorious death. And really, in real life perspective, if I was gonna go out, I would wanna go out in combat, not lying in my bed. I'd like to go out saving somebody's life or something that someone would remember me for. Weird. I think you're the only person I've admitted that to. That I wanna live forever. Not live forever, but you know, my memory. I've never told anybody about that. Did I ever tell you anything about that in the interviews? Something like that, I think. Like how much I care about how my name is passed on. But no one knows how much I care about it. It's kind of weird. It's the whole reason I joined the Army. From that one story about Grandpa. I made up my mind right there.—He knew what he was getting himself into before he joined. It was all over the fucking news. He told me the same bullshit about just wanting to make some money. He knew he was probably gonna go to Korea. He didn't think he was gonna just sit at Kelly Lake and get a couple of dollars every month.

Nobody knows how deeply I feel about my image, not living, but dead. For eternity: not eternity, but at least my family. And I think that's just rooted from my dad. Everyone that I've ever met who knew my dad never had anything to say but the best. But of course, who's gonna say anything bad about a dead person? I'd like to know my dad for who he really was. My mom said he smoked pot. He was a hippie. I was in my mom's body when somebody came to her and told her that my dad was dead. Before my dad even knew she was pregnant. But my dad had told his friend Bobbi when they were at a party, a week or so before his death, "I think Hope is pregnant again!"

2010
Chisholm, MN

After retiring from the Army with full benefits for the rest of his life, Timmy moved back from Texas to Minnesota in the spring of 2010 and now attends the local community college. He stays in a small house in Chisholm, a town close to Hibbing where his parents and Joscelyn and the kids live. In the summer of 2010 he got a DUI and his driver's license was suspended for a year. He needs other people to drive him to school and stays holed up now even more than before. He used to go see his grandparents every Monday for lunch but doesn't have a ride anymore.

He keeps talking about wanting to move away, to New York City or Northern California. Life always seems better somewhere else. He doesn't eat much and he never cooks; he orders take out or has someone bring him something to eat. He also mentions that he has a hard time keeping the house clean. His ex-girlfriend Britney used to take care of him and was in charge of the household but when she started cheating on him, he kicked her out. He stays up late drinking pretty much every night and watches documentaries on cable television or plays Call of Duty. The TV is on all day.

Timmy has constant back pain and needs surgery—before the surgery he has to go for more appointments with doctors, though. He isn't currently seeing a psychiatrist because they can't help him anyway, he says. "The only thing that helps with PTSD is time," he says. If he needs drugs, he goes to the VA and gets a prescription for any drug he wants. He takes Xanax every once in a while and it does make him seem more friendly and optimistic. Timmy's mood is generally a lot better than before (even without antidepressants), he jokes around and makes people laugh all the time. Now that he's out of the Army, he can grow his hair out and groom a beard. He frequently checks his looks in the mirror and asks people if they like his long hair.

The presence of his pit bull Uzi comforts and calms him. Timmy has a special "service dog" license for Uzi and is able to

bring him anywhere: the college classroom or his grandparents' assisted living apartment where pets are usually not allowed. He jokes about how he likes to make people uncomfortable when they ask about his service dog. They ask him, what is wrong with you? He answers, you know, you're not supposed to ask people that! Or he tells them some crazy story that leaves them embarrassed and bewildered.

Timmy likes to teach and tend to things and take care of them, like his dog or plants in his little self-made green house. College bores him; he doesn't really see the point of going. He makes references in class to historic events sometimes and says that no one gets them, not even the teachers. He feels unchallenged and underwhelmed.

The kids come over every other weekend and Timmy immediately turns the TV on for them; afterwards he goes back to bed. He is hung-over and tired and doesn't spend much time with them throughout the day. He tells me that all the kids do when they come over is watch TV anyway. "They don't know their dad," he says but he doesn't seem to make much of an effort to change that. He admits feeling helpless around his kids even though he loves having them around. Angelina, his six-year-old daughter, says, "Our dad doesn't really know how to take care of us," almost apologetically.

On November 5, 2009, U.S. Army psychiatrist Nidal Malik Hasan initiated a mass shooting on the Fort Hood Army base where Timmy was stationed at the time. During the course of his rampage, Hasan killed thirteen people and wounded twenty-nine others. It was the worst shooting ever to take place on an American military base. Government agencies suspected terrorist links at first as Hasan is Muslim, but it was later alleged that he suffered from severe post-traumatic stress disorder and was upset about his upcoming deployment to Afghanistan. The shooting started a nationwide debate about military therapy and the toll it takes on Army counselors. Crushing schedules and the sheer mass of soldiers seeking professional help after a deployment leaves psychiatrists depressed themselves. Mental health evaluations of Army therapists was and still is virtually non-existent, and it is now considered an established fact all over the country that at the time, Fort Hood's program for veterans returning from Iraq was seriously understaffed.

Timothy McClellan

Hasan was my psychiatrist. He was in charge of my mental analysis, like, whether I had PTSD or not. He was a Major, so he was pretty high up there. He liked me. I never suspected that he was crazy or that he was going to do something like that. On that day, I had to get something from him and I was in the building where the shooting took place. I had to get a stamp to get out of the Army—it was my last stamp. I went into the parking lot, and I started to walk in, but all of a sudden I got sick. I called Brit and I said, "I feel really sick, I'm in the parking lot, and I'm throwing up," and she said, "come home," and I came home. I turned on the news and there's a shooting at the exact same place I just was. I was like, oh boy. I called my mom and told her to turn on the news. She finally got the right channel and she goes, "Oh my God, it's not you, is it?" She thought I was the shooter! It was pretty sad. She explained, well, I thought maybe you snapped!

It took Timmy more than two years to receive an honorary discharge for medical reasons from the Army with full benefits, to fulfill all the appointments and put together all the necessary documents that prove that he really does suffer from severe depression and PTSD as well as traumatic brain injury, short term memory loss, and back pain. At least once during these endless months of waiting, his superiors offered him immediate release from the Army if he accepted an honorary discharge without any benefits. Timmy declined and stuck it through. Another time, they told him that he needed to re-enlist for four years in order to finish the med-board process.

I'm doing better now. The war was about four years ago. I never think about it. I don't even remember people's names. Like, last night, when you asked, who is Jason D., from my company in Iraq?—When I was in the Army, I could have told you that like that *(he snaps his fingers)*—now, I don't remember anybody. I don't stay in touch with anybody, I don't want to. Not even Evan. I just forget about everything.

When I imagined my life after the Army, I figured I wouldn't be back here, in Northern Minnesota. I was gonna move. I thought I would have a car and I would have money to move anywhere, instead of back here. Funny how things

work out. My mom guilt-tripped me into coming here. I would have rather gone to California. I can still do that, but I just need to save enough money, which is tough when you live paycheck to paycheck. But sometimes I come into money, I just need to save it when I do.

I think it's pretty bad here, just because I don't have a car and I'm secluded. There's not much to do, you can only drink or go to the movies, there's not much choice—there aren't any places to eat, there aren't any people to see. There's maybe eight single people in Hibbing. Everyone else gets pregnant when they're sixteen. Now I don't do much, I just sit at home and watch TV because I don't have a car. I have nowhere to go. The only people who invite me places are my family, they are the only people I know around here. My friends are married and old now, and they have jobs, they have nine-to-five jobs—sometimes later than that, because they don't have diplomas so they work really weird, strange hours. They work hard, for nothing. Plus, I don't trust anybody. I can't have anybody over here.

I want to go to school for as long as I can and try to get a good job, something that I'd like to do, something that will motivate me. Maybe helping people. I like doing stuff for people. Maybe I'll volunteer for the Peace Corps. That'd be a story: First he joined the Army, then he joined the Peace Corps! I mean, I don't care about what kind of job. Just...like, be an intern at a law office...anything like that.

It's not that I don't like being around my kids. I love being around them, but I hate taking care of them. I love having them around, but I really hate taking care of them. It would be ideal if someone could take care of them. I'm sure everybody feels that way: Oh, maid! I gave my kid his hugging time today, will you take him away now? But unfortunately, that's not the way parenting works. I get overwhelmed easily. I'm not used to them. I don't know what to talk to them about. It's strange. I feel weird when they're around. I'm just not used to them. They're little kids, and they're loud, and they're needy. I don't yell at them or anything. I never hit them and never will. I don't think Josci can say the same, I'm sure she spanks them. I never feel like hitting. I yelled at them one time and they started crying. I was like, whoa,

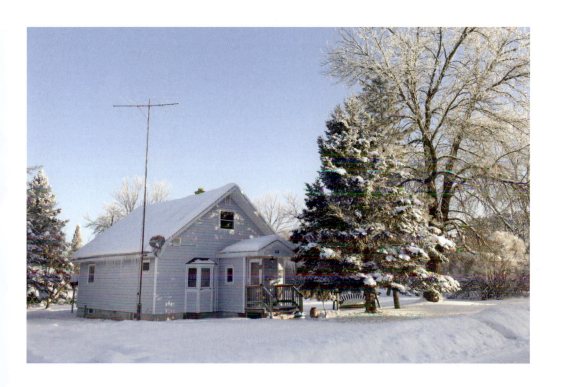

2010 — Chisholm, MN

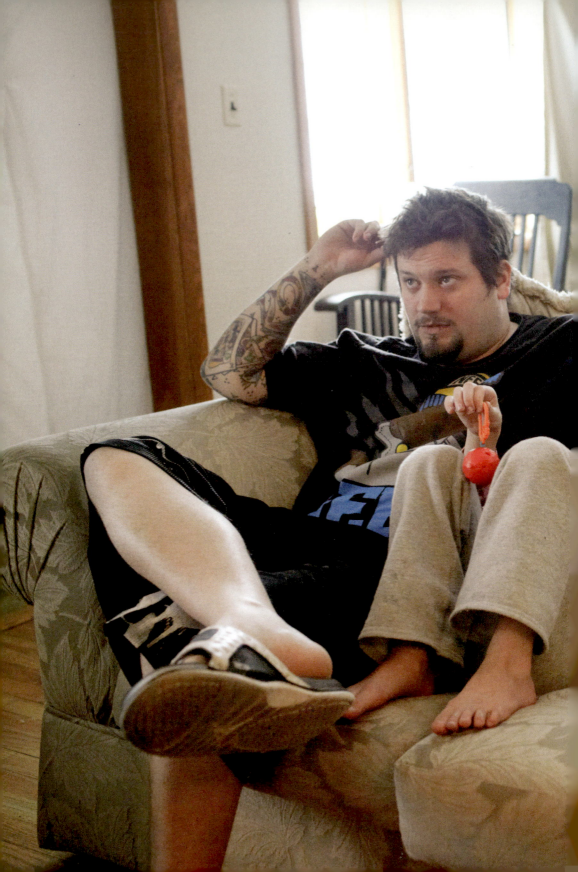

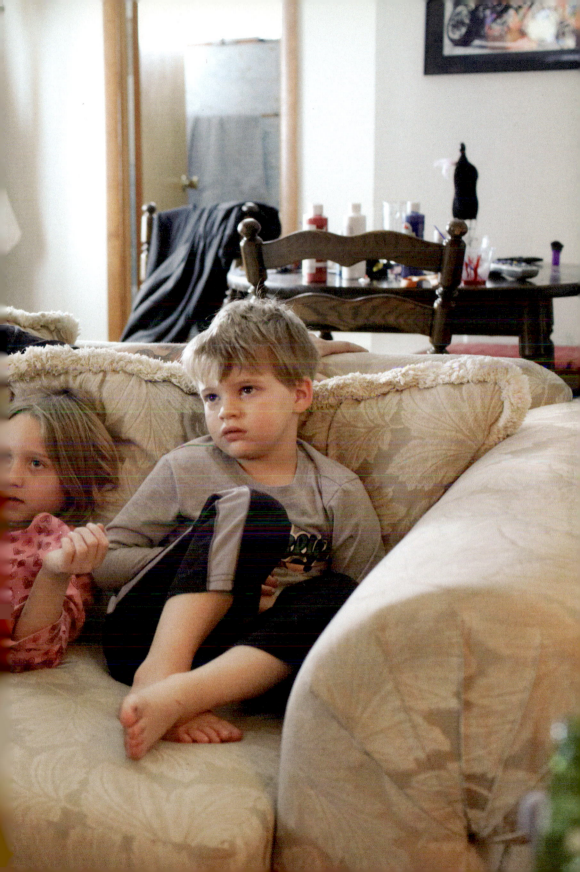

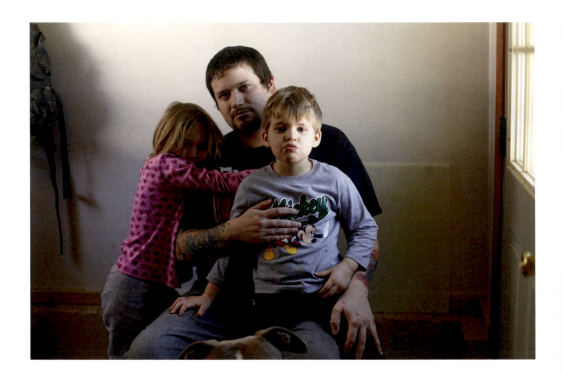

Timothy McClellan

2010 — Chisholm, MN

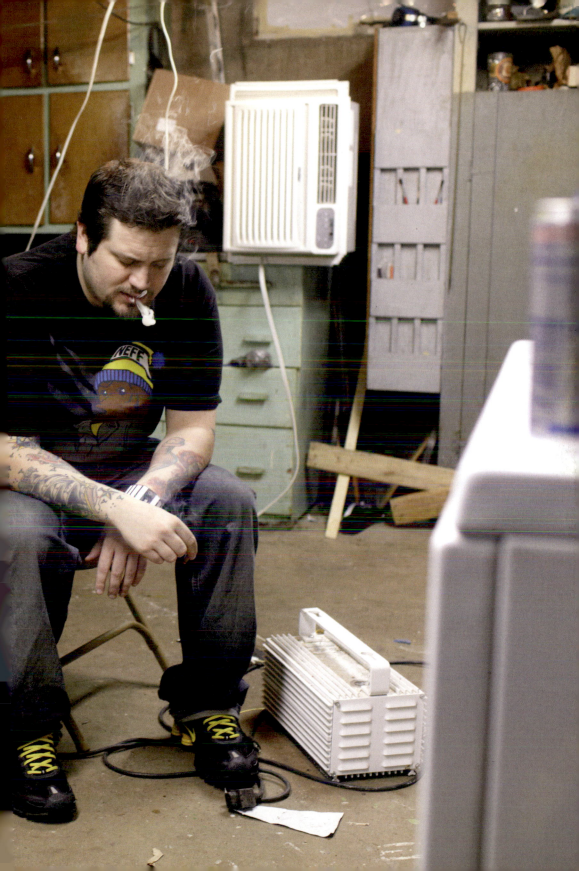

Timothy McClellan

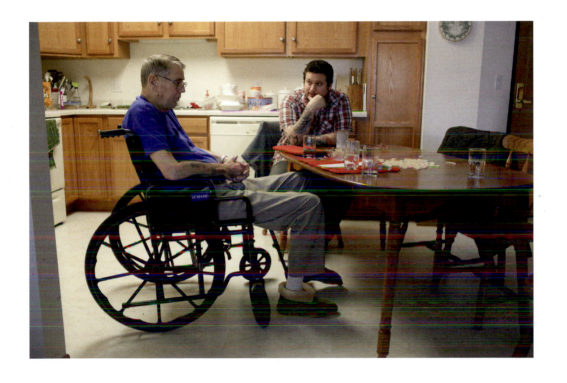

2010 — Chisholm, MN

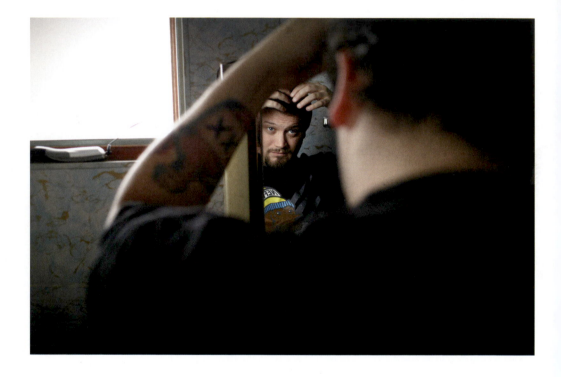

Timothy McClellan

whoa, whoa ... I didn't mean it that way! They're scared to death of dad yelling! I'm a pretty scary guy. They can tell when I get mad and they get scared right away. Quentin will just back away....

I told you not much happened. Not much has gone on since we last saw each other. Except for me getting out of the Army, and that was a really, really long process. If I had taken the Army up on the offer to leave without benefits, then I wouldn't have had to wait, I could have just gotten out. I'm pretty set now, I get about 2,500 dollars a month in benefits, plus my kids get free health care and free college. That's about it.

I threw all of my Army gear away. Then I came here ... I moved up here with my girlfriend Brit, she cheated on me, I kicked her out, now I'm single. Living here alone, it sucks. I'm all alone. I can't even get a job, otherwise they take away my benefits. It's not worth me working until I'm able to get something that pays twice the amount of what I get. It's hard for me to get out of bed in the morning. Harder than it used to be. I used to get up every day for work, now I don't get up for shit. I look at my phone—like, I really don't want to go to this class today! Is there a test? No—I turn the alarm off and go back to sleep. For an associate's degree it would take me two years. A bachelor's degree is four years and with that you can apply to get into a better college.

Uh-oh! (*Timmy's phone chirps.*) It's Brit, saying more crazy-ass shit. I hate you, is what she said. She always writes me these messages as if I'm bothering her, when all I'm doing is replying to her messages. She says, "Leave me alone." I'm like, you initiated the conversation! And whenever she gets mad at me, she just calls me fat.

I don't want to find a new girlfriend up here, though. Maybe something to fuck, but other than that, no. What?! I'm not a monk! I gotta get some ass! Shit ... I go crazy if I go like a week.... Now, it's been less than a week.... When was the last time Brit was here? That's why she always calls me. She's cheating on her current boyfriend with me. She wants to be wanted by everyone. So do I, but I'm not gonna cheat on my girlfriend to accomplish that.

In mid-March 2011, Timmy told me that recently he started feeling really bad about himself and his body and that he stopped drinking and smoking weed. As a result of going cold turkey, he had a nervous breakdown. He had to go to the emergency room where the doctors told him that he was going to be committed to rehab for his substance abuse problems. He then bargained to go to a PTSD trauma center instead, which is located in the twin cities, Minneapolis and St. Paul.

As we talked on the phone, he was on the verge of tears and told me that he would be so lonely there by himself. At the same time he was very motivated to get better. He was working out at the gym every day, had lost a lot of weight, and said he dreamed of Britney a lot. He thought that it was a sign of both a physical and mental cleansing. He badly wanted to turn his life around, finally come clean, and mourn the past.

Timmy's brother Erin and I split up a couple of years back — Erin moved back to the U.S. and Timmy wanted to go to New York City to stay with him and his cousin Karl. They made plans and talked on the phone a lot but Timmy never flew down. Instead, he moved in with Vaughn, one of his friends in Hibbing.

This is what he wrote on Facebook after his breakdown.

Well, I kinda had a little meltdown about my life, and how i'm not doing anything important and my brother and cousin live together and I can stay there till i figure out what i'm going to do. they send me pictures everyday of what they are doing. like eating in china town or eating tapas. and they tell me to get the hell out of here b4 i go crazy and i think it finally happened. All I know is I have some serious cabin fever in this frozen tundra, all my friends are married with kids and we all know my love life situation, so i think a change ... a drastic change will be good for me, i dont think i'm going to stay forever, but i know i do not belong here. i moved to hibbing to make my transition into civilian life easier because my family is here, but it was the worst choice of my life.

2012
Hibbing, MN

*When I arrive in Minnesota, I find out that no one has heard
from Timmy in a long time. Joscelyn is the only person he calls
every once in a while. His entire family speculates about what
is going on: They know that he picked up out of the blue and
left to go to California a few months back, that he rented an
apartment close to Sacramento and met a girl there whom he's
been seeing ever since.*

I meet with Joscelyn to ask her about her side of the story.

Timmy came back from Texas in 2010, and the year that
he was living in Chisholm, he was very good about taking
the kids every other weekend. But then, he had, like, a melt-
down. It was post-Britney—she had already left, something
had happened, and he was back at his mom's. I don't know
exactly what happened, I was out of town at the time. He
ended up moving in with Vaughn, and it's just that he stopped
seeing the kids after that for whatever reason. I'd hear from
him here and there, but he stopped taking them.

I didn't insist on him taking the kids, mainly because of
his living situation—I mean, there were times when I'd say,
can't you take them over at your mom's for a weekend, but
he didn't want to abide by their house rules or whatever . . . I
don't even know what the situation was, but he didn't want
to do it. He ran into one of my friends at the Street Dance one
time, and he told her, it's just not convenient for me to take
them every other weekend. And I was like, it's not always
convenient for me to have them—every single day! But, at the
same time, he would also say, I don't want my kids to see me
like this, breaking down and crying, or Hope would say this,
because he did go through that. I don't know what happened.
I know what he told me happened, but I don't know if it was
actually the root of it. The reason he had his breakdown was
that he was at the bar and he overheard this group of people

saying that Angelina was another guy's daughter. He knows perfectly well that that's not the case. Both of my kids look just like him, they're spitting images.

I don't know if it was just things for him that mounted up, and then they broke, and he wants to blame it on this or wants to blame it on that, but he's someone who doesn't like to take self-responsibility for anything. I mean, even this move out to California. It's gonna fix things? It's not. And I had this conversation with him several times, and it always turns into a fight because he doesn't like to hear the truth a lot of the times. It's not your surroundings. If anything, having people around who love and support you, you've got your mom and your friends ... Vaughn is a good guy, but it seems that when Timmy moved in with him, all they were doing was drinking. With Timmy, it's up and down. Last year, he got interviewed for the Fourth of July parade, and at that time he was gonna go to New York and go to film school! And I'm like, OK. What's next? I'm moving up here to go to school to be a lawyer, I'm gonna be a botanist, I'm gonna do this, I'm gonna do that. And I'm like, get your feet on the ground first! You need to start walking on the same plank that everyone else is. You're not pulling the wool over anyone's eyes anymore, really.

I was shopping one night, I had run out to Wal-Mart, and I simply made a phone call to see when he was gonna get me the rest of my child support. He was always very good about it, but then it was a couple of days late and I was just like, OK, I'll call him up. He says, "I'm out in California right now, looking for apartments." "Oh! Are you gonna be living with Preston?" Preston is one of Timmy's friends from up here. "No, I'm not living with Preston." So, his mom thought he was living with his buddy Perez from the military. But as far as I know, Timmy's in Sacramento and that's it. He was back and forth at first, in November, and now he's been out there and I don't know if he's been back since Christmas time. I don't know because I don't talk to him. I tried calling him this morning and I didn't hear from him. If I text him, it's usually just about the child support. Or he had a girlfriend and he texted me the other day: I got her a watch but we broke up, so I'm gonna give it to you. I said, that's fine but

when are you coming up here, Angelina's birthday is pretty soon, and it sounded like he was driving here, like, this weekend, but then he said he was too busy and couldn't make it.

He was back and forth between California and Minnesota, and he did say good-bye because I think the time he left was right around Thanksgiving, and he was back for Quentin's birthday. He brought him shoes and got Angelina a pair of earrings, and then he took off the next day. He made it back up for Christmas, and I had gone out one night, to the bar, and it was one of those nights when I wasn't really drinking, the bar was crowded, full of drunk, drunk people—Timmy was there and I was so happy to see him! He stopped by the next day and brought us lunch. He's in and he's out. I don't know what the motives are behind it.

This fall, he was being a little bit more active with the kids, or trying to at least. He took Quentin out hunting a few times, but Quentin is really at the point where he doesn't trust him. He doesn't know him, he doesn't trust him, he's always been uneasy, from the time Timmy came home from Texas. I remember, it was at Angelina's Christmas program, and I went to hand Quentin to Timmy and asked Quentin, "do you know who that is?" Quentin hasn't seen him, you know, in years. I said, "That's your dad!" Angelina was all stoked because Hope got her amped up for it. Quentin hated going over to his dad's house. I hate to say that, but I don't know what went on over there. There were several questionable situations. One time, after a weekend, the kids said, "Mom, you know, Dad and Brit have special medicine!" They basically explained to me how to pack a bowl. So I texted him and I said, you can't be smoking pot when the kids are around! They're at that age now where they notice. They have questions and they're gonna know about it. And he said, "Oh, we thought the kids were asleep." It's not OK. You can have a weekend without smoking while you have them.

And then it was another weekend, "Oh, dad just ran down to Brit's work quick and left us there with Uzi watching us." Really? He left you at home with a pit bull? Great.

The kids didn't like to go over there because it was always so messy. He'd claim that the kids made a mess. I never set foot inside the place because Brit was there and I'm not

stepping on anyone's toes. When Timmy would try and pick Quentin up this fall to go grouse hunting, Quentin would cry. He didn't want to go. Finally, he went one time and I think he had fun, and then he started warming up to the idea of having Timmy around, but then he's gone again.

When Timmy told me he was either going to New York last summer, or maybe out to California, I said, "You need to make up your mind because you can't jump in and out of the kids' lives. That's creating an unstable environment, it's not good for them—so either be here or don't. But you can't have it both ways." And of course he takes it the wrong way and he thinks I'm telling him to stay away from the kids, but that's not the case at all. They can't have that instability. It's not healthy for them. Even Quentin … this guy that I'm dating, they met him the other night. The next morning, Quentin said, "Oh, I really like him. You guys make such a nice couple. He would be a good dad." Well, this is telling me that Quentin is really needing that male figure in his life. He needs someone to be his dad. And I told Quentin, "You know what, I don't want you to get excited about this because we're just getting to know each other." I wanna be cautious about it, though, because when I do have someone around now, it has to be somebody that has to be good for them and is gonna accept all three of us versus just me.

Joscelyn recently signed Quentin up with the Hibbing Mentoring Program. He now spends time with Mark, his mentor, about twice a month doing guy things together: four-wheeling, fishing, roasting hot dogs, etc. During my visit at Joscelyn's this Saturday afternoon, Quentin came back from the woods; he was beaming and couldn't stop talking about making fires.

I feel like Timmy wants to live in a different world. He thinks things will be better somewhere else or he thinks things are gonna be better if he buys this or that. Even with the kids. He wants to buy them designer clothes. If he spent time with them he would know that kids are gonna drag their clothes through the mud. He came and he was like, why do you let Quentin wear these white Nikes outside? Because they're shoes and he's a kid. They're sneakers, this is reality, we're

not millionaires. They're gonna get dirty, I'm sorry. Timmy wants to live in this fictional reality in his head where everyone's gonna be cool and well-liked because they've got these cool clothes and he's gonna be the same way—the money that he probably just went and dropped on the stuff that he sent me pictures of—to him, I don't know if it's from growing up, having not a lot, getting passed over the other kids or whatever the situation was, material things to him—and I've had this conversation with him, too—he thinks they're gonna solve everything. And I've told him they don't. Because I like stuff, too. I like to get a new dress, I like to get new shoes, whatever. But I know it's a temporary satisfaction. He tries to not deal with whatever it is that is going on with him, whether it's from the divorce. . . . He's told me he never thought I would leave him. And I'm like, I can only deal with so much. I don't blame it on one thing or another, the fact of the matter is: I knew from the get go we shouldn't have gotten married. We were too young. I felt sick the day of our wedding. I honestly felt like it's too late to back out—people are expecting us to get married. And then you try to make it work after that. We got pregnant with Angelina shortly after, we had her, we get pregnant with Quentin and he tells me everything's going to be fine. I was like, no! I'm not ready for this! I cried. I cried because what was in my head was: I just lost all my baby weight! But I know there had to be something deeper as well. I wasn't happy. I was at my happiest when Timmy was gone. He brought me down. When we first got married, I was sleeping on the couch and I cried myself to sleep every night. We were at each other's necks constantly. After our divorce, we talked through all of this. He lies. That's his thing. There's so much he would say, and I'm like, I just don't believe you. Actually, now that we're talking about this, I realize that a lot of this time is just washed out in my brain.

He would tell me, after he had gotten back from his first deployment—I was still pregnant with Quentin—he said, "what would kill me with you is that you just didn't give a shit about me. All the other wives, all the other girlfriends, if their guys weren't home, they would call them, pissed off. You would say, 'Go! Stay out all night! Be gone!'" And that was me, because I don't want you coming through my door

2012 — Hibbing, MN

at two o'clock in the morning waking me up because I have to get up and I have to deal with our child tomorrow. I have to take care of her. With us, it was always: It would be good, and then it would go down. We'd take two steps forward and five steps backwards. We were just too young. So when everything came to an end, my heartbreak was done. It had been done a long time prior to our divorce.

What happened was that, after I found out about his affair — he actually still hasn't admitted it to me yet — in November 2006, it was shortly after he had deployed, we wanted to get a divorce. I went down to the courthouse, I got divorce papers to fill out on my own, but I was like, shit. This is too much. We had some deaths in my family and Timmy got hit by an IED and got his Purple Heart. So we decided to see how things would go and try to mend it and patch it, whatever. That's when I told him, "OK, here's everything on the table: While we were going through our little separation phase, I did this, this, and this. Just so you know. I'm not going into this with any lies." And he was pissed. "Oh, you should've never told me!" I'm sorry, but I can't live with that in me! So he gets home that Christmas — after his second deployment in 2007 — it was a trial run, he was home for a month. He was up smoking pot every night until three o'clock. I remember him saying — he had just gotten home from Iraq, he hasn't seen his kids in a year — and the question that I get is, "So when do they go back to daycare?" Because he wanted to sit at home and smoke pot and play videogames all day.

At that point, someone else had caught my eye. I'll be perfectly honest. I was done with his bullshit. This isn't what I want out of a partner, a spouse. When Hope had her brain tumor and he came back up from Texas, that was when... because by that time, I had hung out with that person, and he was... so nice. He was kinder to me in the six months that we dated... I think I must have been twenty-three at the time.

Our divorce took from February to December of 2008. I think it took a toll on Timmy. He just didn't think that it would ever happen. But you can't treat people like shit. Don't get

me wrong: I wasn't great to him. I know I wasn't. I hated him so much at that time. I despised the thought of him. I'm so much better with him now where I can actually have—this is gonna sound so horrible—sympathy for him now where before it was, just: I don't care. My life would be easier without him around. Just make him disappear. Just make him disappear.

During our divorce, he said he wanted to take the kids to Texas. Really? You've never even spent twenty-four hours alone with them. And you want to take a three-year-old and a five-year-old by yourself for three months? You gotta be fucking kidding me. You're out of your mind. It's asinine to think that it was even a possibility. But I think it was more Hope pushing for that because she was afraid that the kids would lose contact with that side of the family. It was such a mess. I'm glad it's all done with now. I just said to my best friend this morning, it's nice that I can talk to Timmy about things now.

When he comes and tells me all this stuff, I just wanna shake him, like a kid, and ask, "Why are you doing this? This isn't the solution to whatever problem you have!" I don't know what is. I don't know if there is one. The whole question started when you asked if he's changed from the Army or not. I think it started so much younger. Hope claims that he has Asperger's. From what I read on Asperger's, I don't think that's the case. Timmy might have something wrong with him. I feel like he doesn't think of other people besides himself. He can tell you the things that you want to hear. He can look you dead in the eye and lie to you. He did it to me when I asked him, "Did you have an affair?" He said, "You are being crazy. You are being so paranoid and crazy right now." Obviously, I wasn't! Fuck you! When he's got something wrong, he wants to turn it around and make it seem like he's the good one and that there's something wrong with you. He's very manipulative. He wants to be so well-liked by everybody. He wants approval from this person and that person. Even after the divorce, he asks me, "Do you think women will still find me attractive?" I said, "I'm sure that's not gonna be a problem until they get to fucking know you because you're a dickhead! You don't treat people well. You're selfish."

2012 — Hibbing, MN

Friends of ours are like, how can he abandon his kids like he's done? I tell them, I get where you guys are coming from, but honestly, at this point, they're better off without him because he's so fucked up. *(Tears well up in her eyes.)* It's sad. Because the kids need a parent. They need a father. I can't do it. The new fellow, the other day he said, you're just a hard-ass to your kids. But I have to be! I don't have any other choice. I have to be nice mom, and comforting mom, but I also have to be the tough guy, too. When Quentin mouths off to me, or yells at me, I'm the one who needs to give him a tap on his mouth and say, you don't talk to me like that! Because I don't have someone to say, don't talk to your mother like that. It's frustrating, but at the same time, do I want them being exposed to Timmy? I'm so happy we're divorced on the fact that what environment would it have been for them to see us treating each other the way that we did? You saw it. It's not healthy. I think that my children are relatively happy now. I'm not ever gonna be a person anymore who's gonna depend on anyone else.

The shooting in Fort Hood.... We had just gone out for dinner, I think—I was in Colorado visiting a friend—and I'm looking at the news and I see: Shooting in Fort Hood. However many dead, they didn't have a shooter, they didn't have anything. I'm like, fuck. I think I called Timmy but didn't get an answer immediately. And then I got text messages from a couple of different people. Do you think it was Timmy? I'm like, uh . . . I don't know, I don't think so. No. . . . Like, it could . . . no. It's just one of those things that in my life, that doesn't happen. My life is relatively drama free. There's probably gonna be nothing epically horrible that happens in my life, such as a mass shooting by my ex-husband. Could you imagine? But then I get a phone call, and all I get is a voicemail from Hope, "Hi, this is Hope, just wanted to talk to you about what happened at Fort Hood." Click. This is all I get. So I call her back, "Hi, Hope. What's going on?" She responds, "Everything's OK. Timmy was fine, he wasn't involved."—I honestly would be more concerned about Timmy hurting himself. That is one thing that worries me about him. But I don't think that he would do it. I think he cares too much to do it. You could

look at it a different way and say, he's been destroying himself a little bit every day by smoking pot, drinking too much, and not really caring too much about what's going on in his life. But then it was good for a while, I'd see him at the gym. He dropped a ton of weight, and he would only wear suits. And I'm like, why? You don't do anything! Try to dress age-appropriate! Twenty-nine-year-olds who don't have jobs don't wear suits everywhere they go! It's just this impression that he's trying to give out. It was sad. Trying to appear to be something, living up to this image in his mind what he should be, what's cool, what people think is cool. I wish he would try to like himself. Don't get me wrong, I think Timmy loved me—loved me as best he could—but I don't think he knows how to love someone, I don't think he knows how to love himself. Until he learns that.... Then again, this might be true for everybody.

A couple of months after my visit, Joscelyn emails and wants to know if I saw Timmy during my stay in the U.S. I tell her that I haven't been able to get a hold of him. We email back and forth a few times and she writes: "I just wish there was some sort of help for him . . . he honestly just seems more lost than anything . . . it's really very sad. He came but then he left town before Angelina's birthday and first communion . . . he came home, had dinner with us one night and that was it . . . I have talked to the kids about him, and at this age I don't know what they understand . . . I tell them that basically, he's just not healthy . . . he's been through a lot with the war . . . he loves them, but he has no idea how to show it . . . I would definitely let them read your book when they are older . . . let them try to understand it . . . he just seems to be getting progressively more distant as the years go on . . . he's a stranger to the kids . . . they act the same way around him as they do people they don't know . . . kind of goofy and showing off."

A year later, Joscelyn writes to me again, letting me know that Timmy and Britney are back together and expecting a baby.

At one point during my visit, Timmy's mother, Hope, shows me a big folder containing all the Army documents and letters that she wrote on his behalf while he was stationed in Texas.

To make more sense of them and go over everything chronologically, we sit down and talk.

Timmy was on his second tour, and he had just come home, I had found out after his second tour that I had cancer. Because of that, he got emergency leave and came to see us. Josci had asked us if we would pick him up in the cities, so my husband and I went to the airport, picked him up and dropped him off at his house. That's when she told him she had a boyfriend. We basically didn't even get home, we had to go back and pick him up with all his stuff. She'd packed everything he had out on the driveway. He cried a lot that whole time he was here.

Then he went back to Texas, and someone hit his car while he was in the parking lot, and they told him that in another month or so he was going to be re-deployed to Iraq, without hardly any time back here. He was really upset, and then I found out, on top of cancer, I had a brain tumor and the doctors wanted to operate the next day. I said, no, I need a week to get my affairs in order. I called Red Cross and they sent Timmy back up here. I knew how upset he was in Texas and I just wanted to have him home, besides of what was happening to me. He stayed with me through my surgery and all he did was cry. The whole time, day and night. He was in bad shape.

Then, again he went back to Fort Hood. I was just sick, I couldn't move my legs and my arms, my blood pressure dropped to almost nothing, I had nausea all the time from the surgery, like, motion sickness. I was rushed to the hospital. Timmy calls me and he can't handle that. That's just one more thing that he can't handle is that I'm going to die. He's over the edge: He's going to kill himself. He said he just wanted to die. I tried to talk him down and I said, "You gotta go and talk to someone right now!" He said, "They'll just turn me away!" I said, "You insist. You insist!" So he went—and this is after, like, three and a half hours on the phone—and they turned him away. He couldn't even go see an evaluator to evaluate if he had a problem. So he calls me again and he was hysterical. I said, "Calm down. Tomorrow you throw a fit, you say whatever you have to say to get in there." He said,

"I don't want to tell them that I'm gonna kill myself because then I'll be in big trouble and they'll take away benefits." I said, "Just say whatever you can to get in there!" So, finally he sees an evaluator the next day and this guy sets up an appointment, almost a month later, to get medication. A month later! Not even to see a psychiatrist! Just to get medication!—I just about flipped out. I could hardly deal with it, I was so sick. It took everything in me to sit there and write this letter. I gave my notes to my mom to type, and my sister sent a letter out to the Minnesotan senators and the representative from up here. Jim Oberstar (D) was the State Representative at the time, and Amy Klobuchar (D) and Norm Coleman (R) are the senators. Every single one responded within the day. They emailed, or called me on the phone. The first one to respond was Oberstar. He said that his office sent this to the Congressional Oversight Committee in Washington DC, and that they were going to look into this.

Letter From Hope Renskers to James L. Oberstar, Minnesotan State Representative in Washington DC, March 4, 2008

Dear Congressman Oberstar:

Is it the American way to punish soldiers when they seek medical help? Is it the American way to blackmail soldiers into re-enlisting? Is it the American way to treat soldiers, who have put their lives on the line, with less respect than any other United States citizen?

My son, SPC Timothy McClellan of Hibbing, Minnesota, has served in the Army for five years. Tim enlisted in the Army Infantry because his grandfather served in the Infantry in the Korean War, and Tim wanted to be just like his grandpa. He has a wife and two children. He has done two tours in Iraq, has two R-coms for valor, and a Purple Heart. He has stress fractures in his feet, chronic back pain, and severe anxiety. The Army's remedy for the first two is to drink more water and take Tylenol. As for anxiety—it seems it is taboo to ask for help.

After receiving repeated distressing calls from Tim in the last two weeks, I finally convinced him to ask for emotional help. He tried to seek emotional help the next day and was

denied. I convinced him to be insistent. He was then allowed to see an evaluator. Tim said he felt better after talking to the evaluator, but could not get a medication review until March 13. I feel he needs meds now! He needs to meet with a psychiatrist. Tim has Asperger's Syndrome which is a form of autism. He is under severe stress from killing people in Iraq. (While in Iraq he received some counseling and medication. He returned from Iraq in late November 2007.)

He is under stress because I, his mother, was diagnosed with thyroid cancer in 2007 and a brain tumor in January 2008. While at home in February on emergency leave during my brain surgery, his wife asked for a divorce, both situations adding greatly to his stress.

Immediately after seeing the evaluator, on February 22, Tim returned to his unit and his superior issued him a citation for an improper haircut and a citation for entering a number into his cell phone. He was threatened with demotion.

In January 2008 he received word that he would be transferred in June from Fort Hood, Texas, to Fort Benning, Georgia. He thought he would be serving his remaining military time (08/09) in Georgia. When he was given his official orders it stated he would have to re-enlist for three years if he wanted to go to Georgia; or, he could stay in Fort Hood and receive no promotions or awards. The probability is that he will be shipped back to Iraq for another fifteen to eighteen months.

My son, Tim, has tried to do his part in keeping America safe. I am asking that someone please help him to get the medical help he deserves.

Thank you.
Sincerely,
Hope Renskers

As a result, they started a congressional inquiry and after two weeks, they had set up appointments for three different psychiatrists for him to check out and see which one he might like. Timmy got put on a medical watch list. I was appeased just to know that he was talking to someone and it wasn't just me talking him down all the time. Another one of my complaints was that he had been in such horrible back and foot

pain, for so long, and all they told him to drink more water and take some Tylenol.

It just burned me that these kids are over there fighting for America, yet they get the worst medical care. The commercials that the Army has are all about how they're going to take good care of your child and I would just scream when I'd see that. They are lying! Why aren't they treating them better? I know they want them to be tough, I understand, but when it gets that severe.... When he was in Iraq, Timmy was crying a lot, so that even his fellow soldiers were worried about him. He was blowing up, he was hitting people instead of taking care of a situation, they'd have to stop him, he'd lose control—yet, who's helping him?

During his deployment, he would call me often and tell me stories and things that had happened, sometimes these were things that he would have nightmares about. When he came home, he'd totally blacked out all of them. He didn't remember telling me all these things. He was in bad shape.

The Army tried to hold onto Timmy, because he is intelligent and picked up on languages easily. He was valuable to them and they didn't want to let him go. They kept telling him he should be an officer. Not many soldiers in the Infantry are educated, or come from an educated family. Oh, he told me this once: During one of the deployments, he played basketball with one of his buddies. That kid had a lazy eye. And Timmy told him, "hey, you're not too bad at this," so the kid tells him that he used to play basketball during the Olympics. "What do you mean, the Olympics?" The kid says: "The Special Olympics!"—I'd warned Timmy that even though he wanted to be a soldier so badly, he might not get in because of his Asperger's. So we go to the recruitment office, I tell the guy that he has Asperger's, and the recruiter checks on his list and says, "well, it's not on there." I just about died! I never thought they would let autistic people join the Army.

After he began to seek help, he would get citations for random things on post: using his phone inside a room, etc. Everybody knew it was a punishment for him, for his PTSD. That's the attitude of the Army. If someone asks for help, it's a negative thing. He'd lost all respect. The change in their

behavior was so drastic. The worst was towards the end, when he had faked a doctor's excuse because he overslept, which they were going to court-martial him for, he was in such a bad state, and they knew it. And they were still teasing him, saying, your mom can't save you this time, McClellan! Then they said, "McClellan, you need to go. You're due for a leave, you haven't been home for a long time. Would you like to go?" And he says, "yes." So he gets ready to go, calls the kids, makes arrangements for flights. Then he goes in to sign his papers, to sign out, and they told him, "oh, we changed our minds! You can't go." He was crying the whole time, right in front of them. He would even say, why are you doing this to me? So he's sitting there in the office and he's sitting in one chair, another guy next to him and someone's sitting at a computer desk. Both of them were smirking at him. His state of mind, as he told me later, was: Let's see. There's a pen right there. I can grab that, jab it into this guy's neck, get him bleeding, jump across the desk and get the next guy before anybody can come in and save them. But then he thought: Don't let them make you crazy. Don't do anything that could get you in trouble. You hear things on the news about people who are in the Army and do these things. Like the shooting in Fort Hood. That's why I had the attitude when I turned on the news and they reported about the mass shooting, and I said, oh my God, Timmy, what have you done? When I found out it wasn't Timmy, I said, well, I hope they find him help, whoever the shooter is, because they probably pushed him to this point. He must have been scared to death: The Army is responsible for that.

The Army realizes how sick the soldiers are, yet they do not care enough to do anything for them. They torture these soldiers until the point where they're so sick, they're pushed to their limit—and oops, oh, they end up in jail, they're court-martialed, no benefits. That's how they get out of paying everybody! I saw it in everything they did to Timmy. Not all of these kids have people, family, they can call, people who will stand up and fight for them.

Letter from Hope Renskers to James L. Oberstar, Minnesotan State Representative in Washington DC, September 2, 2008

Timothy McClellan

Mr Oberstar,

Since the last time we spoke about my son, Spec. Timothy McClellan, the Army let him see a psychiatrist. He has two appointments per week. He finally has a chiropractor appointment tomorrow. Thank you again for that help.

Recently I have many distressing calls from my son. They are not honoring the medical profile from his doctor, Dr. W., that states verbatim: No access to ammunition, weapons, range or field exercises. Duty hours should be limited to 0900 to 1700 hours. Given continued difficulty making progress in conventional treatment, rehabilitation can be expected to take six months or longer thus a WTU (Warrior Transition Unit) transfer would be beneficial....

One week ago they told him he will be going to NTC this Friday, in California, where he will do a mock war. This kind of training will be VERY harmful and he would miss all his doctor appointments, which he desperately needs. (Psychiatrist, chiropractor, traumatic brain injury.) They also have him coming in at 0600 and have not transferred him.

He received a letter from LTC P.W., the lead case manager of Behavior Health Division. In the letter she recommends that Tim does not go to NTC. Tim gave this letter to his commander but he just ignored the information.

The Army does not take his health and welfare very seriously, but I can assure you Tim's family does! I'm starting to wonder if I am really in America! I was hoping something could be done before my son does something harmful to himself or another person.

Thank you so very much,

Hope Renskers

Letter from Timothy McClellan to Peter M., staff assistant to James L. Oberstar, Minnesotan State Representative in Washington DC, September 3, 2008

Mr M.

I have gone to two doctors both who recommend I do not go to NTC. I also got a letter from LTC P.W. who is the lead case manager of behavior health division. So three mental health

professionals have recommended that I do not deploy. I have acute PTSD and major depression. I have to see someone two times a week. If I went to NTC it would be a major setback in rehab, and my process of getting out of the Army. My chain is looking at this like a numbers game. They need a certain number of soldiers for deployment. They refuse to take into consideration my mental and physical status. I have done everything right. That is why I need help sir.

 SPC McClellan

I wrote this second letter to State Representative Oberstar when his commander tried to make him go to mock war. It's called NTC, National Training Center, and it's set in the Mojave desert in California. So I wrote to Oberstar again because they weren't honoring Timmy's medical profile even though he had three individual doctors stating that he could not be around ammunition, weapons, or the field in general. His commander called me and tried to talk me into letting him go. He was very respectful to me and said, "I'll keep him away from everything!" He had Timmy pack up, be ready to go and right as they were going to leave, he tells him he doesn't have to go. He tortured him to the last point. Even though the commander knew that he would get in trouble if Timmy went, he made him go to the very last moment. It was sadistic. They tease them and play games with their soldiers.

 The third letter was about when Timmy overslept, he was in Austin and he overslept. He missed morning formation and faked a doctor's slip. I wrote: I know my son did something wrong, he panicked, but I still feel like he was pushed to that point that he was so afraid. They threatened to court-martial him even though his medical profile says that he can't do duty before 9 a.m. The congressional liaison in Chisholm here was tired of my letters and just emailed me, saying, oh, I added it to your son's file. But I thought, this is an important letter! So I actually went to his office. He was still refusing then to send it to Washington. He said, Hope, your son's got the biggest file here in this office. He told me that Timmy should follow chain of command on this and I can't keep writing letters skipping chain of command. He said, you got more action than anyone ever before! But

Timothy McClellan

he also added that his office was equally frustrated with the situation. I demanded that he send the letter, either that or I am going to every newscaster I can, whoever will listen. And they will listen because he's been treated like this, he's autistic and he's in the Army, he's had two tours and been very successful, and he's had a perfect record up until that. That's almost unheard of. Every single one of his monthly records was good. He was a good soldier but he just needed help. It wouldn't have gotten to this point if they had let him out sooner. The Chisholm liaison knew I was serious. So he sent it and I received a response from a general in Fort Hood, basically saying that Timmy will still be court-martialed.

After I responded to the general's letter and she responded again, I knew nothing was going to change. So I felt, like, in one last desperate act, I'm going to try and write to President Obama. I was crying sitting in front of my computer. They just kept stop-lossing him. I didn't understand why they would stop-loss him when he was so messed up? Why keep him there all this time? And they said that he needed to re-enlist in order for him to finish the med board process, in order to receive benefits.

Letter from Hope Renskers to President Barack Obama, July 17, 2009

Dear President Obama:

It is with desperation I am writing to you. My son was born with Asperger's Syndrome, a form of autism. His father was killed in a private plane crash when I was pregnant with Tim. The stress caused me to deliver two months early.

My father was a father figure to Tim. My father served in Korea. Tim's area of obsession was the Army. When he graduated from high school he insisted on going to see the Army recruiter in our hometown of Hibbing, MN. I went with him in order to let the recruiter know that Tim had Asperger's syndrome. He said it was not on the prohibited list and that Tim appeared normal to him.

I called Tim's child psychologist and he said Tim was an adult and I shouldn't try to change his decision. He said that

other people with Asperger's have been known to be successful in their areas of obsession. People with Autism prefer structure and the Army was all about structure. He felt he had a chance to be successful....

He served two tours in Iraq. Near the end of his second tour he started to break. They began to give him medication while he was in Iraq.... He has severe anxiety and panic attacks, chronic back pain (he is now three inches shorter than he was when he entered the military), post-traumatic stress disorder, OCD, substance abuse issues, depression, and has suicidal tendencies. To compound all this he has Asperger's syndrome.

My son is sick and needs help. I am very worried about his mental state and whether it is possible he could lose the medical disability benefits he will need in civilian life. Thank you for your consideration in this matter.

Sincerely,

Hope Renskers

Letter from Hope Renskers to President Barack Obama, July 21, 2009

Dear President Obama,

I recently wrote to you but feel as though I was not clear as to the situation. The early release I refer to is basically terminating their stop-loss. This is very good, but the problem is the soldiers have to re-enlist if they want to get med-boarded. My son is the first one it affects. My son began this process 18 months ago and will not get the benefits he would have received had he been med-boarded. I am thrilled he is coming home soon. He really needs to be away from the Army. I am asking that you help the remaining disabled soldiers get their benefits without having to re-enlist.

Thank you,

Hope Renskers

I didn't receive a response from Obama or any of his staff directly, but I knew that they were taking action. Apparently everything was hitting the fan down in Fort Hood. There were congressional inquiries into different cases. Timmy

said that they are stirring up trouble and investigating, not just his case. I think Obama made a point of trying to clean up Fort Hood. The cruelty and the way they treated soldiers. Timmy started out-processing and according to him, everyone was treating him nicely. He said that one of the ladies who helped him with his case was a big black woman who'd pat him on the hand, and said, oh, honey, I read the letter your mom wrote! The social security money that he was supposed to get for being disabled—his pension—kicked in after about a month. Usually it takes about six months for them to even respond, and usually it's denied the first time. She also went for back pay for the previous two years. People suddenly went out of their way to help him. He couldn't even believe it! He asked, why is this happening? I know—well, you don't believe in God—but when he was in high school I worried about him not having a father. A friend of mine told me, she said, "Hope, it says in the bible that God will be father to the widow's children." It was always peace to me to know that there is a man watching over my sons. I told Timmy while he was in Iraq, "No one else's father can go over there with them. But your father is with you." And that was peace to him. But he got to the point after his second tour where he doesn't believe in God anymore. He saw too many horrible things and he couldn't understand how any loving God would let those things happen. Yet, he still marvels and sees in his life all the time that over and over again, he was chosen.

Before his meltdown, he'd fought with Britney. Afterwards he just lay on the floor and cried and he called me and said he was suicidal. He said that he was hearing voices in his head that said: Nobody cares about you, you're worthless . . . all these things, and then there was another voice saying, no, you're loved too much, you would hurt so many people if you did anything to yourself. He said, "Mom, please take me to the hospital." The VA clinic here in Hibbing . . . Timmy was just so sick, they couldn't handle it. So he went down to Minneapolis. He went to see a foot specialist, a back specialist. They gave him something for his panic attacks, for when he starts sobbing uncontrollably, out of the blue. It was getting to a point where he was around the kids, but all he did was

cry. There's no reason for the kids to be around him when he's crying day and night. He couldn't be alone. He would go over to his aunt's and she would have to babysit him. He had to give up Uzi because he couldn't care for him anymore. He couldn't even take care of himself. So he ended up moving in with his friend Vaughn who watched over him. Vaughn was good for him because he was very laid back and would tell him when he thought Timmy was out of line. Timmy trusted him. I was a little upset that he didn't come here to live with me, but he was so stressed about bugging my husband, and it would have been stressful for all of us.

We were looking at a substance abuse program at the VA because one of the psychiatrists said that he was an alcoholic. In my mind, we should deal with the PTSD first, because that's what's causing him to drink. Timmy didn't want to be labeled "alcoholic," he was fighting that so he never went. But it would have been the best thing for him to just stay there and go through it and get to the point where he's real calm. I thought he was starting to get better on his own, and then he all of a sudden flipped, just taking off to California. He knew it would upset me, so he didn't even tell me. He wasn't answering my phone calls. He knew it would upset me that he would leave here because if he gets in trouble there, how can I help him? Also, he has children! He needs to be a part of their life. As disappointed as I am here ... like, Josci told me that she went to get a mentor for Quentin. She was a little worried that I'd be upset when she told me, but I said, I understand. Even if Timmy was here, he didn't know what to do with his kids. He loves his children, but he doesn't know how to be a father to them. I feel bad for Josci and I try to help her as much as I can.

During my stay in the U.S., I tried countless times to get a hold of Timmy, via phone, text, email and Facebook, and he never once got back to me. He let me know through his cousin Karl—the only relative he texts with occasionally—that he was OK but couldn't talk to me or see me at the moment. After a while, he deleted his Facebook profile and just kind of disappeared.

ROLLINGS

Levi Rollings, U.S. Army Infantry veteran, born 1987, from Toad Hop, Indiana

Angel, his girlfriend
Leah, their baby
Lilly and **Conner**, her kids
Sarah, his sister
Cindi, his mother
Dave, his best friend
Aaron Sonberg
Coury Stevens
Levi "Elmo" Skelton
Bradley "Griff" Griffith, his Army friends

2008
Fort Hood, TX

Rollings is very tall, very handsome, and sometimes reminds me of a young horse. His biggest dream is to tame a wild mustang, back in his hometown in Indiana. He's always totally immersed in whatever he's doing, which makes him seem very innocent at times. Rollings is constantly in motion, hardly ever wears a shirt, eats a hot dog in about two bites and is inseparable from his friend Aaron Sonberg. When the guys go out to the river or the lake, he tries to catch fish with his bare hands, tracks down all sorts of animals, and generally is not afraid of anything. He won the Fear Factor Iraq contest when he was deployed. Not surprisingly, his Army nickname is Wild Bill.

Everybody loves Rollings. He is happy and good-natured and seems content with himself and his life. When drinking at the bar, he walks up to total strangers and starts talking to them—but never to girls because he thinks they're annoying, especially when they want to date him. He is a little bit shy but loosens up when he drinks and will start telling you entertaining backcountry stories that involve transporting little ducks, smoking pot, and being pulled over by the cops all at the same time.

There's only one CD in Rollings' car and the guys listen to it over and over: It's a mix of Johnny Cash, Rehab, and a rap song by Fagan and Cotto, two Infantrymen who started jamming together while deployed in Iraq, making fun of fobbits. Most of the guys in the group know the lyrics by heart and rap along every time the song comes on:

Yeah, bitch
This song's for you fake-ass motherfuckers
who don't ever leave the FOB
Motherfuckers living FOBulous in this bitch
Go to the PX and buy all this shit
Get your fuckin' smoothie and relax on the roof

and get a fuckin' tan, you fuckin' POG
"How you doin', sir?"
"You can't walk and smoke!
You'll catch this place on fire,
what, you think my job's a joke?"
"Oh, shit! Are you fucking serious?
This guy's delirious! Cotto, are you hearin' this?"
Let me get straight to the point
Cause I'm dissin' everyone for fun,
I talk shit and you ain't on my level, son!
So what up, dawg? Oh, you just got off guard!
Man, you're protecting a gym, that must be hard!
You're a POG with no purpose
But to guard the gate, they took away your M-16
And gave you a knife, right?
I'm a fobbit, I do what I gotta do . . .
You're a fobbit, and I can never relate
Cause I'm out there doing missions
while you're watching the gate
Or pulling guard on some shit that makes no sense
How you gonna say that being in the FOB is intense?
You fuckin' liar!
Calling home and saying you go out the wire
And on top of that your weapon's never been fired . . .
etc. etc.

I grew up in Toad Hop. I was born in Terre Haute and my mom and dad got divorced when I was two. I lived with my mom for a while, she wouldn't let me live with my dad. They had joint custody or whatever, so I'd just see my dad on the weekends. And then, when I turned twelve, she let me move, and I went to live with my dad. I don't know why I didn't wanna live with my mom anymore. I just wanted to live with my dad. He had horses and stuff like that, and my mom didn't. I have one real sister, and then I have three stepsisters on my mom's side, and two stepbrothers, and two stepsisters on my dad's side and one stepbrother. We had a lot of animals.

My dad got cancer and died when I was fifteen. He was really hard on me and my stepbrother. My stepbrother wrestled in high school and played football a lot. My dad was

Levi Rollings

always real hard on him about that stuff. I think he was probably harder on my stepbrother than he was on me.

My dad was in the Army—he was a tanker, over in Germany. So joining the Army was like a family thing. Everybody in my family has been in the military, all my uncles, my grandpa, and my dad. I just grew up around it. I always figured I would. I just wanted to do it. Because of the experience, I guess. I joined in 2005, when I was eighteen. I dropped out of high school. I was in a lot of trouble in school, just for stupid stuff, not drugs. I always got in trouble for not showing up to school, or leaving school early, and then they said that the drug dog smelled something on my locker one day. My dean was really cool, I told him, you know I don't bring that stuff to school. I said, "You know I smoke weed but I don't bring it to school." He started talking about getting me kicked out so I just quit when I was seventeen and got a job. Well, before I quit, I had a job working already, I worked at a warehouse, at a furniture store that my aunt owns, and then I quit there when I dropped out and I worked for a landscaping business until I joined the Army.

I didn't really think about what job I was gonna do in the Army before I joined, I just went there and you have to take a test and they show you all the jobs you can get. They showed me the Infantry, and I was like, I'll do that. It's the funnest. It looked the funnest.

I'm from a place that's as big as somebody's family. It's like a neighborhood that is actually almost like a family. Everybody literally knows everybody. No joke. You don't pass by their house on your bicycle without saying hi to them. When I went home on R+R from Iraq, I still had my ACUs on, it was the day I got home and I was driving around with my sister, just to see what everybody's doing. And people were yelling, Levi! I pulled up and they're like, "oh my God, you're home! OK, we're throwing a keg party tomorrow night!" Like that, ain't no question about it. And I said, "alright, I'll be here!" So the next day we had a fucking huge-ass keg party and everybody in Toad Hop came and visited me. There's not even sixty people in Toad Hop. So all those people were there and everybody else who heard I was back home, from West Terre

Haute, and Terre Haute, everybody showed up, it was ridiculous. In Toad Hop, I know everybody. No question. Honestly, if a car goes through Toad Hop, you will hear about it. Let's say somebody drives through with a new Escalade—people talk about that in Toad Hop. It's ridiculously small.

We had a confederate flag in the window of our trailer, and my recruiter when he came to pick me up thought I was, like, really racist. He was a black guy and he wanted to talk to me about that. I would, I guess, call myself a racist. I don't know. I'm not really that racist, but I was grown up in a really racist area, so I am kind of racist.

West Terre Haute: No black people. Toad Hop: No black people. Terre Haute: There's a shitload. I don't like being around a lot of black people. If I see a crowd of five black people, I won't go up and talk to them. I don't have a problem with black people, but black people who are about black people. . . . There's different kinds of every race, you know what I'm saying, there's definitely the races of white, black, Mexican, everybody's got their own racist people. And every race has their own fucking shitheads. That's just the way I see it. Everybody sees that shit different. Like, Stevens, he hates every black person. I don't hate every black person, but if a black person is a typical black person, like a fucking rapper or that shit. . . . But there's also white people like that, or Mexicans like that. I'm a white stereotype, for sure. A lot of black people I get along with because I think most black people are really, really funny. Like, they will make you laugh because of the way they talk. The shit that they say and how they say it. It's just fucking hilarious. Because you can't talk to a white person, like, yeah, nigga this, nigga that. . . . Everybody would be like, what the fuck are you talking about? If a black dude says it, it's funny. Black people are really funny.

We don't really hang out with black soldiers because honestly, we just don't have that many in our company. I give a dude a ride home every day—he's black. The other day I helped Sgt. N. move all day—he's a black guy. Me and him are really cool. He doesn't trust that many people. But for some reason, he trusts me. I've never met anybody who just hated me.

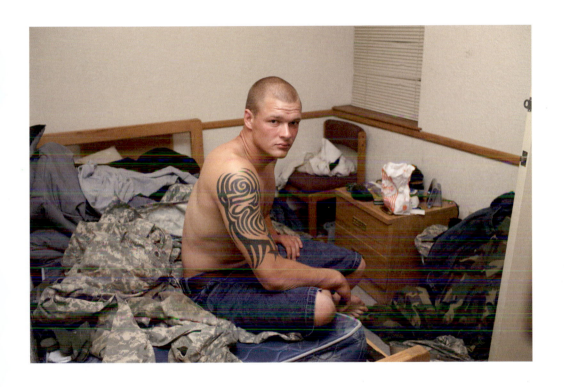

2008 — Fort Hood, TX

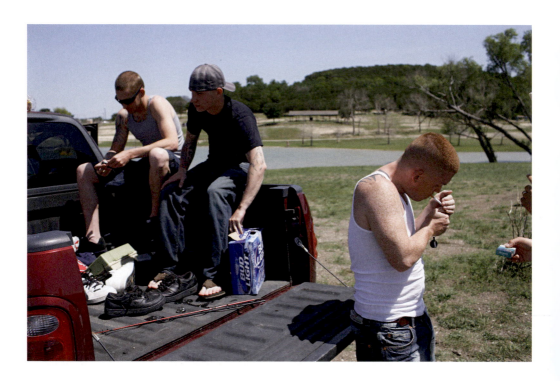

Levi Rollings

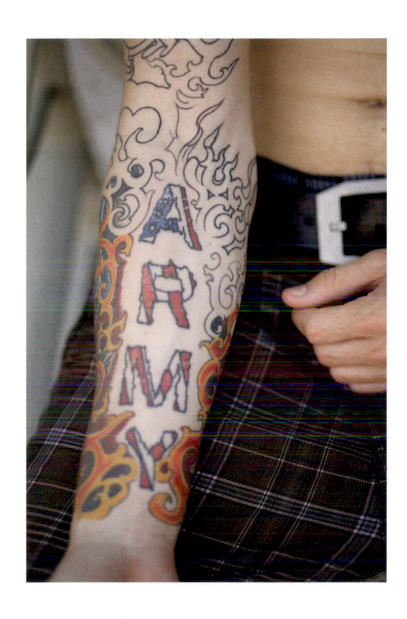

2008 — Fort Hood, TX

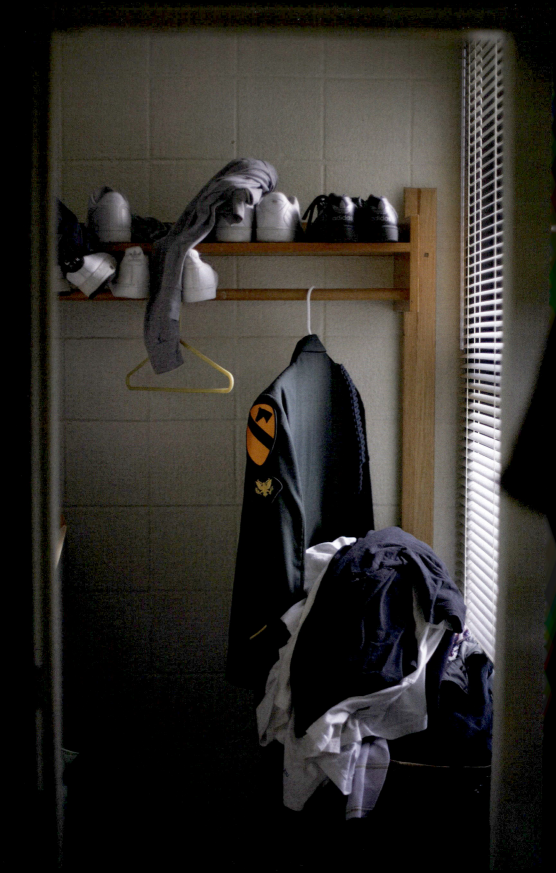

151

2008 — Fort Hood, TX

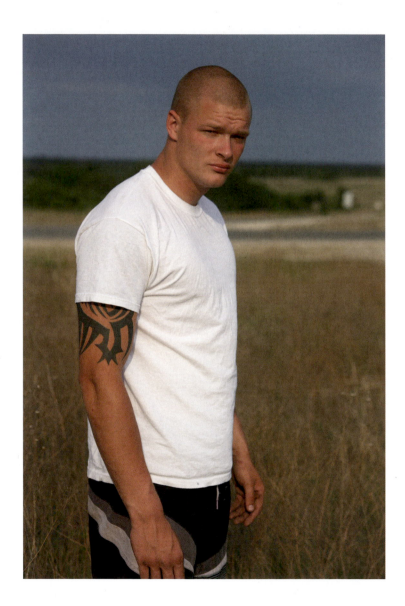

Levi Rollings

Basic training sucks. The first two weeks is red phase, I think that's what it is, and that's the real hard part. They don't let you do anything, you can't go anywhere, you're locked down, that's the hardest part. But then after the first two weeks, they lighten up a little bit, they let you use the phone, like, once a week or so. It was the first time I was away from home, but it was alright. Before I joined the Army, after I dropped out of high school, and I had that landscaping job, I lived by myself, so I was kind of used to living without my family.

After basic training I came here to Fort Hood, for about a year. I did all the training, and then we went to Iraq. I did one tour. I was nineteen when I was over there. Iraq is not that bad. You have missions, and then after your mission, you're off work. Sometimes you do missions that are more than a day long, and you're stuck out there, but it's better than Fort Hood. Here we just do stupid training, I mean, it's not stupid, we gotta do training. In Iraq you don't train. You just go out and do your job and then come back.

It's a really quick year. Fifteen months go by really fast. We got over there, and they said our tour was twelve months. And we were there for five or six months, and then you're like, yeah, I'm halfway through! Then they're like, OK, it's fifteen months now. And you're like, oh, fuck! Every time you go home on leave, everything's weird. Everybody changes. You know, people get married, you go home and you're like, hey, what's so-and-so been up to? And they're like, we haven't seen him since last time you were home. Everybody goes their different ways.

I don't think Iraq really affected me that much. I myself didn't kill many people, but the Bradleys, like Nike, they get a lot of kills. Because if you're in the middle of the night, like on a patrol, you take the people on the ground with you, just in case they need to do something. We were way out in a field, carrying our weapons or whatever, which is usually what happens, there's no reason to put anybody in danger to get shot at whenever you're safe inside the vehicle. And you just shoot with the vehicle. I've only killed a couple of people, nothing big. I don't know, honestly, because we never go and check the bodies afterwards, but I've shot people. It's just your job, pretty much, you don't really think about it that

much. It seems like when you first kill somebody it would be a huge thing, but it's really not. Everybody tells you, you did a good job. Nobody's like, dude, you killed somebody! Before I went to Iraq, of course I was around a lot of guys that had already been there. So you always hear people talking about it, you're like, man, it sounds like it would be crazy, but it's really not. I wasn't anxious to do it, like, it wasn't on my list of things to do but I do it if I have to.

After Sgt. Morris died, we went on blackout: no phones, no internet. It's the worst thing because you lose somebody and you can't even talk to anybody about it. That's hard. They had us sit down in a class, and we had a talk about how our feelings were and all that stupid shit. There's a bunch of people that weren't in the convoy, that weren't with us, like the POGs, you know, and they were all crying and all that stupid shit. I cried, too. I think everybody did. I didn't think, this could have been me, but I did when Cummings died because he was only one day older than me. He'd just turned twenty when he died. So I was like, damn, that's pretty fucked up.

I was kind of anxious before I went to Iraq. I was a little bit excited and nervous, but mostly because I didn't really know what to expect. Once you actually start doing stuff, every fire fight you get in, your adrenaline is pumped, and it's kind of like being scared but not really, it's just a really weird feeling. Afterwards, you're like, yeah, that was kind of fun! But scary at the same time.

What I like about the Army are the people. You meet a lot of different people. Like Elmo and Nike. Just funny guys that you go hang out with. People in the Army party pretty hard. I'd never been outside the U.S. until then. And I'd really only been to a few states before I joined the Army. I'd been to Georgia for basic training, here in Texas, I'd been to Alabama, I'd seen New York when we were on our way out. Not New York City, just New York state, somewhere by the water. I went to Buffalo, NY to visit Elmo one time, and we went up to Canada, stuff like that, so that's pretty cool.

What I don't like about the Army is waking up at four-thirty in the morning to go to work and running every day. I don't like running. A bunch of the guys who have been to Iraq, they know all that stuff, then we come back and we get

a bunch of new soldiers, so you have to train all these guys to do stuff, so you have to re-train on how to do it. Everything's repetitive. You just have to always do the same thing over and over again. That's just boring, pretty much.

I'm not re-enlisting and I'm supposed to get out in September. Either that or I'm getting stop-lossed. Stop-loss is when you're about to get out of the Army, but, like, three months before they deploy, everything's stop-lossed, so you can't get out even if your contract's over. They make you stay in and do the tour and after you do the tour, then you can get out when you come back. I think it's just because they need a certain amount of people to be deployable status, and if people are getting out that means they have to try to keep new guys in, I don't know if it's hard or whatever. Your unit can't deploy if it doesn't have so many people. I guess that's why, but I don't know, honestly. There is a chance that I might get stop-lossed because our unit is going back in December. I'd be pissed off. I really don't want to get stop-lossed. I mean, it's OK, kind of, because, like I said, Iraq isn't that bad, I don't mind going there, but I just want to get out of the Army.

When I get out, I will just go back home and get a job. My stepmom is gonna sell me the house I grew up in, from my dad, she still owns it but she lives somewhere else. So I'll buy the house and move back home. I don't know if I want to have a family. I might have a kid right now, actually. When I went home on R+R from Iraq—mid-tour leave—I met with one of my ex-girlfriends, because before I got home, she broke up with her boyfriend. So, you know, I was with her for two weeks and then I went back to Iraq and she went back with her boyfriend and she ended up pregnant. So I have no clue if it's my kid. I haven't seen it yet but her sister sent pictures but they're all blurry and stuff so you can't really tell. The baby's got blond hair and blue eyes and the baby's mom has blond hair and blue eyes, so it doesn't really prove anything. But now she's just being a bitch. She won't get a test done. She just wants her boyfriend to be the dad. I would definitely take care of the kid if she got it tested and I turned out to be the dad. I would not get married to her, though. Because we're probably just gonna end up being divorced anyway.

I would join all over again. Because before the Army, I was—well, you know, I still do, I smoke weed and stuff still—but before that, it was all I did. I lived in a trailer, and just me and a bunch of my buddies lived there and we partied all the time and got in a lot of trouble. When I enlisted in the Army, I had two weeks until I had to leave for basic training, so the weekend before I went to basic training we threw a really big party. We got busted and I was supposed to do six months in jail, but then when I went to court I was like, hey, I'm leaving for basic training, like, tomorrow. So they took away everything except for one ticket, it was 400 dollars, I had to pay that, that's it. But there's pretty much nothing to do in Toad Hop. The Army is definitely a way out. When I go home, I see a lot of my old friends, but they're all meth heads now, so I just say "what's up" to them, pretty much. There's a lot of friends I still hang out with when I go home, though.

I don't vote. I never have. Because if you vote, then you complain. Everybody complains about Bush—I don't complain about Bush because the U.S. chose who the president is, right? The majority wins. Honestly, I don't listen to Hillary, Obama, or McCain. I don't pay attention to what's going on in the election, so I don't think I have the right to vote. If I watched them and listened to what everybody had to say, and I would really be interested and shit, then I would vote. But I'm not really interested in what they have to say because honestly, it doesn't matter to me what the fuck happens. The way it sounds, it's either Hillary or Obama. Everybody knows that. I hear that they both pretty much got the same perspectives on everything. So, I've never voted before, but even if I was to vote now, I won't even know who to choose from because it doesn't make a difference. Honestly, the only way I've looked at it, is: a woman and a black guy. That's the only thing I've gotten out of it. And then there's McCain, who's not gonna win, pretty much. But whatever. It's always been a white male, in the entire history of the presidency, now it's finally gonna change this year! It don't matter to me because I have no clue what the president does. Like, whatever he does on a day to day basis. Hillary—I'm sure she knows what to do because her husband was president so she's got a lot of experience and stuff. You know how some people are saying,

oh, we can't let a woman run this country? It don't matter to me. As long as she doesn't fuck over the country.

A lot of people hate Bush, but I honestly don't know why. I mean, we got fucked up, we got bombed by terrorists . . . I don't know what everybody calls it, war for gas or war for oil—I call it payback! If fucking terrorists are fucking with your country, and you run the country, do you either just say, "OK, that sucked," or do you say, "Alright, fuck you assholes, I'm gonna whoop your ass"? That's the way I see it. Bush just seems like some country-ass motherfucker, he's just a regular guy, a little bit of a hick maybe. But he's like, you know, fuck that! You ain't gonna blow up my fucking buildings in my country and get away with it! So yeah, I agree with what he did. A lot of people hate him because we're going to war, but whatever . . . who cares.

Iraq is honestly the best part of the Army I've had, the best experience. Being back here, it just fucking blows. And we do a bunch of stupid shit that doesn't make sense half the time and you're like, "why am I doing this?" And they say, "I honestly don't have an answer." And then I think, OK, that's fucking retarded. We go to work. Sometimes before lunch, we do shit. Then we get back from lunch and we don't have anything to do, we just sit around and they have to come up with stuff for us to do, for no reason, which, in my eyes, is stupid. I don't know what's going on at a higher level because they don't let us know that stuff. Training I understand, I don't complain about going out. I'd go out to the field for a month, I understand, you gotta train to go to Iraq and fight. But doing stupid shit like that, there's no reason for it. In Iraq, you wake up, you go on your mission, you come back, you do what the fuck you want. You go eat, you go to the gym or whatever you do that day, you come back and chill and watch movies in your room and go to sleep. Yeah, it sucks because you ain't got bars to go to so you can't drink or nothing, but they're not making you do stupid shit on your fucking free time.

I don't feel the urge to kill, just for no reason, but in Iraq, whenever somebody's shooting at you. . . . Like, when Sgt. Morris died, I really wanted to kill somebody that day because

I was there and I watched him get blown up. That day, I felt the urge to kill somebody over that shit. But I don't just feel the urge to kill every Hadj. If I was told to, I would do it without a problem, but I don't feel the urge to. If it's a known terrorist, that you know has blown up your buddies or you know he's gonna try to do that shit, yeah, I want to kill him. There's no question about that. I wouldn't have a problem killing somebody who is fucking with my family or fucking with my friends, or something like that but it's not like I'm fiending for it. I don't have withdrawals. Whenever you're in a fire fight, it's such an adrenaline rush, it's ridiculous. It's ten times better than riding a roller coaster. It's better than hunting—anything. It really gets you pumped up. You watch war movies and you're like, oh my God, this is crazy! So I understand what people say when they say, "man, I haven't killed somebody in a long time and I'm getting the urge" because they're, like, fiending for it, the adrenaline rush that you will never have again. In a fire fight, I could really fucking die right now. If somebody tells me to do something, I gotta do it, like, NOW! There ain't no fucking uh and oh. It was fun, but I don't wanna do it no more. I had my fair share.

A lot of people in the company think that I should be a leader because I look out for my friends. They look at me as a person that kind of knows a little more than them—but as a friend, you know, not somebody who's telling them what to do, more like somebody who's just giving them advice on what to do. For example, if somebody's looking down while we're doing a patrol, I won't say shit like, dude, get your fucking head up! But after we do it, after training, I'll say, "hey dude, you had your head down, you gotta look up!" I just like to try and help people out. Because I don't think I'm going back to Iraq. But, you know, a lot of these guys I like are and I would fucking hate for something bad to happen to them. Over something stupid like that.

2012
Terre Haute, IN

Rollings and his very pregnant girlfriend Angel, twenty-five, are living in an old but spacious house with high ceilings in what they call "kind of a bad neighborhood" in Terre Haute, Indiana. Their street has a typical American small-town feel: People park their cars at the curb, kids ride their bikes on the sidewalks, neighbors sit on the porch, walk their dogs, smoke, and exchange a couple of words about the weather when they run into each other. Daffodils bloom along fences and you can hear the forlorn whistling of freight trains in the distance.

Rollings and Angel bought their house off of Angel's grandma for $25,000 and will have it paid off by the end of this year. Angel has two kids—Lilly, five, and Conner, three—from a previous relationship and everyone is excited for the arrival of baby Leah, who will be born on April 4, 2012. Their house is filled with photos of their kids, nieces, nephews, aunts, and other extended family members as well as decals that say "Faith," "Hope," "Dream," etc. There's a sign in their living room that says MILF (acronym for "Mother I'd Like to Fuck"). Angel tells me that it used to say FAMILY, but it broke one day and Rollings re-arranged the letters. Buddy, their three-legged cat, lives in the kitchen and every time Rollings walks past her, he gives her a friendly pat. In the morning he prepares his lunch box and ice tea jug for work and feeds the animals with "help" from Conner.

Every night they watch a movie together, as a family. The kids usually fall asleep quickly, and after a while, so do Angel and Rollings.

Angel works as a lab and autopsy assistant at the regional hospital. Her pregnancy is complicated by gestational diabetes (a form of diabetes that occurs only during pregnancy), so she has to measure her blood sugar and inject insulin four times

a day as well as go in for non-stress tests every couple of days to make sure the baby is doing OK. Now, with her pregnancy so far along, she's often tired and yells at her kids. "You guys are driving me crazy," she tells them. "Levi doesn't understand when I'm exhausted. 'You didn't do anything all day,' he says. But it takes a lot of energy to be pregnant. I can't even imagine what it takes to make a baby—the cells, the lungs, a brain. I sometimes feel like someone's stabbing me in the back, it hurts so much, and Leah is constantly moving in my belly so I can't sleep at night."

The two have agreed that they will get married one day, however, it's not entirely clear as to when this wedding will take place. Angel, I think, would prefer it sooner rather than later, but Rollings tells me he's not ready to get married. Still, he has already bought a ring and has shown it to everyone but Angel.

Rollings is still the same, good old Rollings, except maybe a bit quieter. He's grown a goatee, which he strokes a lot, in a pensive way, especially when he drives his truck. It makes him look older, but not in a bad way. It still takes him a while to warm up to strangers, in this case, me. Instead of with his Army buddies, he now horses around with the family: He shoots dog food pebbles with a slingshot at them, chases the dogs around the backyard, and when we go to dinner at his mom's house, he sneaks up on her and slaps everyone else around the kitchen with a dish towel.

Rollings' best friend Dave sports an Amish looking beard, which at one point during my stay, Rollings converts into some mean sideburns. Dave lives in a camper in Toad Hop. He's the proud owner of two pit bulls whom he feeds human food (when he goes to McDonald's, he orders three burgers—one for him and one for each of his dogs).

Toad Hop is a small, run-down neighborhood outside of West Terre Haute, off of the old highway 40, across the Wabash River. Most of the people there are unemployed and live in flood-damaged, derelict trailers. A grossly overweight kid yells "Hot Mama!" at Angel as he rides by us with his tricycle. Rollings tells me about a man who lost his pinkie accidentally while

working on a scrapyard, keeping the finger in a pickle jar on the kitchen table. Toad Hop is a white-trash ghetto. Rollings says: "If you move out of Toad Hop, you move up. It's depressing to everyone here when someone moves away, because it reminds them of their own lower-class existence." Another one of Rollings' friends, a home-schooled, openly racist, but very polite young man, tells me that the local radio station once called on everyone to come out and burn their Dixie Chicks CDs—he, of course, thought that that was a good thing.

I tell Rollings that I have a harder time understanding his English now, that I feel he slurs his words much more than when I first met him in Texas, and we talk about what a melting pot the Army is: So many accents, skin colors, and mentalities are meshed together—you have to speak in a distinctive manner to make yourself understood by your buddies from both upstate New York and Samoa at the same time. Spending time in Terre Haute, I quickly realize that Rollings has probably seen more and traveled further during his short stint in the Army than any of his friends ever will. He is also more open-minded and curious, less surprised about foreign things than they are.

When Rollings hangs out with his friends, they talk about their trucks, about engines, rims, tires, and bar fights. While a friend is over watching UFC videos, Rollings recalls his dad's bar stories—Rollings talks a lot about him and at one point shows me his Army memorabilia: old photo albums, high school yearbooks, and Army badges. When it's just the two of us riding in his truck, we talk about sign language, people who speak in tongues, gambling addictions, religion, and Hawaiian food.

Rollings recalls his Army friends from Fort Hood with a lot of tenderness. He keeps bringing up stories and we talk about the soldiers we both know. "I miss those motherfuckers," he says often. During my week in Indiana, I try to get a hold of Nike everyday to have him talk to Rollings, but he never picks up. We're both disappointed about that. One night, in the car on our way back from his mom's house, Rollings and I start talking about Texas and describe Timmy to Angel, and I tell them about the time that Nike and I stayed up late, drinking and smoking on the porch, and how he cried about all the bad things that he's done, about all the people he killed. "That makes a

lot of sense," Rollings says. "I remember that he always used to sit alone, quiet, when we were all together. I could tell that he was thinking about those things. And you know, when you come back from Iraq, the Army really doesn't check too much whether or not you're sick. They ask you, 'are you OK?' If you say 'yes,' they're, like, 'cool.'"

Indiana is a notoriously red state and many people harbor resentment against blacks and Mexicans. Rollings often contradicts himself in his statements about race or racism. He's always friendly towards everyone and incredibly laid back. Yet racism was passed down to him through his dad and his surroundings and he can't seem to un-learn how to react towards people different than himself. For example, one time, as we cross a parking lot to go to dinner, a black family walks past and someone in the group laughs about something; Rollings, in a half joking, half irritated manner, complains about how African Americans are always loud: "They play their music loud in their cars and they laugh too loud," he says. When I talk to him about the incident the next day, he says: "I'm really not racist. But it's kind of the way I was raised. Like, if that kid in the car would have been my friend, I'd gone up to his car and asked him, 'why the fuck are you playing your music so loud?' I guess if I was around black people all day then they'd be getting on my nerves, and they'd probably annoy me if they'd be laughing real loud. I was just sayin' . . . there's no reason for anyone to hear you all across the parking lot. I know a couple of real redneck black guys, actually, and I mess with them. The last time I joined, I hung out with a lot of black people and I'd always mess with them, too. I don't think I'd be more racist if my dad was still around. I'd probably just still be the same way. My mom said that I used to play with her friend's kids, and they were black. If you grow up in West Terre Haute, you don't know any black people at all. All the way up until I was eighteen, I only met less than a handful of black people, before I joined the Army."

Rollings: In 2008, when we last saw each other, I almost got stop-lossed. The day I left they called me into an office and said I was stop-lossed. I was, like, a week over from getting

out. I didn't get stop-lossed because they thought I was supposed to get out that day. I took too long in the out process, so I was there for an extra week, and the day that I was leaving was the day stop-loss hit. So after a while, they said, "nah, you can go." It was pretty scary though. Then I was home for about a year, and we were at my mom's house for Thanksgiving. I checked the mail, and it was orders from the Army to go back to Iraq for a year. I was out, but whenever you join, you got the eight-year commitment. It's called Recall IRR. IRR stands for Inactive Ready Reserve. The three and a half years that I did were active duty, but even now, I'm still on the eight-year list. As soon as you sign up, you got eight years. So when they called me back in, I went with the Louisiana National Guard to Iraq.

Before I got out of the Army in 2008, I failed a drug test, it was right whenever I was getting out, they were all leaving for training, so nothing happened. They told me to out process and go home. I thought they was gonna make a fuss about it, I went to an office with this lady, and she asked me what was going on, and I told her that I might be getting stop-lossed, make me gonna do extra duty, which is, like, forty-five days, and she just told me that they couldn't do it, they were just trying to give me a scare and nothing happened.

When I got called back after this one year, I was mad at first but I got over it, thought I'd just go, make some money. When I got out the first time, me and Angel got together, we had been together for a while, then I got the orders and I went back.... Yeah, we was together then and I was doing the same thing as I'm doing now, which is landscaping. Angel was pretty upset. We was living in a house in Toad Hop, it was my stepmom's house, she was renting it, and then while I was gone, Angel's grandma said she would sell me this house on contract, so I bought this one and we've been paying on it ever since.

I went back as an E-4, but I made Sergeant when I was there. My second tour was way more laid back than the first one. We didn't do any missions, really. The only missions we did was convoy securities, so we never fired a single round or nothing. It was boring, but it was good. But it ain't worth

somebody getting hurt over. The first time I went, it was just "whatever." The second time, I was in a different situation, with Angel and the kids.

When I came back, I went back to do landscaping work for a different guy because he'd asked me to work for him, but he was just too picky about everything. I told him I didn't want to mow, that I wanted to landscape, and he said that was good, because he got a lot of landscaping, and I was there for about two or three months, and he put me on mowing! So I called up my buddy who owns this landscaping company and he said, yeah, come on!

I don't think I'm gonna go back to school, but I'll probably get a different job some time. I don't know what kind of job, honestly. Something that makes more money! We're alright, financially. It pays the bills.

I don't really care more about politics, but I did watch a little bit of the Republican debates, but everybody's making them out to look like a joke, so I don't really know what to think about that. I'm registered to vote, I haven't decided yet if Democrat or Republican. So I don't know if I'll vote or not. I guess it depends on who it comes down to. It's gonna come down to Obama and someone else.

Before the incident my sister and Angel were telling you about, I was arguing with my buddy about something, I don't remember what it was, though. . . . It came down to arguing about Obama, about the war. I was mad about something. I punched a mirror on my truck. For some reason, it was parked around back. I don't know why. That's really all I remember. I remember calming down mostly after that. Then my brother-in-law came over and told me to calm down, told me to knock it off. But I don't even know what it was about. I was just bitching about something. I got a picture of Cummings, not the obituary picture, but an actual picture from when we was hanging out before, but I don't remember what I was saying. I guess that was when I went out to my truck because I had a picture in my truck of him. It was stupid, I was drunk. I was really drunk. I know it freaked Angel out a little bit—she said she was scared. I told my brother-in-law the next time I act stupid that way, he should just punch me

and tell me to stop being a crybaby about stuff. Angel and I never really talked about it afterwards.

After his breakdown, Rollings went out and had a buddy bracelet made: It commemorates his fallen Army comrades Daniel Morris and Branden Cummings. I notice it right away and he tells me that he had lost it the other day in the couch. "I felt really weird without it," he says.

One time, when I was staying with my sister, I woke up and there was a big thunderstorm. In Iraq, they send out the light flares, you know, like BOOM! BOOM! But it's not even a combat thing, because they do them at night time—BOOM! BOOM!—I heard that, I woke up, and thought it was that and went back to sleep. The next morning, I was like, that was stupid, I'm not even in Iraq! And, you know, when you come back from Iraq, you always grab for your rifle, no matter where you're at, you reach for it? I did it when I was walking up, like, when we were doing the re-integration stuff, I was walking up to everybody, and I was reaching for it, and I was like, what am I doing? So I went up to Griff, and I was like, "dude, where the fuck's your rifle at?" He was like, "aw, shit!" He started looking for it and was like, what the fuck? I didn't have that after the second tour. I never reached for my gun when I got rid of it. It was just way more laid back this time than it was the first time.

I actually ran into Nick Martinez when I was over there. I saw him at the chow hall, in Iraq, I started yelling at him, we talked for a little bit—he was actually on his way home, he was just stopping at the FOB I was at. Later on, he came by my room and he gave me some movies. That was cool. It was cool seeing someone I knew before.

Sometimes I dream about the Army. But I never dream about the war. Sometimes I dream that I'm in the Army, but it's, like, people from around here are with me, and it's just weird dreams that don't make any sense. Or sometimes I would be home, and people from the Army would be hanging out. But I don't think I've ever had a dream about being over there, honestly.

The night the van burnt down, I had had a really bad day, because the night before I got drunk, and I had a crazy hangover the next day, I was throwing up. . . . People had drawn penises all over my head the night before while I was sleeping. I was about to go to a birthday party, I opened the van and everything in there was black! I didn't know what it was, I looked in, and I smelled smoke really bad, I opened the back doors and I smelled fire. It had melted everything. It melted the bow that my buddy Dave gave me.

Then I just kind of sat around for a little bit, you know, called people and told them what happened. Finally people talked me into calling the cops, and the cops came over and they looked at it for a little bit, and then they ran my name—they apparently had a warrant out for my arrest, from a probation violation in 2010. I had a DUI and I had a "resisting law enforcement." I was supposed to do community service, but I got my orders to go back to Iraq, so I didn't do it. They had sent paperwork to my mom—a bench warrant—she went to the community service place and talked to them, and they said they would drop everything, all the hours, if I would pay. So my mom got a money order and paid—well, apparently it never got back to the prosecutor's office. So they arrested me. My brother-in-law was there when they did, so he came and got me out of jail. I went to court, and now I got to do my forty hours of community service still! Even though I was already serving my country and that was like serving the community, they still want me to do it. We went back to the bank and they printed a copy of the money order, I mean, we got proof that we paid for it, so . . . I told the judge the story and he agreed with me but the prosecutor lady didn't want to drop it. She said since all I had was forty hours, I should just go ahead and do it. The court didn't even give me the right paperwork to sign up for it, so I have to go back to the courthouse and get the right paperwork. It's just a big pain in the ass right now. What happened was: I was riding my four-wheeler, and I was coming down this road in Toad Hop, and I passed a conservation officer, he turned around to pull me over. I just turned into the woods, and I was in the woods for a while. I was caught on a log and I was just sitting there, you know, I wasn't even worried about

the cop because I was way back in the woods, but here comes this cop! This conservation officer, fucking, like Rambo, on feet, ran through the woods! After he caught up with me, I just let him arrest me. But I got "resisting law enforcement" for that. They got me for some other stuff, too. Like, operating a motor vehicle without a driver's license from when I had my DUI. Since I was on a four-wheeler on the road that was a violation as well. So, yeah, it was a bad day.

They tried to talk me into staying in the Army. When you re-enlist in Iraq, you get a 16,000 dollar bonus that's tax free. I guess I could have made Corporal, and they told me that as a Corporal, they pretty much have to put you wherever you want to go. But I didn't believe that. I missed Indiana, I guess, so I just got out. I didn't miss home that bad, you know, we was always occupied with something. You see, I hang out with all my friends, that's what I do, and I had plenty of friends in Texas.

I could see myself doing something else other than landscaping. One of my buddies said that his work's hiring right now. He works at a factory, they make all kinds of stuff. He works on the machines, but you're starting out as a beginner's position. They got benefits. That's really the only difference. That and I'd have to work inside a factory all day. They have a lot more rules and stuff. But the kid's on the way, so . . . I'll do the right thing, I guess.

It takes a long time to get any good at landscaping, you have to register the business, and usually you have to get loans to buy all the stuff you need. Or you just have to do overtime. I'm not that passionate about landscaping, but I like it because you work outside and you get rain days off. Sometimes it's nice just to have a day off. I don't work in the winter, and that's too much free time. I got bored. Lilly would go to school and I'd usually keep Conner, and me and Conner would hang out all day, do whatever we wanted. I'd take him to the fish store, or go see Dave, or watch TV. It's boring. It's really, really boring. I did have a hobby, which was riding my four-wheeler, but the weather really sucks around here. It doesn't snow enough to actually do something in the snow—I used to have a snow mobile, but there's no snow. And you can't go

sledding with the kids. Wintertime is boring. I guess I need to find a better hobby, huh. Maybe next time you visit I'll have a stamp collection going. I'm sure Nike will call me then to see what's going on!

Yeah, I was drinking a lot before Angel got pregnant. But not a lot like in Texas. Every weekend, go out to the bars and stuff. Then I stopped because she can't go anywhere, so I would argue with her just to go. Before I went back to Iraq, I drank a lot. It got me in trouble, so I quit. I just never calmed down from the Army, I guess. When I first came home, I dated Angel, but we didn't have a house payment, I was living at my sister's, I only paid fifty dollars a week for rent. So I could just do whatever I wanted. Do I ever miss doing whatever I want? Yeah. Yeah. I miss it now that you bring it up! I miss when I was in the Army. That was always fun, you know, you get off and just everybody goes and hangs out. Now everybody's got kids and they're married. It's all boring now. You can't just go and knock on somebody's barrack door and ask if they want to go get drunk. You could always find somebody there to do something with. You were surrounded by guys so somebody wanted to do something. Now everybody has to find a babysitter. . . . But it ain't too bad.

I was never thinking of going someplace other than Indiana. I was gone for a long time so I just wanted to come back. Unless a really good job opportunity came up I would not want to move anywhere else.

I'm not ready to get married yet. I've pretty much settled down, as much as I'm going to. I miss being in the Army. I had a lot of fun in the Army. I miss the people, hanging out with everybody. I don't miss the training but Iraq, that's an easy job. You know, even the last time I went I liked it. You get money and it's not hard work at all. It was a piece of cake.

Angel: Something came on about Obama, and I don't remember really what happened, but Levi said, "oh, that's crap," and it kind of progressed from there. It was bad. Then I called Sarah, and I said, I think you should come over. It happened at home, just me and another buddy. And I think his buddy said something about whatever Obama said, and it escalated from there. Levi wasn't fighting, he was just crying, he was

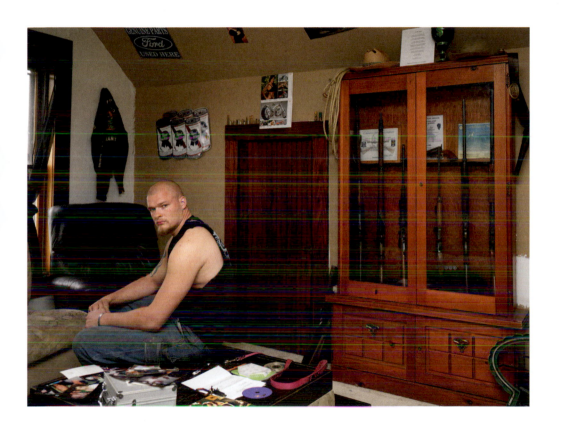

2012 — Terre Haute, IN

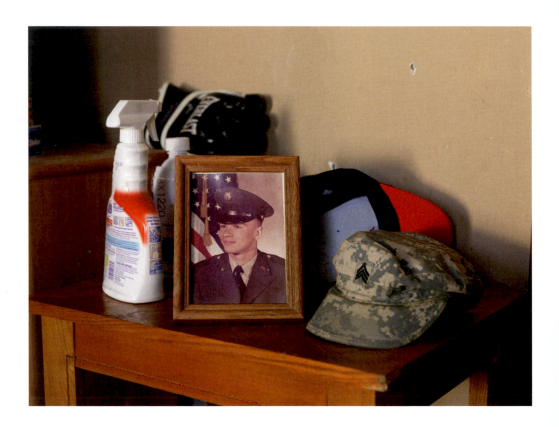

Levi Rollings

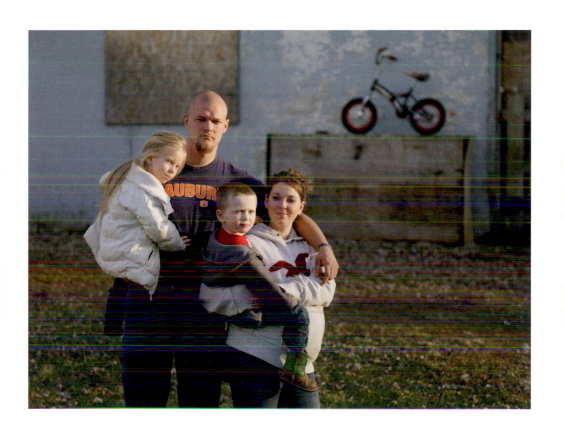

2012 — Terre Haute, IN

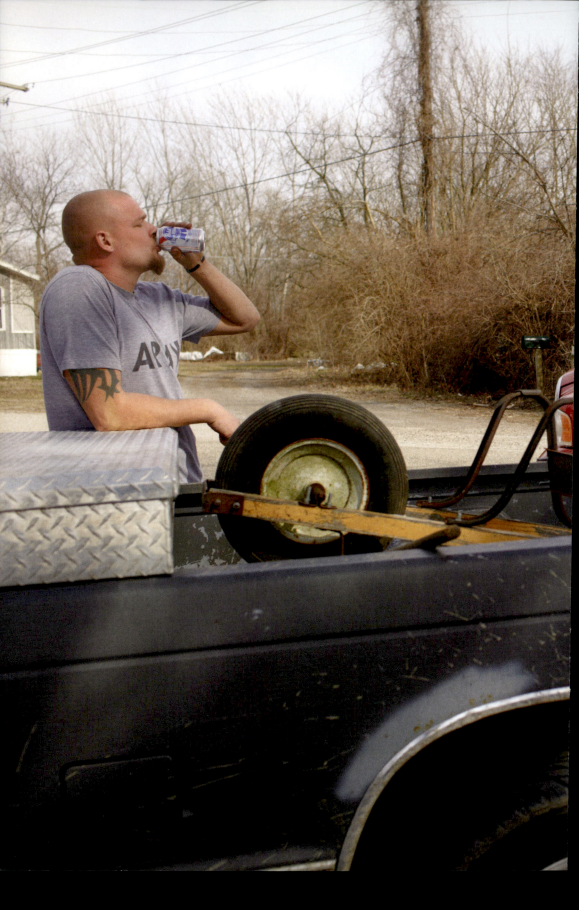

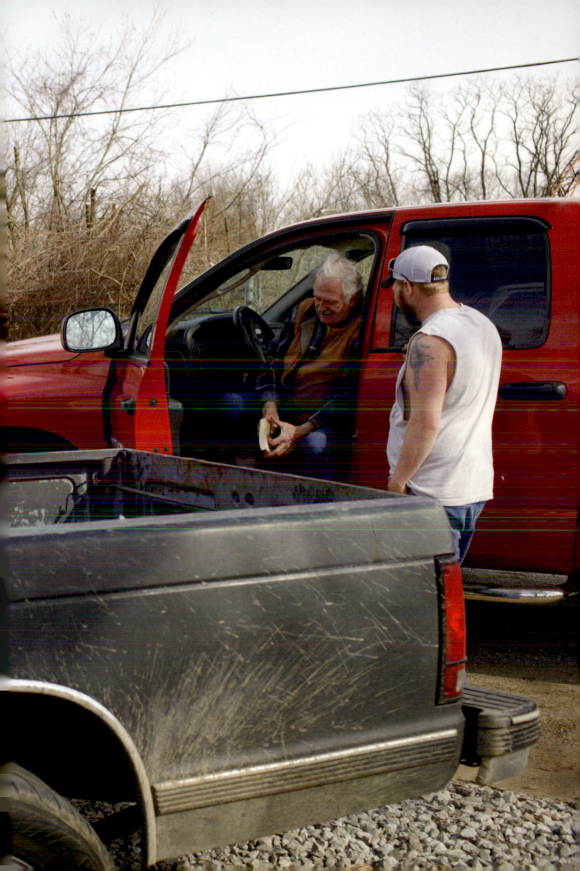

174

Levi Rollings

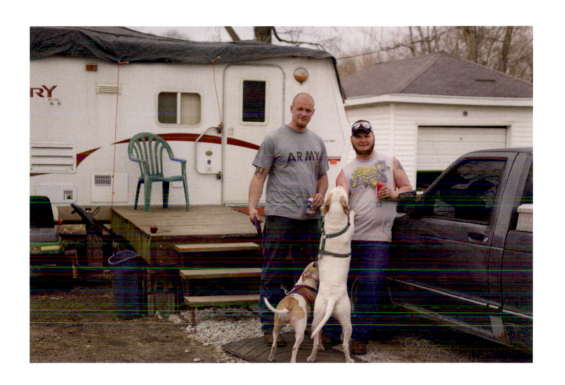

2012 — Terre Haute, IN

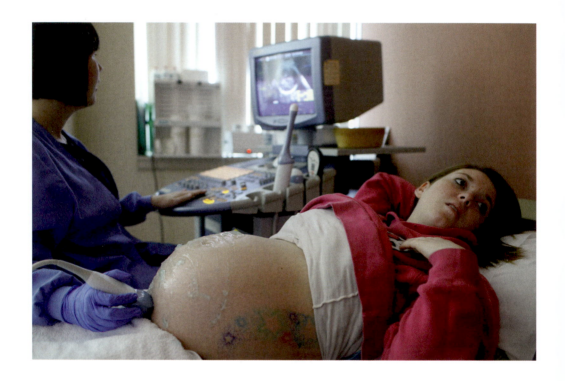

Levi Rollings

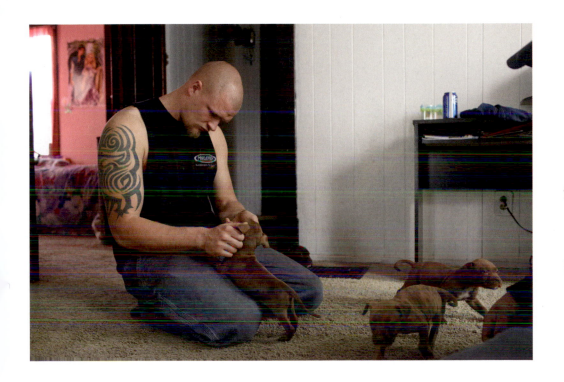

2012 — Terre Haute, IN

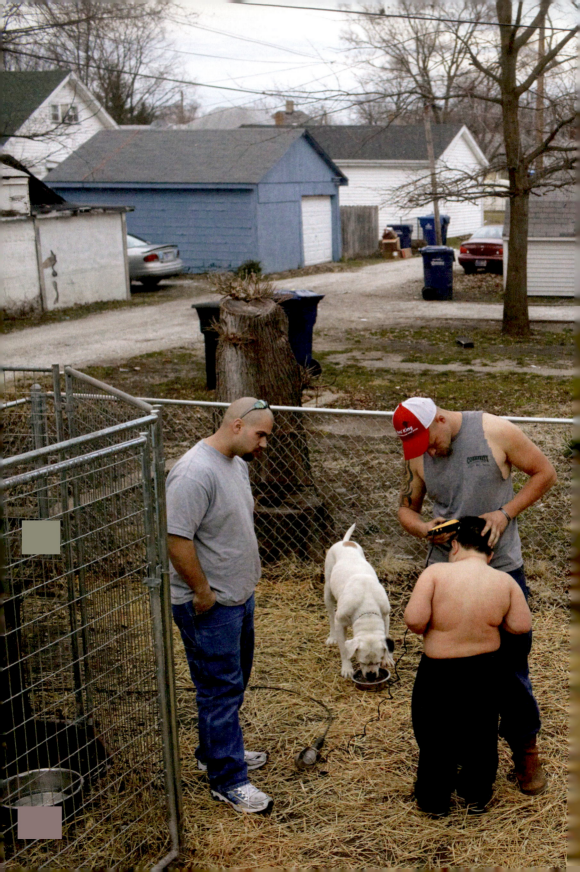

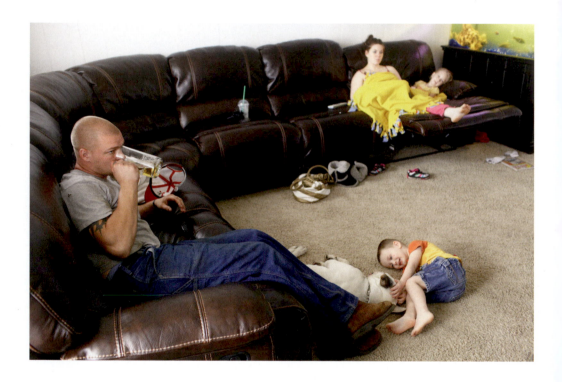

Levi Rollings

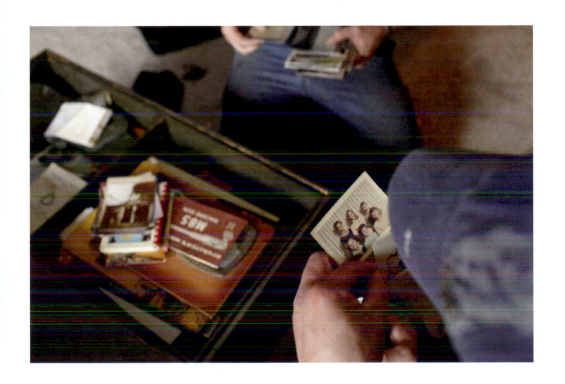

2012 — Terre Haute, IN

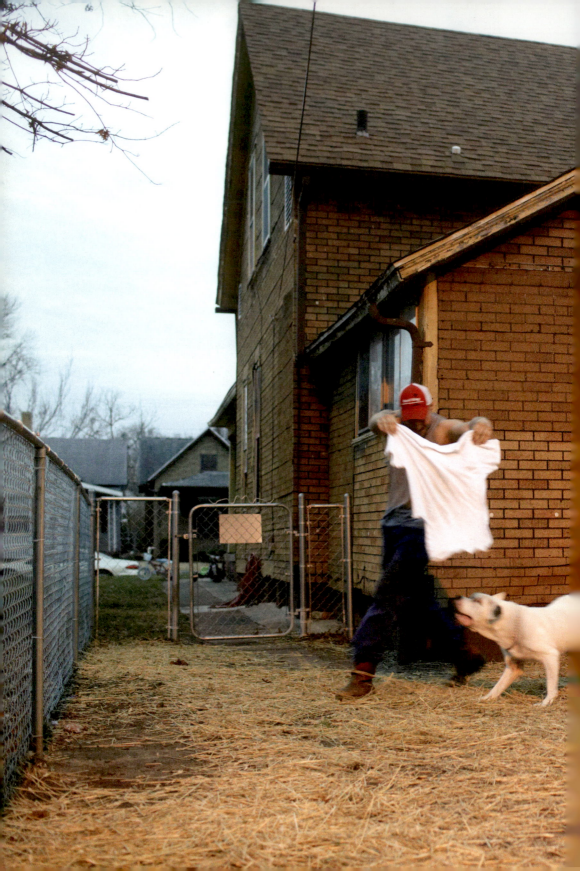

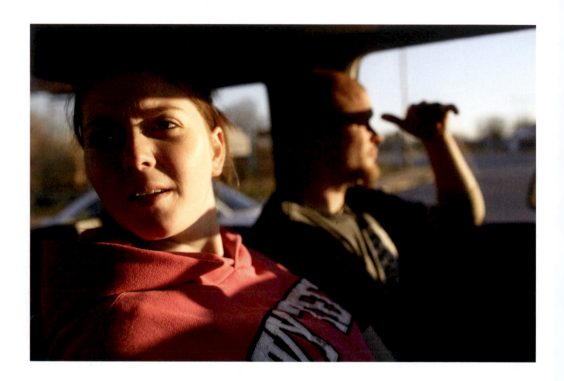

Levi Rollings

mad because he was trying to show the picture, show us, like, this is what it is! I wasn't scared because he wasn't being mean, he was just crying and trying to get his point across, and getting aggravated. When they came over, he finally calmed down. In the three years that we've been together, that was the only thing that ever happened.

He was getting so upset because he felt that no one understood what he meant, what he was talking about. Then I said, I do understand, but he said I didn't, and I said, I'm trying. He just kept pointing at the picture and got more and more frustrated and started crying out of frustration. It was definitely super intense and I was really uncomfortable. I think it happened because they got really drunk and went to a mixed race bar, there were a lot of Indians and black people, and that's what might have triggered it. I'm so glad that that was the only craziness, though. I'm so glad he hasn't been affected by the war more, like other soldiers have. He's taking a bad thing—the war, and the Army—and he turns it into a good thing: He says he met a lot of really good guys, and that's why he liked it.

When he received the orders to go back, I cried—it was bad. It was the first time I'd ever seen him cry! It was rough. I was worried because I had worked with his mom at Pizza Hut when he was gone for his first deployment, and she would come into work crying because two or three weeks had gone by and she hadn't heard anything, so I was like, oh my gosh, it's gonna be like that! But it went by super fast. When he went back for the second time, he called every night and the longest he was gone was six months.

We've been friends since we were sixteen, but I've never seen myself dating him because we were sort of different. But in December 2008, we started talking and we went to see a movie, *PS. I love you*. Levi is not a romantic guy at all but he came to see that movie with me. One time, I had a really bad fight with my kids' dad, and I needed a place to stay so I went over to Levi's sister's house where he was staying with his ex-girlfriend. It was very awkward because all of her things were still there, but he told me that they were broken up. So we stayed with him for one night and one week later I broke up with their dad and we started dating. He's very honest. He

would never lie to me and I trust him completely. Basically, I'm in a relationship with my best friend!

Levi was used to a lot of partying, down in Texas, so when we first got together, it was really tough. At first it didn't work. He said he didn't want a girlfriend. I told him, "You know, I do have these two kids, so it's either me with a package, or nothing." And we sat down and talked about it, and then he said he wanted to try again. So ever since then, we've been together. We hardly ever fight. When I'm crabby and want to pick a fight, he just jokes about it, and then it's all good.

When me and the kids' dad split up, it just kind of fell into place—we've been together since Conner was five, six months old. He's been there since they were babies. My kids still see their father, every other weekend, for one night. We all get along. So Levi's like their dad and he takes care of them as if they were his kids. And, my kids, they don't even know that Levi's mom is not their real grandma. That Sarah is not their real aunt. So, we're all comfortable.

My kids' father, he is not a good guy. He constantly cheated on me, and he was abusive, abusive, like, physically. One time he put my head through a wall. And one time he threw his current girlfriend down the stairs, right in front of her daughter. Now we all get along, like, we will talk on the phone about the kids' schedule, but other than that, we don't converse. His current girlfriend is awesome, though. She's really turned him around. He used to be in and out of jail, for drugs and alcohol, and we had a really bad, kind of an off/on relationship. We had only been dating for five months when I got pregnant with Lilly.

I had a miscarriage right when Levi left for Iraq. After the miscarriage, we tried so hard to get pregnant, we just kept trying and trying, and I started to think that there was something wrong with Levi, because, you know, it couldn't have been me, since I already have two kids. Then we stopped trying and it worked. Maybe we were trying too hard. The miscarriage was very, very sad, but now, looking back, I see that the timing was off: Levi would have been in Iraq during my pregnancy, me and his sister were constantly fighting, we were living in Toad Hop, and my kids' dad was in jail, so

I wouldn't have had a babysitter. With this baby, at first, we didn't even want to get excited about it because we didn't know if it was going to live.

We had a huge fight before I found out that I was pregnant again. Because Levi, he was drinking a lot, and he used to go out to the bar every weekend with his friends. He was going out three or four weekends in a row—he was on a streak. I had to get up at 3 or 4 a.m. to go pick him up. It was just disrespectful. After a while I was fed up and I lost it. I went on a rampage and broke the glass of his gun cabinet. He pushed me on the bed and told me to get the fuck out. I said, "Fuck you!" Then I started looking at apartments because whenever Levi was drunk, he would say that he wasn't responsible for my kids. Once he sobered up, he wouldn't remember saying that. You can't choose when you want to have a family! So I just knew I had to start taking care of myself and my kids without relying on him. Oh, and around the same time, I didn't get my period! So it was bad. After I came back from looking at apartments, I was taking a bath and stayed in the tub for a very, very long time. He came in the bathroom and told me that he didn't want me to move out. I did a blood test at Planned Parenthood a few days later, which confirmed that I was pregnant and we haven't fought ever since.

Cindi: Levi has changed, and it's not just his age. The war changed him a lot. Of course, you know, he joined the Army so young! He came to me, and...his dad passed away and I was really glad—after his dad got cancer—that I'd let him go live with his dad. He learned a lot and he had that quality time with his dad before he passed away.

When his dad and I got divorced, Levi was only two years old. He just loved his daddy, he always wanted to go live with his dad and I always told him: after you go into elementary school and you're going into middle school, if you still want to go live with your dad, I won't stop you. I was kind of hoping he would change his mind but he didn't. And it was hard. It was hard, hard. It ended up being a good thing because he learned so much, things that I would have never been able to teach him. I mean, at my house, Levi would get grounded from the TV or the skating rink—but at his dad's house, when

he got into trouble, he had to pull up horse-patch fences. I think he had to roof a garage one time. It was really good for him, obviously, just look at him.

He was fifteen when his dad passed away and he had to come back and live at my house. I know he didn't really want to—his dad had a little mini-farm, horses, goats, dogs, cats . . . I lived in the city, in a little house—and he brought a rabbit, two different kinds of turtles, ferrets—oh my God, those things stunk so bad! The horse had to be boarded, he brought the dog . . . I think the only animal I put my foot down about was the goat. He brought all these animals to my house—he just had a really hard time with the loss of his dad, he really did, and, you know, I don't know if it was just the regular teenage rebellious stuff, or if it was his dad dying, and him having to come back to live with me and Sarah . . . Levi's whole life has kind of been to me that way, to tell you the truth, so he comes back at fifteen, and he starts getting into trouble, he changed schools, and then he decided that he wanted to quit school. The principal called me and said, "you need to sign this paper giving Levi permission to quit school," and I said, "no, I'm not going to!" Because he doesn't have permission to quit school! But he just quit anyway. He told me, "Mom, I'm not even gonna finish school." He said, "the Army was good enough for my dad, and it's good enough for me. I'm gonna join the Army." Then he wanted me to sign papers for him to go in the Army at seventeen! I said, no, I'm not doing that either. Not that I don't want you to go in the Army, I think it's honorable—every man in our family has been in the Army, I don't know if Levi told you that. Every uncle . . . everybody. So it was something I wanted him to do, I just didn't want him to do it at seventeen without finishing high school! Then, when he quit school, I thought, oh, he'll never do it, he'll go and party and all this, but he did, and I was really proud of him. As soon as he turned eighteen, he went and took that GED test so he could go in the Army and he did, without any pushin' or anything. But then, of course, he was set on going in the Infantry, just like his dad, and I was like, oh my God, please no! Because by then, the war was starting, and it's not like it was when his dad joined. But he was all gung-ho about it. I couldn't believe he did it. It was

the hardest thing I've ever done but it wasn't like I had a choice. I mean, at that time, he did turn eighteen.

Now, that first term, he would call at two or three o'clock in the morning, and even though I had to get up and go to work, I'd talk to him on the phone, sometimes we'd talk for hours, but that was OK. It was just so good to hear his voice. That was the year of no sleep for me, I'll tell ya. My husband would wake up in the middle of the night, and I'd be sitting there, just bawlin'. I couldn't sleep, I had bad dreams—then, of course, I went a couple nights like that, and then he'd call the next night! When he was over there, he was there for nine, almost ten months, his tour was almost up, before he got his two-week break to come home, and then he came home for a couple of weeks, and when he went back, I don't know, but I was OK. I slept a lot better, I wasn't crying all the time. I think I just had to see him and see that he was OK. But then as soon as he went back, they extended their deployment. So instead of twelve months, they had to do fifteen months. Gosh, this is just bringing up so many memories for me! You know, when he first got over there, he was real good about calling all the time. And then, one time, he went several weeks without calling, and that was really scary. I didn't know what was going on. And when he finally did call me back, he explained to me that if somebody was killed in action, they locked down all the computers, and all the phones, so that the family members back here couldn't find out from another source that a loved one had died. That made sense but it was hard to deal with, too, knowing somebody passed away.

I don't believe in war. My husband thinks that women should be able to serve in wars. I disagree, I think men start the wars, and they can finish them. I'm just so glad Levi is back and it's over. It's not over for all of the families, though, and I have to try and remember that.

Watching the news, for me, that didn't work so well, because it would just upset me more. I used to get up and have to have two cups of coffee and a half-hour of CNN before going to work. Every day. That was my routine. But then, all of a sudden, they're not talking about the war anymore! And then you're upset about that, too! I remember one time, I was watching Keith Olbermann's show, and he had that top ten

thing? Well, I thought, it would be on that, so I watched his show—the number one thing was something about Britney Spears! So, I got upset when I heard things about the war all the time, but then nobody talks about it, and then you're upset because they're talking about Britney Spears instead of the kids over there fighting for their lives.

When Levi came back, I offered him to live at my house, but he went and stayed at his sister's, and she told me a couple of weird things that he did. She said he got up and got his gun out in the middle of the night. . . . He wasn't the class clown anymore, he was more serious, and he was fighting. I think he was actually looking for fights. Because I think if you're not looking for fights, you don't get in that many of them. If you get into a fight every weekend, I think you're looking for them. And he was drinking. A lot. And cussing. A lot. Every night. I don't know. All the things I heard . . . I was kind of scared, to tell you the truth. I was almost as worried about him when he got back as I was when he was over there. For different reasons, but you can get killed in the United States in a bar fight just as well as you can get killed over there. West Terre Haute . . . I don't know how much of it you've seen. . . . When I was a little girl, my parents used to say, never go across the river! It's not as bad as it was during my parents' day, but it still has a bad reputation, for fighting and crime, and prejudice. That's a big one with me: I'm not very prejudiced. That was one of the reasons why I didn't want Levi to go live with his dad, because his dad was very prejudiced. One of the straw-that-breaks-the-camel's-back situations: I was having a Tupperware party one time, and a black girl lived across the street and we ended up being very good friends for years, I was gonna invite her. But Levi's dad said, "I'm not having her at my house!" I said, "well, yes, I am!" I mean, we had a pretty big fight because he didn't want a black person in his house. I just didn't want Levi to grow up with his dad in West Terre Haute because racism would just be an automatic thing. I wanted Levi to make those decisions for himself, not just be taught it. I think Levi says the n-word too much. Fuck is a cuss word. Nigger is a hate word. That's what I always taught my kids. I didn't want him to be a rac-

ist. And you know, in the Army, there's a lot of bigotry, and I think he was saying the n-word a lot when he was in the Army and just getting a bad attitude towards African Americans, and I don't really know why. But—it's been a couple of years now and he's way better. He got back to his old routine, maybe? Again, and I got off the subject a little, but as I was saying before, he was fifteen when his dad died, it changed him, but I'm not sure if it was because his dad died or the normal teenage rebellion. When he was eighteen, he automatically went in the Army, so as soon as he's back from the Army, he's changed again, and I'm hoping that was the Army, because now, he's changed again, and he's back to his old self. Levi, pre-Iraq, he was always real happy. It's just in his nature. I think he's back to being that. I can't wait to see what he's like as a dad! I mean, Conner is not his son, but have you seen him and Conner together? I think he'll be a good dad.

He's just went through so many changes, in a few short years. From sixteen to twenty-one, he went through dramatic highs and lows—losing his dad that he was so close with and then going off, killing people and seeing friends be killed. I can't imagine what that would have done to my life. I would like to know what Levi would have been like without these experiences. But that's his life.

I guess a couple of his commanders or sergeants or whatever really tried to get him to stay, they said he was officer material. But Levi says he doesn't like to be in charge of people. But I think a lot of his friends look up to him. Like, have you met Dave? Dave would call me when Levi was gone, he would hug me when we ran into each other. And he kept Levi's little ID card, he kept some of Levi's other stuff. They were really good friends. Yeah, he worried about him a lot, too. Dave was one of those kids who came to live at my house for a short time. Levi was always bringing home strays! He hung out with all the kids that had nothing, even their parents sometimes didn't take care of them. So they would come and live at my house for weeks, and sometimes months at a time. Their parents never called to check on them, never sent any money to help with food or anything.

Most of the kids who join the Army do it for a job and an income more than for serving their country. Levi—although

we don't have a lot of money, but we're not dirt poor—I think it was more out of a sense of patriotism on his part. And that's another thing that just upset me about the war: Even though Levi was home, we found out on Thanksgiving that he had to go back. It's because they didn't have enough people joining the Army at that time, because nobody wanted to go to war! It's not fair. I understand that the draft in Vietnam was awful but. . . . Oh, I hate to say it, but I do wish that there had been a draft for the Iraq war! So that the few poor kids that had to stay in the Army because they were afraid that they couldn't get another job didn't have to do four, five tours of duty. I mean, how many times can you go over there before something happens to you? I thought it was great that Levi did his part, he went over there and he served and he came home, and then somebody else should have went back the next time, in my opinion.

When they first went over there, there was this saying in the Army that if it's an AK, it's OK. What Levi said what that meant was if they saw an Iraqi person carrying an AK, it was OK to kill them. By the time his second tour was up and he was coming home, he was furious because our government was giving them AKs! I guess there were certain people that weren't harboring extremists and they were on kind of our side or whatever, and our government would give them guns and he said that our government would give them money to clean up their yards. He said from the beginning of his first tour to the beginning of his second tour, he went in gung-ho ready to do his job being a patriot and after his second tour he came home pissed because we were giving them guns and money! I mean, what did they tell the soldiers? That we were wrong the first time? Or that it's different now? It doesn't change that much that fast. It is a really messed up situation. I don't like to talk politics with people too much. It's just very touchy, it's like religion, but I'm definitely—for the sake of your article—I'm definitely a Democrat. I'm definitely anti-Bush. That guy was so out of control! Levi didn't feel that way his first tour, and again, I know it's the Army pumping him up, and I didn't want to tell him how naïve I thought he was being because, well, that's just rude for one thing, but

also I needed him to keep the bad-ass attitude. But yeah, it makes me mad that Bush would send my son over there. Oh, my husband was nervous for me, because I had a shirt that I wore, I wore it all the time, everywhere, and I know people looked at me, it said: "If the Iraq war is worth the cost, why aren't the Bush twins over there fighting?" I had a couple of other shirts that said "Proud of my soldier" and "Army Mom" bumper stickers on my Jeep, but then I also had "Anti-Bush"—I can't remember all the bumper stickers and what they said. I didn't talk politics with too many people but I let it be known by the signs in my yard, the shirts that I wore—I think my husband was afraid that I was gonna get my ass kicked. Indiana is a Republican state. We're in a bad place. We hate the politics around here.

I'm just glad that we live in the times that we do, because I was thinking about the soldiers in World War II or Vietnam. Like, Levi, his second tour, we all thought he was home! He was calling Angel every day, and talking to us on Facebook.

It totally ruined our Thanksgiving. I had a package that came in the mail, and I didn't even know what it was and I'd had it for probably two or three weeks, and during dinner I said, hey, you got this in the mail, he opened it and it was his orders to go back. So we all sat around, trying not to cry on Thanksgiving. The three times I've seen him cry in his adult life, it all had to do with the Army.

TRISTAN

Luis Tristan, U.S. Army Infantry veteran, born 1979, from Brownsville, Texas

Jennifer, his wife
Ozzy, their dog

2008
Fort Hood, TX

Tristan is a quiet and serious person. He stands out among the group of friends as the oldest, most sensible soldier. Timmy and Tristan share an apartment and while Timmy's room mostly looks like a pigsty, Tristan's looks immaculate. His shades are always drawn because he says he doesn't like daylight. He likes to travel and is very open to foreign cuisine but eats fast food most of the time and usually comes home with a bag of take out from Taco Bell's or Wendy's. Whenever he has more than two days off, he drives seven hours south to Brownsville to see his wife and his family.

Tristan doesn't drink very often but when he does, he drinks until he passes out. When he's drunk, he talks about very personal, dark things in a matter-of-fact voice that lacks any kind of emotion. It sounds to me as if he's talking about somebody else's life, not his—as if he was watching all these feelings happening to him without really being able to feel them.

I grew up in Brownsville, Texas, which is the very south tip of Texas right at the border of Mexico, in the countryside. I wasn't really into the whole city life. Both my parents were born in Mexico but they moved up here to the States. They now have a mutual agreement: They're divorced but they're still living together for the kids' sake, because the kids don't know. But the divorce is final. I'm the oldest of five, and I'm the only one who knows. So I got all that to deal with, too.

During high school, I stayed away from drugs—I was your typical jock, I played football, I ran track. I socialized with everybody, there wasn't anybody that I didn't get along with growing up.

Initially, my plan was: Join the military, kind of get a feel of what I want to do later on, and now it's been five years, and I'm pretty positive I want out. Our opinions have changed since I joined. When I initially enlisted, I was all, hey, we just

got attacked, we all need to do our duty, and throughout the years, it's become more like, OK, some of these things that we're doing now are wrong. When I joined I felt patriotic.

I'm gonna vote for Obama in the upcoming elections because I don't think this country is ready for a female president. Hillary doesn't have the experience, you know, she claims she's about the experience because she's lived in the White House and her husband was a president, but that doesn't mean she knows jack about running a country. Obama pretty much seems like he's heading on the right track. He's got some good plans for the economy. It'll be interesting! I've always voted democratic and my decision to vote for Obama has nothing to do with my war experiences or being in the Army. Plus, I would definitely not vote for McCain. He might be a war veteran and all that but he's planning on keeping us in Iraq for a while. So fuck McCain.

After I graduated from basic training, I went to Korea. That was my first duty station. I chose to go there, because the whole, you know, "go to the Army, go see the world" and stuff, so I was like, hey, they gave me an option to go to Korea and I took it. I had a blast in Korea. I had a blast! I didn't stay around the post like a lot of the other guys did, because around the post you have your bars and clubs and stuff, it's pretty much like an American town and that's where everybody used to get in trouble. So what I did, I'd actually go down to Seoul, the actual big city part, and see everything else. We were told to stay away from the universities and certain areas, but I broke those rules, and I hung out at a lot of universities and met a lot of cool people. I was in Korea for a year, right out of basic training. If I could have extended, I would have extended it to have more time, that's how much fun it was.

When I came back, I got sent to Fort Hood and I was only in Fort Hood for two weeks before deploying to Iraq. That was a shocker because I was actually supposed to be given six months stability time to get all of my things together, but they were like, no, you're Infantry, we need you to go to Iraq with 1st CAV division. And I was like, wow. I was pretty...well, not upset, just a little shocked that it happened so fast. But,

you know, I was ready, all that training I was doing in Korea, to actually start applying it and doing my job.... So it turned out well.

I can't remember if I was scared to go to Iraq. I mean, I had the butterflies in my stomach, and I didn't really know what to expect, but eventually you just learn as you go. That's all there really is. There's no set training out there that will prepare you for it. When you go to Iraq, that's where you're learning. Learning by doing.

The second time I was in Iraq was completely different—of course we've been fighting with them for the past four years. In four years, they're gonna learn how to fight us and they're picking up a lot of things, a lot of new techniques, they're learning just like we're learning. And they're building bigger bombs, they know how to hide better now. We're each evolving to each other's tactics.

Iraq has definitely changed me so much. Everybody has noticed the change in me since I've come back: my wife, my family.... After the first deployment, I had my typical symptoms, you know, PTSD, trouble sleeping, trouble concentrating, I had anxiety attacks, I became claustrophobic. I became claustrophobic because we were in a Bradley, and one of the tracks broke. Next thing you know it's swinging left and right and all of a sudden: BOOM, it flips on its side and we're stuck inside there for, like, a good thirty minutes in the dark, it's hot, everybody's all crammed up, I got stuff all over me, and I'm beginning to freak out. And ever since that accident, I can't be inside enclosed areas. That's why for about two years, they had me as the company armor—I had a desk job, basically. I was a liability—which is OK, hey, I have no problem with it. But now they're putting me back on the ground again and it's causing problems.

The PTSD symptoms also include wanting to hurt yourself or other people. There's no way I'm gonna hurt myself, but there's possibilities of me hurting other people if they push the wrong buttons. That's there and that's always been there. I control it, but you know, if somebody really tempted me, yeah, things could get bad. I premeditate attacks on people that piss me off and it's scary! Sometimes I really feel

the itch to kill again. I'm pretty positive a lot of guys feel the same way, too. They don't say it unless they're in a confined area, because, it's kind of, you know, serious and a private kind of conversation. A lot of guys have that itch. They need to feel that rush of taking somebody's life. It's like a high. It wasn't my first kill, but it must have been, like, my third or my fourth.... It wasn't with a weapon, it was with a knife. I was actually enjoying it when I stabbed him—watching the life exit his body. It's just something that you gotta experience. It has something to do with the way that we are trained. Always: "Kill, kill, kill!" One of the mottos that we yell out when we are in training: "What makes the grass grow? Blood, blood, blood!" There's actually a mosque here somewhere in Killeen. There's a few of us guys that are thinking about blowing it up. During prayer time.

You can't come back and lead a normal life. After two deployments, it's, like, we can't shut off. I'm holding back a lot of things, like hurting people, and after constantly being out on alert, you gotta be aware of all your surroundings, you can't just shut it off. The wife sees that, everybody else sees that, they notice it from each other, and they just can't relax. Any little sound that sounds like a gun fire, or a mortar, you will jump. It'll never go away. They can give us as much meds as possible, they still haven't figured it out. They probably will never have a cure for PTSD.

After my first tour, I didn't talk to anybody, any counselors, about the PTSD, because our leadership was like, oh, give it some time, it'll go away. It never really did go away from me, so all I did was bottle it up. I just kept it to myself. After the first tour. The second tour, I really didn't have a problem with it because of course I had a desk job and then eventually, they said, it's time to go back down to the line. That's when I was like, OK, it's time to start facing my little fears again, the claustrophobia, etc., that's when I had to start taking medication and went to see a psychologist. And they said, yeah, you got the symptoms of PTSD, we're gonna go ahead and start the paperwork for you and diagnose you with it.

The company will automatically start casting you aside, once they see that, oh, you're going crazy, you're not tough enough.... It happens. Every single guy that I've seen, seeking

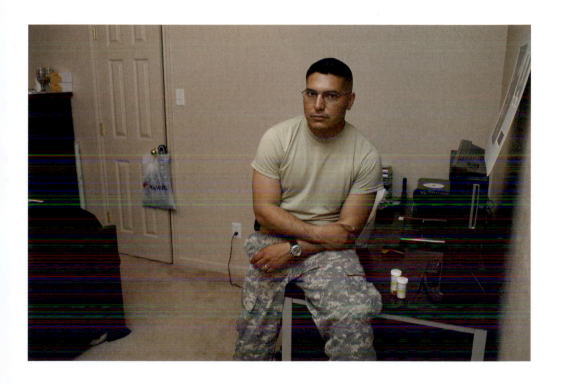

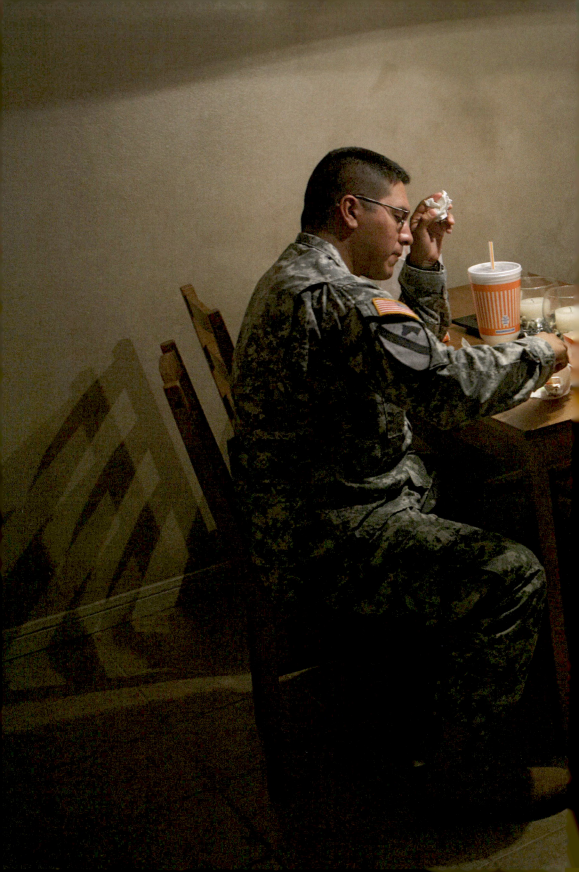

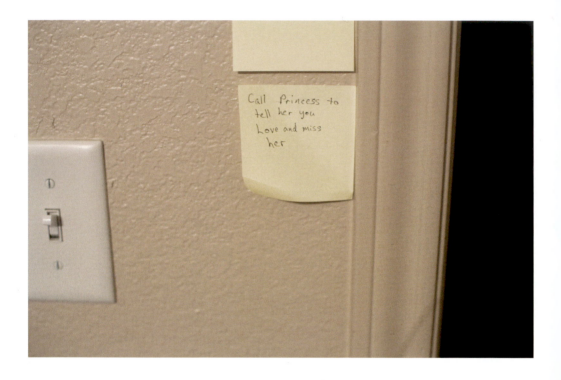

Luis Tristan

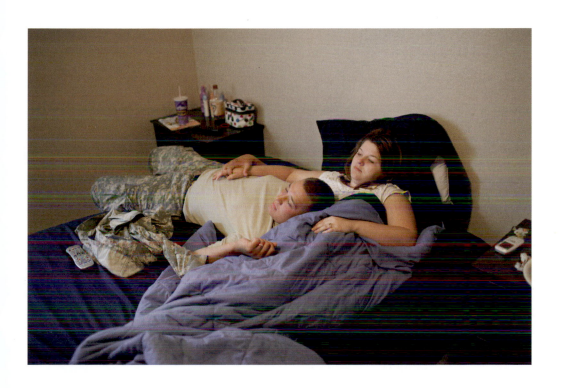

2008 — Fort Hood, TX

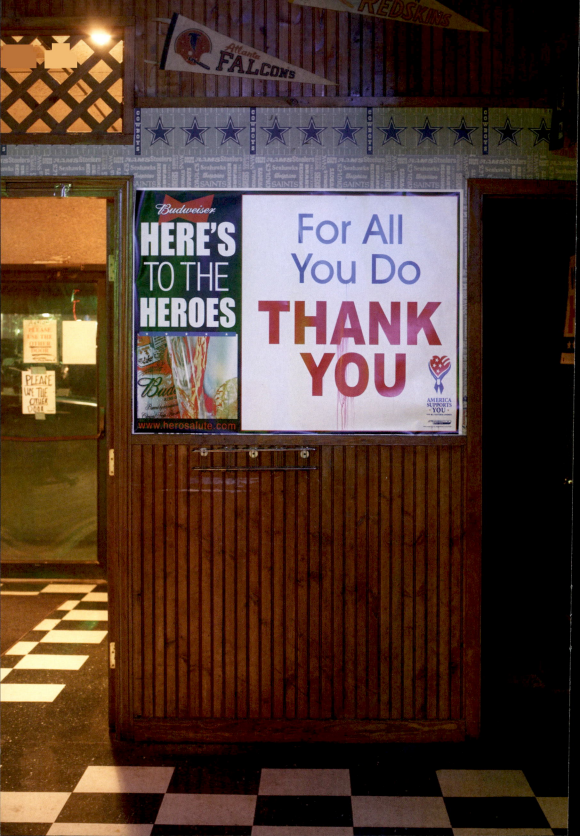

help, he'll get cast out. Just kind of brushed off. I guess now it's improving a little bit. The company is actually doing their part of helping you out. That's why I decided to finally ask for help. Plus the wife, she's the one who was like, hey, you need to get help, so . . . I don't want to be crazy for the rest of my life. Medication helps, though. It does. I'm on Zoloft and Klonopin. The Klonopin is helping, the Zoloft isn't. The Klonopin mellows me out.

The Bradley incident was one thing that helped cause the PTSD, being enclosed in that little small compartment for a long time. Oh my God. . . . Some of the accidents that we got into involved innocent people and other vehicles. We were in a vehicle in the back seat, one of our Bradleys accidentally hit a van full of women and children and when we got out to survey the area there were just body parts everywhere. Pieces were just torn apart. Another incident involved a shooting, a car, that we thought was implanting an IED, but really, somebody made a mistake, and we ended up shooting this guy's brother, and it was pretty bad. It was pretty bad.

I kind of lost count of how many people I've killed. You know, you count to the first five and stuff like that, but after a while, it's just, like, OK, there's no reason to be keeping count at all . . . I didn't really feel bad about killing because that person was either gonna kill me or I was killing him, so it was self-defense. I don't have nightmares about that. What I do have nightmares about, though, is some of the guys we lost, some of the scenarios that they were in. I have dreams, like, oh, I need to get to them, save them. Those are recurring dreams, constantly. At least twice a week. I don't wake up screaming or sweating, but I get up in a jolt, looking around trying to see where I am at.

My psychologists asked me exactly what kind of symptoms have been recurring. One of them is, I had to write little notes down, because I've got short term memory loss. I can't concentrate, you tell me something, five minutes later, I'll be like, I can't remember you saying that. Anxiety: I don't like being within a group of people that are just crowding me, like a lot of people, that starts freaking me out. If I eat at restaurants, I don't like my back to the door so I can see people

coming in constantly. Road rage—I got a lot of anger. My wife and I recently just started talking about PTSD because I told her that I'm seeking counseling now, that I got medication and stuff. She didn't really know the extent, you know, the seriousness of it, until I started telling her some of the things that happened down there, and now she's actually scared. Of me. Like, me possibly hurting her. We've only been married for two years, but we've known each other for ten years. Our relationship is stable, but she fears that any little incident might cause a divorce. She doesn't wanna be there when I flip out. I haven't snapped in a long time. I've been able to control it. But like I said, it's all being bottled up. I don't know when I'm gonna explode.

I would like to continue my career in the military, continue getting help, I want to change my MOS into something less stressful, a desk job, that I can do. But as far as deployments go, there's no way I can do another deployment. Not even as a fobbit. Mentally, I'm done. I wouldn't go AWOL if they sent me back, but they would not get me on that plane. I mean, I'll still be reporting to work—they can't consider you AWOL if you're still reporting to work—but you're not gonna get me on that plane.

What I like about the Army is the group of guys that I met along the way. There's some really good guys that I met along the way, who support you, who got your back constantly, and that, I would never trade. That's one thing I love about the Army. One thing I hate about it is how there is so much red tape, so many obstacles you gotta go through to get certain things done. Our job, as an Infantry soldier, is: Go out there, destroy the enemy, and leave it at that. When we're in Iraq, we gotta get special permission now before we actually kill somebody. A certain kind of routine we gotta take, like, oh, he's got a weapon, if he's got a weapon, he's gotta be pointing it at you, if he's pointing at you, you gotta shout at him. You gotta give him a warning, you know, shout at him: "Put it down!" If he doesn't, then you give him a warning shot, you don't shoot him, just a warning shot. If that doesn't work, then you can take him out. But there's like three different things you gotta do before you can take him out. That makes

it more dangerous for us. All these rules of engagement that they make us follow, you know, the Geneva convention rules: The insurgents don't follow those rules at all. Why should we?

Right now, I'm disappointed in the Army. Yes, I am. The way the leadership is going. . . . They're not promoting people that should be getting promoted. They're just filling in the gaps. A lot of people are leaving, so they have no choice but to promote people that are not competent enough to lead these brand new soldiers. Another thing: Our supplies, you know, we go to war, we don't have the right equipment out there, proper gear that we need to fight the enemy. I guess it's budget cuts or something so it's, like, way out of our control, but that's another thing that I don't like. The times that we spend away from our families—I've been in the military for five years. Out of those five years, I've been deployed three times, Korea and twice to Iraq, so I've only really been home for two years, and then of course that one year was in basic training. So I'm hardly ever home. The longest I have seen my wife, at one period of time, was a month. That was when I came back from Iraq in January 2008. That was the longest—one month straight.

If I don't finish off the military, as a career, I'm gonna go back to school. My wife is gonna get her master's degree. She wants to go back to school also. I want to study business and accounting, open up my own firm, go that route. I'm planning on living in San Antonio because that's where we used to live for a couple of years. The wife and I just love it there. No plans on kids yet. Tops may be one child. But that's not gonna happen until our mid-thirties.

A few days after our conversation, Tristan went to triage and talked to a counselor about his symptoms because he felt more depressed and anxious and didn't think that the medication was helping him at all.

My whole plan right now is to get into WTU. I'm not really too sure exactly what's involved with the WTU, but I guess that's the path that I'm going right now. I'm not getting any better. All the symptoms are just getting worse. The counselor

I just spoke to right now really didn't give me much advice to work with, it's not what I expected. I need help, you know? He just recommended, oh, hey, you can do these little exercises here and there and then we'll take it from there on. I was like, that's it? And now I'm just disappointed.

2012
San Antonio, TX

Tristan and Jennifer rent a big, two-story house in a quiet middle class area in the suburbs of San Antonio. Friendly neighbors have yard sales, kids play basketball at dusk, and cats roam around once the air cools down at night. There's a hiking and biking trail nearby. The couple owns an English bulldog, Sir Ozzy Studd Muffin. Jennifer calls Ozzy her "baby," and they refer to each other as mom and dad when they talk to him. During Christmas and Halloween, they dress him up for family photos. "Yes, we're pet owners who treat their dog like a child," Tristan freely admits.

After Tristan's discharge from the military, they moved to San Antonio because "there's always something to do here and it never gets boring." It's also close to Brownsville where their families live. They tell me that their house is too big for them, though, and that they're looking for a smaller place, a duplex or maybe an apartment. Even though it's hot and bright outside—with the sun blasting—they live in a state of perpetual twilight and cool A/C air. The TV is always on.

Jennifer works as a science teacher at a local high school; Tristan goes to college full-time and works part-time as a day trader. The three of us talk a lot about American politics and discuss our brilliant left-wing, liberal ideas (or "socialist," as the Americans tend to call them). Even though Tristan and Jennifer lead a solitary life, they don't seem lonely. The people they're closest to are their families.

Tristan usually wakes up at 5 a.m., showers, shaves, irons his clothes for the day, and feeds Ozzy. Then he stops for breakfast on his way to school and buys a Trenta ice coffee to go at Starbucks. He arrives at his local community college early, diligently goes over the material for his next class and checks his phone to see what's happening on the stock market. Throughout the day, he carefully balances a diet of sugar, caffeine, and

Ambien. He often complains that the meds he recently started taking make him feel groggy and nauseous.

Again, Tristan stands out among his classmates as one of the more sensible and serious students. In class, he remains quiet, but attentive. His macro-economics professor, who fought in the Vietnam war, observes: "What veterans have in common is that they wait and listen to what's going on. When their time comes to respond, they'll respond. But they don't volunteer. I guess they've volunteered one time, they don't want to do it anymore!"

At one point during my visit, Tristan recruits some of his peers to come over to his house for a study session—he lures them with gourmet brick-oven pizza. In the run-up to their visit, he explains his plan to me in almost a military fashion, down to the minute: Get sodas at the store, clear off the living room table, worry about whether or not Ozzy will behave, pick up the pizzas and re-heat them so that everything is ready by exactly 2 p.m. As only one of the three students shows up, he's disappointed. "I was excited to have people over," he says.

Something that has always intrigued me is that Tristan seems like such a normal guy. There is nothing abrasive in his behavior, he is always friendly and calm. What he tells me in our interviews starkly contradicts everything I see. However, after a while I notice how controlled he is, how much he keeps himself in check: Nothing in his daily life is unplanned or spontaneous.

In his relationship with Jennifer, he overcompensates for his PTSD shortcomings, and as a consequence he's very courteous and doting towards her, always opens the car door for her, and addresses her as "love." He surprises her with cupcakes and buys her favorite sushi rolls from the grocery store. At one point, while we were having dinner in a restaurant, Jennifer mentions that she's feeling a bit chilly so Tristan walks to the parking lot to find a sweater for her in the car. While he's gone, I comment on how sweet of him I think that is. She says that it's all just part of keeping up his façade. "He wants me to think that everything's OK," she says. She doesn't trust him. I start wondering to what extent my presence alters his behavior.

On the eve of my departure, as Jennifer and I sit in the car outside a Burger King, waiting for Tristan who's inside order-

ing, she turns to me and asks: "Why can't every week be like this? He hasn't freaked out once. He hasn't snapped at me, he's been calm and patient."

When I arrive, they are making plans to visit a farmers' market the next day, and explain to me that, because they're both so busy during the week, they really enjoy spending time together on the weekends. I think to myself, I've never seen a happier couple! The next day, when I spend time with them, they open up a bit more and talk to me about the incident when their dog Ozzy bit Tristan, in December 2011.

Tristan: There was an incident where I was trying to put Ozzy away because he was misbehaving. I approached him calmly, and I tried to wrap my arm around him—I guess he must have sensed that I was upset with him. He grabbed me and bit me. Jennifer says I lifted him up from the harness and tossed him across the living room floor—I can't really remember because it's all a blur. It was pretty bad, though. Of course, she was freaking out, she was crying....

Jennifer: Because he didn't approach him calmly! He approached him aggressively. He got up, with a certain kind of assertiveness, and abruptly went towards him—he snatched him and tried to grab him and of course, Ozzy would behave offensively. That's when he snarled at him and got a hold of his arm—he got in there pretty deep. Luis picked him up out of anger and flung him across the room—he didn't hit the floor, he hit the wall! *(She points to the wall that is probably about two meters away.)* Luis said to me, "You need to put him away!" I asked, "What happened to you? Who does that? What's wrong with you?" He's like, "Nothing! I didn't do anything!" It was a pretty deep gash and we had to get it looked at. I was like, fine, I gotta take care of you.

Tristan: I initially got Ozzy because my psychiatrist in Fort Hood mentioned that a dog would probably calm me down. Ozzy is much closer to Jenny because he senses my aggressiveness. That incident made me realize that I need to find a way to control my anger. It was the last straw....

Jennifer: There were other little things. He doesn't see or think.... Like, I have to point out to him that this is not how people react. He'll admit to his road rage thing—simple little

things, like, someone not using their blinker, cutting him off, not finding a parking space within two seconds: I have to tell him, relax! I can't take you anywhere! Because I don't know how he's going to behave. Last weekend, we had to go do some errands and I was surprised that he actually went to do all of them with me. We went to the store and three or four other places. Usually, the maximum is two.

Tristan: I just get aggravated.

Jennifer: Like a toddler, when they get fuzzy.

Tristan: Sometimes it's just the people — they're just so materialistic, I guess.

Jennifer: Says the person who's wearing a Burberry shirt!

Tristan: I hear their problems and stuff, but compared to what I've been through, they really shouldn't complain about anything. Another incident was when we were trying to find a parking spot in front of Whole Foods in Austin—this was when we were still living in Killeen—and finally we found one where a couple was getting out of a spot. I was like, let me go ahead and wait for this vehicle to come out. There wasn't enough space in the parking garage for the other cars to go around, so there were at least two or three other cars behind us. Well, this couple was taking their sweet-ass time to get out. One car behind me was getting impatient and started honking his horn. I was like, OK. I'll let the first one go. Then he honked again, the second time. I let the second one go. The third one, I've had enough: I tried to get out, but my sandal got caught on the door, so I couldn't get out. The fourth one....

Jennifer: It was the third one!

Tristan: Was it three? Anyway, after the last honk, I open the door and go up to the car right behind me. There was a girl in there, she rolled up her window and I yelled at her: "Are you honking?" She shook her head and pointed to the car behind her. It was an older gentleman. I go over there and scream: "What's your fucking problem? I'm trying to get into this spot right here, is that OK with you?" He nods, yes, yes, so I go back to the car. Jennifer was like, I can't believe you did that!

Jennifer: I was appalled. That was the first time I'd seen it. In the back of my head, with everything he says, I knew

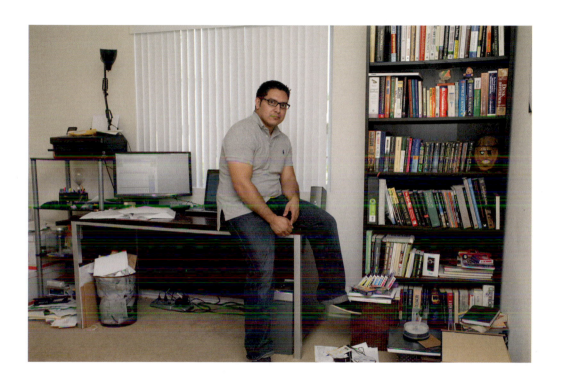

2012 — San Antonio, TX

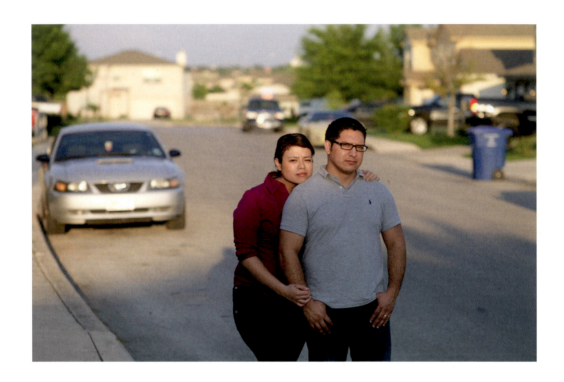

Luis Tristan

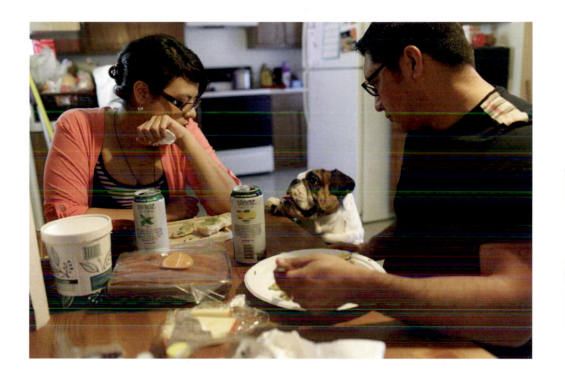

2012 — San Antonio, TX

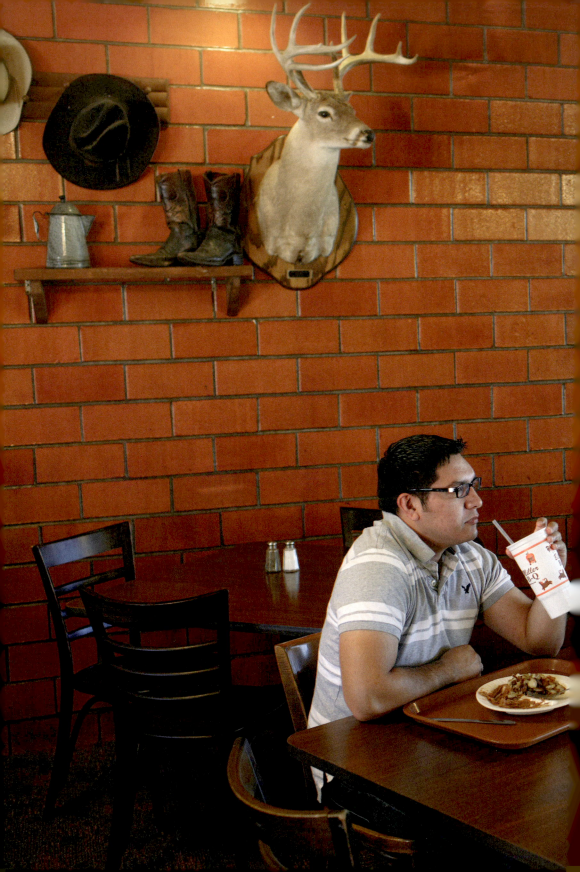

Luis Tristan

2012 — San Antonio, TX

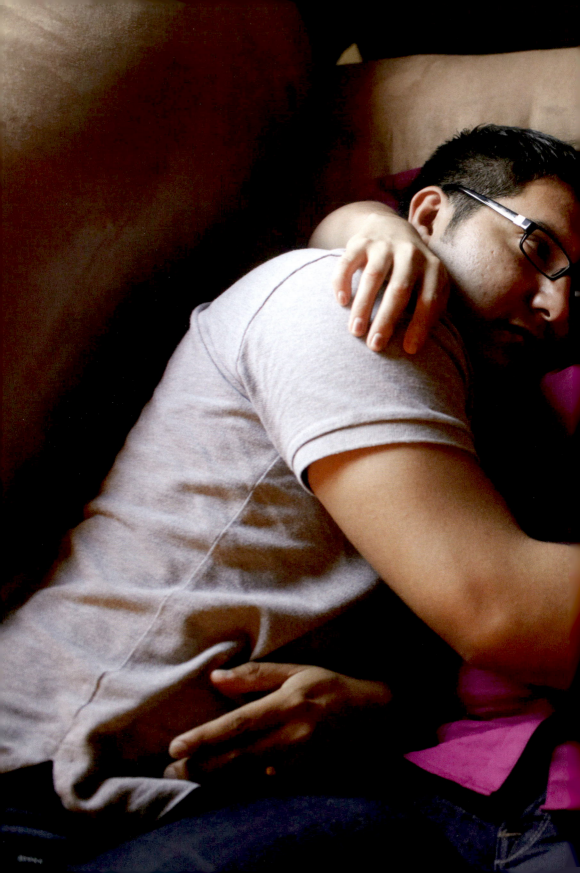

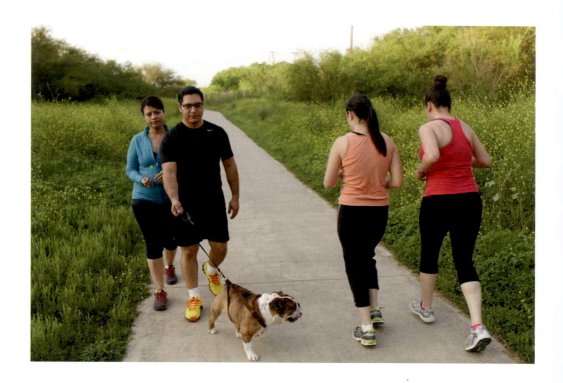

Luis Tristan

2012 — San Antonio, TX

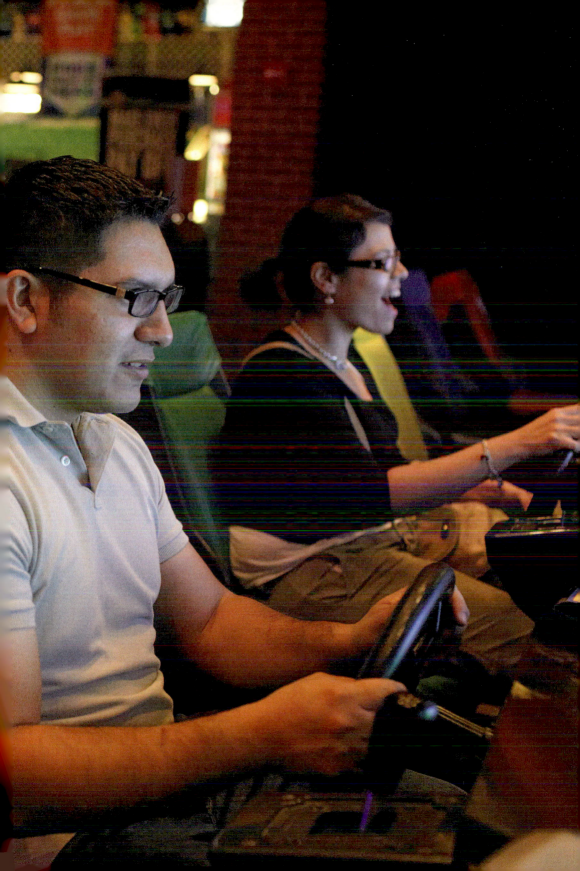

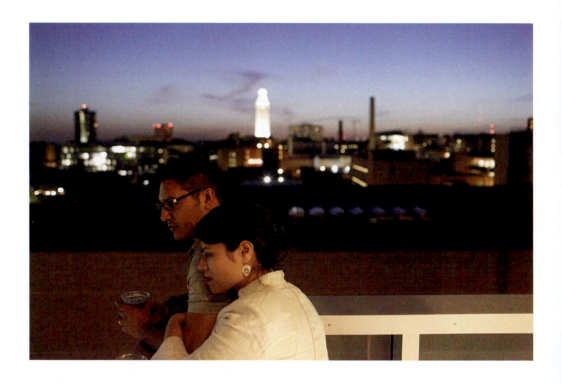

Luis Tristan

he could flip the switch anytime. I just couldn't talk to him. I told him, I don't want to speak to you—get away from me. You need to go find that person and apologize. Because that's just crazy. People don't react like that.

Tristan: I found the guy and apologized. Initially he looked a little tense when I approached him. . . .

Jennifer: When we were going in, he gave us the finger.

Tristan: I did feel a little bad about that. But I also told Jennifer, I can't believe you made me apologize to him.

Jennifer: It's the least you can do! But there are other little things where he overreacts to stuff that other normal people don't. I'm just so opposite of that. I'm just like, whatever . . . I asked him, what if I reacted like that? You would totally flip out! Someone would get hurt. I can see it in his face when he gets antsy or fed up with something. Then I'm like, fine, let's just go. Let's just not do this, whatever it was we were gonna do, and let's just go home. And then he gets upset about that!

Tristan: Usually, whenever we go out, we're supposed to go out to only one or two places. But then she adds on a few things—and I say, well, that wasn't on the schedule! I didn't plan for that! From the military, we're supposed to adapt to new situations, but. . . .

Jennifer: Luis has got an issue with time—we're not on the same page there. He's got to get from A to B in the shortest, most effective amount of time. People blocking the aisles and just standing around aggravate him. I always have to plan everything, whether or not something is in the vicinity—it's like walking on eggshells. I've read that, too, in books about PTSD. I've told him before, if I wasn't here, I can only imagine some of the things that you would do! You would be just like one of those guys that shoot up cars or something like that. He wouldn't have gotten that far in school, I don't think. But he's, like, no. Other veterans probably don't have someone. They were married and then divorced. . . .

Tristan: I'm seeing now that if she wasn't around, I would have probably lasted . . . two semesters at school?

Jennifer: The first year was just a lot of stress for him and finding a balance between marriage and school.

Tristan: Just now, I think we're beginning to find a happy medium, I guess—finding time to go walk on the trail. . . .

Jennifer: I would ask him, how come you're not spending a lot of time on your homework? Because when I was in school, that was what I did—I'd spend hours and hours late at night, studying and getting very little sleep. But he needs his sleep, otherwise he'll get cranky. So he needs to spend most of his day doing school work and then the other stuff. I don't know if it was because he felt I needed attention—I've never said anything about needing you after work! I would ask him sometimes, can we go do this, or that? But you can tell me no! You can say, I can't! I need to study. He wouldn't. I didn't get why.

Tristan: I would just feel bad not being able to spend time with you. And she's not used to me saying no, either.

Jennifer: I'm still gonna feel whatever it is I'm gonna feel and tell you, but that doesn't mean that it's not OK. We had several little discussions about it. I don't know which part of that is the marriage part, and which part is his PTSD stuff. And when you mesh that together, it's just a mess.

Tristan: I destroyed an iPhone once. Jennifer would always ask me about stuff about it, like, why is this deleted? What does this do? And eventually, I lost my mind and yelled: "You know what?"

Jennifer: Because he was keeping things from me. I mean, there's more background to all that. We're married and he doesn't see right or wrong. Like, as a husband, I shouldn't do this: If I'm your wife, I'm not gonna go to a bar and hit on other guys in front of you. That's just an example—he's never actually done that. I didn't even accuse him, I was talking to him in a quiet tone, but he didn't want to talk about it. He didn't want to have that conversation. So all of a sudden, he goes and comes back with a sledgehammer . . . you could only see—in those seconds—what was going through my mind! He goes into the garage and smashed his cell phone.

Tristan: It was beautiful! I remember the sparks and the smell—the iPhone caught on fire! As I was hitting it, there was smoke coming out of it. . . .

Jennifer: The iPhone he wanted forever. That's the extreme he had to go to instead of having a conversation. I know he's perfectly capable of reacting irrationally.

Tristan: I have yet to be put in a situation in which my limits are really pushed.

Jennifer: Imagine if something worse could happen, you hurt somebody else or you do something, then all of this is gone: You won't have school, or me, or Ozzy.

Jennifer and I go upstairs to talk privately.

Jennifer: In Killeen, at first, it was weird, because there were other people living in the house—besides Nike, there was Nick Martinez and his wife—that was certainly interesting. But I would never see them, I would be gone all day and in the evening, we would just do our own thing. It was an adjustment, because there was all this stuff that I knew he wasn't telling me, that I knew about, but he wouldn't talk about, and he had this kind of façade and it was just so unnerving. I didn't get it. I didn't get his whole military thing—he wouldn't talk about work, he wouldn't talk about the stuff he did over there. There were little things that he told me but most of the stuff, he said, he didn't want to scare me with. I could only imagine the worst.

It was weird because the whole time I was in Killeen it didn't really feel like a home to me. When I left Brownsville, I liked the school that I taught at, I was living with my family... I was fine. So when I moved to Killeen, there was a lot of his PTSD stuff, and there was the whole new marriage thing that we were working at. He just wants it to be, like, not work. For me, it's a simple formula. But for him, it's either school, or being married. He would make it sound like he could only focus on one thing at a time. When we moved here, in the beginning, he was very stressed out all the time, and to me, I was like, you're just going to school! You're not working, and you're getting home early!

Basically, it's just been sort of mellow since that accident with Ozzy. But I had been telling him that, since we left Killeen, as soon as we get here, you need to see somebody. You need to find a therapist to talk to. Because I don't know if it gets better or if it goes away.

He doesn't talk about things with me and that's why I told him, you need to find someone to talk to about all this. Only

when it got really bad he would say certain things, but then
he would say, I can't talk to you about these things. Holy crap!
I'm your wife! Who else are you gonna talk to? There were
other things, like, he was making inappropriate comments on
Facebook—not to other people, but in general. Things that
people would say if they're upset. I don't understand because
I don't behave like that. I've never gotten into a verbal con-
frontation with anyone, ever. To me, that's not normal.

I didn't really think about him being in the military when we
got married because I don't think war was even a thing. He
had gone to Korea and after that, he had one deployment to
Iraq. Then we got married, but we had always had a long-
distance relationship and I'm not the type that needs that
constant thing all the time—so it worked for me. We would
write a lot of emails. That was enough for me because I was
busy doing other things. I was doing schools and at night,
I was teaching at universities. I think that helped. I know
there are other military families where the wife just stays
home with the kids all the time—not me.

When he first came to me and said he had PTSD, I asked
him: "How long have you known?" He had already done a
tour in Korea, and one in Iraq, and then we were married and
I'm thinking here, you didn't talk to me about this before! It
felt to me like he had let it go for long enough and that he
had to tell me. He already knew before we were married.
That's how I had interpreted it. Not knowing about that
and just hearing stuff on the news about PTSD and soldiers'
aggressive behaviors, and him not telling me much about it,
I remember just having all these questions: What does that
mean? What is the extent of it? How severe is it? It's a con-
stant thing. He says, I don't like talking about my feelings.
What feelings? I'm just asking you a simple question! I could
totally see him doing things . . . taking off to California with-
out telling anyone, you know, like Nike.

When I moved to Killeen, he was still drinking and it was
bad—from what he told me he said he was no better than
any of the other soldiers. There are things that he does that
he doesn't even acknowledge, that he just brushes over and
says, I don't want to talk about it, I just want to forget about

it. And that affects our marriage, too. That's why I asked him before this interview, "What is it that you don't want me to talk about?" There's a certain way that he wants to be perceived and so he puts on this façade on the outside. We even saw it when you were here yesterday: Ozzy was getting a bit wild, but Luis stayed very calm—that's not how he would have behaved normally. He would have been more aggressive and loud.

I asked him, "Should I be scared of you?" He said, "No, I would never do anything to hurt you." That's what they all say to make you feel comfortable. So when he reacts the way he reacts—I know he's capable of flipping out. I don't know what I would have to say or do for him to flip out. But you heard the story with Ozzy—and he loves him! So who knows. I don't get scared because if it's gonna happen it's gonna happen. There's nothing I could do to prevent it. If he was gonna do something to me, he's gonna do something.

He does little things—I have this thing about not being home alone. I just don't like it because it gives me anxiety. What he likes to do is scare me: He'll turn off all the lights and I'll hear noises and it's him, or if I'm taking a shower, come out, and I would see him, just standing there. I'd ask him, why do you do that? He says, because he likes it. That's not good. One time in Killeen, he told me about this elaborate thing. He was going to tear the screen out in the window, and have the window open and the door open and then start making noises in the garage and have the door open and.... Who does that? Just to scare me! Just to get a reaction, a rise. That's just not right. He's dark like that.

I started reading about PTSD before moving to Killeen, when he told me about it, because I can't talk to him about my end. Whenever he does things that are inappropriate, I don't know if they are a result of his PTSD . . . he doesn't know and he doesn't say. He wouldn't talk to anyone about it. I had asked him to see a psychiatrist—he needs to fix this. I don't know if it's fixable, but he needs to treat it. He replied, I don't have time, with school. Well, then, this isn't gonna work if you're not going to try and you don't think that you have a problem! He doesn't realize that it's an ongoing thing. It's not

like a rash that comes and goes: It's an everyday thing that he has to deal with. It's definitely been a strain on our marriage. Whenever we're in an argument, we don't yell at each other. He's said mean things... I'm very aware and very cautious about the things that come out of my mouth because you can't take those back. For me, when he says something, it plays back—I've tried to explain it to him but he doesn't understand. It's hard trying to find a balance between... is his PTSD affecting the way he is or is it just him? That's probably why I've stuck around. But there's been times when I did have to take a break. We've talked about divorce, several times. But it was funny, because we were both, like, so, what do you want to do? I don't know, what do you want to do? I just don't want to pack.... If I wasn't married to him, I probably wouldn't be married at all. Dating is just such a headache. I told him, you were work! You're, like, an investment, and you throw PTSD in there, and it makes things even more difficult. He has such a short flexibility level—but we try and do things together.

I told him, you know what? If I went down to the VA office, I bet I could find you a therapist because this is ridiculous! He was telling me: I've already made an inquiry, I've already talked to the VA, and I haven't had any response from them. And part of me thinks that he didn't. That he was just telling me that he did, just to.... But I don't want to make a big deal out of it.

Even though he's only been on medication for the last couple of days, he's a little more mellow. I remember, though, when we were in Killeen and he was on medication, I was kind of on the fence because he didn't seem like himself. His personality didn't come out. He was very dry. Kind of how he is now. Monotone and dry. Over a long period of time. I said, "I don't know if I like you on this!" So indifferent. It was aggravating to me. That's how I feel how he acts sometimes, and it's unnerving because I don't know how to take that, his indifference. Because when I say, it hurt me when you said this, he's very cold. Even without medication. I think it's one of those things where any person might have that in them, and you put them in a situation—the war—where they can act out on things. Situations where someone is like, oh,

I could just...then you put them in that scenario, and they can just act out. That completely changes you. That's why he has such a hard time with people and their stupidity, and has such a short fuse. He'll fixate on it and feel angry about it. I ask him: "Why do you do that to yourself? It will just make you feel worse, just let it go." It makes me antsy and rushed, too. Today was a good example when we were at the store: I was looking for something but I was keeping track of the time to see how long it would take. I was thinking, you guys were in the checkout and there was somebody in front of you. How long would it take them to pack things and for you guys to get to the car? So, even though I hadn't found my pins yet, I thought: I better go. He gets upset when he has to wait for me. He's not gonna say anything though, while you are here. So, I do things like that and I don't even think about it. The reason why we haven't gotten a divorce is because I'm so opposed to ending up like all these other military families. I'm like, no—that's not going to happen to us. It was me who mentioned divorce first, when we were in Killeen, after not even six months there. I had left Brownsville and I remember telling him in Killeen: You made me leave my family, leave my school, for this? I thought once we were out of Killeen, things would get better. But then, six months into living here in San Antonio, I ended up moving out. I was staying with a cousin of mine who lives here. It was convenient because it was my Christmas break.

I hate having this not knowing what's going to happen—I said, we have to fix this. It was bad, because he did something...very... (*Jennifer starts crying.*) I'm just going to forget about it. That's what he wants me to do. He did something bad—but I don't want to talk about it. I would tell him, "you haven't acknowledged that it was wrong. You just apologized." He says, "I know what I did was bad. I want to forget about it, and you keep reminding me." So, for the longest time, we had this thing where...it was uncomfortable. And, like I said, it's just been recently where it's been OK. But it's always something. I told him, "I think part of me would feel bad if something bad happened to you." When he tells me some of the things that his friends did or were doing or when

something bad happens in our relationship, I feel, like, I want to leave, this isn't going to work. That some point down the road, it's just going to be all this work and then: nothing. But then I think about: He wouldn't finish school, he would start drinking again, he wouldn't see a therapist—he would engage in all this behavior that's just negative and bad and he wouldn't have anyone to talk to.

You know, he has his parents but he doesn't tell them about the things that he's experienced. When we go home, we're a happy couple. That's the outside part. My sister-in-law notices, like, that I don't wear my wedding ring. I stopped wearing it when that happened. She noticed that I would go visit home, but he wouldn't come. I always say, he's got homework to do. But sometimes, it's, like, you need a break from that. I don't tell him that—you will have to phrase it in a different way! I told him that he gives me anxiety. Like, I don't know what to tell him and what not to tell him. And then I have to think about how to say something, putting it in the right words. Sometimes I just say, "OK, fine, be on medication!" When he's off meds, he's got more emotion. The medication just subdues that. I want to see that emotion, but it's frustrating at the same time.

He used to tell me, "I don't have time to get OK, it's just not a priority at the moment." But, see, I feel all the effects. He can just let it go because he's harder on the outside. We can't work on our marriage until you fix this. It's not rocket science. Now that he's on Ambien, he sometimes tells me stuff at night that he doesn't remember in the morning. Things he did, like, "we were at a bar and we did blah, blah, blah"... I'm like, interesting! You know I'm your wife, right? Sometimes he sees Smurfs playing by the bookshelf in the corner. He's had a couple of nights where he woke up screaming. And I ask him, "What was that all about?" Usually it's one of his nightmares from Iraq. On two occasions, I woke up and he had his arm on me, choking me. I was sleeping and kind of out of it, but I felt pressure on my throat and couldn't breathe right. When I woke up in the morning I asked him, "Were you choking me last night? I think you were!" The second time I definitely felt it. "What if you're sleeping and you acci-

Luis Tristan

dentally choked me!?" He said he would never hurt me. He was asleep and so he must have been dreaming something. He would always take several sleeping pills, before he was on Ambien, and they always took a while to kick in. They make you feel very awful in the morning, like you're still sleeping and trying to wake up. He would have to take so many and it wasn't good for him. One time, I had the flu and he took my cold medicine so he could go to sleep.

When I read the first interview that you did with Luis in 2008, I didn't like how he referred to me as "the wife." He told me about the article and I didn't read it until later and I was, kind of, like, what is that? It's like "the chair." Can you go park "the car"? I felt like he was referring to me as some sort of inanimate object. It sounded very disconnected and, for a long time, that's how we were.

I don't think he realizes how certain things sound to other people and how they would be interpreted. For him, it's OK. I never associate the way we are with what I read about PTSD. Whenever I read something, I think: That's horrible! But now that I hear myself, I think: Oh, that is just like that article I read in the paper the other day. I kind of have the same reaction like you, earlier: How can they still be married? When I was in Killeen, I kept thinking: Where is my hazard pay?

At one point while Tristan and I are driving to school, I mention a few of the points Jennifer has raised in her interview and how her life is affected tremendously by his PTSD. I tell him how much respect I have for her, trying to support him, sticking around. Statistics show that since the start of the wars in Afghanistan and Iraq, the divorce rate among military families has risen steadily. I'm so happy for them that they're defeating the odds. "If I didn't have Jennifer, I'd fall apart," he simply responds.

Tristan: When you last saw me, in 2008, I was in Rear Detachment with Nike, and it took what seemed like forever to process me out. While I was in Rear D, they didn't want to give us any job duties, you know, because we weren't stable, so they would just tell us to check in in the mornings, to make sure

that we're still alive, then come back at noon again to check in, then an evening check out—and that was it. If sometimes the NCOs were too busy during the day, they'd say, just give us a call or text us, saying that you're at your house, or whatever, but yeah . . . that was it. We didn't really do much. Once in a while, there would be a detail, like, go clean this Connex, or this office. Unfortunately, whenever we would see the counselors, it was only for about thirty minutes at a time and maybe once a month. There wasn't much progress as far as talking to them, face to face. All they would do is give us medication, and then ask us: "Did this work? Did that work? How are you feeling now? Well, let's up the dosage, there you go!" And then time was up and they had to see the next person. It seemed like they had a crap load of people they had to talk to. It's bad. The Army counselors are overwhelmed with the amount of people they have to see. I don't want to say that the medication they gave us helped, but at least it turned down the levels of anxiety and depression.

They finally finished my whole process in June 2010. Wait, it took them two years of processing me out of the military? Wow! I honestly didn't realize it was that long! We knew a couple of guys in Fort Hood who were that messed up that they got accepted into the WTU but the rest of us. . . . We just had to stay there in Rear D. In WTU, they held your hand, they took you everywhere. We didn't need that. Some of us did, though, because they would miss appointments or didn't take their medication and then they got sent to WTU.

I was still ranked a Specialist even though I was due for a promotion for a couple of years. And it wasn't until I finally got out-processed that they were like, OK, you're gonna get your E-5. So I retired as an E-5 which means more money for me through my disability. That's actually one good thing that they did. Finally, I'm a Sergeant! I think Nike retired a Sergeant, too.

I honestly don't recall what I did during these two years, because, as you know, my memory is shot. My memory is really bad. It's just a blur. I think I just sat around, played video games, and watched TV. I wanna say that's what I did. I felt like I was wasting time because it was just taking so

long for the process to finally go through when I could have been doing other stuff. I started taking online college courses for Homeland Security and emergency management, just to occupy myself.

Unfortunately, on my last day in the Army, there wasn't a ceremony. You go to the main building and you see a counselor there. All he does is sign your paperwork to clear you out, then you sign it, he opens up a box and hands you an American flag and a little retirement pin, shakes your hand and it's good-bye. Jennifer and I packed all our stuff: We were gone the next day.

I've got a 50 percent disability rating from the Army for PTSD. They tested me for traumatic brain injury, and it came back negative. But my new psychiatrist said that at that time the tests were still in their infant stages so I'd like to go back and get re-evaluated. Fifty percent is the minimum, but for me, it's pretty good. I got what I wanted. The maximum amount of time that I can be on this temporary retirement is six years. By then I'm hoping that the therapy sessions and the medication will have helped. I will be done with school and so I won't have to be collecting disability from the Army anymore. I don't want to depend on that at all. I'm also on social security disability, so I get a paycheck from that, and since I go to school full-time, the military takes care of the tuition and the books, but they also give me BAH, basic allowance for housing, which means that they pay my rent. So basically, I don't have to work at all. The way the GI bill works is that you fill out the paperwork at school and the school sends their bill directly to the VA—there's nothing that I have to pay upfront and get reimbursed or anything like that. When I initially joined the military, my GI bill was for 50,000 dollars, so I get that money to use. Whenever that money is used up, since I live in the state of Texas, they have a program that's called The Yellow Ribbon Program, and they pay tuition for disabled vets. I'm doing OK with school, I'm getting As and Bs—I don't like Bs at all, though—I've always been an A student so when I get a B, I start freaking out.

The stock market day trading actually started as a hobby during my first deployment in Iraq. I invested in Ford, I bought stocks out there and I made a good return on that. I

was like, wow, this is pretty easy! Let me actually learn what I'm doing! Other than that, I want to finish school and get a masters in accounting and maybe a minor in math—then get my PhD in economics and work for a major investment bank in New York City. I wouldn't mind being a CFO. Or maybe fix our economy. They won't like my ideas, though, because they are a little bit unorthodox: You can't lower the national debt without raising taxes. It's a must. We gotta cut back on our defense budget. There is no reason why we're spending billions of dollars on fighter jets when there's no other country in the world that can compare with what we have right now. Bill Maher once asked: Who are we gonna fight? The Transformers? Also, we need more money in education. Through Jennifer, I see just how badly we treat our school system. It's just horrible and very heartbreaking to see.

If we're gonna spend money on the defense budget, it should be diverted towards helping veterans who have PTSD and health issues. The Army is just now realizing, wow, everybody's coming back with issues. Have you heard about the Afghanistan massacre, Sgt. Robert Bales? I don't condone the killing of women and children, but a lot of people are asking: How could this happen? I'm like, how did this not happen sooner? Considering the strain that we have put on our soldiers with all these wars. And after the Quran burning with how the Taliban retaliated—they've killed, like, six NATO and U.S. soldiers in total—do they expect us to just sit back and do nothing? Robert Bales went on a personal vendetta against Afghanis, and honestly, I would have done the same thing, too, if I was out there. If they killed my buddy next to me or however many. Not women and children, no. But those that are protesting against the Quran burnings. They're just books! The protesters were throwing rocks at soldiers and suicide bombers were out there . . . it's bad.

Not too long ago, there was another incident where Marines were pictured urinating on dead bodies of insurgents. Those pictures started circulating on the internet and I think it was a group of five Marines that ended up being identified. What do you expect us to do? You send us out to war multiple times and we basically become animals. That's what we evolve to. We're supposed to be held to a higher

standard, we're professionals . . . no! We're not those guys that you see in movies. We're not heroes and we don't do the right thing all the time. War is ugly and it gets bad. Plus, I'm pretty sure that if we get captured by the enemy, they're gonna treat us just as bad. They cut off our heads on video. What we're doing is pretty mild compared to that. It's unfortunate that those five soldiers are being charged and kicked out of the military.

Bradley Manning, the guy who leaked all these Army documents to Wikileaks, he's treated worse now than how we treat our prisoners of war. He's deprived of being outside, he's confined to a really small cell—he's a U.S. soldier and automatically, as soon as that came out, he lost all his rights.

I don't harbor resentment against Muslims as much as I used to—I'm more accepting of religions now, whether they're Muslims or Catholics. As long as they don't try to shove their religion down my throat. I'm an atheist. I was raised Catholic but eventually I grew out of it. The bible is a good story—a man walking on water, turning water into wine—they're just magic tricks.

Just two days ago, I had my first counseling session with a psychiatrist since I've been discharged. My first session in two years. The reason why it didn't happen sooner is because I was lost in the system. When I got out, they told me that, as soon as I arrived here in San Antonio, to go ahead and go to the VA here and let them now that I'm a disabled vet and all that. I did that, and they gave me some paperwork to fill out. They told me that in December 2010, I would have to go through a re-evaluation with a counselor to see how I was doing. But they must have gotten my address wrong, because they were still shipping my stuff out to Fort Hood, and they must have done that at least twice. Because then eventually they sent a letter down home to Brownsville and they were requesting, like, hey, we need to get a hold of you, you need to update your address! It had already been a year and I was still waiting for my re-evaluation. I contacted them and they took my number down, my address—and I never heard back from them. It's ridiculous how horrible. . . . Eventually, I just gave up. I got tired of having to go to them and being, like, hey! Help me out here! Do something for me! I can't imagine how

2012 — San Antonio, TX

back-logged they are . . . I got tired and I decided just to deal with the PTSD myself. I wanted to see if I could just live with it. Without the medication, without the therapy—I'd just let it be a part of me. I can't get rid of it—I have to accept it. I just got irritated with their system. Alright, they're not gonna help me, I don't care anymore. But Jennifer said, you can't do this by yourself. It was mostly my fault, too, for not being persistent at the VA, but then again, I got tired of having to go to them. The system is broken. It's messed up. There's got to be a better way to do it. It sucks, because after the military, you still need to have your hand held and be guided—they tell you: These are the steps that you need to take. But as soon as you walk off that post, it's: Good luck! Jennifer holds my hand now, but it's not been easy for her. She has to pick her words carefully, because anything would just set me off.

They just recently gave me a counselor for the re-evaluation. They said, hey, we haven't heard from you for a while! I said: I haven't heard from you either! Y'all were supposed to let me know where to go, what time, and who to see! They asked: Did you never get that letter? I said, I haven't gotten a letter from y'all until maybe a month ago. They said, "oh, you must have gotten lost in the system, blah, blah, blah. Somebody will be calling you within seven days to let you know where to go for your re-evaluation." I've not yet heard from them since. Maybe I'm lost in the system again!—The psychiatrist asked me if I felt guilty about the things that I did in Iraq. I should feel guilty, but, like, I don't. I was telling him about some of the things that I'm doing now: I do Habitat For Humanity with school, I give to the food bank, sometimes I find small little charities to give to here and there. . . . He asked me, does that make you feel better, knowing that you're giving back? I guess I'm doing that to lift some of this guilt off my shoulders.

Some of the things I feel guilty about: In Najaf and Fallujah, we spear-headed that campaign, and we went from building to building—whoever's in there, you know, is an enemy. Just take them down, like a video game. There was an incident where my weapon, it jammed, and this guy was so close to me that we were, like, chest to chest, and he was, you know, trying to get my weapon, and all I could do was use

my own hands to, basically, strangle him. That, right there, sticks with you. That's actually one thing that re-occurs in my dreams, like, I see his face. There have been instances where I wake up screaming in bed when I'm asleep. Jennifer would ask, are you OK? Yes, I'm fine. It's usually that scenario there that I dream about.

I haven't told the psychiatrist this yet—we haven't gotten there yet—but when you strangle somebody, when you take somebody's life, you can see their life essence just leaving, and I think that was the trigger that made me realize that this is something I enjoy doing. After that, it all becomes a game. How many kills did you have? I'm at number twelve, number thirteen, whatever.... Oh, I need to catch up! There are a lot of things that I keep from Jennifer. Some of the psychiatrists I've talked to, they're like, whoa, that's fucked up! I'm like, yeah... I'm a bit scared with some of the materials that I've been reading and how these psychological problems can evolve into something worse: Sociopathic tendencies.... Serial killer tendencies... I'm like, crap! Because I think of some of these things. Like, I can get away with this, doing this, this and this, and no one will ever catch me. *(Tristan continues telling me how he would use a cell phone after committing a crime.)*

I do think of the war a lot. Oh, and I can't watch any military movies without getting all teary-eyed. I cried when I watched *Restrepo* because I knew exactly what these soldiers were going through. It reminded me so much of Iraq. And whenever I see on the news, oh, a soldier just got killed or attacked, or they're talking about pullbacks—we should have been doing this a long time ago! There is no reason why we should be in Afghanistan anymore. They don't want us there! I don't see what our national interests are there. We're doing pretty well with Homeland Security putting people on the no-fly list. With the CIA and the FBI doing all that stuff.... There's no reason for us to be there. All the billions of dollars wasted on these two countries!

The doctor that I just saw last week asked me what kind of medication worked for me in Fort Hood, and I mentioned that Celexa was the last one I was on. And that actually did help. I've been on Celexa for three days now, which helps

with anxiety and depression, and Ambien, if I can't sleep. I take it every night, to help me fall asleep. It takes me about an hour to fall asleep if I don't take it, once I lay down in bed, I just stare at the ceiling, and also I take it because I still get the occasional nightmares. I need to be able to sleep through the whole night. He mentioned that there have been a lot of improvements and progress as far as treatment for PTSD goes. It has been two years and we're just starting out so I'm hoping that something will work. He mentioned that there is no cure, of course, and that all you can really do is turn down the levels of anxiety. He told me that I needed to let the meds work their way into my system. Once that's settled, we can work on your whole communication issue with the spouse. He asked if I ever did any kind of group sessions with other soldiers at Fort Hood, and I said, no. Like, anger management classes. But they were never offered to me.

Honestly, if I was to break something or got sick, I would just pay the hospital bills out of my own pocket. I wouldn't want to go to the VA. I don't want to see military doctors—I want to see regular, civilian doctors. Plus, the way they've lost track of me, I don't really trust them to be competent. They're overworked. Not too long ago, we began realizing how the Vietnam war had affected the vets. And they're being bombarded with the soldiers from these current wars. Then again, some of the Vietnam vets never did seek help, or their paperwork got lost. They said they're getting better at tracking down soldiers. But I don't see it. I don't know how many times I've turned in copies of my medical records. They're probably sitting in some closet collecting dust—I have no idea who's got them now.

My doctor asked if I had a problem with alcohol. I said, luckily, no. I will drink socially, and have two or three beers a night, but I don't get drunk. He said, OK, that's good, because a lot of soldiers have substance abuse problems. He asked me whether I was taking any recreational or illegal drugs and again, I said, no. I should get my hands on some weed, at least! I'm in college, I should be able to get it pretty easily! But it's just not my thing.

Honestly, I feel a huge difference now that I'm taking Celexa. I've only been taking it for three days and just being on

it for three days, I've definitely calmed down. Like I said, my dog tried to be aggressive with me and usually I'd get really upset about that. He was trying to press down on my arm and usually, I would fling him or toss him. But I was calm and I was trying to get him calmed down . . . I can definitely tell a difference—I'm not all antsy and anxious.

But all in all, I can definitely say that I feel worse now than four years ago. I've been reading a lot of stuff on PTSD and some of the things that they've been noticing is that psychopathic tendencies are triggered. Like, the urge to take a life. It's still there. It's even more of a presence now than before. Sometimes I get the urge to just easily take a person's life—mostly when I'm driving, like, if someone cuts me off. I wouldn't feel guilty about it. There have been scenarios when I followed people in my car. It takes a couple of minutes for me to calm down and turn around. There was one incident in which the person realized that I was following them, so they maneuvered to get away from me. . . . It was interesting! I thought, alright, I need to give this guy up. It's been bad.

I only saw the psychiatrist for an hour and a half—it was the initial evaluation—and we didn't get to cover much. We mostly talked about my family history and what I'm doing now. My next appointment is on April 12th—in roughly two weeks. It's better than once a month! Hopefully we can talk more then. You know, we—as male vets—thought we were overlooked—well, women are overlooked completely! They're suffering from unemployment after they get discharged from the Army, and some of them even end up homeless. The numbers of homeless veterans in the U.S. are growing. And just recently, there's a lot of reports of Air Force instructors here in San Antonio that have sexually assaulted female cadets and that causes a different form of PTSD as well.

I feel like there's so much I want to accomplish now that I'm out! I have all these opportunities available to me, and I do want to take advantage of school and I do want to travel—there's just not enough hours in the day! I'm playing catch-up. Being in the military for eight years and missing out on a lot of stuff—I'm really anxious to do everything now.

It didn't take Jennifer and me long to adjust to living together. It's mostly learning to separate responsibilities that we're still getting the hang of, but honestly, I don't mind doing the cleaning and the cooking, because I got all the time in the day to do that, where she actually has a job. Me playing around with my stocks—I do that for fun. It's a learning process right now, a trial-and-error phase. But other than that, we get along fine. She's gotta be careful what she says around me, and I know she feels like she's walking on eggshells—this was, of course, before I was on medication. I used to get upset really easily over some small little things, like, her spilling something on the floor or leaving appliances on—I get irritated for some reason. I'm just now realizing that that was nothing to be upset about. Stuff happens, you know?

I can't do both at the same time: Work on our relationship and focus on school. I always need to set priorities and when I started school, working on our marriage wasn't a priority for me. So of course, Jennifer suffered. We were at the point where I started looking for separate apartments, for me and for Jennifer. If we'd split up, I'd start from scratch. She could have everything. But I don't think Jennifer would ever divorce me. She's too dependent on me. Little things, like putting gas in her tank and, like, she can't keep track of what bills need to be paid. I guess I've deprived her of certain life skills. Only because I don't want her to make a mistake. I'm OCD: I need things to be done a certain way. For example, when she does the dishes, they're still dirty afterwards. So I just started doing them myself. And it's OK, because she works longer hours than I do. Plus, she can't be by herself. She watches too many dramas on TV about women getting attacked in their own house. I scared her once and she started crying. I felt bad but that's what I like to do: scare people. Sometimes I pull an all-nighter for school and then she's just tossing and turning until I come to bed. She can't sleep when I'm not beside her. Marriage is so much work. I'm more of a solitary person and she just needs attention, constantly.

My psychiatrist mentioned that I need to be careful about what I say. Like, Jennifer was unhappy about some things that I used to post on Facebook. Soldiers really don't have a filter, and people in the military can understand what you're

talking about, but other people would be like, oh my God, that's cold, or that's mean! I could be a little bit sarcastic at times. I don't literally mean what I'm saying—it's just my sense of humor. Other people might take it seriously.

Tristan later remembers a status update he posted on his Facebook wall: "The San Antonio Spurs just absolutely raped the Pacers!"—a comment that some people might have found offensive. On Jennifer's urging, he's since removed his profile.

We hardly ever go down to see our families, and when I'm there I'm always the friendly, happy kid. They don't know the full extent of what PTSD means. They know I get disability for it, but they just think it's because I have nightmares sometimes or that I can't sleep at night. And my sisters just think I'm crazy because I'll make really violent comments about people. Like, I'll smash that person's head in with a baseball bat.

Who knows how messed up I really am? The reading scares me sometimes. When I read about the other soldiers and some of the psychological problems they have, like, some develop serial killer tendencies . . . I hope that doesn't happen to me. I might be close to that. Just recently a stalker shot a girl who worked at a gym because his advances were turned down—I was like, you know what? Put me in a cell with him for five minutes! He's gonna regret doing that. She's paralyzed now from the waist down. Just being in San Antonio and seeing how people drive around here with complete disregard for people's safety, I get upset. Somebody needs to do something about this! I don't even know what to make out of this Trayvon Martin thing. Zimmerman was told not to follow him by the dispatcher—he's not a cop! He shouldn't have put himself in that situation. But then again, maybe I would have done the same thing, I might have followed him. Zimmerman had a concealed hand gun license. My way of thinking is: When I got my concealed hand gun license, initially, I was like, yes! Now I can carry a gun and just wait for somebody to do something! I had that trigger finger. I think Zimmerman was trigger-happy, too, and was just waiting for the right moment to use that weapon and to kill somebody. It

wasn't an accident. Initially, that was the reason why I got my gun. I got it in Fort Hood, shortly after we got back after our second deployment. And you know what's fucked up? I was already in PTSD counseling! They don't do a background check at all. They check to see if you have any felonies or warrants. But they don't check to see if you're messed up in the head. I'd keep my gun in the car or in my messenger bag, when I would go to school on post. And here in San Antonio. But then I got rid of the gun because it could have created more problems. I didn't know how bad things could get—that I might actually use it. I knew that gun would have eventually gotten me in some kind of trouble. I'm getting better as far as making rational decisions goes. I know I can't overreact over stupid little things.

I tell some of my class mates that I've been to Iraq and that I've done certain things. They never ask me, have you ever killed anybody? I guess when I tell them that I was an Infantry soldier and deployed twice, they automatically know, yeah, OK—they make the connection. They're pretty sympathetic to what I did and don't ask me too many questions. I don't really make it a point to announce that I'm a veteran, unless somebody asks, who's on the GI bill? Most of the veterans at school are much older than me anyway. Some of them are Gulf war veterans.

I try not to overwhelm myself with classes: Last semester I took fifteen hours but I couldn't handle it, mentally. It's a lot of work. Twelve hours is the most that I can do. There are students who have fifteen hours of school and work full-time. I'm like, Jesus! I don't know how they do that! I miss playing *Call of Duty*. I used to come home from school and play video games and then had to rush to do my schoolwork at the end of the night. I had to give them up. But it's so hard. Shooting things—it helped. Now, I spend time in Charlie's shop, buying and looking at football cards. Some kids party all night and go to school the next day. I'm getting old—I can't do that. I have to take multi-vitamins now, go jogging, go to the gym to keep the joints lose.

I remember one time in Fort Hood, I had missed an appointment—it wasn't intentional—and they called me into the office. I guess the Sergeant must have been having an

issue with somebody else but he was pretty upset about it. He was yelling at me. There was another guy there that I've been with on both deployments. We were real buddy-buddy even though he was already a Corporal. I told him, "hey, it won't happen again!" But the Sergeant was like: "You! Stand at parade rest when you talk to Corporal So-and-so!" I'm like, is this a joke? Usually I don't get talked to or treated like that because, you know, I've done my time. But this guy didn't know who I really was—I didn't go to war with him—so I put my hands behind my back and he's yelling at me, in my face. I was like, fuck this! I rolled my eyes back and walked out of the office. I was like, fuck this shit! He's yelling, "Hey! Come back here!" The other sergeant, Sergeant S.—he was in charge of us in Alpha and Bravo Company—screams, "Come back here, Tristan!" But I don't need him to talk to me like that. Who the fuck does he think he is? The other Sergeant cuts me off and started yelling at me and spits in my face and I guess I said something in reference to, basically, I won't kill him, but I will fucking destroy him! And for him to get the fuck out of my way. Sergeant S. pulled him to the side and told him to calm down. Nobody would have thought that that would have come out of me, walking away cursing. This happened towards the end, after Nike was already out.

I'm not holding any kind of resentment towards Nike for not going to NTC. There were some soldiers who were like, oh! He did it again! He doesn't have to do anything! They got upset. But he just found a way to beat the system. There's always a way, except that he always beat us to it first. But he did what he had to do to get out of going. I give him that much credit. Nike was untouchable after his mom sent all these letters—they went to the White House and to the Pentagon. The company was getting calls from who knows who, and it got all the way up to our commanders. Nike's not going, that was understood. They were telling the rest of us, though, we have to have an x amount of soldiers going to NTC regardless of whether or not you have a medical profile. They needed the personnel. With Nike's case, they didn't want to cause any more problems for the company. They said to us, OK, we understand you're in the same boat as Nike but we need you to go. They were actually being nice about it so I told my First

Sergeant from 3rd platoon, for you, I'll go. I respected him. We were in California for a whole month, training. The cities and villages that they built there looked exactly like Iraq. It was weird. We were stuck with the details of environmental control—any kind of spilled oils or chemicals, we would go out there and pick it up. It wasn't too bad but we were doing that for a month. Nike was back in Killeen and Jennifer didn't like being alone for so long. Then, of course, we came back from NTC and got treated like shit again.

Whenever somebody died in Iraq, they would try to find any way to see if it was the fault of that person. You know, like him not wearing his equipment properly, or not having all of his equipment. . . . Was he wearing his Kevlar? Where was his bullet-proof vest? A lot of times, the drivers wouldn't wear it because it was so hot in the Bradley—they would just sit on top of their vest. So they were asking: Was Cummings wearing his equipment? Anyway they can find loopholes, so that they don't have to pay the life insurance policy. Initially, it was 250,000 dollars that the families or the beneficiaries would get. Then they jumped up to 450,000 dollars per soldier. It got expensive! So let's find a way to make it the soldier's fault. Also: Was he suicidal? Maybe he wanted to get killed! Can you believe that shit? Sergeant Morris died through an IED. He was a passenger and you really can't dispute that. But if he hadn't been wearing his vest, they wouldn't have paid. Because they investigate, do an autopsy, and they would be able to tell if his body was wearing a vest or not.

After my visit with Tom Edwards in Arizona, I pass through San Antonio again and stop for a coffee with Tristan. I ask him how he's doing. He says: "I feel more lax now, with my medication. Before, I was always alert, always conscious of what was going on in my surroundings. I'm getting too relaxed now, and emotionally disconnected from everything. I still need to get used to that. One time, I forgot to take my meds, and I could tell that by the end of the day, I was already getting anxious and cranky again."

We talk about Tom and his bad experiences with the VA. Tristan feels great empathy for Tom and everything he's been going through. He says: "I recently saw online that the VA held

a job fair for veterans with PTSD. I would have loved to go! What the heck? My case manager should have sent me a notice! I would love to be in their system. It would be awesome if they'd keep track of me. Because, in case I flip out, then at least there would be a paper trail, some sort of documentation that leads up to this point. Even just a support group of veterans would be nice. You know, where we could meet once a week, kick back, have some beers, and share war stories. Because Jennifer, she's so tired of my war stories. I'm making Jennifer crazy with my PTSD, and no one takes care of her. At least I have the VA to go to, if something ever happened. She doesn't fall under the criteria of the VA. Who takes care of all these people who suffer because their loved ones have PTSD? No one."

TOM

Tom Edwards, U.S. Army Infantry veteran, born 1983, from Peoria, Arizona

Jessica, his sister
Big Show, his roommate
Miguel and **Anthony**, his friends from the skateshop
Anthony, his friend from college
Duke, Anthony's uncle
Ouze, his dog

2008
Fort Hood, TX

Tom is twenty-four years old but looks like thirty-five. He is very polite and helpful and treats me like a friend with utmost respect and kindness from the first day on. He and Timmy are both on the waiting list for WTU. Meanwhile, they pull guard at the motor pool which only takes a couple of hours a day and after work, they usually hang out and have some beers at Timmy's house. If Tom finishes early, he goes to the bar around the corner from his apartment and drinks. He tells me that his hands start shaking if he doesn't drink.

He loves his parents very much and calls them all the time. His wife just recently sent him divorce papers and he acts as if it's some kind of achievement even though he's still in love with her. He gets extremely irritated about other drivers in traffic and curses at them constantly. Tom cares about things a lot and always ends up being in charge of people or schedules. Even though he hasn't been working his regular Army job for a while now, he still wakes up every morning at six. He seems older in comparison to all the guys he hangs out with. Tom is gentle, sincere, and reliable.

I grew up in a high middle class family. I dropped out of regular high school, went to night school, dropped out of night school, so I started working. I had two jobs: I was a manager at Popeye's Chicken during the night and I worked at a body shop during the day, fixing cars, and I never went back to school. I dropped out of school because my parents moved away. I was on my own, so I was like, fuck school! I think I was seventeen. Well, the first time I dropped out was regular high school, I was sixteen, then I went back, and I dropped out again when I was seventeen. And I was working, I was making money, and money was like, wow, this is money! I've got two jobs, I'm making money, I got a car, I got everything... I got my GED later so I could join the Army.

My grandfather was in the military. My father was not. My parents moved away, and I actually lived with one of my teachers from high school. We were walking through the mall one day, and he goes, you should join the Army! Maybe. So I walked in there, I got the pamphlets, but I didn't even read them. I went in the next day: Fuck it, I'm joining the Army! I signed the papers, and I was gone. As a kid, you play G.I. Joe and all that shit, but I never really thought.... Because my parents, when I was sixteen, they pushed it on me: Why don't you go join the Army, you should do this, you should do that... I was like, fuck that! But then one day I was like, I'm gonna do it!—I was nineteen.

My parents didn't even know I joined the Army until I called them from basic training. I was like, "Hey, I'm at Fort Benning, Georgia, I joined the Army...." My mom was like, "Yeah, OK, what are you doing?" And I was like, "No, I got like a minute and thirty seconds left, here's my address, I'll send you a letter!" And they were like, oh my God, he really did it!—I didn't really miss my family. I wrote them a lot of letters, just out of boredom, and I had a girlfriend that I had broken up with right before I joined the Army, so I wrote her letters, but that was a bunch of wasted time.

I smoked a shit ton of pot when I was young, but drank more alcohol, because.... Well, when my parents first left, I was pretty straight-laced. I was living with my teacher, so I couldn't really get away with much. Then I moved out into a guy's house that I worked with—it was me, his name was Mike, there was another guy, Chris, and Mike's mom. That was it. And she really didn't have any rules. The first time I ever drank, they brought home a thirty pack of beer, and I was like, where the fuck did you get that at? Because we weren't old enough to drink. Then I drank that one night, we all smoked pot, but we started drinking, drinking, we used to go out to the desert and just drink and hang out. I've never done any drug except pot. I tried mushrooms once, and it made me puke, so I didn't even get the effect. Right now, if I was not in the Army, I could have anything I wanted. I got some extremely wealthy friends that would have done any-thing for me. It kind of pisses me off because here I am, in the

Army, trying to go AWOL, and they've got huge houses and shit. I wasn't joining because I had to make money. I joined because I was bored and I was like, fuck it.

After basic training, I went home to Arizona for a week, then I reported to Fort Hood, and two weeks later, I was in Iraq—in Baghdad. I was pretty excited to go, just the adrenaline, "holy shit, I'm going to Iraq!" And they packed our shit so quick, gave us everything we needed to go, and then they were like, OK, get on the plane! You didn't really have time to be worried. Our drill sergeant told us when we were in basic training: "You will be in Iraq within ninety days." I was like, damn! It wasn't that bad. I wasn't scared because it really hadn't hit me yet, you know? Because I didn't see any combat until, well, it was actually my birthday, November 18th, I haven't seen a bullet, I hadn't heard a gunshot or nothing. It was just cool, we're driving around in the dirt in our Humvees, you know, the whole Army guy shit, and then actually seeing BOOM—holy shit, something just blew up! Then you're like, hey Mom, hey Dad, I love you, I'm in Iraq, shit's real now, I'll call you when I can.

When your friends die, at the time, it's, like, man, that sucks, and it really doesn't register until you get back and you're at the bar drinking a beer and then somebody says something and you're like, motherfucker! He's not here anymore. He can't be here because he died in Iraq, because he was doing what he had to do. The deaths of my friends do affect me, but I'll be like, at the house, watching a movie or something or a certain song will come on, and it just triggers it. Then I'm all crying and shit, like a little girl.

Going to Iraq changed me a lot. Like stupid little things.... For example, I came home from Iraq, after my first tour, I got married, and I took my wife to meet my sister and her husband. We were at the restaurant, my sister ordered salad and it had cheese on it. She threw the biggest fit in the world because there was cheese on her salad! And I'm thinking, you know, I just got back from getting blown up, from getting shot at, from everything, and you're bitching because there's cheese on your salad. It could be a lot worse!—Stupid

shit doesn't bother me anymore. If it's not gonna kill me, I don't care. That's pretty much how it's changed me. Petty shit doesn't bother me. The war made me extremely more mature. I was such a kid—my friends even tell me that now.

I'm in psychiatric counseling because, about a month ago, I left a bar, I pulled into the parking lot of my fourplex, and it's extremely in the ghetto, and I will not park.... My truck is my life, and I will not park my truck in the street because either it will get hit by a drunk driver because I live right by the clubs, or it'll get stolen. I pulled into the parking lot, the neighbor downstairs was having a party, and somebody was in my spot. I remember, I rolled down my window, I pulled in between the three parking spots: "Hey, can somebody move this car, so I can park my truck?" They told me to fuck off. So I parked my truck in the street, walked upstairs, got my .45 pistol, walked downstairs, and shot the car that was in my parking spot. And that's what put me.... Well, now, this time. I went to see a psychologist when I was in Iraq the first time, because my wife left me when I was on mid-tour leave, and my captain found out about it and thought I was gonna go crazy, so they made me go see a shrink in Iraq for that. I wasn't going crazy, though. She told me she wanted a divorce the day I got home from Iraq. The next morning, I packed all my shit and I was gone. It didn't really hit me. I put the block up, I was like, fuck this, I'm outta here. And I just left. After a couple of days, I was like, damn! My wife just left me! It sucks. It sucks real bad. She calls me every day. And I'm like, what do you want me to tell you? If you would come back tomorrow, I'd take you back! She cheated on me, all kinds of shit, I wouldn't care, I'd take her back. But she's not at the maturity level yet. She's the same age I am, but she's extremely less mature. Her life is: I'm gonna go to work, I'm gonna go to the bar, I'm gonna get high. That's how I am now, which is kind of funny, but that's where she's at in her life. So it really didn't hit me until a couple days later, when I was at home.

And then, they made me go see a shrink again in Iraq. Well, I was already going because of my wife leaving me, and then I got hit by an IED in Iraq, and my best friend was driving, I

was gunning, and my other best friend was BC in a Bradley. We hit a road side bomb and it blew all the road wheels off. I got out of the turret, and I looked—it's called the hellhole, you can look from the back of the Bradley to the front of the Bradley to the driver's hatch—and I looked, and all I see is the hatch open, the sun shining in, and the fire extinguisher stuff, this white cloud, is just coming out, so I thought my best friend had just got blown to shit! I was fucking shaking, freaking out, shooting whatever I could see ... I get out and he's on the side of the Bradley, just sitting there. What the fuck, dude? And he was like, I was on fire! It burnt his fucking eyebrows off, it burnt his arm's hair off, it burnt the side of his hair off on his head, and they made me go see a psychiatrist because of that. We also had to go see a doctor, they made us do all these tests to see if we could still hear, etc., and they made me go back to counseling for the traumatic experience. When I first came back from Iraq, they made me continue going, and then my doctor's like, well, you got PTSD! And I was like, yeah, you're full of shit. So I just quit going. When I shot the car they made me go back.

I wouldn't be able to tell if I've got PTSD. Do I get angry and depressed at stupid shit sometimes? And when I think about the war? Yeah. And if that's one of the signs, OK, I might have some of the signs. Am I gonna go crazy and kill a shit ton of people? No. I will never do that. A car is not a person, it's an inanimate object. There were fifteen people right there, if I had wanted to I could have walked down the stairs and popped eight rounds off because that's all I had, and killed eight people. But I didn't, I walked past them to the inanimate object, and shot it. But, I guess, I'm sure I do have PTSD. I'm sure I'm pretty fucked up, but what's to be expected? With all the shit that we've been through? You could be a fobbit in Iraq and all you see is maybe a mortar round go off. Yeah, it might fuck you up a little if you're right next to it, but if you're not, you go back to playing your fucking video game. But the guys that leave the wire, and actually see the shit that we see and do the shit that we do, yeah, you're gonna be fucked up. Especially if you're in a bad town, there ain't nothing you can do about it. It's to be expected.

2008 — Fort Hood, TX

After I shot the car, everybody ran inside. I casually walked upstairs and put my gun on the refrigerator. They called the cops, like, four hours later, they didn't come knock on my door or talk to me or anything. My neighbors were scared shitless, they thought I was gonna kill them all! I went to sleep that night, I woke up the next day and my mind was, like, you fucking shot a car last night! I looked out the window, there's no cars in the parking lot except the one I shot and there's glass everywhere. So I drove to the police station.... Well, first, I went to drop my gun off somewhere else, I dropped it off at a buddy's house, then I drove to the police station, slid my ID under the glass: "I'm pretty sure you have a warrant for my arrest," and they looked my information up and were like, "No, we don't have a warrant, but did you shoot a car last night?" "Yeah, that was me." "OK. We'll be in contact." They gave me my ID back and I left. And then I called my boss at work, and I was like, "Hey man, I shot a car last night." He was like, "You did what?" So he called First Sergeant, they made me come into work, it was a Saturday, made me turn my gun in, and then they yelled at me a little bit. Monday morning, I come to work, I had to go see the Sergeant Major, because I was intoxicated while I was driving. He told me he would have done the same thing about shooting the car, but he would not have been drinking. So it's OK that I shot the car, just that I was drinking and driving was the horrible thing! That's pretty much what they told me. And then the next day, BAM, I'm gone. I get kicked out. I'm on motor pool guard now. That's pretty shitty.

I was a team leader in the Army, so I had three guys under me, and they knew nothing, they were straight from basic training. I liked taking them out and actually showing them something and then watching them do it, for example, showing them how to clear a room. And I can tell them all day, but when I actually get to show them, and then watch them, and they do it just right, that's, like: I did something that day, you know? These guys now know what they're doing. They can go through a room in Iraq and actually do it right and not get fucking killed.

I love combat. I love it to death. I'd go back to Iraq tomorrow, I would. But they won't let me. It's just the camaraderie,

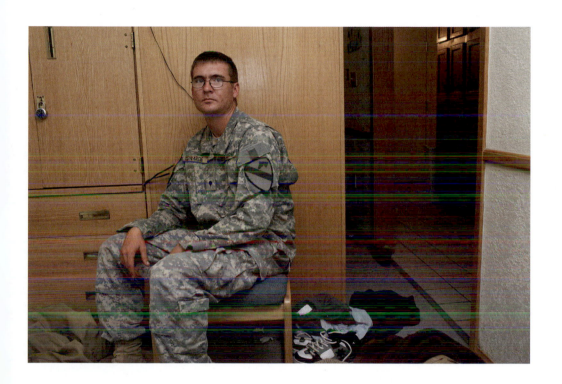

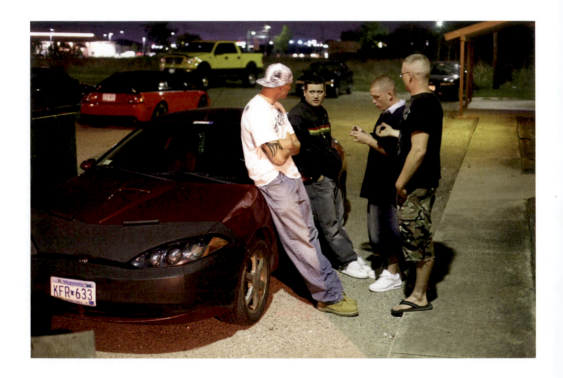

Tom Edwards

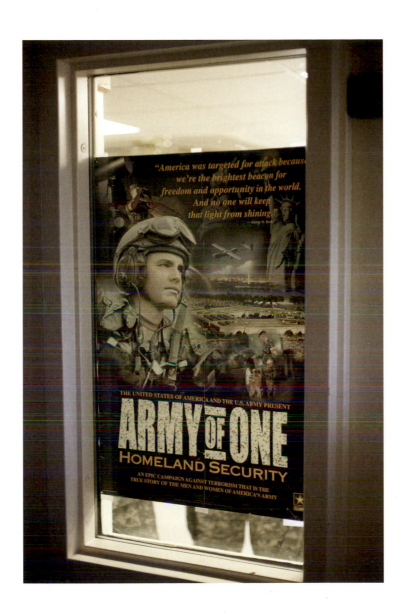

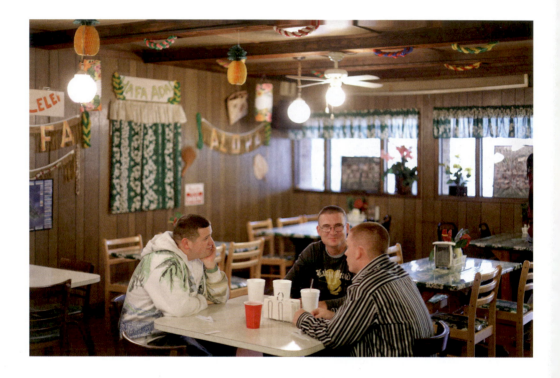

Tom Edwards

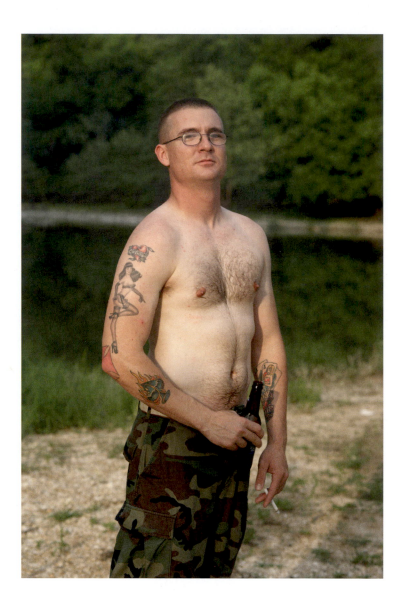

Tom Edwards

once you're over there and you start going to houses, and shit starts blowing up, the guy to your left, you could hate him back in the States, but when I get to Iraq, and we're actually bobbing and weaving and doing the shit, he's an alright guy, you know? All personal shit aside: He can save my ass, I can save his. I love the adrenaline. It's the best drug in the world. You get shot at, you shoot back, it's just a rush, I love that shit. I love guns, I carry a gun every day, I do what I want. Where else in the world can I go to any house I want, kick the front door in and put everybody on the ground in the front, and just say: "Hey, shut the fuck up, stay there!" and tear their house to pieces? Where else in the world can you do that? Nowhere. I love every aspect of it, except getting blown up, that sucks. But you get through that, as long as you don't die, hopefully. I've been blown up numerous times, most of the bombs were small, so it was like: BAM! Ha, ha, they didn't get us this time!

I was a Humvee gunner when I was in Iraq the first time and I gunned for the LT, and then they made me a dismount, I loved that. They're walking everywhere doing your shit. Then they put me on the ground. Which was good, because my BC at the time would not let me shoot anybody. We had a guy on the rooftop, and we had guys on the ground, but there's an Iraqi on the rooftop, and an RPG came in, and this is a blown-up fucking building that this guy is hanging out on. There's a guy downstairs in the window, too, and I can see him clear as day through the sights. I asked my BC, "Hey, these guys aren't up to any good, can I shoot them?" He's like, "No, you can't." And then the guys pulled up an actual rifle and started shooting, and then he let me shoot the guy at the bottom, but the guy on the roof—we couldn't see a rifle on him. If there's two guys on a blown-up fucking building together, one guy shooting, the other guy—he is no good. He does not need to fucking be there. I know I killed the guy, though. Because he got his head poked over the edge, the BC told me to put the rounds right on top of the rooftop. With the Bradley, it's pretty sighted and you're not gonna miss. I aimed right for the guy and killed him anyways. I got fucking chewed out for that. Why did you kill him?—He's a bad

guy, don't worry about it, dude. But my BC is a people-lovin', everybody-deserves-this kind of guy. Which—to each their own.

I didn't really kill a lot of people in Iraq. Not me personally, I didn't. Did WE kill a lot of people? Yeah, we killed a fuckton. Me, I couldn't even tell you. I'm sure it's not many at all. I know for a fact that I killed two people. This tour. Last tour, I killed one person. But, as an accumulated group, we killed a fuckton of people. But I don't really see them as people. I see it as an object that is trying to destroy me. They're trying to kill me just like I'm trying to kill them. It doesn't bother me at all. Once you get shot at, there comes the survival instinct: Fuck that guy, he's shooting at me, I'm gonna kill him first! Hopefully I'll get him first. It's not like it's close, though, either. This guy is a hundred meters down the road. You can't see his face, it's not like you're shooting him point blank. It's not a person, it's an object. He's running, he's got a gun, BAM BAM BAM, and that's it, he drops to the ground, you see him skid on the ground. I didn't see his face, I don't know his family, he had a gun, he was gonna kill me if I didn't kill him, so fuck him. It's no big deal. I'm sure if I saw a guy face to face, like if I kicked a door in, there's a guy right there, looking me in the eyes, and POW! I'm sure that would fuck me up for a little bit. I'm sure I'd see his face in dreams and shit. But I've never been that close up to killing somebody. . . . No, it doesn't matter. It's kind of like hunting. In a different perspective. But it is hunting.

A lot of my friends got more affected by killing people. I got a buddy, his name is Sgt. A., he's all fucked up. He was in Fallujah—I was outside of Fallujah—but he actually went in. And they were killing people the distance that you and I are apart right now. They were kicking in doors, shooting people in the face, and moving on. His whole squad almost got killed in five minutes. He took grenade frags in the leg. He's all fucked up. Just mentally. . . . Like, we'll go to a bar and drink, he'll have one fucking beer and he'll be drunk. And then it's just tears, and crying, and hugging. . . . One of his friends died. And it just fucked him all up. He's all koo-koo. I love him to death, I'd never think anything bad about

him, but he's emotionally and mentally fucked up because of the shit that he's seen. And he even told us that in Iraq—he was my boss for a little bit this time when I was there—he's like, none of y'all fuckers are dying. It's gonna be me before y'all. And I was like, dude, shut the fuck up! You know, you never wanna hear that kind of shit. We get new guys in, they wouldn't listen to him, and he would flip the fuck out. He'd be like, I've had buddies die, I've been here twice, I've seen this and this, you better listen to me or I'm gonna beat your fucking ass! And then they would finally realize: Wow, this guy, he means this shit! He knows combat like the back of his hand. But you get him back here and we start talking about it, drinking beer, he's all fucked up. He can't handle it anymore.

A lot of marriages end in divorces because of Iraq. Because we come home and the wife is like, do this, do that! Calm the fuck down, I just got back from Iraq, relax! It's hard for anybody to understand who hasn't been there and done the shit that we've done to realize: Maybe he needs to go easy on this part, but he can do this.

What I don't like about the Army? I hope you've got enough tape on this recorder! What I don't like about the Army is: If you can't run fast, and you can't do push-ups, you're a shitty soldier. What I don't like about the Army is: If you don't know the right people, you won't get promoted. Like, in Iraq, my boss was like, you need to get promoted! All my peers said: Hey, you need to get fucking promoted! Why aren't you promoted yet? Why do I have to go stand in front of these First Sergeants that don't know me, have never seen me in combat, they just know what I look like, and if I know the answers to: What's the regulation for the PT uniform? That's all they know. If they would come out with me on a day in combat, and see me running through the streets, directing my guys, killing the bad guys, you know.... What the fuck do I know about PT? Who gives a shit? Promote me on my job, not on what I know.

Let me give you an example: My old Platoon Sergeant was like 250 pounds, big fat black guy. Worthless piece of shit. Didn't do anything combat-wise. Didn't know shit about combat. Gets a brown star with Valor because he's an E-7,

leading a platoon. He didn't lead shit. He stayed back, ate his fucking ice cream and his chow hall food, while we were out getting him phone cards. Vanessa is the main route through Baquba. Bad fucking place. You don't wanna be caught out there just fucking around. I'm in the back of the Bradley, it's my team, and Bravo team is in the other Bradley, there's so many people in the back of the Bradley, and I'm squashed against the ramp. Well, my ramp drops, the next ramp drops, Sgt. A. is the leader in the other Bradley and I come rolling out under the ramp, and I stand up and actually realize where the fuck I am. Shit, I'm in the middle of Vanessa and Coyotes! Bad fucking spot! You don't wanna hang around! Our Platoon Sergeant stands up out of the Bradley, and: "Hey! You gotta go down this road!"—Coyotes, you don't fucking walk down. You're gonna get shot, you're gonna get killed. What the fuck are we doing?—"Well, just take Evan," who is our interpreter, "and get me some. . . . " He wouldn't say it but he meant whiskey. Just shitty-ass whiskey and some phone cards. You can't be fucking serious! Sgt A. and I look at each other, we're like, we're going down there to get this fat fuck phone cards and whiskey? I risked my life, my whole squad's life, for a bottle of Five Kings whiskey and some Iraqi cell phone cards so he can call his wife tonight.

What else? There's so many damn things. When we first got there, before we could shoot at the bad guy, we had to call it up and say, hey, there's a bad guy here. By the time we called it up he'd be gone. Why can't we just kill the guy, we call you up, take some pictures, and show you later? You know, yeah, I smoked some pot this past week, no fucking big deal, I'm not gonna go crazy. A guy got busted at work two times for cocaine and still got promoted to E-5. I shoot a car, I'm gone. They kick me out. From going to a great soldier one day, twenty-four hours later you're a fucking dirtbag, get the fuck outta here. They shit-canned me so quick. I was a great soldier, all my guys were like, I will not go back to Iraq without you. So what if I shoot a car! In the civilian world I might go to jail. But I didn't get a ticket, I didn't go to jail, I didn't kill anybody . . . I'd rather go back to Iraq with a guy that shoots a fucking car than a guy that's fucking doing coke.

Tom Edwards

I do not wish harm on anybody. I was fucking intoxicated, not a good excuse, but I was. I think I'd had just so much bullshit at work that I was like, you know what: Fuck this.

Now I sit in a shack all day in the rain like today, it's fucking depressing as shit, and everyone walks by and looks at me, and they're like, ah, that sucks to be in there, and I'm like, you don't even fucking know, dude. I had everything going for me. And then they just fucking dump me, twenty-four hours later, what the fuck? So I'm extremely disappointed in the Army. Extremely. All the guys that get DUIs, that's supposed to be the biggest, worst thing in the Army is a DUI. If you get a DUI in the Army you're supposedly fucked. You'll get in huge trouble. Certain people get DWIs or DUIs and nothing happens. It's on who you know. There's guys that are getting DUIs that aren't losing rank, aren't losing position, I shoot a fucking car and I'm gone. I don't even work with the guys I used to work for anymore. It's extremely disappointing. It pisses me off every day, makes me mad as shit. Because I know I can take my guys back to Iraq, do my job, get them home safe, and destroy the enemy, that's my fucking job. I know my job inside and out, when it comes to combat and training.

After this car incident, Friday night I shot the car, Monday morning I went to work, I went to see the Sergeant Major, I did PT, and then—to cover my own ass—I went to mental health to see the doctor that I was seeing before I quit going. That was just to cover my own base. And I went in there, and this lady—they made me go talk to this lady because my doctor wasn't available—so I told her what happened. She fucking went nuts! She's like, "what do you mean, 'shot a car'?" Well, I don't know how to be any more obvious about it: I shot the fucking car! Uh . . . so you gotta go see this person. They made me sit down with this other lady and they prescribed me Prozac and Ambien, because I can't sleep for shit. And I thought that was it, you know, I was like, cool. OK. I'll come back and see you in four weeks just like you said, no problem. Well, I get back to work and my First Sergeant's like, where is your fucking profile? What are you talking about, First Sergeant? He says: You got a fucking PTSD

profile! Naw, I just left the doctor, I ain't got shit. No, they just called me, you do. You better go get a copy of it.

So I go back: "You gave me a fucking profile?" She's like, "Sit down for a second." I was like, "What did you give me a profile for?" "PTSD." I asked, "Why?" "Well, you shot a car!" I said, "I'm very fucking aware of that!" And she's like, "Well, this medication you're taking, you shouldn't be handling weapons with." You just neutered me! You took away my bread and butter! My bread and butter is fucking guns, and bullets, and combat. And now I can't go back to combat, I can't handle a gun, I can't train. You just castrated a bull, you know, he is fucked, he can't do anything. I left there, I told my First Sergeant, "I'm out of here, I can't fucking do this, I'm gonna kill somebody." And I went to the bar. I was just so pissed that all of a sudden, I'm garbage. Worthless. That's exactly what our First Sergeant told me, Nike, Skelton, and some other guys: You are no use to me anymore, time to go.

I don't have any plans for my future. I have no idea what I'm gonna do. I was gonna re-enlist, do my twenty years and retire. I was fixing to get promoted, I was gonna be a Sergeant, and now it's not gonna happen because of my incident. So: Fuck the Army. I could get out and work for a private security corporation that goes to Iraq, and does the same shit I do but has a lot less rules and a lot better fucking gear and guns. It'd be a life-long dream to work for Blackwater! To just go out and start mercenary? If somebody does something you don't like: BOOM! What do you think they could do? Put it on the news? They're not gonna do shit! Like, they got in trouble a while ago for killing some fucking people in a car. They're still back in Iraq. They're still fucking doing crazy shit. But if I get out for PTSD, I don't think they would take me. So, I'll probably get a job, be a mall security guard, and beat the shit out of some guy for shop lifting, stealing a pack of gum or some shit.

I'd go AWOL if my doctor cancels the appointment on Friday. I waited from the 25th till now to find out what's going on, and I'm supposed to clear Fort Hood completely to transfer to Washington. But if he tells me on Friday, "Hey, here's

your paper work, start going to WTU, fill this out," I won't go anywhere. If he tells me, "Hey, you're not going to WTU, you're just gonna do this motor pool shit for now and then you go to Washington," I'll be like, "No, I'm gone." I won't go to Washington. Period. I'll tell him, "Either you do this, to the best of my interest, or I'm gone." They can't do anything to me till I do something. Friday night, I'm gonna be driving to Arizona. The only way, if I don't get what I want from the doctor on Friday, the only way I won't leave is. . . . My dad called me and said, call me before you do anything. If I call him and say that I'm going AWOL, and he fucking flips out and loses it, because—he had a stroke, like, two weeks ago so I'm real scared that I'm gonna put him in fucking cardiac arrest or something. I'd feel guilty as fuck. That's the only other way that I wouldn't do it. But he said he'd support me in anything I do, so fuck it, I'm leaving.

Something I wanted to do since I was a kid was to have my own reptile store. I actually wrote a business plan for it when I was seventeen. They found me three guys that were gonna invest in it, and then I joined the Army, like, two years later, and it never got started. So I would wanna do something like that. Just be low key. I don't need money, I'd live in a fucking trailer. I don't give a shit. I'll figure it out when the time comes.

All of a sudden, about two weeks after our conversation, Tom disappears and stops answering his phone. Nobody knows where he is but everybody suspects that he really did go AWOL just like he said he would. A few weeks later, he is back. I am curious to hear about his adventures.

The night before I went AWOL, I went out to dinner with Sonberg. I was actually not planning on going AWOL that night, we just went out to dinner. I get back to my house, and I was stuck on motor pool detail before that with Nike, but Alpha Company called me that night and said: "Hey, you need to come to work tomorrow, 06:30 for PT, you're back in Alpha Company." I was like, "Fuck no, I'm not! I'm supposed to be going to WTU!" And they're like, "No, you're coming back to Alpha Company." So I got off the phone, I went to

the bar, stayed there for ten minutes, did a bunch of shots and jumped in my truck and left. Before that, I stuck a note on my front door, it said: Dear Sgt. B. and all you guys in First Platoon, you taught me everything I know, I love you, good luck in Iraq. Your cocksucker. And I stuck it on the outside of my door because I knew the next day they would come look for me.

And then I drove . . . I got to Lampasas and I was like, I'm fucking drunk. I stayed in a hotel and just drove to Arizona the next day. I was gonna see some friends I had in Tucson, my extremely wealthy friends, because they told me, come here, we'll get you to Canada. But as I was driving there, I called my dad, I said, "Hey Dad, I'm in New Mexico," he's like, "What the fuck are you doing in New Mexico?" "I went AWOL." "Aw, shit!" So I called my sister, she also lives in Arizona, and she was like, "You're coming to my house!" I was like, "No, I'm going to Tucson"—"No, you're coming to my house, blah, blah, blah, blah!" I love my sister—she's my sister. She was freaking out and having a panic attack on the phone and so I was, like, OK, I'm coming to your house. I drove right through Tucson and just kept going. I went to my sister's house—I got there at about two o'clock in the morning—then the next day she made me call these AWOL groups to get advice. But it's a bunch of . . . I am not anti-war. That's what pissed me off about the whole thing. I called these people up—they're all based in California—and they're like, "Congratulations on going AWOL! I'm glad you don't support the war!" I got pissed! I was like, "I didn't go AWOL to run from the war! They won't let me go back!" So they were like, "Oh, we can't help you." I was like, "That's right! Fuck you, too," and I hung up. It just pissed me the fuck off.

I hung out in Arizona—my sister knows a lot of people because she's a teacher, her husband's a professor and they know some high-ranking Air Force people. They talked to them and they told me that pretty much I'm fucked. They told me: You might as well stay thirty days if you're already gone—because thirty days is the limit: from thirty to thirty-one, you're a deserter. You might as well just hang out for thirty days and then go back. And then my sister was freaking

out and she made me find a lawyer so I found a lawyer. In my opinion, he's a piece of shit. He hasn't done anything for the money that we're paying him. My sister pays him. My dad's doing more by himself than the lawyer is doing. I think it's a waste of money.

My superiors called my parents. They called my mom, "Do you know where your son's at?" And she was like, "No, I have no idea." Of course she knew exactly where I was. I called my commander three days after being AWOL and I was like, "Hey, I'm AWOL, Sir." He's like, "Where you at?" I was like, "Washington state." I just pulled something from the top of my head. He was like, "What are you doing in Washington?" "Uh … I'm going to Canada." "No, don't do that, that's not a good idea!" So I asked him, "What if I come back on Monday?" He said, "You won't get in trouble at all, we'll pretend it never happened." Which was BULLSHIT. I told my dad, hey, he's bullshitting, I'm not going back. My dad was disappointed that I went AWOL, but he tells me all the time: Look, I can tell you what to do, but you're gonna live your own life and do what you think is right. I have no idea what you've been through, so at least take my advice. If you don't, oh well, do what you do.

I just hung out in Arizona for thirty days. I hung out with my friends but they're all idiots now, we have nothing in common anymore. I did drink—not as much, though. I think I drank three times the whole thirty days just because my sister was hounding me all day, driving me nuts. I did smoke some pot—I smoked a decent amount of pot. Then my sister—finally—was like, when are you going back? She had the days counted out and everything, she knew how long I'd been gone, what time I left and all this shit. She rented a car because my lawyer said that if I turned myself in at Fort Sill, Oklahoma—that's where the AWOL processing center is at—there's a good chance that they would kick me out there, which, again, was bullshit.

The reason I finally did go AWOL is because if the Army tells me I have medical issues they should give me the treatment for it. Put me in WTU. Quit jerking me around. It's not that hard to get people in there and they haven't done it. It was

just to get my point across, like, hey, I'm really fucking serious, I'm not playing around! It took that for them to realize. But now I'm gonna lose all my fucking rank, I still haven't been paid and I'm gonna be on extra duty for forty-five fucking days which means I'm gonna have to work till midnight. Restriction, for forty-five days—I'm supposed to stay in the barracks for forty-five days. Yeah, right. Bullshit. They can kiss my ass. Extra duty—ain't happening. And they made me move back in the barracks. So it's pretty shitty. The barracks lifestyle is awesome, though, I love this shit. It's like a giant frat house.

So I turned myself in at Fort Sill. My sister and her friend came with which was quite an interesting travel. I turned myself in at Fort Sill on midnight on a Friday. We went to a police station, they filled out a police report, handcuffed me and shackled me and shit. My sister was acting like I'm going to jail for the rest of my life, she was freaking out and crying. I said, "You need to get the fuck out of here right now." "I can't." "You need to get out of here now because they're gonna put me in handcuffs and you're gonna get all freaked out. I know that's gonna happen." "I'll be fine." "Get out of the building NOW!" So I made her and her friend get out of the little area that we're sitting in. They took me out back, put me in a police car and drove me to another building, and there's my fucking sister at the building already. She's just standing there, "Can I say good-bye to him?" I mean, I love her to death, but it wasn't a huge deal.

Then I go in there, and there's a bunch of civilians who think they're hard-asses because they're ex-military, like, "You will call me Sir! You will call her Ma'am! Do you understand?" Yes, motherfucker, I've been in the Army four years, I'm not one of these basic training guys you got in here! So they go, "Lights out!" It was already past lights out. "You take a shower here!" I took a shower, I went into my room and it's got four bunks in it and all the other guys were already sleeping.

The next morning, we all get woken up—it's like basic training, you get woken up, you gotta make your bed, you gotta mop the floors, you gotta scrub the toilets and all kinds

of shit like that, so I was like, what the fuck is this place? And then you sit outside, there's a bench separated by a big ass tree, and there's another fucking bench, and this is the girls' and this is the guys' and you're not allowed to look at females or talk to them. This is the place where they take all the kids that go AWOL from basic training. It's called Personnel Control Facility—PCF, because everything in the Army has a fucking acronym. So I wake up, I start cleaning all that shit and you gotta ask permission to go outside, you gotta say, "Returnee Edwards, request permission to go outside." But you have to be outside because you're not allowed to be inside. Every time you go and have to take a piss: "Returnee Edwards, request permission to use latrine," either "Ma'am" or "Sir." And it's these fucking ex-Army people sitting in their chairs with their dicks all hard because they get to tell people what to do. Whatever. So I'm out there and these guys are thinking that I'm from basic training so I started asking them, "Why did you go AWOL?" "Oh, I just can't handle getting yelled at like that! It's hard!" "Are you fucking serious? Are you kidding me? You were in basic training and went AWOL?" "Yeah, didn't you?" "No, motherfucker, I've been in the Army for four fucking years! I've been to Iraq twice!" Then I started asking, "What's your job?" "Oh, I'm a cook." Oh my God, I got so fucking mad! I just don't even understand....

I hung out there for a couple of days, and they were like, OK, we're either gonna in-process you here and kick you out or we're gonna send you back to your unit. Well, they started in-processing me, so I was like, sweet, I'm gonna be out of the fucking Army!

Then they told me, "Go get your civilian clothes back on!" I changed into what I arrived in—my BDU cut-offs, a white t-shirt and flip flops—and they're like, get your bag! There was a police officer standing there when I came back. I already knew what to do: I turned around, put my hands on the wall, he searched me, he handcuffed me, and he walked out to the car. He was like, I'm taking you to the airport. There's a bunch of us in there, so we get to the airport, they un-handcuffed me but they leave these other

guys handcuffed. That was weird. Here's your plane ticket!
Go back to Fort Hood! All the other guys are sitting there,
handcuffed in the airport with these guards on them while
I'm drinking beer in the little fucking restaurant, waiting for
my airplane.

I flew back here to Killeen and they found out that I had
a civilian lawyer. They were like, oh, shit. It was really like
I never left. I mean, there's punishment pending right now,
but I don't care. I went back to work, then I went out to the
field and here I am.

While we were out in the field, I called my dad on some-
body's cell phone, and he was like, I wrote an email to the
White House. And I was like, OK. You know, because you
never think shit like that is gonna get answered. About an
hour and a half after that, my First Sergeant comes flying
up in a Humvee, "Edwards! Get over here! We have a con-
gressional investigation going on. Do you know what that
is?" "Negative, Sir, what is that?" "It's an investigation usu-
ally done by a congressman. But this one's being done by the
White House. Do you know anything about what your father
might have written?" "No, I don't, but I'll call him!" I walked
away and started calling my dad, laughing my ass off, "Dad,
do you know your shit got answered?" He's like, "Really?"
"Yeah! They're under investigation right now! And they're
not happy!" "Well, good! I'm really shocked it got answered!"
They're afraid I'm gonna freak out. I told a lot of people
yesterday I'm gonna shoot them. Which was probably not a
good idea because they take me very seriously when I say shit
like that. And now they're saying that I should be in WTU,
which—why wouldn't they do that whenever they were sup-
posed to do that? Like three months ago. So now they're like,
we'll get you in there. My dad said, "You got thirty fucking
days or I'm drafting this letter . . . "—which he already typed
up—"and I'll send it to the one hundred largest newspapers
in the United States." They don't know that yet. I just told
them they got thirty days. And they keep asking me, "How's
your dad? Is he happy with the situation?" I'm like, "No. I'm
still not fucking getting paid." "Alright, alright. We're work-
ing on it." So that's where we are today.

Coming back to Fort Hood was such a relief, to actually get here.... Yeah, there's certain people who call me shitbag, but everybody knows those people are idiots and nobody cares. And everybody's like, "Hey, we're going out tonight and party!" "I didn't get paid." "Don't worry about it, we got you. Come on out with us!" It's been awesome to come back and see everybody again. Because that AWOL place they stuck me in, those little kids that had no idea what the fuck the Army was about and they were crying because basic training was too hard. And the civilian people there were yelling and screaming. It's really unnecessary. But that's all these kids know from basic training so they figure that will keep them in line.

2012
Goodyear, AZ

In October 2011, I traveled to Tucson, Arizona for an assignment. Tom contacted me to tell me that he was living in Kearny, really close to Tucson, and we agreed to meet early the next morning for breakfast before I leave town. Even though he'd have to start driving around 6:30 a.m., he said that it wasn't a problem and that he would definitely make it. He sounded excited on the phone. The next morning, he didn't show up and didn't answer my texts. I was very disappointed and called Timmy to tell him about it. "He probably got wasted after you talked to him, passed out and then couldn't get up in the morning," Timmy responded.

In April 2012, when I arrive in Goodyear, a suburb of Phoenix, after a long drive through Texas, Tom is bubbling and almost manic with excitement and information. It's very sunny and hot outside and one of the first things he says to me is, "If we were in Fort Hood, we'd be at the fucking lake. Right now." This strikes me as a very random comment at first—that was four years ago!—but he keeps talking about Fort Hood and I understand how much he misses Texas, and his Army life. I'm his only lifeline to Nike, Rollings, and Tristan. We run to the gas station to buy cigarettes and then sit on the porch for hours, smoking and going over everything that happened in the past four years. When I mention his no-show in Tucson the year before, he blushes and says that he was stoked about the prospect of seeing me, but that he was hung over and just couldn't get out of bed. "I even had my buddy's truck parked out front, all gassed up, so that I could just get up and start driving. But I passed out," he says, embarrassed. "Nike nailed it."

Tom still wears his uniform: T-shirt, cut-off Army shorts, and flip flops. He has some new tattoos and smokes even more now than four years ago. When he gets out of bed in the early afternoon, he usually throws up after smoking his first cigarette.

His hands shake all the time now, and when I ask him if this has to do with his sobriety, he says, no, they just shake, ever since the military.

A month ago, he moved into a three-bedroom apartment in the Palm Valley Luxury Apartment Complex (even though "the 'Luxury' is complete bullshit," according to Tom). His roommate is Big Show, a friendly Hispanic kid he knows from work. "When I grew up, there was nothing out here. It was just the desert," Tom says. Now, the area is a giant shopping mall: There's a Barnes&Noble, a Starbucks, a Target, and a McDonald's Drive-Thru within walking distance. Tom's place is pretty much empty except for a couple of white leather couches and a tiny TV. He and Big Show own about two plates, no silverware, and they both laugh when I ask them if they have pots and pans. "I'll buy you pots and pans if you want to cook," Tom says, "but Big Show and I always eat at the restaurant where we work at." The floor of their patio is littered with cigarette butts.

To get to work, Tom crosses his parking lot, walks a bit further across an empty little field towards McDonald's, and arrives at "Gus' New York Pizza and Bar," a restaurant in a strip mall where he works in the kitchen. His decision to rent a place so close to work was based largely on the fact that he could drink at work, and walk home afterwards. "I was wondering if that was really a legitimate reason to rent the place, like, isn't that kind of embarrassing? My addictive nature placed me in this apartment. It's ridiculous." His only means of transport at the moment is his motorcycle, but the battery has been dead for quite a while and he relies on Big Show to drive him around.

Work in the kitchen is hectic—during dinner rush hour, Tom is in the zone, humming and rapping along with the music on his headphones while frying batch after batch of chicken wings, moving fast and efficiently, and still joking around with the Mexican pizza cook. Every chance he gets, he sneaks outside to smoke a cigarette over which he tells me—if he became a manager at Gus'—he'd turn this kitchen around into a military operation, in which everyone would know their place, their duty, and their station. "Everyone in here is just doing the minimal thing. They don't see the big picture. It's aggravating."

Right next to the restaurant is a very cool, independent skateboard shop called "Play Outsyde," owned by Californian cousins

Miguel and Anthony. The shop just opened a couple of months ago and the guys clicked with Tom right away. "Tom is a really mellow dude, not acting like he's higher than anyone else. He's one of us," Anthony says.

Apparently, one week before my arrival, Tom got really, really drunk at work. When I ask Anthony and Miguel about the incident, Anthony says, "that wasn't Tom in there," and Miguel walks by, joking, "yeah, was that you, Tom?" I ask Miguel if he would tell me what exactly happened that night. "Tom got loud, said pretty much anything that popped into his head—really loud—and didn't care who was around. It was interesting! He was belligerent, but he was still kind of calm at the same time. Like, when I talked to him, he didn't raise his voice at me or nothing. I knew he wouldn't remember anything the next day. The things he was saying...I was like, damn! That's pretty brutal! For example, he started texting a girl. As he was texting her, he was yelling out the sentence: 'Do—you—want—a—penis—injection?' He said it loud and everyone in the bar heard. I said, 'Tom...relax!' He was like, oh well....And then it was just on to the next thing. I've never seen him like that before! It was a different side of Tom, that's for sure. It got pretty sexual. He told a customer that she had nice tits. And there was a girl at the end of the bar, and he was like, 'I'd hit that if I could!' Really loud! She just looked back and kept on ordering her take-out. He even fell off his chair, with a chicken wing in his hand. After he fell, he got all red and embarrassed and stomped out the back door. Then, outside, he started yelling at his boss."

Tom takes it from here: "I yelled all kinds of dumb shit at my boss: 'Fuck you! I killed your cousins at war. Welcome to my country!' Because my boss, he's of Muslim decent. My boss said, 'but I love your country!' And I did a long, drawn-out FUUUUUUUCK YOOOOOOOUUU, all loud. Even though I'm not a racist person at all. The only thing I had against him at that point was that it was my day off and he made me put tables together. But I didn't even do it. I got drunk after the first three! My boss was just the only person who happened to stand outside at that point, and I had to have someone that I could direct my rage to. Apparently I went on saying more self-righteous bullshit, like, after what I've seen and been through, I'm

allowed to express my opinion . . . Miguel told me: 'But he wasn't in the war fighting you, Tom!' And I was like, 'I don't give a fuck. I've killed all the motherfuckers!' After that, everyone kind of stopped talking to me. One of my friends took me to McDonald's, and then I went home. I had started drinking at 11:30 a.m. that day. It was sad. They didn't fire me because I've worked my ass off for those people. When we first opened, I worked fifteen hours a day, and I didn't have a day off for a month. I didn't bitch about it, I just did my job. I can work any station in the kitchen. They call me the human octopus. Now, some of the people there are—I don't want to say scared—but very cautious of me. I used to make 500 dollars a week, but I drank almost all of it away at the bar so that on pay day, they'd give me about sixty dollars in cash. I don't like to drink at home, I get all depressed. I need the company.

I went back the other day and apologized to everyone. I knew I did some wrong shit, but I didn't exactly remember what happened. But at least I had the testicles to come back up here and say, 'Listen, I fucked up. I realize that. Thank you for not firing me!' And everyone's reaction was like, it's cool. Now I'm not allowed to drink at work anymore.

But anyway, I spend most my time here at the skate shop when I'm not at work," Tom says. Everyone's a big family—Tom, Big Show, his other co-workers, the skater boys, the restaurant customers. Tom's friends from the restaurant usually stop by his apartment at night, hit the hot tub, and later on fall asleep on the couch.

Tom—still—is very caring and, in a friendly way, kind of fatherly to his friends. He's older than most of them, and he duly looks out for them, making sure they get to work on time, making sure they eat. He shares his cigarettes with Big Show and pays rent for both of them, and in return, sends him on errands every once in a while.

At night, we usually sit out on the porch, I smoke the occasional cigarette while Tom smokes weed. Often, we order takeout from Gus' and wait for one of his friends to deliver the food. We talk about politics, America, society, veterans, the wars, weed, the legalization of weed, and as the nights progress, and the more Tom hits the bong, the more talkative he gets.

Tom Edwards

Tom exudes loneliness, even though he's barely ever alone. He longs to find his place in this world, to have a wife and kids, a house and a dog. There's a girl who waitresses at Gus' whom Tom has a crush on. They spend a lot of time together—she usually comes over after work, they watch movies or sit in the hot tub and talk. She's very flirtatious even though she has a boyfriend, and it's a very confusing situation. "I'd totally straighten myself out for her. I'd stop smoking cigarettes and weed, I'd buy a vacuum cleaner, I'd kick Big Show out to build a family with her. I'd keep working at the restaurant and I know she wouldn't judge me for that. Maybe I'll get a promotion and become a manager. I wanna have kids so bad. I want a daughter really bad. I want a tattoo that says 'For her, I will fight the world,' and I will get her feet print in the middle and her name under it. I want my little princess. I'd be a great dad. If I had to suck dick to get my daughter whatever she wanted, I would. I'd love to have a son, too, but I want a daughter more. My son will be smart. I will teach him everything. But I'm afraid I'm gonna be an asshole to him. I'm gonna be too strict with him and I don't want to be mean with my kids. But I got that in me. I don't want to treat him like we're in the military."

He constantly reminds himself that he's doing well for himself. "I have a place to rest my head at night, and I have a job. I don't need anything else," he often tells me. But the only things in his life that he seems thoroughly proud of are his two deployments to Iraq. Whenever we talk about something, or he tells me about a conversation he's had with someone, the phrase "I went to war twice" will most likely come up, no matter what the topic is.

It's ironic that his sister Jessica is the person closest to him, even though they both claim that they're not getting along at all. He talks a lot about her, though, and I remember that he used to, too, in Texas, four years ago. Before my interview with her, we have dinner and he gets jumpy and nervous and keeps telling me that her bare presence makes his skin crawl. Afterwards, he immediately asks me, "Did she say anything mean about me?" I have to assure him several times that she did not.

Tom: Four years ago, when I came back from being AWOL, the locks to my apartment were changed, but all my stuff was still

in there. I made up some bullshit excuse to my landlord—"I got locked up in jail!"—and I got all my stuff and moved into the barracks. All my superiors treated me like shit. It was time for me to get out of the fucking Army. After my dad wrote that email to the White House, I did what I wanted and no one said anything. I slept until 9 a.m. every day. That's when I did a lot of hanging out with Nike and Rollings and all them. I was supposed to go into WTU but that never happened. They just asked me, "What do you want to do? Do you want to get out or do you want to change jobs?" I said, "I want out," and I was out twenty days after that. They wanted to get rid of me because my dad was making noise. Noise that was being heard by the five-star general. They don't like that shit at all. I got out real quick—no questions asked.

I had to talk to a psychiatrist, when I was in Fort Hood, to get my disability approved. I've got 50 percent disability, the ear-ringing is 10 percent, and my knees are 15 percent, there's a bunch of little things in there, too. Jumping off the Bradleys and running for miles and miles and miles on pavement—my back and my knees still hurt so bad! Sometimes I feel like there are electric jolts running through my body, it sucks.

I got diagnosed with PTSD when I was still with my regular unit, so they already had my medical files from the Army when I went to my disability hearing. The doctor lady called it a psychomania. I don't know what that is. She said I liked the war so much—not physical enjoyment but the adrenaline from the war—that I can't adjust to society because I like that so much. And that was it. The check came in the mail, and I get 1,300 dollars a month. It's pretty cool.

The day I was getting out of the Army, I woke up, went to the Copeland Center, and waited with all these other people that were getting out to get our DD214 forms. I was supposed to get mine, and then the lady was like, "Oh, I think this is wrong! You have Marine awards on here!" I was like, "I know! I was in Fallujah. I got awards for that." She didn't believe me! She had to do all this research and shit and I had to wait another two hours, and then she came out and gave it to me. My fucking official fuck-you-I'm-out-of-the-Army papers. I took my hat off and I was happy as shit! But I couldn't believe that she couldn't believe that I had Marine awards!

Tom Edwards

She thought I had somebody bullshit-type that on my paper-work. I never returned my gear, told them that I had lost it, but actually it's all in Mississippi, at my parents' house. It's kind of cool to look at it every now and then.

I hung out with Nike that day, I went to one of my other buddies' houses and I crashed on his couch, smoked a joint, and the next morning I started driving. I had bought a big Jeep in Texas, because. . . . Were you there when they weren't paying me? Well, they finally paid me all the money they owed me, all in one lump sum. So I went out and bought a Jeep and partied and went to the river a lot. Started doing coke with some other people. Then I was gone. I went home to Mississippi.

I really don't remember much from that time. I started fishing. All the time. I met this old black ex-con named Louis. He was a drinker, like a mother . . . I mean, two bottles a day. And I started drinking with him and fishing with him. All day, every day, we drank and fished, smoked the occasional joint. We drank bourbon whiskey straight out of the bottle. We would sell fish to make money because I wasn't on disability yet and I didn't want to work. So we would catch fish—there were three lakes around my house—and we'd catch these little fish, bream, like a blue gill? We'd sell them for two dollars apiece in the poor black neighborhoods. We'd catch seventy-five, no joke. The money we would get from that, we'd buy cigarettes and our booze. We didn't have to pay for fishing worms because we knew where to find them in the ground. We made good money. Enough to support a drinking and a smoking habit!

My parents and I were cool until my dad and I got into it about drinking one time. My mom, sometimes, she would say, "You smell like a brewery!" Well, I drank all fucking day! I don't know if I really didn't give a shit or not. I spent all my disability money, when it started to come in, on fishing lures, fishing rods and booze and parts for my Jeep. And I was happy. But my dad and I were just bumping shoulders every time in the house so after about a year, I was like, fuck this. I came out here to Arizona on my buddy's birthday, and I called the college here and said, "I'm thinking about taking classes." I was in college, like, two weeks later. And I never went back.

I got very depressed after my second deployment, when my wife left me. I grew up . . . marriage was marriage, a wife is your wife until the rest of your fucking life! She's your queen, you treat her the best you can. I'm gonna scrub a toilet with a toothbrush to make sure she can get whatever she wants. I was married, and I was like, my life's going great, I'm taking steps to adulthood, next is a house, and kids . . . and then, all of a sudden, it was gone. And after that, I was depressed. I was happy as hell when I was married. We argued a lot, but I was still happy. Now, looking back, I wish I would have never gotten married, so that, at least, I could say "no" whenever girls asked, "were you ever married?" I wouldn't have to say "I'm divorced." It's, like, I'm damaged goods now. I wasn't married for very long, only a year. We were only actually together for five months. Total, knowing her, marrying her and being together: five months. It was a stupid decision.

Tom goes on to tell me the details of how he and his ex-wife met and how she started cheating on him while he was on his second deployment, which, ultimately, led to their divorce. There were some warning signs before, which he chose to ignore: He saw her make out with another guy once, and one of her friends told Tom that she sleeps with a lot of people. "And I still married her!" He found out later that she had already been married once before, to a soldier from Georgia.

Her parents told me that they told her to stop sleeping around when I got home on leave. I was like, "why didn't you shoot me an email? Drop a line? Give me the hookup before I came home?" They said, "We didn't want you to worry about it while you were over there because you'll get distracted and get killed." But I was already distracted enough when I talked on the phone with my wife, because I knew what the fuck was going on. I had inclinations overseas. You either walk from the phone booth floating back to the barracks, or you drag your feet, shaking your head. And most of the nights, it was, like, fuuuuck. . . .

I was twenty-one when I got married. I think about her every now and then, like, if we weren't divorced, where would I be now? I'd still be in the military. I'd be at least an

E-6, making bad-ass money, and I would have knocked out a couple of kids. My wife couldn't have kids, though, I don't think. We tried, but she had had surgery and the doctors told her that there was a chance she couldn't conceive. We tried to get pregnant, right when I got orders to go back to Iraq. We both drank, and she smoked weed. We'd be two co-dependent motherfuckers in here, both working at Gus' Pizza, living off of my disability. I only started smoking weed when I was put in Rear Detachment and hung out with Nike. When I was married, I was all gung ho about the Army and hoorah! hoorah!

She cried so much when I got on the bus to get on the plane to go to Iraq. She fucking bawled. You lying bitch!—I'm glad all that shit's done with. I think she just forgot about me, honestly. I think she just pushed me out of her head while I was gone. After two weeks of leave, I got back into the uniform and went back to Iraq. Everybody already knew what happened. My First Sergeant greeted me with, "I hear your wife's a whore!" I said, "yep," and he went on to ask me, "are you OK? Are you ready to kill?" or something stupid like that. "Roger that, First Sergeant!"

I went to school for my dad. It was free for me to go to college and I got paid 1,500 dollars a month to go to college, for living expenses. Plus, my disability on top. . . . So I was just doing what I wanted. I had a house, a 52-inch TV, a full couch, everything. It was fun. I did a lot of drinking in college. In Killeen, I would dissolve Ambien in beer and drink those before going to bed or simply snort them. I was so fucked up then. I'd wake up at night to drink and go back to sleep. When I went to college, I used to have a bottle of Jim Beam in the car with me. During lunch time, we went to the gas station, bought alcohol and drank it in my buddy's van. I didn't smoke pot at first, because I was scared to go to school high, but then I saw all my classmates getting stoned, so I started lighting up every day before class. It made it easier for me to deal with all the kids at school. It's the whole disrespect thing. The kids at that school . . . they thought they were all bad-ass motherfuckers, nineteen years old, walking around like they got a twenty-foot dick and they're King Kong. They just say what they feel, they don't think about shit before they

say it to somebody. I'm not your normal person—if you say shit to me, I get mad, I do stupid shit! They figured this shit out real quick. They knew that our group . . . we all hung out at the same spot, and everyone's like, don't talk to these guys, they're crazy! I still have issues. At work, I have to bite my tongue so much because I want to slap the shit out of those little waitresses. It's so hard. Just to shut people the fuck up. They need to quit yelling at me or I'm gonna freak the fuck out. I just take it to the next level.

A girlfriend is too much hassle. I dated when I got out of the military. Well, I moved to Mississippi for a year, and no girlfriend. I moved back out here to Arizona, and I dated a girl, for, like, six months. She was driving me fucking crazy. And then she cheated on me, and I acted all, like, oh my God! But I really wanted to break up with her, because I was fucking tired of her. She was too young. I was twenty-five, I think, and she was not old enough to drink. Very immature, still lived with Mom and Dad . . . I met her because Matt, my best friend—well, I guess we're not best friends anymore—I came out here for his birthday, and I never left, and my girlfriend was his niece. But her dad and I, we started doing coke together, but I was like, oh, I can't be doing that shit because I'm going to college. . . . Women are so materialistic. That's why I don't have a girlfriend. Well . . . I say that now, but if I did have a girlfriend, I would buy her whatever the fuck she wanted.

I can't keep my mouth shut when I hear a guy tell a bullshit war story. And when you've seen this shit—you can ask any of the guys that are in this book—you can pick out a bullshit story from a mile the fuck away. Dudes do it to try and get pussy. And that irritates the fuck out of me! That's how I met all the veterans at school, because I was sitting in class, and there was this kid telling this girl this bullshit war story, Hollywood as fuck, and I called him out! Right in front of everybody. Turns out he was a mechanic in the Marines. Like, you didn't see shit! Motherfucker, I was Army Infantry, I fought in Fallujah and Najaf, and I was in Baquba in 2007! And then all the other real veterans were like, yeah, motherfucker! Somebody finally said something to him! I just had enough of it. My

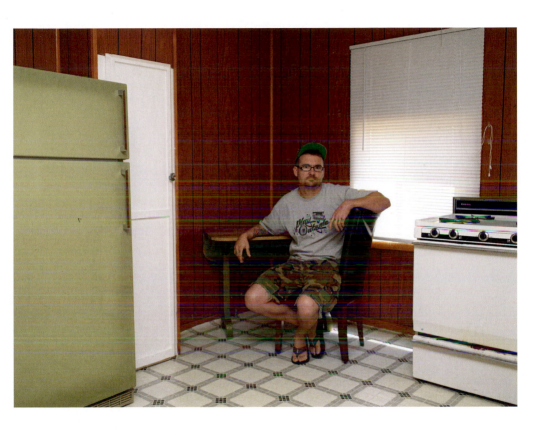

2012 — Goodyear, AZ

Tom Edwards

2012 — Goodyear, AZ

2012 — Goodyear, AZ

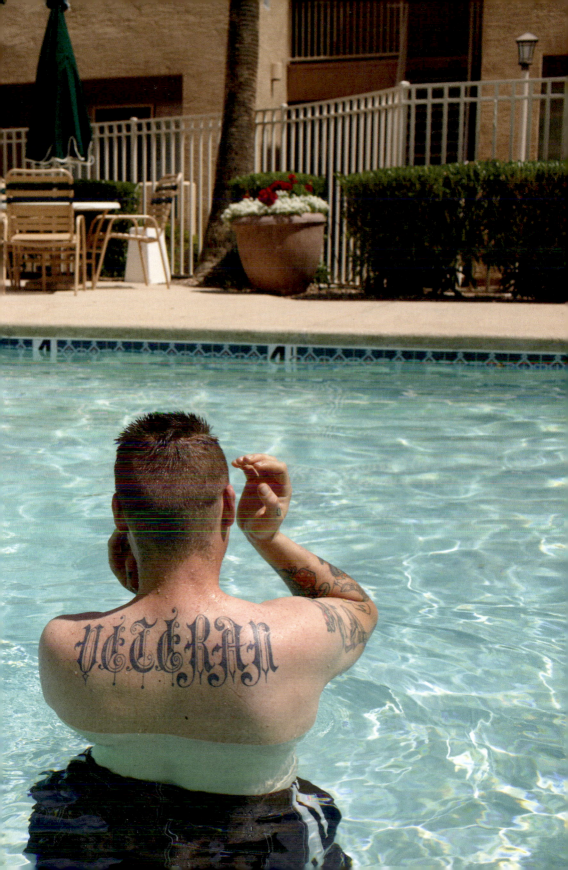

Tom Edwards

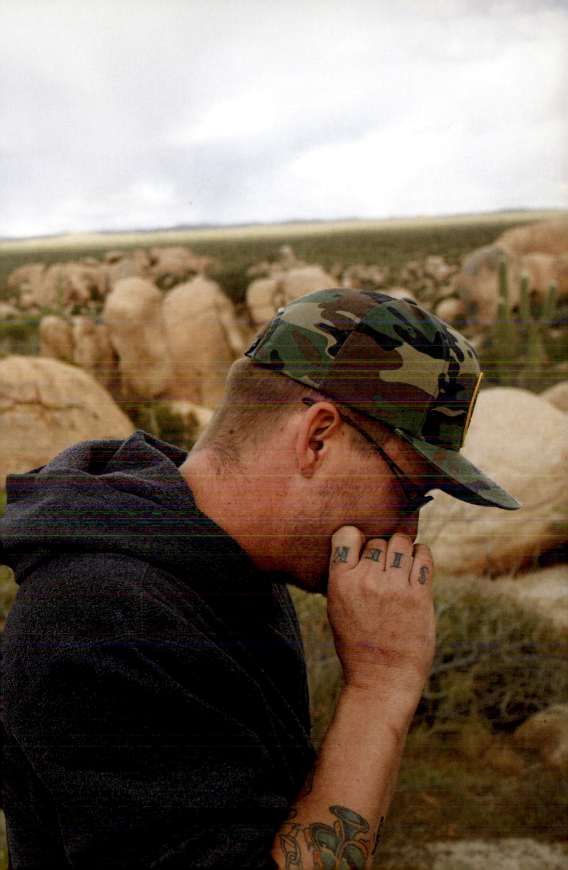

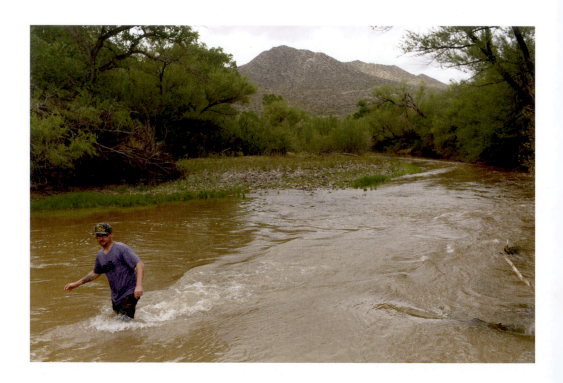

Tom Edwards

veteran buddies were all, like, real fucking combat. Except for Anthony. He was just cool. At first. I mean, I don't hold it against him, he's just an adult man with a child's mind. He just doesn't think before he does shit. Which I don't either, but at least I think I'm on a little bit a higher level.

I started selling weed as soon as I started college. It was just so easy to make money that way! Most of the kids there are young. Mommy and daddy are paying for school. They don't know where the weed's at, and I had the adult hook up. I even told my dad I was selling weed one time. I sold a half-pound of weed in two days at school. I was shocked! My buddy's house was two seconds away from the school, and we had fifteen and thirty-minute breaks in between classes and I'd call up my buddy and tell him, you need to bring me two oranges for lunch—an orange was an ounce bag. We'd just walk out from the parking lot, and that's it.

I was in school for eighteen months and got an associate's degree in automotive. It was simple. To me, at least—I'm not super intelligent, but I'm very mechanical. You just work your way around until you find out what is wrong with the car. It's easy. And there was no homework at the school. Most of the teachers, I could get away with murder with, because I was a veteran. They didn't fuck with me. I barely showed up to class most of the time and still had a 3.9 something GPA. 4.0 is the best you can get. All the tests are multiple choice.... It's, like, really? Come on!

When I was done with school, I stayed around until my buddies graduated and started selling weed full time. Anthony's brother came from Washington, and he was a hardcore fucking gang banger, and we clicked because he smoked weed and I smoked weed, and we just came to the assumption that, fuck it, we'll sell weed. We didn't even have to go back to school, they'd come to the house. All we did was sit and smoke weed all day. I got a 10,000 dollar check when I graduated—which was stupid of them to give me that much money!—because we get a military reduction. It's 10,000 dollars cheaper for me to go to college, but since the military is paying for it already, they gave it to me, they do it to all the veterans. It's fucking sweet! The day you graduate you get ten grand! So I probably spent three grand on bongs, and

vaporizers, and weed, and a lot of weed, and I was buying really, really good, expensive weed that I broke down into smaller quantities and sold at an affordable price. I didn't have to do anything. Once school got out at 8:15 p.m., we were busy for at least an hour. We were living good. We were ghetto-rich.

Then Anthony, my veteran buddy from college and I, we moved out to Kearny, and I quit smoking weed completely. I wanted to get a job at the mines for twenty-two dollars an hour. His uncle, Duke, is the landlord of the trailer park that had the house that we lived in. Duke told us to move out there and get a job at the copper mine since we got degrees in the whole mechanic thing. I had weed in my system so I had to wait ninety days because they did a hair test. So I waited for seventy-two days and I had met this girl out there that lived across from me. Well, I started smoking weed with her, and I decided not to apply for a job because I had my disability anyways. Anthony lived there with me and we got into a huge fight one night. That's what fucked everything up. I dragged my mattress out into the living room because my 52-inch TV was there and I wanted to watch a movie and fall asleep. And he was at work anyways. He got jealous because I had talked to his wife on the phone—his wife and I are friends. But she called me to talk, or something, anyway—he got mad because I was talking to his wife on the phone and that's when we actually had physical interaction. I was lying down on my bed and I kept telling him to shut the fuck up. He was drunk because he came from the bar after work. It was four o'clock in the morning. I was like, dude, you're stupid! He keeps yelling at me and got in my face, and I just pushed him all the way down the hallway into the swamp cooler. And he got all, "you want to fight? We'll fight in the front yard!" He walked out to the front yard, I walked out behind him and he said, "Alright, I'm not gonna fight you." Well, then shut the fuck up and quit barking like a fucking dog! He moved out after that. Because he knew that I was gonna kick his ass to put him in his perspective. He's not Hercules. He's a giant pussy. I don't want to fight nobody. I'd rather just shoot you and get it the fuck over with. It's easy and economical and cheaper than hospital bills. My gun is my tool. In the military, I used to use it all

the time, so now, in certain situations, I'd feel naked without a gun. Like, if someone broke into my apartment. I'd have to stab the person and it would be a lot messier than using a gun. But I don't want people to know I have a gun. I'm not gonna show it around like a fucking badge of honor.

Me and my roommate Anthony clicked because we were veterans. He was trying to be the hardcore killer motherfucker, but he was in the Navy. He was on a boat! So I called him out on his shit all the time. He's seen me flipping out a bunch of times. In Kearny, I crawled almost a mile in the bushes one night, leaving the bar. I was all fucked up, and some other guy was in the bar talking about the war, and he was saying some dumb bullshit that wasn't true, and I fucking lost it on him. They tried to grab me. I was like, fuck this! And I ran. Because they checked on the streets—I'm not gonna walk on the streets if I don't want to get found! So I crawled through the fucking bushes, all the way back to my buddy's apartment, through a ditch and a canal. They don't know what I know. I can sit and watch you motherfuckers and they won't know where I'm at. The motorcycles were going up and down the road, looking for me.

I almost jumped in front of a car, one night, too. But the guy driving was the bartender, looking for me. I was just at the side of the road, fucking hammered, and I was like, fuck it, stepped out, and he slammed on the brakes. Rolled his window down, "Get in the fucking car!" It was a bad night. I was trying to jump in front of a car, trying to kill myself. I've called the fucking PTSD hotline, like, nine thousand times. Well, not that many, but a lot. I'm telling you. . . . Sometimes you get into these fucking things, and it's, like, fuck it. You know? Sometimes you wish that you had just gotten shot over there. My parents would have a fuckton of money, and I'd be done. I wouldn't have to worry about anything.

Did you know that in the Army, before we got deployed, they had us write our own obituaries? One time, in Iraq, we were going on this mission—it was Arrowhead Ripper, I'm pretty sure—and they expected it to be fucking crazy, and people are gonna die and it's gonna be all whack—it did end up being nuts, but it wasn't as bad as they had expected. But they had us write down our own obituary. You had to write

down, on a piece of paper, where and when you were born, what you did in your life, etc. If you care that much, you should already know this shit. It was just so that the Lieutenant Colonel would be able to say at your ceremony, oh, I was just talking to the deceased last week and he told me.... No, you didn't! The Lieutenant Colonel would not just happen to talk to a grunt like that!

Some colonel who doesn't know me, I don't want him standing up there talking about me. He can keep his coins! They put little coins down by your boots when you die. We used to have to sit in the gym for the honoring ceremony when somebody died—I don't want to be disrespectful—but after you do that so many fucking times, you don't want to go back every time someone dies. The psychological effect on a person who just wrote their own obituary is, like, well, fuck! I think I'm really gonna die now!

I called my dad one night and I'm pretty sure that I was lying in bed, in Killeen, and I had a Glock pistol, which was coated with Tenifer, a non-stick surface, and I had my 19-11 shotgun, which was raw metal. The Tenifer, it slides smoother on your teeth. The metal feels heavy and it tastes bad. I called my dad and I said, "I don't know, but I think the Glock's the one." He's like, "What the fuck are you talking about?" I said, "It slides easier." He started crying and lost it. I said, "Fuck this, I'm done." That's probably the closest I got to actually doing it. Sometimes you just don't want to be here no more. Sometimes, this fucking place sucks! I've never felt like this before the war. Not that bad. I was diagnosed depressed, when I was in elementary school. I wasn't depressed—I got ADD medicine, too—but I just didn't like school. It was stupid and dumb. I took all their educated IQ tests and they were like, well, he's fucking smart! He just apparently doesn't like to do his school work! It's just boring. They diagnosed me with all kinds of shit. It just wasn't interesting to me. It was nothing with my hands.

Anthony came back one night because he wanted to use my bad-ass front loader washer and dryer. He was too cheap to go to the laundromat! I was like, whatever—I was already fucked up on, probably, ten Xanax at the time and I was drinking. We got into an argument about something. By that time, I had

eaten fifteen pills, and then I snorted the last three, just to piss him off. In a forty-five-minute span. And the whiskey, mixed with it. . . . A person that did not have drinking experience like me in the military, and after the military, I'm pretty sure they would have died, or gotten real fucking sick. They couldn't even believe what was in my system when they checked my blood at the VA, later that night.

Then I went into my room. I had a Hi-Point .45 carbine—it's an assault rifle—I had three bullets, and I loaded it and walked into the front yard and, fucking, BAM! BAM! BAM! Lit the ground up. The dog went crazy and Anthony got scared as fuck. I blacked out after that, and he took me to the bar to wait for my sister. I was drinking like a motherfucker at the bar. They sold liquor at that bar, so I bought a bottle of Jim Beam to go once my sister arrived. My sister says that I got the gun after the bar, I'm really iffy about the whole thing because I don't remember much of it. The Xanax fucked up my memory. She and Anthony both said that I said something about killing myself. I had called her and told her to take me to the hospital. I knew she would come and get me even though she lives two hours away. We got to the VA at four o'clock in the morning. She had to teach at 6 a.m. the next day. It was crazy.

I was getting so fucking depressed in Kearny. That was one of the reasons why I wanted to kill myself. Getting high on Xanax, down on whiskey, up and down, up and down. . . . One time I sat on the couch in Kearny, with my shotgun next to me, and I could have ended my life right there. I didn't leave my apartment for two weeks. People would stop by and say, "Hey, I haven't seen you in a while, is everything OK?," and I'd put on a happy face and say, "Yeah, yeah, everything's fine." They'd go away and I'd lock my door again and be alone. If I'd stayed in Kearny, I'd be dead by now. I just had nothing to do. I sat in this old house all day, or went outside. I went fishing and we partied at the river. Redneck stuff. I killed rattlesnakes, fixed leaky pipes. . . . It was not a good place for someone with . . . well, we all have depression from the fucking bullshit . . . Post-traumatic. There's guns getting shot off all the time out there. Too many drugs. I used to crawl on the floor—because, like, weed's hard to get out there. Harder than meth. So I would crawl on my floor and look through the

carpet and look for leftovers from where I would always break up my weed. That's horrible! That's crackheadish. That's, like, wow, man! Easy! And then I just ran out of weed and the Xanax were there. Fuck it. Why not? It put me in a total fucking zone. I didn't know what the fuck I was doing. I was coherent, like, I could talk to you like this just fine. But my mind was somewhere else.

It's easy to picture how someone would get depressed in Kearny. It's a little one-horse-town surrounded by nothing but hills, rocks and cactuses. Duke's trailer park is even more remote, set up a little bit outside of town in the middle of nowhere. The only excitement is a mine train going by every once in a while. When we visit, we meet Duke for lunch at one of the two town cafés and talk about his nephew, Tom's former roommate Anthony. "He's a total piece of shit," Duke says. "He's never worked a day in his life and just lives off of good-hearted fellows like Tom." Other people that we run into share that sentiment.

My sister brought me to the VA first, but I didn't like the way I was treated there. I signed a "refusal of medical treatment" or something like that. They had me evaluated by one of their psychiatrists who then deemed me a threat to society and myself. So therefore, my sister, unknowingly—she didn't know what she was doing, she was just trying to help me and I understand that now but I was pissed back then—signed this petition. She says now that she didn't know what it meant. All they need is one signature to put me under the care of the county. Once they told me, you have no rights, I fucking tripped. I threw a big-ass fit and signed that thing because I told them, I didn't want to be treated at the VA. Then the police transported me to a holding place, and the next day to a state-funded detox place in Mesa, via ambulance.

Mesa was fucking awesome, compared to the VA. It was like night and day! There were a lot of fucking crackheads there, that was a little iffy, but the food and the atmosphere were a little better. I could go outside during certain times. I did, like, ninety-six lay ups in one day just because I hadn't been outside in so long. I don't play basketball, but I had to do something or else I was gonna go crazy.

One time, I was at the VA, not too long ago, because I had to agree to go to an appointment after rehab. So I go in there, and the fucking psychiatrist lady's like, blah, blah, blah, we're talking and shit, she brings up the post traumatic from the war and everything, and then she goes, "I just think you're an addict." And I was like, "Really! Fuck you too! Thanks!" You know, what a bitch! I got mad because that's a customer-relation job. You relay your information to the customer: me. Fuck you! I didn't say you're fat but you are! I'm nice, I kept my fucking mouth shut.

I hate going to the VA because the homeless guys sit out there in the smoking section, which is right by the front entrance. And they're just out there, homeless...they're fucking veterans, at the veterans' hospital. Let them come inside, feed these motherfuckers, give them something! But no, they don't. They just sit out there until the cops kick them out, which is fucking bullshit. There's a shit ton of home-less veterans. I watch videos on YouTube all the time. I do research on this shit. It makes me mad as fuck. Because I feel bad. I mean.... All these fucking commercials saying, send your money to Africa and feed these kids.... Fuck Africa! Fix us first! Then we can go to Africa. And I'm not into politics at all, I don't care who's president. Just do what the fuck you say you're gonna do and fix the goddamn country! Quit promising all this bullshit. Legalize weed, who gives a fuck if you do or don't, we're gonna smoke it anyways! Veterans shouldn't be homeless. They did something for this country. They shouldn't be living on the street. I could see the smok-ing section from my room on the fifth floor. And they just sit there until a cop on his little scooter shows up and tells them they gotta leave. But there's a huge outside area covered from the heat, and they're veterans, and that's where I would go, too. I'd go out there, I'd give them cigarettes and I'd listen to their stories. I was at the VA one time, and this guy in a wheel-chair—a big, fat dude—he couldn't go around by himself, and this guy was pushing him.... He gets paid to take this veteran to the VA. But he just left him there and the veteran pissed his fucking pants! I felt so bad for him. This guy was supposed to make sure that the veteran got what he needed. Why is he walking off to go bullshit with somebody? It does not speak

highly of this country. And do I think I'm owed everything in the world? No. Not everybody knows I'm a veteran. But if you're at the VA hospital, you're obviously a veteran. So they deserve something. Especially if he's in a wheelchair already. I don't know.... That place is bad. Bad juju.

At one point during my visit, Tom listens to his voicemail messages, grins at me over the top of his reading glasses and says, "Oops, I guess I missed a VA appointment yesterday!" I offer to drive him to the hospital but he says, "Oh, I'm not going to the VA. It takes all day, and I get so fucking irritated, especially when it has to do with PTSD. They keep asking me the same questions over and over again. Well, if you'd read in your computer what it says in the file before my appointment, you wouldn't have to ask all these questions for the nine millionth time!"

The Phoenix VA hospital is a huge building "surrounded by liquor stores and titty bars," according to Tom. Nevertheless, I urge Tom to visit the place with me, hoping to speak to homeless veterans. The only person we run into is an obviously homeless, toothless, older African American gentleman who bums a smoke from me, and as I'm trying to talk to him, he mumbles and repeats the same things over and over again: "My wife passed away...I'm trying to keep to myself...I'm here for medical reasons...I was in the Marine Corps, in Vietnam, yes Ma'am...I'm not looking for any relationship....Please let me be now...." He's barely intelligible.

A big mural outside the main entrance reads "Here We Mark The Price Of Freedom," and as we walk around, a police officer suspiciously ask us if we need help. "I got it," Tom responds curtly and whispers to me, "Let's get the fuck out of here, this place gives me the creeps. My palms are all sweaty—I hate the fucking VA." We leave.

That night, in the VA, they put me on the fifth floor, which, in every military hospital, is the loony bin. I wasn't freaking out at first—my sister said that I was cool, when I was lying in the hospital bed, down in the ER. They checked me in and I told them about the Xanax and the alcohol, and they didn't believe me but then they checked my blood and saw that I

wasn't kidding. The VA—it's just shit. They don't treat you right. They treat you like you're a fucking criminal. I'm not a goddamn criminal. The only crime I've committed in my life was that I sold marijuana. Big fucking deal. But I've never been prosecuted for it so therefore I'm not a criminal. They treat you with no fucking respect at all. Obviously, I'm at the VA for a reason. Motherfucker, I need some help. Quit being a dick. They don't listen to you at all, they don't care. The doctor who was doing my initial intake didn't give a fuck. All he said was, "You're fucking crazy." Done. I got issues, yes, but I'm not crazy. I didn't trip at the other hospital because they were cool—they said, "look, you do your time here nice and quietly and do what we tell you to do and get the fuck out. If you flip out and go crazy, you'll stay here longer." I was like, "Roger, can handle that."

I went to a bunch of AA and NA meetings in Mesa. What I expected from an NA meeting was that there was gonna be this Jesus-freak bible thumper to be there, preaching to us. And it was not! It was this dude, looked like a normal dude, and he described his life—he cussed, he was tattooed, down-to-earth, he was a real motherfucker! In the NA meeting, we didn't have to say anything. In the AA meeting, they made us each individually go around and share. I told them what was up. I didn't care. At that point in my life I was like, fuck it, I'm sober now! I just put everything out there. The doctors asked me, what got you here? I said, I don't know what you mean . . . I declined medical treatment at the VA. They're like, oh, OK. They asked, "Are you post-traumatic?" I said, "Yes, I'm disabled for PTSD." And they got some other lady to come in there and she said, "Can you tell me about the war?" I'm like, why? That has nothing to do with what I'm here for! I'm here because I took a bunch of pills, drank too much and almost shot somebody. I need to be evaluated to make sure that I'm mentally capable of being able to function in society. It doesn't have anything to do with the fucking war. She doesn't need to know about it.

NA and AA—it's a bunch of commiserating bullshit. People who go there just feel sorry for each other. I can't deal with that, I already got depression issues. People in there were, like, I've been sucking dick for heroin for the past sixteen

years—what the fuck!? I'm not even close to this bad! I don't need to be here!—I was in rehab for sixteen days. I had charges against me . . . for being crazy, I guess—well, I don't know the exact terms, but, like, for being a threat to society. It was pending, and they told me, you're gonna see a judge. Cops will come and pick you up and you're gonna see a judge. But they waived all the charges because of how I acted in the hospital. They just let me out. My sister came to pick me up and I just walked out the front door. I was lucky. Because, some of these people, they can't own guns now, forever. I could go and buy a gun right now if I wanted. I have no firearm restrictions against me.

I had a calendar in my room and every day I was clean, I put down in there. I was clean for a while, and my extended family was all, like, super-excited: Oh, you're sober! Hooray! It was exciting, but that was the only time they've ever talked to me in my life. So fuck that. The night I got out of rehab I smoked a joint. I was staying at my friends' house and his wife was driving me crazy. I did feel happy and felt a sense of accomplishment that I was sober, yeah. But then I got back into reality and I was like, fuck it.

I went back to Kearny to pick up all my shit, stayed there for a week and moved in with another buddy and his family here in Phoenix and I stayed with them for about two or three months. They were against drinking and smoking. I drank at work and didn't tell them. Once I got this apartment, it was fucking over with. I'd stay after work and drink and then come home.

Do I think I'm an addict? Like, an alcoholic? I use marijuana as a coping mechanism, yes. So that would also mean that I'm dependent on it. Alcohol—I'm a classified alcoholic, but I'm not your standard alcoholic. I'm not a drink-everyday alcoholic. I'm a binge-drink alcoholic. When I drink, I drink! I will drink until I can't function anymore, until I cannot move.

Depression's a huge issue. I smoke weed. I was on Depakote—a mood stabilizer—for about a month. It was cool, but when I'm not on it, that's what I don't like. With me, if I don't take any anti-depressants, I'm stable. When I'm on Depakote and I forget to take it, it's BAM! I feel the crash. I don't want the fucking crash. I'd wake up and be fucking pissed

already. It's an artificial happy pill! So I don't take that shit. Do I smoke a little too much weed? I don't think so. Do I smoke a lot of weed? Yeah! It keeps me sane. And I can go to work, high as shit, and work fast, do my job, nobody says shit to me. I stay focused. There's something in there that helps me. Am I saying that because I'm an addict and I just want to smoke some pot? Maybe. I could get a medical marijuana card, but I don't want to spend 300 dollars on it.

I still want to go back to Iraq. Because it's so simple. It's either you die or you don't. You ain't gotta worry about anything else. You gotta make sure you don't blow up or you don't get killed. That's it. The easiest job in the world! It pays decent, there's always food, you ain't gotta worry about electrical bills or nothing. You just wake up every day and go on patrol. I tried to re-enlist, called a recruiter and he said, you'll lose your disability. If I go back in and get out, I'm not allowed to have disability. Period. That's health care for free for the rest of my life. That's not cheap, so I didn't do it. Then I wanted to leave the U.S. just to get away from all the dumb shit. We just got too many fucking rules and regulations. Like, if I wanna smoke pot, I wanna smoke pot! Who gives a fuck? I'm not hurting anybody! I'm not gonna get high and go out and beat people up. The stigma . . . my parents. . . . You'll hear the way my dad talks on the phone with me. I'll put him on speaker-phone one time and won't even tell him that you're here: It's just sheer disappointment. Out of every word. It's just: You're not gonna work in a kitchen for the rest of your life! You can't get tattoos on your neck because you're going to ruin your life! I'm happy with my fucking life right now! I'm sorry I'm not a millionaire. I don't want to be a fucking millionaire. I enjoy the work that I'm doing and it's easy. I enjoy hanging out with the people that I work with here. It's fun!

It's just that nothing's ever good enough for my parents. It's like, ah, you're doing this, you bought a motorcycle again, you're smoking pot. . . . Well, they don't know that. They know that I'm drinking again. My dad's not happy. I know he's not happy. It pisses him off that I have a degree in the automotive field, because that's where he's in, and I'm not using it. It's just sitting there.

My parents think I'm just a loser who works at a restaurant, smokes pot, and has tattoos. Because I smoke pot, I'm not going anywhere in life. Marijuana is my Depakote. You can ask people: If I don't smoke, they don't want to talk to me. I'll be a straight asshole. I smoke weed to stay calm and be functioning in society. It's organic. America is a pharmaceutical-dependent country. If Percocets were no longer available, do you know how many people would go into withdrawal and freak out?

That's another reason why I wanted to move away, because . . . Canada just seems so friendly. I've never been there, but it seems like they care about real shit, like health care. They take care of their people. I want to go and move to a more relaxed place where not everyone is all hustle and bustle about the fucking dollar. Yes, you need money to live, I understand that. But if you work your life away just so you can look like you have money? What did you do with your life? Here, you have to be something to be accepted into society. Who cares that I'm almost thirty and still live in an apartment? Who cares that I don't have a car? Do I want to get married and have kids? Of course! When the time's right. But I gotta get my shit together before I even think about that.

I researched living in communes. I even called one and talked to them on the phone. I think it would be a great idea! But the only thing is . . . one guy warned me and said, you gotta watch out! There's a lot of religious bullshit . . . and I'm not into that at all. In Kearny, I had my whole yard planned, for when the gardening season came back around—I just want to be self-sufficient. I don't have to worry about a bunch of people deciding whether or not I'm good enough to do whatever I wanna do. People judge me wherever I go. They see me and think, oh, he's just poor white trash.

I miss Fort Hood like crazy. I miss the camaraderie. My friends here . . . I've known them all my life but I can't relate to them anymore. Their noses are so stuck up and they're superficial and fake—the only thing they care about is impressing other people with their belongings, their cars, their houses. It just irritates the shit out of me to be around them. The soldiers in Fort Hood were real. We hung out at the Sport Shack, this trashy-ass bar. We didn't care what anyone thought of

us. Sure, Nike every once in a while would put on a show and dress super fancy, but Rollings sure didn't give a fuck about anything.

As far as I know, every year that I was in the service, when George Bush was President, I got a raise. But everybody's like, fuck Bush! He's a murderer, he's a baby killer! That's the first thing everyone wants to know when I tell them that I was in the Army, they're like, what do you think of Bush? I like the motherfucker, he gave me a raise every year! I did my job, I don't care who the president was. I don't even know what Obama is—I don't know the difference between Republicans and Democrats. I don't care about oil. I was over there because I wanted a job and to make sure that my buddies made it home alive. I have never once voted. I don't really care about this country, to be honest. I care about the guys that I was in Iraq with. And my grandpa was a fucking veteran, I'm a veteran, I got veteran buddies, and I want other people to know that, you know, I'm flying the flag for the guys that can't fly it no more. I'm not flying it because I'm like, go, USA! I'm flying it for a reason and it's not just a yard ornament. I don't display being a veteran much. The only people who know are the ones who need to know. The people at work ... I had to fill out some paperwork before I started working there. "Do you have any medical conditions?" was on one of the papers. I asked them, do you really want me to fill this out, and they said, yes, go ahead. So I put down: post-traumatic. They're like, what's that? I said: Research it!—99 percent of people have no clue what PTSD is.

I really honestly don't care anymore. Like, people come into work and bitch. I'm like, smile, motherfucker! You're alive. You're here, breathing. You made it to work. What do you got to bitch about? Be happy. Just quit being greedy and be happy. Distribute! Help out other people. There's so many people in this country who need help. Like, legit people. Not even just veterans. Just fucking quit everybody being about themselves. Help out society and get this place fixed! It's ridiculous. I could live with such minimal shit, and be happy. That's pretty much my view on society—is that we're all fucked. We're gonna eat until we're all 400 pounds, and we're gonna die of horrible diseases of all the bullshit that we

eat and all the pills that we take. And stress. Even the History Channel is going down the tubes.

You know, when the wars first started, it was cool—everyone was like, oh, we support the war! Now, fucking, ten years into it, they're, like, pshhh. . . . They don't give a shit. The masses don't. Half of the kids I work with, they don't know nothing about Iraq and Afghanistan. It's their generation! Whenever I tell them that I was in the war, they ask me, "How old are you?" I ask them, "What do you mean, what fucking war was I in? It wasn't Vietnam or Korea! It's only the war that has been happening for the last . . . well, forever!"

What would my reaction be if some dudes in the same uniform showed up at my house and banged on my door? I'm gonna defend myself! You ain't touching my house! Now, flip that role. That's exactly what happened over there. Maybe the dude just didn't want you in his house, or his country. I don't blame him. If you kicked my door down, I'm fighting. I understand that—he's protecting his family. The amount of dead people—I don't even mean just the amount that we killed—but through the sectarian war . . . every day, there were dead people.

I don't remember who told me, whether it was our Iraqi interpreter or a soldier, he told me that Iraqi women wear black for thirty days after a death in the family. That's why all these women were always wearing black! You might see a random woman wearing something colorful, but that just means that she hasn't been to a funeral yet. Holy shit! Look at all these ladies! The amount of suffering that we've brought to Iraq is unimaginable. We destroyed it! We took their infrastructure and crushed it. They have nothing. All the factories that we used to walk through—like, a potato chip factory. There were still potato chips in the boxes, ready for shipping. Bottle factories . . . they made twenty-ounce bottles for Coke. We tore it up. The Iraqis used to have legit infrastructure. We de-fucking-stroyed that place! People will never understand what I mean when I say we destroyed it: The buildings are gone, it's rubble, like in World War II. I don't know what we've gained. I lost my wife . . . Blackwater and Halliburton got rich. And European companies, too. Little Iraqi kids. . . . They're gonna live in poverty for God knows how long because no

one's gonna rebuild that country overnight. They have to now walk down to the river and get buckets of water, which is probably contaminated—welcome to the caveman era! Half the schools are bombed, they have bullet holes in the walls. Would you send your kids to a school like that?

Jessica: We never really had a strong brother-sister relationship. We always fought. When Tommy first went over to Iraq—I'll probably get really emotional when I talk about all this—when he came back from his first deployment, I think our relationship got stronger, because of what he had gone through. My parents had been living in Oregon at the time and I remember driving with them to the airport. *(She starts crying.)* I was living in Arizona, I was married here, but I went to Oregon to see my brother for the last time... I remember my dad was working and we had to take my brother to see my dad, then I went with my mom to the airport, but I couldn't even go in, I just sat in the car the whole time and cried... because... the guilt. From having such a poor relationship as younger children. It was really hard to see him go to war. I'm older, but we're only eighteen months apart. When he was over there, we didn't really know.... We knew he wasn't safe but we didn't understand how the war.... It brought a lot of tension, really, between my ex-husband and my parents. At the time, it was when Bush and John Kerry were both up for election. My parents very much wanted Bush to win, and my ex-husband was very anti-Bush. Just the different views on weaponry and how much money was supposed to be provided for the military—all these views brought a lot of unspoken tension. Of course, my parents were just supporting whatever my brother was supporting.

So he left, and we knew that there was a lot going on in Iraq, but we didn't know to what extent. We had heard from him every so often, not a whole lot. When he came back, I remember he had a CD—or it was on someone's Myspace page—he had a slide show to a Toby Keith song, he showed it to us, and I just broke down. They were just pictures of the guys that he was with. They weren't nearly as gruesome as the ones he brought back the second time. Just pictures of the people, the vehicles, the gear—stuff like that. Having him over

there was so hard that even—like, once a month, the school where I worked at had what we called a Patriotic Assembly, and they did the national anthem—I couldn't even listen to it without crying. I would always have to leave.

It's kind of hard to see, initially, the changes to his personality, because when he came back, like I said, our relationship was stronger because I tried to be more patient and easygoing. I've always been known as a high strung person. Things were OK. The second time he went to war was when things got a lot worse. Before he was deployed the second time, he had met his ex-wife, and called to say that he was getting married. Of course, it was, like, the day before that was happening. There was no way any of his family could be there. It seemed like he wanted to get married because he needed a reason to want to live while he was in the war. If he didn't have something to come back for, he didn't have any motivation to want to live.

While he was in Iraq for the second time, he didn't seem like he was having any issues. He would call and ask, "Can you hear that in the background? That's just a bomb." Like it was an everyday thing. So it seemed like he was doing OK. It was when he came back that you could see the drastic changes that were happening in him. He would call me and my parents, drunk, at any random time—you know, at two o'clock in the morning, and then two-thirty, and then three o'clock—but yet, you'd never actually finish a conversation because he would hang up. Because maybe you said something that wasn't right and now he's gonna go kill himself. It was really hard for us, being away...what do we do?

He wasn't back for too long when he had that incident in which he shot up a car. I'm sure he's told you about that. That definitely sends out alarms. On the other hand, he's kind of pre-disposed to bipolar behavior and a mood disorder. But then adding all that extra stress from the war just makes it even harder for him.

The summer he went AWOL, it was 2008—I remember he had called me and said, I'm on my way! I was like, oh, what are you doing? And he said, I just left. I'm going AWOL. He was coming to me to stay with me and my husband at

the time. He was with us for maybe a week. You could tell just from that experience right there—all the hardships that he was going through, mentally, from the war. The nail polish story—have you heard the nail polish story? Him and some guys had befriended an Iraqi family. They spoke English. . . . These stories came out when he was meeting with the lawyer who was helping him with the AWOL stuff. He had to talk about his experiences in the war and I was there for a lot of them. So this Iraqi family would make desserts and tea for the soldiers, and one day the little girl who was about seven wanted to paint one of the guys' fingernails. My brother—you know how he is—he agreed to let her paint his nails and they took pictures. When the soldiers went back the next day, the entire family had been killed. That story sticks with me more than. . . . That's just one of the many stories. At the time, I was teaching eight-year-olds. . . . He struggled with that incident a lot.

Then, the friend who was killed when they switched shifts? One of his really good friends who was married with kids— Tommy had switched shifts with him, and then that guy was killed on my brother's shift, stepping on a mine in a house they raided. So he did carry—and I'm assuming still does carry—a lot of guilt from that. He was very upset: Why did he die? I was supposed to die! And then of course, his near-death experience, being blown up in the Humvee. The second deployment had a greater impact on him.

Most recently was his trip to the hospital. He called me in early December 2011, and he had been, for a few weeks, calling me and my parents on and off, really drunk and upset, "I'm gonna kill myself," and then he would hang up. Really depressed. He doesn't know why he's there, he hates where he's living, his friend is screwing him over, he doesn't know what he's gonna do with his life. . . . The whole gamut of: Everything isn't right. Of course, you can never get through . . . I mean, you can't have a conversation with him when he's like that and then if you try to bring it up when he's sane, or not going through one of his little episodes, then he doesn't want to talk about it. He will shut you down. He doesn't call my dad very often—I don't know why but it does actually hurt my dad. My dad is really pretty upset about it—but he'll just

hang up and yell, I'm not gonna talk about this! Especially at me. He talks to my mom more than anybody.

Leading up to the most recent event with the hospital.... A couple of weeks before that, he called me around one o'clock in the morning, and he said, I'm calling to say good-bye now, this is it, and he would hang up. I called my parents, like, "Oh my gosh, have you talked to Tommy? I don't know what to do! I tried calling him back, but he won't answer!" And then he'd call again. Going through the whole thing again. What are you supposed to do? Anytime he would call drunk, that's what he would be saying. He was carrying around a lot of guilt. He was saying that he would have to kill dogs over there, because the guys would just shoot them for sport, and then he would have to put them out of their misery. For me, you know, I'm really into animals, so that's just heartbreaking to hear. But I know that's not even close to anything that was going on. I think it has a lot to do with that guy dying on his shift.

He called me, it was a Wednesday night, at, like, eight o'clock. I had just gotten home from work. And he said, you need to come get me now. I asked, what's going on? He said, I need to go to the hospital. Then his friend Anthony took over the phone and told me that I needed to come get him right now because he's all messed up. I'd been out to Kearny once, so I got in the car and I didn't even print directions because I just assumed that I knew how to get there and I could call people and they would kind of give me directions. I realized on the road that I only had enough gas to get there and that my cell phone was about to die. I was a wreck. I was like, oh my gosh, what's going on? I have to work the next day! I was supposed to participate in this basketball tourna-ment.... Anyway, I had to stop and get a phone charger, and I got lost and I had to stop at a truck stop to get gas. I had ended up an hour out of the way. Of course, they're expecting me to be there by eleven o'clock. I finally got there and it was one in the morning. I parked, it was freezing and Tommy was com-pletely wasted. Had a beer even in his hand. Or some sort of can in a bag, that he ended up putting a dent in my car with, falling against it. Anthony and Tommy were fighting—Tommy was totally drunk and kept saying, I'm gonna kill myself, all of these different things. Tommy went into the house and I

asked him what he was looking for. He wanted to find one of his guns. He was looking for ammunition, and was just super angry. Angry in general, but very angry with Anthony because he was moving out to Washington and Tommy felt that the whole reason he moved out to Kearny was to help Anthony. That's kind of what sparked the whole thing, apparently.

So he's looking for guns, and of course, he had his dog, which was a big black Lab. I have two dogs of my own and I tell him, I can't take your dog! He says, I'm not going if the dog's not going! So I tried getting Ouze—the dog—into the car but he wouldn't get in the car. I said I will come back the next day for the dog, but Tommy started breaking things and said the dog needed to come with him. Tommy went back to the house and started breaking things, throwing things—he started looking for anything and everything that he could possibly break. All the way down to a jar of salsa that he threw out of the house, into the street. I was outside, and he was throwing all this stuff—he throws a huge bong out and breaks it. And he starts punching things . . . the wall—just everything. Then he finds this big gun—I'm not exaggerating, it was a huge gun! He goes outside and starts shooting rounds off, up into the air. I was freaking out. I was scared to death. I was calling my dad, I was in tears, I said, I don't know what to do, he's shooting! I was supposed to be taking him to a hospital, like, what am I supposed to do? My dad told me to leave. "Get out of there," he said. "There's nothing you can do!" Being who I am, I couldn't leave him there.

Somehow we had finally managed to put Ouze into the car and had his food in there as well. And as Tommy is freaking out in the house, he's putting things into my car. Random stuff—his paper work, all of his military papers. He's loading up his belongings that he feels that he needs. Tommy starts pulling the mail box out of the ground because he had paid for it. He's kicking my car and he's literally shaking the wooden post and taking the mail box out of the ground. Then Anthony got angry and I'm just like, oh my God! Can somebody please just fix this? What am I supposed to do? Finally, Tommy gets into the car and just starts cussing at the dog, telling him what a worthless piece of shit he is . . . this is ridiculous, you don't just start yelling at the poor dog! So, here I am, driving, at now

two o'clock in the morning, with him saying how he's gonna kill himself with the gun in his hand, and he can't stand me. And it's freezing.

That was a long, two-hour drive to the hospital. I didn't want him to smoke in the car, so I had his cigarettes hidden, but he didn't know that. The whole drive I tried to question him about the day. I knew this was more than just alcohol. I asked him, what did you do? What happened? So I could get as much information about what he had done. He said he'd snorted the Xanax and taken Klonopin, plus he had been drinking the entire day.

It's been an episode that I've been pretty traumatized by— that I actually went into some therapy over—because it was so scary. I've never been so scared in my life. My brother who can't stand me! Saying he's gonna kill himself and he has a gun! And he's angry because I'm not giving him his cigarettes! He ended up putting the gun in the back of my car, thank God.

We got to the hospital, and of course we had to argue about where I was supposed to park because he remembered it from how it used to be. They've changed things and he screamed at me because I wasn't parking in the right spot. So I parked in the unloading zone—which I knew wasn't gonna be a good place for me to park permanently—but I wanted to get him in the hospital. It says everywhere at the VA: No smoking, no smoking, you can't smoke here. Oh, well, yes, he was smoking. Now it's, like, three-thirty or four o'clock in the morning. He's going, you know, like, I've served this country! I can smoke here if I want to! I just sat down and waited on the bench, while he was going off. I needed him inside these doors and inside the hospital, because otherwise he would change his mind and then, what was I supposed to do?

So we get in and there was nobody else there at such an odd hour. The lady asked us, what are you here for? He rattles off why he's there, he rattles off killing his own dog, he gives her his social security number, says he's depressed, went through the things that he had had, tells her everything. She wasn't very nice. At that point, I had to pee because I had not peed since Anthony had called me, so I went to the bathroom and when I came out, he was gone. I asked her, where did my brother go? She said, he's in triage. I didn't know what that

meant and eventually they let me come back while he was undressing. He's whispering to me, that, he needs his cigarettes, he needs his phone, that I need to sneak in whatever he asks for—he's telling me all of these things and I was just, like, uh-uh, yeah, sure, as he's putting his clothes in a bag. The nurse came and took his blood and heart rate. He was doing a pretty good job of, like, customer service with my brother, trying to get him to talk—my brother was just rattling on. Tommy said, eventually, it was all my fault, but I'll get to that part later.

He was drunk when he killed his dog—and I don't know everything about it, but he was complaining about things that one of his dogs had destroyed, like his shoes, and that he dug a hole in the living room—and Anthony's uncle, Duke, he said: Just kill him. So he killed his dog, and Anthony's dog. Which, for him to do, is completely out of character. Completely! My brother is such an animal lover, all the way down to lizards. So for him to have done that . . . you know that something is not right. Beyond not right. He doesn't even know where Ouze is right now. He's actually staying with one of my friends, his name is Trapper now, and he's doing phenomenally well. But Tommy has no idea—he hasn't even asked about him once.

Mind you, the VA—I don't know how much you're doing about the quality of the VA care—well, the room that he was in and the bed that he was laying on had blood splattered all over. In the intake of the VA hospital! I'm dead-serious. I had seen shows on TV talking about VA places but I thought, no way that's what's happening here. But I'm not kidding! I'm not being sarcastic: Blood splattered all over the bed. Of course, my heart is breaking because here I am and he's going through all of this. I know how hard it's been for him. And it's been emotional for me and my parents, just not knowing what to do. Whatever we do is not the right thing. (*Jessica starts crying again.*) We try to help, he doesn't want to listen. . . . It brings a lot of stress, and actually, just throughout this incident, a lot of tension between me and my father, because of disagreements and choices.

So, anyway, he whispers angrily at me to get him cigarettes and his cell phone. I told him, you can't have either of these

things here! I even asked them, is he allowed to have his cell phone? They said, no. "See? You can't have that here." "But that's what I want," he said, and he was getting so angry with me to the point that he kicked me out. He said, go! I wasn't welcome anymore.

I went out to my car and behind my car—still parked in the unloading zone—were cops. Here I am: There's alcohol in my car, guns, and a dog. I haven't slept. It's now, like, four-thirty in the morning and they're telling me that I can't park here. I said, "I understand!" Then I just broke down, in full-blown tears. I explained to them what happened and they said, OK, but you can't park here. I'm scared to death to get into my car: I'm a teacher and I could lose my teaching license with the alcohol and the gun in my car! Ouze was still in there as well and when I approached him, all the hair on his back stood up. I went to the cop car and said, "Look, I'm not comfortable driving with all that stuff and the dog in my car." I was a total wreck. So they took everything out and covered the weapon—as long as it's concealed it's not a problem. I made sure that they took my brother's phone into the hospital. As I was driving home, I called my ex-husband and he took Tommy's dog for a couple of days. I got home, I took a shower, and I went to work. I was emotional and completely traumatized from the incident. It wasn't a very good day at work. I had to talk to my boss about what was going on.

I had been on the phone on and off with my parents that whole day. My dad said that the hospital had called him and that my brother had refused treatment and that they weren't allowed to give any information out to him. So they called me, also because I'm the one who was with him the day he got in. The lady told me more than she was supposed to. She said that they're gonna petition him. She said that I could possibly be asked to go to trial to testify for his state of mind.

I think it was later that day that Tommy called me, screaming at me, that it was all my fault that he was at the hospital. It's all my fault that he doesn't have any of his rights, that he wants a lawyer, the treatment has been horrible—I took him there and I told them about the dog and about the drugs! "But I did not!" I told him, "you spilled everything!" He said, "I don't remember any of this."

The VA never contacted me again. Later on the same day, Tommy called me again and told me that he was going to be transferred to Mesa. It turned out that one of the cops I was talking to that night was with Tommy in Iraq. I was really worried about him being there but I thought, thank God there's somebody there who knows him.

I went out to see him in Mesa the next day. It was the start of a complete and total change. I had no idea how much my brother was addicted to drugs! I knew he was smoking pot because he would argue with you, you know, whenever you said that it wasn't a good idea. Just why it should be legalized, etc. I had no idea about all the other stuff. So that Saturday I went there, he wasn't wearing his glasses because they broke during a session with a dog. They had brought in a therapy dog because he said that he missed Ouze so much. His vision is absolutely horrible and I wish he would go to the VA and get his glasses. He's still wearing reading glasses I bought him at Wal-Mart in December!

I took his glasses and he also asked me if I could bring him food from outside. I said, "yeah, I can come back tomorrow and bring you food and try and get your glasses fixed." They wouldn't fix them at the mall without a prescription. So I tried to fix them myself, with some stuff I got at Home Depot. It was the nose piece that was broken. I went and bought him clothes and socks, and he wanted Popeye's Chicken—well, the next day, when I went back, I couldn't find a Popeye's Chicken but there was a KFC, the next best thing. When I went in there, he hated the way I fixed his glasses and broke them again. He'd let me stay for all of five minutes before he kicked me out. After I drove an hour and a half to drive out to where he's at. I got so angry at him: You gotta be kidding! I just drove one and a half hours, I brought you food, I brought you clothes, I fixed your glasses—and that's all I get, five minutes?! But, OK, I had to get over it, whatever. He's just very impatient with me. Not with anybody else. We've never gotten along, so sometimes it's hard for me to separate him not getting along with me and him reacting to PTSD. It's hard for me to draw the line.

When he got out of rehab, I drove him over to Buckeye, where he was supposed to stay with his friends, the people

who also, in the meantime, had adopted his dog. In the car, he was talking about how he doesn't need drugs, how the therapies were so helpful, he wants to get a job so that he can work in those hospitals.... He was talking about how he was working in there with the different people and helping the workers calm people down ... just, like, completely changed! I was so hopeful that this was gonna work and that this was going to be different. We got his medications filled and I dropped him off.

The next day, I'm getting texts from the people he was staying with, asking, where is Tommy? He's left! I don't know where he's at! So I call Tommy and he tells me that the wife is addicted to Percocet and that she's pregnant. Of course, I had to be a character witness for these people in order for them to discharge him! I was angry with her! He ended up moving in with other people. He was doing better, and I thought—I mean, every time I talked to him he was talking very positively—you know, I'm gonna be changed, and he had all these positive quotes.... It seemed, like, oh my gosh, this was really good! It's worked! Well, the day that I went to pick up my landscaping tool at their house in March—before he moved into this apartment—I knew immediately that he wasn't clean anymore. Because of his appearance—his hair, his beard—and he was being short, rude, cussing at me, no patience, wouldn't answer any questions I had—I knew he was not clean anymore. I helped him move in here and we did a couple of trips back and forth, and I just flat-out asked him, "Are you still clean?" He said, "nope!"

So, here he is. Back on drugs and drinking again, and not getting help. And he was off his meds, too, last time I saw him. He's not getting the help that he should be getting. It's always an excuse, though. It's never his responsibility. It's always: The VA is too far. I work too much. I can't get there. My appointment was too early, I couldn't make it. He doesn't see the effects of the decisions that he's making. I understand that he's upset by the VA, but why does he have to suffer for that, too? Can't he go get help that he needs, get the medication so that he can do something still with his life? It's hard because he's so smart and very talented with hands-on kinds of things ... but he makes the most irrational decisions and

does things that I don't understand. That summer that he went AWOL, he lived with me and my ex-husband and he fell asleep in the shower and flooded the back of our house because he was drunk, passed out. We weren't home, we were on vacation.

He has spent so much money on drugs, on alcohol—he could have so much more, you know, a more stable environment, but he hasn't made the choices. I know he was really close with our grandfather who was in the war, and I think his initial reason for going in the war was to honor him because it was about the same time as my grandfather passed away, on January 14, 2003, and he went into the war not too long after that. Did he tell you about our grandfather, that he was in a book? Your book is important to him. I guess he's always felt kind of insignificant—if that's a good word to use—and for someone to take an interest in him, like, in what he has done, it does mean a lot to him.

I remember I had a job interview—I ended up turning the job down—but they'd asked me, "Who is your hero?" And my response was, "my brother." Before his experiences, that would have never been my answer. I started crying, actually, in the interview. I didn't go into any of his story, but I explained to them who he was and what he was doing. I do feel very connected to him and I feel some guilt for the way I treated him as a child. But, you know, he was just as awful to me! You see how short he can be with me.

I had spent a lot of money—I wanted to make sure this whole experience, his medication, the clothes, the glasses, all that I took care of because he had nothing. After he got one of his disability checks, he asked me, "How much do you want me to pay you?" I spent about 300 dollars on him. I said, "just give me 100 dollars—I would be real happy about that." I wasn't really expecting to get anything back. He drove to my house with Anthony's wife and gave me the money and we turn to go say hello to my dogs—he goes, "man, your ass is getting huge!" In front of her! That's just how it is, though, with me. He cannot say a nice thing to me. But then, he calls whenever he needs something.

Tommy being over in Iraq has affected me tremendously. When I was teaching around Luke Air Force Base it was just

amazing to see how little people really understood. . . . To understand the effect the war is actually having. . . . My biggest concern is not our generation, but the next generation. Because of all the soldiers our age and their kids. What the military dads and moms went through and how that has affected them and how that's going to impact the next generation. That concerns me. Their parents in the war. I had a girl in one of my classes, she's a junior now in high school, and her dad was one of the military police who actually caught Saddam. Seeing her always worrying about her dad. . . .

If my brother had kids—I know he would be a really good dad—but I think that there's a lot, emotionally, that would be missing, if that makes any sense. I don't think people understand—yeah, they understand we're in a war, yeah, it financially affects our country, yeah, there are people dying—but it's so much more than that! It's all the damage that it's doing to those that are over there. And then, in turn, for example, just in my brother's situation: Everything he went through, and the impact that puts on his family members, and that has even gone to friends of mine—just my stress from my brother's experiences. . . . It isn't just a one-and-done and it's over! It's a domino effect. It's trickling down. It spreads. It's to the point now where almost everybody knows somebody who was in the war. But the people that don't, they don't have any idea what's actually happening to these soldiers! They don't see the changes. They don't understand. I don't understand it very much at all, either, because I haven't been to war, but I see the changes and what's happened to my brother and how sad it is that what could have been a really productive life is now, after this experience, going through what's hopefully just a hardship and he will adjust and not be so scattered. I don't think that's understood. People say, "Oh, PTSD. Whatever. . . . That's just something that's made up." No! This is serious! There is a complete separation between these two wars and the American people. Everyone's very disconnected. It's not talked about, at all.

Tom Edwards

EPILOGUE

Jamie McFarland, U.S. Army Infantry veteran, born 1986, from Zachary, Louisiana

Jasen Nolting, U.S. Air Force veteran, born 1982, from Metairie, Louisiana

2012
New Orleans, LA

After my week with Tom, I drive from Arizona to New Orleans, where I stay with a friend for a few days. I visit the local VA, hoping to meet and get a perspective on homeless veterans, and run into Jamie, twenty-five, and Jasen, thirty, both ex-military, suffering from PTSD and, not too long ago, homeless. Right off the bat, they agree to talk to me about their experiences. When I ask them where they're staying now, they tell me about a halfway house—"sort of a homeless shelter for veterans." The facility is part of the Louisiana Veteran's Health Care System and the VA covers the costs for ex-military members. Once you get admitted, you're required to attend daily meetings at a VA Outpatient Clinic, or at the transitional housing facilities. "We have AA meetings every night," they say. Patients can stay at the facility for up to two years—Jasen plans on staying for at least six months, and Jamie for about ninety days.

Jamie talks in an interruptive manner, he's fidgety and nervous, in a way that seems common with ex-addicts. He readjusts his baseball cap a lot, often begins a sentence and then trails off, or jumps from topic to topic. I notice a green 550 cord bracelet around his wrist, and when I ask him about it, he says, "In the Army, we used this cord for pretty much everything, like, parachutes, or just to tie our gear down. You normally see soldiers wearing buddy bracelets made out of black metal, with the name of the fallen engraved, but we lost so many fucking people, those bracelets would go up to my elbow. So our unit started wearing these. We also got tattoos made especially for them."

Jasen is introverted and soft-spoken, his green-brown eyes quietly focusing on me as he speaks. Even though he and Jamie haven't known each other for very long, they seem like old friends. When I tell them about the veterans I've been working with and what they're going through, they laugh. "We're not

laughing because it's funny. . . . It's just because what you're telling us is such a familiar story. It feels like we're looking into a mirror."

After our talk, we go to Burger King to get a milkshake. As we walk back to the VA, Jasen checks his phone and reads out a news headline that popped up on his screen: "Four Soldiers Feared Dead in Afghan Helicopter Crash." Jamie, who walks in front of us, stops and turns around. "We're good, Jamie," Jasen reassures him, in a heartbreakingly caring tone, but Jamie asks: "What unit were they in? My old unit is over there now . . . " and he can't let it go.

Jamie: My first time, when I came back from Iraq, we lost fifty-five people the first six months we were there. Whenever I came back, my friends and my family asked me, what's going on? Because they saw that I was just hangin' to myself, I didn't want to talk to anybody and they asked me how it was over there, and I didn't really want to talk about it, so I just showed them pictures, and once I saw the pictures, everything started playing back in my mind, and I started explaining it to them, and everyone was like, dude, you're a psychopath now!

Then I got stop-lossed and had to go to Afghanistan, I was supposed to get out a year earlier but they kept me in. I went there as a sniper. . . . The main thing, though, the way the insurgents did stuff, they would just use kids . . . in villages, and we would just dump on villages. I was a 50cal gunner on a Humvee. . . . That's what it was all about. There is no point to be over there—just to stay alive. And once you got past that fact that you're gonna die, it was kind of easy. We really quit giving a shit about humanity in general. So when I came back, I hated much of everybody. People were talking to me and looking at me, like . . . I just quit talking about it. People would ask me, "Are you in the Army?" And I'd say, no, I'm a garbage man. I would just make it up. But they still knew that I was Army because of my haircut. When I got out, I wouldn't shave, but. . . . It's just been tough being back, you know? I can't relate to anybody. And when I try to, they just think, literally, that I'm a psychopath or I enjoyed the war so much, and I guess I kind of did, so I tried to get back over

there, but I ended up going to jail because I started using Oxycotton. I hurt my knee from jumping out of a helicopter and they prescribed me Oxycotton and Xanax. And that was just a field day for me because I didn't have to worry about failing any drug tests so I just got high all day, and I could relate to people again! It was mainly about drugs, you know. Now I'm in the process of trying to clear that out. It's tough.

My First Sergeant was a really good guy, and he knew something was different about me. I wasn't able to run, because of my knee, and so I pretty much did other duties, or did nothing but going to doctor's appointments. I was stationed in Alaska. He came up to my room one day and he caught me using, and asked me, "How long have you been doing this?" I said, "Pretty much since I got prescribed to it!" He said, "We're gonna get you help." I went to a mental institution in Oregon, for forty-five days. Rehab, for my knee, for pills, for everything. It was a great place. That pretty much saved my life until I got back home. I just didn't work with my coping skills. When I came back I was sober for seven months. Then I got out and came back home, got with my ex-fiancé. She was on some stuff, too, and it was just an excuse for me to get back on, you know? Everybody started coming to me and hang out with me because if we got pulled over by the cops, I could show them my ID and they'd see that I was ex-military, and it was like a get-out-of-jail-free card. So . . . I kept doing that until I got arrested for possession.

Jasen: When I was in the service, I was in the Air Force, so we didn't leave . . . you know, I was in AMMO, so we stored all the munitions and we loaded them, we built and assembled all the bombs and missiles. . . .

A big problem I see with all the vets is that a lot of people hold their feelings in. It's not cool going to your superiors and saying, hey, I need help. I've had bad experiences with the VA, but actually this VA here in New Orleans, believe it or not, I would love to commend this VA because they've helped me out tremendously. It got to the point where I hit rock bottom. I mean, I've been to some dark, dark, shitty places. I was sleeping on the streets for, like, a week. I didn't even think about the VA, because before, they've never done anything

for me in the past, you know, it's always been a hassle, this and that . . . but then I talked to someone and they said, hey man, you should go and see what the VA can do for you. So I came here and I found out about this program, and they were saying, it's an apartment complex and you get groceries, you just basically live on campus and go to counseling and whatnot here at the VA, and also there, at the facilities, where we're staying. I said, "Wow, that's great, anything will beat, you know, freakin' sleeping on the ground!" I asked them, "When can I get in?" This was on April 1st—I've only been here for two weeks—the lady at the front said, "You gotta go through some clearances, you gotta get a physical and get blood work done, and see a psychiatrist just to make sure you're physically capable and you're mentally stable—so that you're not gonna go freakin' postal and kill everybody," you know? So I ask her, "How do I do all this stuff?" And she says, "The first appointment I have available is in a month, on May 2nd." And I was like, I can't wait to May 2nd, it's too long! What am I gonna do for a month? I was really down at that point, like I said, I really hit rock bottom. I wouldn't say that I was suicidal, and I wasn't really homicidal, but it was almost to the point where I was, like, fuck it—excuse my French, but you know, I don't care anymore. So I told the lady, I said, "I can't do it anymore," and she said, "well, let me see what I can do for you." So she started calling other VAs, they've got little satellite offices all over the metro area, and she was able to get me an appointment that day! I went to the doctor, I went to the psychiatrist, did everything within three hours. So the following morning I went to the shelter. Within twenty-four hours, I was in. So, like I said, this VA . . . they care.

Jamie: Right when I came back and I messed everything up with my fiancé, I got arrested for what I did to her, because I blacked out on alcohol and I woke up . . . I hit my fiancé and I thought I could never do that, I couldn't even remember it! I shattered her face. She pushed me out of a moving car . . . I did never believe in flash backs, I thought a flash back was just remembering it, but my parents said that I was possessed by the devil. And that scared me, so I checked myself into a mental home, talked to the VA and said that I needed help. So

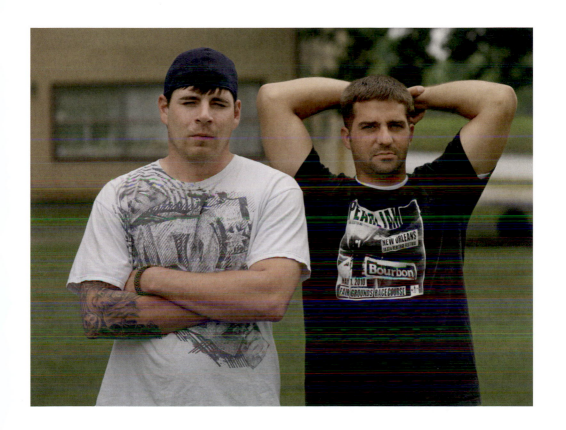

2012 — New Orleans, LA

Epilogue

2012 — New Orleans, LA

Epilogue

it took me going to jail ... well, I finally called and they said that they could get me in this program but you gotta stay in jail. And I was like, fuck that! So when my taxes came in, I bailed myself out two weeks later. My parents weren't gonna bail me out. They were like, you belong in there! And I did. I belonged in there.

Jasen: Well, it gets to the point, this drug problem, where your parents ... you don't care how loving they are, they can't do nothing for you anymore.

Jamie: Yeah, because, I have really good parents but they just couldn't deal with me anymore. My dad has never seen that, like, how can you destroy stuff that fast? In a year.

Jasen: When I came back from Afghanistan, I had twenty grand in the bank. And you had what, fifty?

Jamie: I had 55,000 dollars. I spent that in eight months. On dope. I shattered my knee, twice, I fell out of a Chinook, and when I landed, my knee flexed backwards. After that, it was really easy to get prescribed stuff. The Army put me on it for about three months, and then they just took me off. And I told the doctor: "You cannot do this!" He's like, "Why, are you dependent?" I said, "Yes!" I told him, "I'm gonna get sick...." They were like, sorry, here's some Ultram—which is not a narcotic. And they wrote me off, told me just to come back once a week to check the knee. So I started buying pills off the streets, in Alaska, it was 120 dollars per pill, and I was doing ten pills a day. So I spent that money real quick. In five months. And then I pawned some of my stuff that I bought when I got back from my deployment so I literally had nothing to show for but a habit. So whenever I came back, all my friends were expecting a war hero and all that. I was Airborne Infantry, I got two Purple Hearts, I was put in for a Bronze Star, I didn't get it because I was ranked too low.... A lot of stuff pissed me off because I was real selfish, you know, I thought I deserved a lot of that, but.... And my friends thought that I was gonna be something else when I came back, and I was big and I looked good and everything, but they were just.... Whenever I got back with my fiancé and we started doing drugs, they were like, dude ... you're going to hell, man. There is no hope for you. But I refuse to believe that. Because ... I've accomplished a lot in my life.

2012 — New Orleans, LA

Even whenever I was fucked up, you know? But that gives me hope to get clean, and I know I can be a success.

Jasen: I was originally based in Seymour Johnson Air Force Base in North Carolina. Like I was saying, when I was in the service, I was in the Air Force, so we never left the base. We were in Kabul and we were confined to the base. We had mortar rounds shot at us, other than that...yeah, we had to carry around M-16s, but I never fired one round. I'm thankful for that. But the MPs—the military police—they would have to leave and go do patrols and whatnot, and I had two really good friends of mine, from my base, actually not come back. So, I mean, that hurt me. And then right when we got back from Afghanistan, my best friend—he never showed up for work one day. So I was like, what the hell? I went to his house—I had a key to his house, he lived off base—and he was laying in his bed with his brains all over the wall. Killed himself. Shot his head off. I don't know why. I found him and I had to go back and tell my First Sergeant what was up....And they knew that I was closest to him, so I had to go pack all his stuff, I had to drive his car into a container so they can bring all this stuff back to his parents. It was sad, you know....And that's when I was like, man, this is, like, ruining people.

When I came back after my deployment in 2008, I was clean, of course—well, Jamie has a different story, he got injured—I never got injured so when I came back I was fine. I got me an apartment, I had a girlfriend...everything was peaches and cream, as the saying goes, but....See, when I was in the service, my mom...she threatened....My mom, she had a substance abuse problem and she had a miscarriage in the 1990s, so they gave her some medicine because it hurt her, and she got hooked on Oxycotton and shit, and I have a younger brother and younger sister, and they got taken away from her, because of her drugs and drinking. I was real close with my mom and she didn't want me to go in the service, she was like, "Well, if you leave me, all my kids will have left me, blah blah blah," you know, she was all sad and everything, and she said, "I'm gonna kill myself." She always said that she will. Well, she did, when I was in basic training. So I always had that on my shoulders, like, am I

the reason she committed suicide because I left? And then I feel bad for my little brother and my little sister...so I had a problem with trusting women, if that makes sense. I was always afraid that they would leave. I was abandoned once by a loved one, I don't want to have that feeling again. So for a while, I never dated.

But when I got back, I hooked up with this chick. I loved her to death, she was perfect, everything I wanted in a chick, but...well, I got into a car accident and my life changed from there on. I got hurt, I got two herniated disks in my neck so I got prescribed Percocets and then Oxycotton. I ended up using, I was hiding it from my girlfriend, and before you know it, I was getting fucked up all the time and not remembering things...I would hide it. Mask it. She thought I was just drinking. She just finally left me and I went, fuckin'...just straight, I started shooting dope, heroin...I just didn't care anymore. You know, when you start doing dope, you start pawning shit, things just start disappearing...basically, I started slowly losing everything and then before I know it, I'm getting kicked out of my apartment, the cops are knocking on my door telling me I gotta leave, and I lost my car. Then I went to live with some friends, and I just continued to use and they were like, dude, you can't be getting fucked up! They kicked me out and I had nowhere to go. I went back to my neighborhood that I grew up in and I would hang out by my friends' house during the day and then, at night, their parents wouldn't let me sleep on the couch, so I would go by the playground. I would just sleep behind the backstop, they had the press box, where the announcers for the game are in? I'd sleep there, underneath the stairs or something. I was by myself and I had nothing. I didn't even have the cardboard box! I skipped that. Believe it or not. I lasted about a week and then I was like, there's gotta be something out there. That's when I came to the VA. I was getting rained on and shit at night. It sucked. For a few days, I didn't eat—I lost a lot of weight. Sometimes I would eat at my friends' house, you know, get something there....Those friends, actually, basically shut the door on me. I guess they were not really friends. That was a time in my life that I definitely don't want to go back to. That's why I cherish all this recovery. I think

that had to happen to me because before I went to rehab, I always went back to my apartment, went back to my car, went back to my job . . . and my dad, he's wealthy, so he took care of me, he'd send me money, but then it got to the point, that time, where I had nothing to go back to. If I left the shelter now, I'd have nothing. I'd have the bag that I went there with. Literally. And I got achieving medals, I got commendation medals, I was a decorated troop at one time, too, you know. And proud! And here, look at me now. Fuckin' sleeping in the streets. It's bullshit. And Jamie, you know what I'm saying, because at one time, I was mad at the United States for making me go through all this! I'm not suicidal, but at one point, I was homicidal. I was just mad. I was angry! You start thinking some crazy thoughts.

Jamie: And you get wrote off. The VA in Baton Rouge, they would write me off. I had thirteen different doctors telling me who I am. I was like, dude, you've met me for about five minutes! And y'all are reading my story and writing me off as this. I don't know . . . being back has been a complete nightmare.

When I was living in the woods, I actually enjoyed that. As Infantry, we were used to staying out. So I was like, I'm gonna do this and save up some money and then go and join the French Foreign Legion. I was looking forward to this all summer! Me and three of my buddies were gonna go join the Legion just because I couldn't escape . . . just war. I got so addicted to it. I could sleep good over there in the Middle East, I could talk to people, relate. . . . Everything made sense. When I came back. . . . But while we were over there, we were bitching, too. Because I lost a lot of friends. My second week in Iraq, I was a cherry private, and I was talking, like, I can't wait to get in the war! Well—I got in it. Six of my best friends were liquefied by a bomb, in my second week. That day, everybody got hit. Once or twice. It was just a bad day. We called all the medics to do BDA, body damage assessment, and we had to pick up our friends. It took us six hours to pick up pieces of our friends and to put them in a bag. I just didn't know what to feel. I was like, this is no joke. And after this, that's when I got that mentality, like, fuck it, I'm gonna die here. And it was easy after that. Our sense of

humor changed. I mean, we were just disgusting. Like, you know, the way we talked . . . but that was normal for us! We all took gruesome photos—I have files on files of dead bodies because we just had to take pictures of it . . . we did, and we wanted to, because we were proud of that—they were shooting at us, and it was justified. Easily.

Well, it stopped being justifiable, in Afghanistan, when I was a sniper . . . the Taliban started making the bombs bigger because we had bigger tanks, and one of the IEDs killed two of my friends. I wasn't there, but I heard about it, and we had to move to that area. I was scared shitless, you know, I'm, like, we're about to go home . . . we got six months left, and a car was parked on the side of the road. It was called the K-G Pass. Have you ever seen that TV show, *The World's Worst Roads*? Well, the road was like that, it was real thin, as wide as your truck, and when you're looking over the turret, like, if you dropped, it's, like, a thousand feet down. Cars would pull over into a little ditch and this one car, it was pulled over and I was the lead truck gunner, and he just pulled out in front of us and I . . . whenever I got scared, I shot, you know, and I got scared and I opened: Boom! Booom! Booom, into the car. I put two rounds into the road, two in the engine block and one through the window and it went through the passenger side. A 50cal is damaging, and it went through the little girl in the back. She was about three. (*Jamie's eyes well up, his voice starts quivering, he pauses and breathes heavily. Jasen, in a calming gesture, puts his hand on Jamie's back.*) We had to do BDA by ourselves, and my Platoon Sergeant got so mad at me about that . . . he made me get out the truck and get a Private and we had to pick that up. He said, "This is on you! Look what the fuck you did!" And I'm like. . . . He got in trouble for that because you're not supposed to do that shit. And that really tore me up. I'm not over there to kill little kids! I don't care what the fuck. . . . That's not . . . no. And when I had to justify it to my First Sergeant, I started choking up and they were like, don't worry about it, it's OK, you didn't do nothing wrong. You're not getting in trouble for it. . . . Well, I was glad about that, but this shit is not right, man! And that's what we're losing, people over there. . . . Right then and there, I saw the bullshit and everything. If a Platoon Sergeant who's

been in the Army for nineteen years and deployed once and I was only in for four years and this is my second deployment? And he's getting away with this shit? Something's gotta give. And I would like to say that I'm glad to be back, but sometimes I really think that I should have died over there.

Iraq was more violent. But the Taliban in Afghanistan fought harder. I respect the Taliban. I really do. Anybody who wants to fight for something they believe in . . . yeah. They're agile and whenever they hit you, they hit you. In Iraq, they were just setting up them damn bombs. In Sadr City, we got hit and we didn't know what to do, so we opened fire on a village and we killed thirty-seven people in one night. And we were proud of that! Just because they hit us so hard! But Afghanistan and Iraq, they were just completely different.

I was living with my parents for about six months, when I got out. I had my own place when I got out of the Army, and I was living with my fiancé, but that wrecked and . . . that was a year ago, in April 2011. And after I hit my girlfriend, I checked myself into a mental hospital, because I was raised by my grandmother and my mom—I'm a mama's boy—and I thought I could never do that! So I got clean for a little while, but I'd still go and smoke weed just to escape reality, and then I went back to school and I was doing fine. My dad was like, if you keep doing this, man, you'll be alright! But then I took a semester off because . . . I mean, basically, I just wanted to get high. Me and my dad just kept getting into it and I was just, like, alright man, I'll leave, so I just kind of packed up my shit and went to the woods. I started getting rained on and shit. I made my own tent because I still had all the gear from the Army, so I made shit out of my poncho, I was just living like that, Rambo-style, you know? I lived there for a little over a week, just in my neighborhood.

Jasen: Were you eating critters?

Jamie: No, just a bunch of Ramen noodles. But I got tired of that and went back home and my dad was like, "I ain't got nothing for you." So I pretty much stole his truck and that night I went to jail. My parents came and watched me get arrested, and I was like, "y'all got to get me out of here," and they said, "no." They just told me that I belonged in there,

and I really did. So I sat there and thought about it and when I got my tax return, I bailed myself out. I was in jail for about two weeks. I was detoxing hard in there! I also got into three fights in jail. So on top of my charges that got me in jail, I got to fight three battery charges from jail. Because I was a rookie in jail and people would steal shit from me. And I'd just hit them, you know? I just didn't take shit. And that's just a bad way to be. So when I bailed myself out, my parents had already been talking to the VA, and the VA said that they'll get me out of jail, but that I had to stay for another month and a half. I was like, "No, I'm getting out of here!" I got out and I stayed clean for about a week, and ... it's just really easy to get back on, you know? I just wanted to escape. I really didn't care about living, at all. I didn't have the balls to shoot myself or hang myself, so, you know ... I was trying to overdose a lot. . . . The night I went to jail I did a lot of drugs and I went to a store and I was robbed at gun point. I chased the dude down, and I got arrested because I had drugs in the car. It was a turning point for me. I'm just better than that, you know? Because I did do good in school. . . . The way I been living is not working. The way I'm used to being violent like that and thinking that you're tough when you're really not ... I'm not in the Army no more. It's done. I don't have to go back. But it's what I ultimately wanted! And now that I'm out, all I can think about is getting back over there. So I'm just trying to get rid of that.

Jasen: A big problem, you know, being in the service, is that there's a schedule, and a regiment, and everyday it's the same thing. It's routine. PT in the morning, chow hall, then you get dressed, go to work, get off of work, hit the gym, chow hall ... then sleep, and then do it all over again.

Jamie: And you have the best friends you'll ever meet. People who would die for you. Camaraderie. . . .

Jasen: Camaraderie, no doubt! But when you get out in the civilian world, out here in New Orleans, it's, like, what do I do now? It's weird. It's different.

Jamie: It's depressing. I haven't gotten my disability for PTSD yet, I'm still waiting on it, but I claimed it. It's been a year since I claimed it. I know I'll get it. I used to look forward to that, but I don't want to use that as my only income,

you know? I better get something for it, though! I'm still waiting for my knee replacement. I at least want them to pay for surgery! That's what I meant when I said I've been written off... I shattered my knee twice and they scoped it and kind of cleaned it up, but it still hurts, and it's still dislocated, but they're like, well, you gotta wait till you're older, because you're not old enough for a knee replacement. I'm twenty-five and that makes no sense. What do you have to do? It still hurts, but not as bad because I've strengthened muscles around it. But I'm not how I used to be. I'm just kind of broken, you know? I jumped out of airplanes, in the Army, for a job, and I came out all beat up. Then again, I get nervous about getting surgery because I know I'll get prescribed again.

Do we know a lot of soldiers who got hooked on painkillers? Yeah.

Jasen: We could tell you stories about Afghanistan and heroin....

Jamie: We brought our habits with us from the war. When we got back from Iraq, we all drank about it and we'd talk about our buddies and cry. We drank a lot. A lot! Ridiculously a lot. You'd drink yourself into a coma, and I wasn't the only one. When we went to Afghanistan, like I said, we got stop-lossed. Half my unit did! We were supposed to get out, we weren't supposed to go over there! We had just gotten back from Iraq and we lost so many people. We just went to Afghanistan with the attitude, like, fuck it. It took us about two months and we got our hands on them steroids from Special Forces guys. We got them for real cheap. So we were all juicing up and we got huge! You get, like, 5,000 dollars worth of pure Iranian steroids—which are probably funding the dudes that are blowing you up—and we got real big, so we looked mean. We focused on our bodies a lot, over there. We used to raid people, you know, kick in doors and stuff.... Well, we told one pharmacist, you're good, we'll leave you alone, just keep giving us Xanax, pills, and all this. You pay, like, thirty dollars and you'd get 6,000 dollars worth of drugs over there.

When we were in Ghazni.... Have you ever heard of PFC Bergdahl? The first American soldier who got captured?

Well, that was my unit. We spent forty-nine days in the desert, just out there, looking for this kid. One time, we had just gotten into a TIC, troops in contact, or a fire fight, we found this dude who was riding on a camel. He had two bags full of stuff and our PL looked into it, and he's like, man, that's a lot of hash! Me and my buddy both looked into it, too. We said, that ain't hash. That's heroin! We paid the dude 100 dollars and we got a ridiculous amount of heroin. We didn't have any needles, because we were still in the desert, so we couldn't shoot it up, but we smoked it. On tin foil. You get the same effect, though. I was falling over on guard and stuff. . . . But I didn't care. If I was going to die, at least I'm high! That was the way I was thinking. And that's the way a lot of dudes thought. A lot of dudes did it that you don't think were gonna do it. Like my First Sergeant did it. That's why he looked out for me so much. Pretty much, if you found a way to get drugs, you were gonna use them. It was there. We would take cover in marijuana, hash. . . . It was ridiculously easy to get over there. Because we were running the show! I mean, you go into a village—when you go in there, you run it! That's a powerful feeling, you know? You get addicted to that. When you're behind a gun, you get a big power trip. So we would take over villages and then get cool with them, that's what it was about. We took that back with us.

We're still in touch with our Army buddies. Oh, yeah, big time. They're doing pretty much the same.

Jasen: One of my buddies, he just got popped for heroin possession, up in Baltimore, he's facing six years in prison.

Jamie: They're either still in school, or trying to do what we said we would do, and just kind of working towards where we're at: rehab . . . or they re-enlisted.

Alcohol. . . . Just because it's legal doesn't mean it's OK, you know? And the way soldiers drink. . . . That's what affected us when we got back from Afghanistan, when the Army just wrote us off. . . . Like, my friend, he got kicked out after three deployments, for a DUI. It used to not be like that. They would just counsel you and get you help. A lot of dudes wanted to stay in the Army. They re-enlisted, they had nothing else! Their wives were divorcing them, every single one. If you're in the Army, you get a divorce. It's a curse. I mean,

it's not the girls' fault or anything. It really is us, you know? And then we started taking classes on why we're like this, and the Army and the Marines . . . I mean, the two combat forces, we're 85 percent more affected than. . . . We put a big population dent in there. Have you ever heard the expression "Generation Kill"? Like, our generation is amped up on video games and music and stuff, so we're a lot more violent than our parents. It really does come out and I don't want to be that way. Not anymore. It was essential over there, but I'm not over there. And I want that to stop. It's painful.

I gotta move away from Louisiana, I gotta get away from here. I just want to change my setting into something where I can start over new. Where people don't have to know me and write me off, right there. They can get to know me if they want. All my friends from high school, they're either afraid of me, or they want nothing to do with me. It just hurts, you know. I guess people don't think it does.

The VA shrinks were telling me, y'all are psychopaths and sociopaths, y'all don't have a conscience! And I was like, yes, I do feel bad about stuff! Maybe not as bad as I should but we're used to numbing stuff out. When they told me I didn't have a conscience, I fought with them on that. It's not right to say that to someone! And they told my mom that, and my mom is really Christian and always good to me. I had a really good childhood, I even went to private school. . . . They brought my parents in and said, "Some kids are born blind, and your son was born without a soul." And my mom was looking into my eyes and asked me, "Is that true? You really don't feel nothing but negative?" And I was like, "yeah, now! Because y'all are saying this! But, no!" Thirteen doctors confirmed it, yeah, he has sociopathic tendencies, and I'm sure I do, because that's just how we were trained. I mean . . . I don't think it's true, because I do feel bad for people and I feel bad about stuff I did. I'm sure you've heard this a lot, how veterans are against the government and stuff, because it's just a bunch of rich dudes getting richer off of something that we have no idea about! If we're going to war, let's take the whole country. If we're gonna help people, let's help people! Go over there and help people. We really were just bullies to the Iraqis. I'm happy about doing it, because that's the way

you were trained. When I went to Ranger school … I mean, it's a good school, but there was a point where the instructor would come up to you and say, "By the end of this, you will be able to kill your own mother with a smile! Y'all will be savage fucking dogs!" And you're like, "yeah, yeah, yeah!" They're really good at pumpin' your head up. The Iraqis—or the Hadjis, as we called them—they're no longer human. They're cattle, and that's what you're taught. So when you come back here and you're seeing people you grew up with. . . .

Jasen: There's a lot of triggers. There are a lot of things that people will do that remind you of over there.

Jamie: And you're real paranoid.

Jasen: Yeah, yeah … like, I can't have people behind me, can't be in crowds. . . .

Jamie: I don't enjoy doing what I used to do, like going to football games and stuff … all those people … I can't do that.

Jasen: Noise fucks me up a lot.

Jamie: That's why I started using again because when I'm high, I'm two different people. I can be social. And then other people just don't trust you even more. Because you're a junkie. And that sucks. This recovery thing … it really is a blessing that they have something like that. But you have to put in the work for it. There's no magic cure for this.

I feel so bad for Vietnam vets. . . . At least the VA addresses this issue now. The Vietnam vets, they got home and got spit at! And they didn't even want to go, they got drafted! We volunteered and everybody pretty much welcomed us in. It's just that, you know, I blew it. You get that saying a lot at the VA: You knew what you were getting into. But you really don't.

Jasen: That's what we're trying to do now, we're trying to let it all out. So you kind of caught us at a good time. We're willing to talk about it. But there's a few years where I just didn't talk about anything.

Jamie: Once I got drunk and high, I would start talking about the war and somewhat … bragging about it, and people were, like, just really put off by me. They'd say, dude, how did you do that?—It's not hard pulling a trigger, it's not even hard picking up body parts … you're just working. You gotta look at it that way, and you take that home with you.

I grew up being a patriot, I'd always admired my grandfather because he was in the Army during D-Day, and just the way he carried himself . . . I just grew up on that. 9/11 really pissed me off, and I think a lot of people forgot about that. When you see that shit on the news. . . . That shit pisses me off! I don't watch the news. Because they're intentionally making soldiers look bad. That one Marine that pissed on dead bodies. . . . A lot of us used to do shit like that. He was just an idiot, posting it on YouTube. You don't do that. But you gotta go insane to stay sane. It's just a bunch of guys like us, you know? We're going through a lot of shit, and we do have souls. But over there, you gotta put that shit aside or you'll go nuts. Once you put it aside, it's kind of a good time because you're just around your best friends—who will die for you.

I had a really good childhood, but I was getting into a lot of trouble back home, being a kid and fighting. I flunked out of college my freshman year because I never went. I needed the discipline. The Army was good for me and good to me.

Jasen: You grow up, you become a man. . . .

Jamie: And that was what I thought being a man was, you know? But you don't have to go to war to be a man. I guess it was something I had to go through, but we need to not be over there. What are we doing? Can anybody really answer that? I was deployed twice, and I don't know what we're doing. It's just causing more problems. It's like the start of World War III. I will still support anybody that wants to join the Army, but I just warn them: It's not what you think. And a lot of the stuff, like, when you're not in a fight, is extremely boring. You're just kind of stuck there, and that's when your brain . . . you just lose it. You have to lose your brain a little bit to stay over there. Nothing you train for will ever prepare you for what you're gonna go through, the people you'll lose or what you'll turn into. I don't want people to be afraid of me because . . . I don't think I'm a bad guy.

Two days later, I visit the guys at their recovery facility in a New Orleans suburb. It's an uncharacteristically gloomy day and it rains on and off. "This is kind of a poor ghetto neighborhood. You can hear guns going off every once in awhile . . . it's really not the best place for post-traumatic veterans," Jasen

says. Nevertheless, the house they share with two other men is spacious and friendly. Bikes are parked in the living room—it's their only mode of transport besides the facility buses, and they ride them to get to the main office and meeting venue which is about five blocks away. Jamie and one of his roommates go fishing sometimes in the river behind their house. The guys share smokes, cook, and watch movies together, and seem to get along very well. There's a quiet understanding among them that needs no words. Like back in their Army days, they are surrounded by brothers.

There are two bedrooms upstairs—next to each bed is a bed stand, a lamp, and a locker which holds their medication. All the men in the program are on antidepressants and take sleeping aids. They are obligated to clean their house once a week, with an inspection the following day. Jamie says he wants a beard really bad, but unfortunately, the patients are not allowed to have facial hair. So instead of grooming his own, he draws pictures of lumberjack-looking men in his sketchbook, while he complains about that stupid regulation. Their living situation reminds me of the barracks I visited in Fort Hood four years ago: The guys can't seem to escape their military life.

Glossary

ACU — Army Combat Uniform, the new uniform with the "digital" pattern. The ACU uses a new military camouflage pattern that blends green, tan, and gray to work effectively in desert and urban environments. See also: BDU.

AIT — Advanced Individual Training. Where a new soldier learns the skill he will use when he arrives at his first unit.

AK — Russian assault rifle

Ambien — a prescription drug for patients who suffer from insomnia

Article 15 — an Article 15 is "nonjudicial punishment." It's kind of a mini-trial conducted by the commander if someone commits a punitive offense under the Uniform Code of Military Justice (UCMJ), and the commander feels the offense is too minor to warrant a full-blown court-martial. It's best to think of it as a misdemeanor court, vs. a felony court (which would be more indicative of a court-martial).

AWOL — Absent Without Official Leave. Being absent from one's post or duty without official permission, but without intending to desert.

Bales, Robert — United States Army soldier, known primarily as the alleged perpetrator in the killings of seventeen Afghan civilians in Kandahar Province, Afghanistan, on March 11, 2012. On March 23, 2012, Bales was formally charged with seventeen counts of murder and six counts of assault and attempted murder. He is currently being held in detention in Fort Leavenworth, Kansas. "Three deployments in Iraq, where he saw heavy fighting, and a fourth in Afghanistan, where he went reluctantly, left him struggling financially, in danger of losing his home. And there were more direct impacts. During his deployments, Sergeant Bales, thirty-eight, lost part of a foot and injured his head, saw fellow soldiers badly wounded, picked up the bodies of dead Iraqis, was treated for mild traumatic brain injury and possibly developed PTSD, his lawyer and military officials said.
Dr. Stephen Xenakis, a psychiatrist and retired brigadier general who was an adviser to the Joint Chiefs of Staff, said that after a decade of combat, where hundreds of thousands of troops have sustained traumatic brain injury and PTSD, those syndromes by themselves seem inadequate to explain how a seemingly normal and widely admired sergeant might have single-handedly committed one of the worst war crimes of the Iraq and Afghanistan conflicts. With his multiple deployments and wounds, Dr. Xenakis said, Sergeant Bales seems emblematic of bigger problems: an overstretched military battered by eleven years of combat; failures by the military to properly identify and treat its weary, suffering troops; and the thin line dividing "normal" behavior in war from what later is deemed "snapping." Quoted from an article in The New York Times, published March 19, 2012: "At Home, Asking How 'Our Bobby' Became War Crime Suspect," by James Dao

BDU — Battle Dress Uniform, the old-school uniform with the green, brown and black organic pattern.

BC — Bradley Commander

Bergdahl, Bowe — PFC Bowe Bergdahl (born March 28, 1986, in Sun Valley, Idaho) is a United States Army soldier who, since June 2009, is in the captivity of the Taliban-supporting Afghanistan Haqqani network. Bergdahl is assigned to the 1st Battalion, 501st Infantry Regiment, 4th Brigade Combat Team, 25th Infantry Division, based at Fort Richardson, Alaska. He went missing on June 30, 2009. Since then, the Taliban have released five videos showing him in captivity. The Taliban have demanded $1 million and the release of Afghan prisoners in exchange for Bergdahl's release and have threatened to execute him if their demands are not met. Bergdahl

claimed to have been captured as he fell behind on a patrol.

Blackwater (current name Academi) —one of the many private military companies that employ mercenaries. Blackwater Worldwide played a substantial role during the Iraq War as a contractor for the United States government. Since June 2004, Blackwater has been paid more than $320 million out of a $1 billion, five-year State Department budget for the Worldwide Personal Protective Service, which protects U.S. officials and some foreign officials in conflict zones. Going mercenary as a private security contractor in Iraq is a lucrative job for Infantry soldiers after their Army discharge, especially because they earn up to $200,000 a year—up to five times what a regular soldier in Iraq makes.

Bradley—the U.S. Army's current light armored vehicle

Chinook—a type of helicopter

Dismount—the Infantrymen on foot who accompany the armored vehicles on a mission

DUI/DWI—"Driving Under the Influence" of alcohol or an illicit substance/"Driving While Impaired" by alcohol

E-4, E-5, E-6, E-7—synonyms for the Army ranks of Specialist, Sergeant, Staff Sergeant, Sergeant First Class

ETS—Estimated Time of Separation

FOB—Forward Operating Base: American Army posts in Iraq and Aghanistan

Fobbit—a derogatory term for soldiers who are deployed but only stay on the FOB and pull guard on cafeterias or gyms etc. Grunts who go out the wire look down on fobbits because they have never seen combat.

GED—General Educational Development (or GED) tests are a group of five tests which (when passed) certifies that the taker has American high school-level academic skills.

Grunt—a grunt is a soldier who does the dirty work, who leaves the wire, i.e., an Infantry man. The opposite of a fobbit.

Hadji—a derogatory term used by soldiers to describe Iraqis

IED—Improvised Explosive Device, or a roadside bomb. In the Iraq war, IEDs were used extensively against coalition forces and by the end of 2007 they were responsible for approximately at least 40 percent of coalition deaths in Iraq.

Infantry—Infantrymen are land based soldiers who are specifically trained for the role of fighting on foot to engage the enemy face to face and have historically borne the brunt of the casualties of combat in wars. As the oldest branch of combat arms, they are still the backbone of modern armies.
Infantry units have more physically demanding training than other branches of armies, and place a greater emphasis on discipline, physical strength, fitness and spontaneous sustained aggression. The Infantryman himself, with or without his personal weapon, is considered a weapon system.

JRTC—Joint Readiness Training Center in Fort Polk, Louisiana. The Joint Readiness Training Center (JRTC) is focused on improving unit readiness by providing highly realistic, stressful, joint and combined arms training across the full spectrum of conflict.

Keith, Toby—American country singer. Since 2002, Keith has made numerous trips to the Middle East to bring entertainment and encouragement to U.S. men and women serving on or near the front lines although he doesn't personally support the war in Iraq.

Klonopin or Clonazepam—a prescription drug that helps relieve anxiety, seizures and panic disorder. It is also a muscle relaxant.

Leave the wire — the FOB's wire. Soldiers who leave the wire leave the Army base and go on missions in Iraq.

Maddow, Rachel — American television host, political commentator, and author. Maddow hosts a nightly television show, "The Rachel Maddow Show," on MSNBC. Maddow is the first openly gay anchor of a prime-time news program in the United States and known for her liberal views.

Maher, Bill — American stand-up comedian, television host, political commentator, author, and actor, best known for his HBO show "Real Time with Bill Maher."

Martin, Trayvon — The fatal shooting of Trayvon Martin by George Zimmerman took place on February 26, 2012, in Sanford, FL. Trayvon Martin was a seventeen-year-old African American male who was not carrying a weapon. George Zimmerman was a twenty-eight-year-old Hispanic American who was the community watch coordinator for the gated community where the shooting took place. While on a private errand, Zimmerman — a member of the volunteer neighborhood watch — saw Martin walking inside the gated community where Martin was visiting his father and his father's fiancée. Zimmerman called the Sanford Police Department to report Martin's behavior as suspicious. Martin was wearing a hoodie with the hood up because it was raining. He was also carrying a soda bottle and a small bag of Skittles. Shortly afterwards, there was an altercation, which ended with Zimmerman fatally shooting Martin once in the chest at close range. When police arrived on the scene, Zimmerman told them that Martin had attacked him, and that he had shot Martin in self-defense. Zimmerman was bleeding from the nose and mouth and had two vertical lacerations on the back of his head. Emergency medical technicians treated Zimmerman at the scene, after which he was taken to the Sanford Police Department. Zimmerman was detained and questioned for approximately two hours during which time he taped a video statement, and was then released without being charged. Police said that they had not found evidence to contradict his assertion of self-defense. The circumstances of Martin's death, the initial decision not to charge Zimmerman, and questions about Florida's stand-your-ground law received national and international attention. Allegations of racist motivation for the shooting and police conduct contributed to public demands for Zimmerman's arrest. A stand-your-ground law states that a person may use (deadly) force in self-defense when there is reasonable belief of a threat, without an obligation to retreat first. The Trayvon Martin case brought a large degree of criticism to the law. Legal experts are split as to whether charges will be dropped under Florida's stand-your-ground law before the case even goes to trial, as the extant Florida law allows the alleged shooter, George Zimmerman, to argue that the charges should be dropped before trial even begins. Legal experts are also split as to whether Zimmerman's actions will be viewed as self-defense, should the case go to trial.

MOS — Military Occupational Specialty: the soldier's job.

NCO — Non-Commissioned Officer

Olbermann, Keith — American political commentator and writer. Most recently, he was the host of the weeknight political commentary program, "Countdown with Keith Olbermann." Olbermann established a niche in cable news commentary, gaining note for his pointed criticism of mainly right-leaning politicians and public figures such as Fox News Channel commentator Bill O'Reilly, President George W. Bush and 2008 Republican presidential nominee, John McCain. Though he has been called a "liberal," he has resisted being labeled politically, stating: "I'm not a liberal. I'm an American."

Oxycotton — slang for the prescription drug Oxycontin which contains oxycodone. Oxycodone is a very strong narcotic pain reliever. When used recreationally the high is very similar to that of heroin.

There is a great risk of experiencing severe withdrawal symptoms if a patient discontinues oxycodone abruptly.

Percocet — a narcotic pain reliever

PL — Platoon Leader

POG — People Other than Grunts, in other words: fobbits. Pronounced like "pogue."

Prozac — an antidepressant

PSYOP — Psychological Operations. Techniques used by the military and police to influence a target audience's emotions, motives, reasoning and behavior.

PT — Physical Training

PTSD — Post Traumatic Stress Disorder. Post-traumatic stress disorder is an anxiety disorder that can develop after exposure to one or more terrifying events that threatened or caused grave physical harm. It is a severe and ongoing emotional reaction to an extreme psychological trauma. This stressor may involve an actual death, a threat to the patient's or someone else's life, serious physical injury, or threat to physical and/or psychological integrity, overwhelming the usual psychological defenses. In some cases it can also be from profound psychological and emotional trauma, apart from any actual physical harm. Often, however, the two are combined. PTSD has also been recognized in the past as shell shock, traumatic war neurosis, or post-traumatic stress syndrome (PTSS).

Purple Heart — The Purple Heart is a United States military decoration awarded in the name of the President to those who have been wounded or killed while serving with the U.S. Military.

PX — Post Exchange: A type of retail store operating on United States military installations worldwide. Originally akin to trading posts, they now resemble department stores or strip malls.

Rear Detachment or **Rear D** — When each unit deploys, there is always a detachment of soldiers from that unit that remain in the rear (on the base). These soldiers are responsible for keeping the unit running at the duty station as well as providing a link between the deployed unit and the Family Readiness Group.

R+R — Rest and Relaxation (military slang). Usually used to describe the two-week leave during which the deployed soldier gets to go home.

RPG — Rocket-Propelled Grenade

Stop-loss — the involuntary extension of a service member's active duty service under the enlistment contract in order to retain them beyond their initial end of term of service date. In other words: If your ETS is too close to the deployment of your unit, the Army forces you to do one more term in Iraq, even though according to your contract you're supposed to be clearing.

UFC — The Ultimate Fighting Championship (UFC) is the largest Mixed Martial Arts promotion company in the world which hosts most of the top-ranked fighters in the sport and produces events worldwide. It is based in the United States.

WTU — Warrior Transition Unit. A special unit for soldiers with PTSD and other war-related injuries. From an Army-related website: "We are an Army at war. The Army Medical Department supports the war effort by providing the highest quality and most advanced medical care for Soldiers on the battlefield–saving more lives of Soldiers wounded in combat than ever before. Army leaders and medical professionals know that some wounds lie beneath the surface and are not always visible upon first assessment."

Xanax — an antidepressant

Zoloft — an antidepressant

Acknowledgments

To "my" soldiers Timmy McClellan, Levi Rollings, Luis Tristan, Tom Edwards, Jamie McFarland, and Jasen Nolting: It was an honor and a privilege to meet and spend time with all of you and I can't thank you enough for being part of this project and sharing your stories with me. I hope that we will remain friends, always.

The following people have provided important additional views and thoughts on the veterans portrayed in this book: Joscelyn McClellan with Angelina and Quentin, Hope Renskers, Larry Christianson, Karl Jacob, Angel Barrett with Lilly and Conner, Cindi Skaza, Jennifer Aldama, Mike Muñoz, Jessica Edwards, and Anthony and Miguel from Play Outsyde. I am very happy to be able to include all of your testimonies in the book. Thank you for your trust.

This book would never have seen the light of day without the generous help and support of Aaron Sonberg, Bradley "Griff" Griffith, Jeffery Marder, Levi "Elmo" Skelton, Coury Stevens, Lisa and Nick Martinez, Melisha Clark, Justin Dooley, Erin McClellan, Rhonda, Hana, and Ron Wiiliainen, Kristin and TJ Renskers, Mikey and JJ Smokrovich, Tim and Christian Renskers, Georgia Christianson, Lisa and Kevin Knoop, Gloria and George Maras, Andreas Hoffmann, Toni Booker Hart, Kayte Muniz and the staff at Sport Shack, Charlie DiPietro from Sports Cards Plus, Dave Dispennett, Sarah and Andy Rodgers, and Big Show and everyone at Gus' Pizza in Goodyear.

In Switzerland: Dieter Glauser and Michael Häne at Resort, Nadine Olonetzky, Thomas Kramer, Lisa Rosenblatt, Chiho and Christoph Bangert with Anna Banana and Lilli, Sereina Rothenberger, Julia Hornberger, Ludovic Varone, Christoph Miler, my brothers and my parents.

This book is dedicated to Larry Christianson, Timmy's grandpa, and to Brandon Sapp, Branden Cummings, and Daniel Morris—may your souls rest in peace.